NATIVE NORTH AMERICAN ART

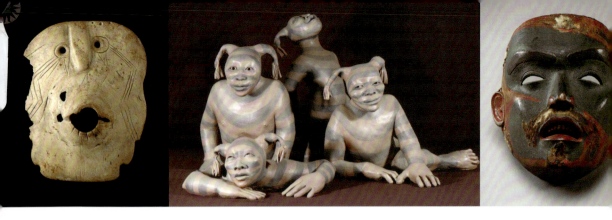

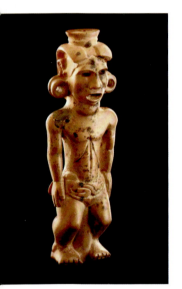

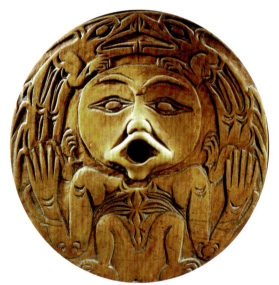

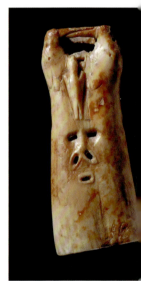

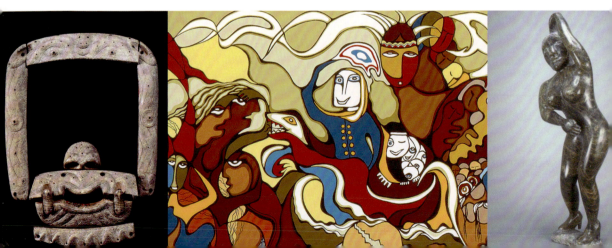

NATIVE NORTH AMERICAN ART

SECOND EDITION

Janet Catherine Berlo
University of Rochester

Ruth B. Phillips
Carleton University

New York Oxford
OXFORD UNIVERSITY PRESS

Oxford University Press is a department of the University of Oxford.
It furthers the University's objective of excellence in research,
scholarship, and education by publishing worldwide.

Oxford New York
Auckland Cape Town Dar es Salaam Hong Kong Karachi
Kuala Lumpur Madrid Melbourne Mexico City Nairobi
New Delhi Shanghai Taipei Toronto

With offices in
Argentina Austria Brazil Chile Czech Republic France Greece
Guatemala Hungary Italy Japan Poland Portugal Singapore
South Korea Switzerland Thailand Turkey Ukraine Vietnam

For titles covered by Section 112 of the US Higher Education
Opportunity Act, please visit www.oup.com/us/he for the
latest information about pricing and alternate formats.

Published by Oxford University Press
198 Madison Avenue, New York, New York 10016
http://www.oup.com

Library of Congress Cataloging-in-Publication Data
Berlo, Janet Catherine.
 Native North American art / Janet Catherine Berlo, University of Rochester, Ruth B.
Phillips, Carleton University. -- Second edition.
 pages cm
 Includes bibliographical references and index.
 ISBN 978-0-19-994754-6 (alk. paper)
 1. Indian art--North America. 2. North America--Antiquities. I. Phillips, Ruth B. (Ruth
 Bliss), 1945- II. Title.
 E98.A7B47 2014
 704.03'97--dc23
 2014004553

Printing number: 9 8 7 6 5 4 3

Printed in China
on acid-free paper

We dedicate this book to Native North American artists, past and present.

CONTENTS

5 THE NORTH 165

6 THE NORTHWEST COAST 205

PREFACE TO THE SECOND EDITION

In the mid-1990s, when we took on the daunting task of writing a one-volume history of Native North American Art for the *Oxford History of Art* series, this field had only recently begun to be taught within North American art history departments. The literature was small, and much of it had been written by earlier generations of anthropologists. The preparation of this revised edition has been both humbling and exciting because of the remarkable flowering of scholarship that has occurred in the intervening fifteen years. Much of this new literature is the product of a new generation of academic scholars, both Native and non-Native, trained in art history, history, anthropology, and art practice. They have filled in missing documentation of artists' lives and creative trajectories, reinterpreted archaeological traditions, fine-tuned our understandings of technologies and materials, and elucidated many other topics. Most important, and often through the contributions of Elders, they have introduced Indigenous knowledge and perspectives that complement and sometimes radically alter older accounts written from the standpoints of outsiders. Museums have again become important sites for the development of such understandings, primarily through the new models of collaborative research with Indigenous communities that have been developing since the mid-1990s.

What is sometimes called, simplistically, "the Native voice" is really a polyphonic chorus which can be dissonant as well as harmonious. We have come to understand that the explanation of the meaning of an image or the function of a work of art may be the property of an individual or a family whose authorization is needed for it to be shared. And we have also become aware that Native experts may regard the sharing of cultural knowledge as a threat to the integrity of traditions that have been subjected to much invasive investigation in the past. Our intention in this book has been to respect the wishes of community members about the appropriate dissemination of knowledge while being aware that there is a great diversity of opinion within Indigenous communities. Inevitably, we have sometimes had to make choices among the conflicting positions held by respected Aboriginal specialists.

WHAT'S NEW TO THIS EDITION

- A new chapter on contemporary art
- New focus boxes in each chapter highlighting individual artists, works of art, and distinctive techniques and materials
- Updates to regional chapters and bibliography
- Seventy-two additional illustrations
- Updated names of tribes and First Nations

The biggest change in the book is the expanded discussion of modern and contemporary art from one chapter and twenty illustrations in the first edition to two chapters and fifty-six illustrations here. Chapter 7 now covers art from 1900 to 1980, and Chapter 8 examines the vibrant contemporary art scene of the last thirty-five years. As in the first edition, we also incorporate modern and contemporary works of art into each of the regional chapters. This strategy recognizes the many dialogues between the old and the new that have always propelled the historical development of Native North American art and continues to do so. The work of a new generation of Native artists has transformed this field, offering insights into contemporary art-making in global as well as local arenas. Artists fearlessly combine the oldest of techniques with the newest of approaches, and the newest of materials with the oldest epistemologies. Within necessary limits of word length and illustrations, we have tried to give a sense of the diverse ways of being an Indigenous artist in the twenty-first century.

A second edition offers a chance not only to fill in gaps and correct mistakes but also to highlight recent research and the intellectual advances it accomplishes. We have further expanded the framing issues that are discussed in the introduction as well as in the regional chapters. We have added three "focus boxes" to each chapter in order to delve more deeply into the careers of individual artists, the cultural biographies of specific objects, the expressive properties of media and techniques, and other timely issues. These boxes tap recent research and are also intended to suggest the comparable depth of discussion merited by countless other examples both noted and omitted in the chapters.

We are keenly aware of how much is *not* covered in this book, and the wealth of artistic and cultural traditions that are *not* mentioned. A one-volume survey limited to 233 images and eight chapters cannot possibly do justice to an entire continent, whose hundreds of artistic traditions span three millennia. It will be for the next generation of scholars to initiate the multivolume, multiauthored approach to Native North American art that we are beginning to see in surveys of other great world arts.

The new edition also provides the opportunity to update tribal names and to correct their spellings. Such names are as accurate as possible at the time of writing and we provide older names in parentheses the first time each appears. The process of renaming is, however, ongoing, and readers will find the most recent preferences on official tribal websites. Some of these changes—such as "Wendat" for "Huron" or "Ancestral Puebloan" for "Anasazi"—respect the relevant community's replacement of a name assigned by outsiders with the one used within its own language. In other cases, such as the term "Anishinaabe" to refer collectively to the Odawa, Potawatomi, and Ojibwe of the central Great Lakes, name changes may restore a broader affirmation of political and cultural identity or nationhood. Still other changes, such as the use of the older term "kachina" as well as the spelling "katcina," better approximates correct pronunciation. To refer to the Indigenous peoples of North America collectively, we use several different terms. While many Native people, especially those of an older

generation, continue to use the term "Indian," younger tribal members often prefer "Native," "Aboriginal," "Indigenous," "Native American" (in the United States), and "First Nations" (in Canada).

ACKNOWLEDGMENTS

Our book is built upon the research and publications of many scholars, as well as advice and discussion with colleagues too numerous to be named here. We are grateful for help given in specific areas during the preparation of this new edition during 2012 and 2013 by the following individuals: Arthur Amiotte, Bill Anthes, Jonathan Batkin, Heidi Bohaker, Alan Corbiere, Kristin L. Dowell, Eva Fognell, Aaron Glass, Elizabeth Hutchinson, Jonathan Holstein, Emil Her Many Horses, Jessica L. Horton, Joe Horse Capture, Elizabeth Kalbfleisch, Karen Kramer, Andrea Laforet, John Lukavic, Bill McLennan, Jennifer McLerran, Nancy Mithlo, Trudy Nicks, Judith Ostrowitz, Zena Pearlstone, Jolene Rickard, Nancy Rosoff, Jackson Rushing, Dan Swan, Judy Thompson, Gaylord Torrence, Norman Vorano, Will Wilson, Robin K. Wright, Jill Ahlberg Yohe, and Susan Kennedy Zeller.

We are grateful for the valuable recommendations made by the teachers and scholars who reviewed the book for Oxford University Press: Andrea Donovan (Minot State University), Michael Holloman (Washington State University), Peri M. Klemm (California State University, Northridge), Jennifer McLerran (Northern Arizona University), Crystal Migwans (Carleton University and Columbia University), Alexandra Nahwegahbow (Carleton University), Karen O'Day (University of Wisconsin-Eau Claire), and Zena Pearlstone (California State University, Fullerton), as well as two other anonymous reviewers.

As in the preparation of the first edition, our dear friend and fellow scholar Aldona Jonaitis led both by example and through her wise and invaluable advice, especially as this manuscript approached completion.

We are particularly grateful to our students Sheena Ellison, Carlie Fishgold, Anne De Stecher, Alexander Brier Marr, and Christopher Patrello, who helped with so many aspects of this book, from the mundane to the intellectual—from photocopying, typing, and identifying resources to conducting research and making substantial suggestions concerning artists and topics. Ellison and Marr updated the timeline, while Patrello worked on the bibliography. Our greatest debt is to Alexander Brier Marr, who began work with us in the summer of 2011 and saw the book into production in 2013, overseeing all aspects of the structure and formatting of the manuscript, paying prodigious and meticulous attention to the figures and their captions.

We are grateful to many generous colleagues at museums and research institutions across North America and Europe who helped with the identification of objects and facilitated the procuring of illustrations. Bethany Montagano's able help in this last task was critical and we are much in her debt. We also thank the seven anonymous reviewers commissioned by Oxford to assess our detailed proposal for the second edition and to comment on the strengths and weaknesses of the first. Their many useful critiques and suggestions helped to clarify what was needed in an updated edition.

The first edition of this book was published in the Oxford History of Art series in the United Kingdom, and we thank Janet Beatty at Oxford's New York division for energetically pursuing the idea of bringing out a second edition in the United States. While she retired just as we undertook this work, we are grateful for her efforts in getting it started. She left us in the very capable hands of Richard Carlin, executive editor for music and art. In our quest for more words and more images with which to elucidate the magnificent history of Indigenous arts of the North American continent, Richard Carlin has been our enthusiastic champion and intercessor.

Janet Catherine Berlo and Ruth B. Phillips
January 2014

TIMELINE

	ARTISTIC	CULTURAL/POLITICAL
4500 BCE	First mound architecture along Lower Mississippi Valley	
3000 BCE	Finely wrought stonework, Indian Knoll, Kentucky	First horticulture in Southwest
2500 BCE	Earliest pottery in Southeast	
2000 BCE	Recognizable aspects of Northwest Coast artistic style begin to appear	• Arctic small tool tradition develops in the North • Copper mining in Lake Superior area
1800–1500 BCE	Earthworks, Poverty Point, Louisiana	
1100 BCE–200 CE		Adena Culture develops in Eastern Woodlands
1000 BCE		Maize domesticated in the Southwest
600 BCE–1150 CE	Mimbres Pottery in southwest New Mexico	
500 BCE–1000 CE		Norton Tradition, Old Bering Sea Culture, and Dorset Culture in the Arctic
100 BCE–500 CE	Ohio Hopewell peoples embellish burials and build geometrically precise mound complexes	Hopewell societies, Ohio River Valley
100 BCE–700 CE		Basketmaker Phase of Southwestern Culture
200–1150 CE		Mimbres Mogollon Culture in the Southwest
550–1400 CE		Hohokam Culture in the Southwest
700–1400 CE		Ancestral Puebloan (Anasazi) Culture in the Southwest
800–1500 CE	Mississippian mounds in construction and use throughout the Southeast	
1000 CE		Thule Culture spreads east across the Arctic
1050–1200 CE		• Norse people establish settlement at L'Anse aux Meadows, Newfoundland. Make contacts with Thule people, possibly following earlier contacts with Dorset people. • Construction of road system from Chaco Canyon
1050–1200 CE		Height of Cahokia, Illinois, largest Mississippian city

	ARTISTIC	CULTURAL/POLITICAL
1070 CE	Serpent Mound, Ohio, built	
c.1100 CE	• Pueblo Bonito achieves its greatest size (800 rooms) • Artistic peak of Hohokam Culture	
c.1105? CE		Hopi Village of Awatovi settled
c.1150 CE		Severe drought in Southwest affects settlement and migration
1200–1500 CE		Athapaskan people (Navajo and Apache) arrive in Southwest
c.1250 CE	Highpoint of architecture at complexes such as Cliff Palace, Mesa Verde	
c.1275 CE		Second widespread drought in Southwest causes migration to Rio Grande River Valley and Mogollon River area
c.1300-1500 CE	Heightened ceremonial activity associated with "medicine wheels" on the northern and central plains	
1492 CE		Christopher Columbus reaches the Americas
1497 CE		John Cabot's voyage of exploration
1500 CE	Makah community at Ozette, Washington, covered by mudslide, which preserved plank houses and numerous artifacts	Calusa culture flourishes at Key Marco in Southern Florida
1500–1800 CE	Navajo learn weaving and ceremonial arts from Pueblo neighbors	
1503 CE		Passamaquoddy and Abenaki (Maine) trade with English fishermen
1505–1518 CE		Wendat (Huron) and Haudenosaunee trade with Basque and French fishermen.
1513 CE		Calusas drive off Ponce de Leon expedition, Florida
1521 CE		Second Ponce de Leon expedition among the Calusa, Florida
1523–4 CE		Verrazano encounters Narragansett and Wampanoag Indians along the Atlantic Coast
1528 CE		Timucua resist Spanish settlement near Tampa Bay, Florida

	ARTISTIC	CULTURAL/POLITICAL
1534 CE		Mi'kmaq trade with Jacques Cartier, Gulf of St Lawrence and Iroquoians
1535–41 CE		St Lawrence Haudenosaunee trade with French at Hochelaga, Montreal
1539–43 CE		Hernan de Soto's expedition through southeastern US unleashes violence and epidemics across a broad region
1540 CE	Cicuye (Pecos) Pueblo at its height as great architectural complex and trading center (artistic)	
1540–2 CE		Coronado's expedition from Mexico into the Southwest
1541 CE		Tigeux Rebellion, Kuaua Pueblo, New Mexico
1576 CE		Martin Frobisher's first contact with Inuit of Eastern Arctic
1579 CE		Sir Frances Drake sails into bay near Point Reyes, California
1585–1607 CE		Sir Walter Raleigh founds settlement on Roanoke Island, North Carolina
1590–8 CE		Spanish invasion of Rio Grande Pueblos
1598 CE		Acoma resistance to Spanish invasion in Southwest
c. 1600		Final formation of the League of the Iroquois (Five Nations Confederacy)
1600 CE	Seventeenth-century Northeastern peoples enrich burial offerings of indigenous shell and copper with new trade goods	Juan Oñate colonizes New Mexico for Spain; Apaches, Navajo, and Utes taken as slaves
1607 CE		Jamestown, Virginia, settled by British
1609 CE		War between Powhatan and English in Virginia
1615 CE		The Wendat welcome Champlain, leader of New France, as a guest in their villages; French-Wendat trading partnership formed
1616–19 CE		Smallpox epidemic decimates tribes of New England
1620 CE		Arrival of Pilgrims at Plymouth, Massachusetts
1622 CE		Jamestown Colony burned by Powhatan

	ARTISTIC	CULTURAL/POLITICAL
1633 CE		Zuni Revolt against the Spanish
1636–7 CE		The Pequot War (Connecticut)
1636–48 CE		The Iroquois and Wendat Wars result in the destruction of the Wendat Confederacy
c. 1637 CE		Ute (Great Basin) acquire Spanish horses
1638 CE		Quinnipiac (Connecticut) confined to reservation
1639 CE		Taos Indians take Spanish horses to the Southern Plains
1670–85		Hudson Bay Company builds five fur-trading forts on Hudson Bay
1675–6		King Phillip's War, New England
1680		Pueblo Revolt
1682–3		Lenape (Delaware) make a treaty with William Penn permitting a colony at Philadelphia
Eighteenth century	• Wampum belts widely used to seal agreements between Europeans, Haudenosaunee, and Anishinaabe nations • The Pawnee's Calumet dance spreads east to the Haudenosaunee	
c. 1700		Siouxian-speaking peoples migrate from Great Lakes to Plains
1701		Forty First Nations and the French sign treaty, the Great Peace of Montreal
1700–1800	Creek, Anishinaabe, Haudenosaunee and other eastern peoples invent new styles of dress combining European and Native elements	
1721		Danes and Norwegians settle in Greenland
1722–3		The Tuscarora join the Haudenosaunee Confederacy
1724–9		The Natchez Revolt against the French on the Lower Mississippi River

	ARTISTIC	CULTURAL/POLITICAL
c. 1725	• Quebec nuns, taught to use moose hair by Native women, invent souvenirs of moose hair and birchbark • Mi'kmaq invent new forms of porcupine quillwork for the curio trade	
1741		Vitus Bering explores the Northwest Coast and Russians settle in southwestern Alaska
1754–63		French and British ally with Aboriginal Nations during the Seven Years (French and Indian) War
c. 1760		The horse spreads to all the nations on the Great Plains
1763		British defeat French and acquire New France; the Royal Proclamation creates boundary for European settlement and establishes treaty system
1769		First Spanish Mission in California at San Diego
1774–80		Canadian traders and Hudson Bay Company establish fur-trade posts across Northern Plains
1778		Captain James Cook sails along the Northwest Coast, contacts Nuu-Chah-nulth and Haida
1780–2		Smallpox epidemic decimates tribes in the Great Plains
1775–83		American Revolution creates conflicts among Haudenosaunee, and destabilizes the Confederacy
1784–5		Joseph Brandt leads Mohawk and other Haudenosaunee groups to lands reserved for them by British in Upper Canada (Ontario)
1791		Alejandro Malaspina sails through Northwest Coast region
1799		Seneca prophet Handsome Lake (Sganyadái yo) receives the visions which later result in the Longhouse religion
1802		Tlingit Indians destroy Russian settlement of New Archangel (Sitka)
1805–6		Sacajawea, a Shoshone woman, serves as interpreter and guide on Lewis and Clark's expedition
c. 1820	Haida invent new uses for argillite to supply the eastern curio trade	

	ARTISTIC	CULTURAL/POLITICAL
1820s	Tuscarora artists Dennis and David Cusick use Western pictorial formats to record indigenous oral traditions and to chronicle contemporary events	
1823		Sequoyah develops the Cherokee syllabary
1830–50	Grey Nuns begin to teach floral embroidery to Métis and Dene at schools in Fort Chipewyan and Winnipeg; style spreads widely	
c. 1830–1900	Northeastern Native artists create new souvenir commodities in beadwork, basketry, and quillwork to serve demand at Niagara Falls and other sites	
1830–60		US Government Removals policies force the Five Civilized Tribes of the Carolinas and many other Eastern tribes to move to 'Indian Territory' (Oklahoma)
1833–4		Artist Karl Bodmer and Prince Maximilian of Wied visit Missouri River tribes
1837		Smallpox epidemic decimates Mandan and Hidatsa on the Northern Plains
1848		Maidu discovery of gold on the American River (California) inaugurates the Gold Rush
1848–50		Pomo massacred in California
1850	Navajo Atsidi Sani learns jewelry making techniques from Mexican blacksmiths; technology spreads throughout Navajo and Pueblo regions	
1851		First Treaty of Fort Laramie with Plains Indians
1862		Smallpox epidemic decimates Haida on Queen Charlotte Islands
1862–4		Navajo Long Walk and imprisonment at Bosque Redondo
1864		The Sand Creek Massacre of Southern Cheyenne people by the Colorado militia
1867		Transcontinental railroad built through Northern Plains; Inauguration of "Reservation Era" in the Great Plains
1870–80	"Eyedazzler" patterns and Germantown yarns introduced in Navajo weaving	

	ARTISTIC	CULTURAL/POLITICAL
1871–90		Near extermination of the buffalo by white hunters in the Great Plains
1875–8	Southern Plains warriors incarcerated at Fort Marion, Florida, draw many autobiographical sketchbooks	
1875		Gold Rush in Black Hills, South Dakota
1876		Lakota, Cheyenne, and Arapaho defeat Custer's seventh Cavalry at the Battle of Little Big Horn
1877		• The Nez Perce War • Sitting Bull and his Lakota followers flee to Canada to avoid persecution by US Government forces
1878		Hampton Institute, Virginia, a school for blacks, accepts Native students
1879–85		As part of its massive collecting project, Smithsonian Institute anthropologists remove more than 6,500 pottery vessels from Pueblo towns
1879		Carlisle Indian School founded, Pennsylvania
1880		Bacone College established as an Indian College, Oklahoma
1882		Railroads bring manufactured goods and tourists to Navajo and Pueblo region
1883		Sun Dance banned by US Government
1885–1890	Hopi Potter Nampeyo and husband Lesou revive the fifteenth and sixteenth-century Sikyatki style based on pots recently excavated by Fewkes	
c. 1885–1905	Influx of prospectors and tourists to Alaska causes boom in curio trade	
1885		Canada amends Indian Act making Potlatch, Sun Dance and traditional rituals illegal
1887		US Congress passes Dawes Severalty Act—facilitates alienation of Native reservation lands
1889–90		Ghost Dance movement spreads across Great Basin and Plains through teachings of Paiute prophet Wovoka

	ARTISTIC	CULTURAL/POLITICAL
1890	Kiowa artist Silver Horn works with anthropologist James Mooney of the Smithsonian	Massacre of Lakota at Wounded Knee by US government soldiers
1890–1920	Persian carpet designs adapted by Navajo weavers	
1899–1908	Pueblo and Navajo artists make first paintings on paper for non-Native audience	
1904	Martina and Julian Martinez demonstrate pottery making at the St Louis World's Fair	
1900–1910	Kiowa artist Silver Horn works with anthropologist James Mooney of the Smithsonian	
1910–20		Many Native children in Canadian residential schools die of tuberculosis
1912		Jim Thorpe (Sauk and Fox) wins the decathlon at the Olympic Games, Norway
1914	Washoe basketmaker Louisa Keyser's fame reaches its peak	
1915	Baleen baskets first made by Inupiaq men as by-product of whaling	
1918		Formal establishment of the Native American Church (peyote religion)
1919	Martina and Julian Martinez make first modern black-on-black ware	
1920	Work of Kiowa Five exhibited at the International Folk Art Congress, Prague, Czechoslovakia	
1921		Forty-five Kwakawka'wakw people arrested for attending Daniel Cranmer's Potlatch. They are forced to surrender all masks and other regalia to avoid imprisonment.
1924		Native American peoples granted US citizenship and voting rights
1927	Northwest Coast and Euro-Canadian art exhibited together in "Exhibition of Canadian West Coast art," National Gallery of Canada	
1927–28	"Kiowa Five" study art with Oscar Jacobson at University of Oklahoma	
1930s	US Government New Deal programs support Native art initiatives across the United States	

	ARTISTIC	CULTURAL/POLITICAL
1931	Exposition of Indian Tribal Art, New York City	
1932	• Dorothy Dunn establishes Studio School art program, Santa Fe Indian School • Native American watercolors and Heye Collection objects shown at the American Pavilion, Venice Biennale	
1934		The Indian Reorganization Act passed in United States
1936	Indian Arts and Crafts Board established in the United States	
1939	Indian art featured at the Golden Gate International Exposition, San Francisco	
1940	Oscar Howe paints WPA-sponsored murals, Carnegie Library, Mitchell, South Dakota	
1941	"Indian Art of the United States" exhibition, Museum of Modern Art, New York City	
1944		National Congress of American Indians founded in United States
1945	Hopi artist Fred Kabotie receives Guggenheim Fellowship	
1946	Annual juried exhibitions inaugurated, Philbrook Museum, Tulsa, Oklahoma	
1949	• Apache artist Allen Houser receives Guggenheim Fellowship • Success of the first exhibition of Canadian Inuit soapstone sculptures at Canadian Guild of Handicrafts, Montreal, leads to rapid growth of new art	
1945		Native soldiers returning from World War II boost Native political activism in the United States and Canada, increase trend to urban migration
1948–60		Canadian Government establishes permanent settlements for Inuit in the Arctic, some groups experience forced relocation
1950	Mungo Martin hired to restore totem poles at the University of British Columbia, stimulates renewal of traditional Northwest Coast arts Lakota openly revive the Sun Dance	
1951		Canada's Indian Act amended; compulsory enfranchisement and ban on potlatch dropped

	ARTISTIC	CULTURAL/POLITICAL
1953	Mungo Martin holds potlatch at the British Columbia Provincial Museum	
1958–62	Norval Morrisseau develops new pictorial style using traditional Anishinaabe imagery in northern Ontario	
1959	Prints West Baffin Eskimo Co-operative issues first limited edition of prints	
1961	National Indian Council formed, the first national Canadian Native political organization	
1962	• The overnight success of Norval Morrisseau's first one-man show, Toronto, gives momentum to new school of Anishinaabe painting; • Founding of the Institute of American Indian Art, Santa Fe	
1965	• Native Arts Program inaugurated, University of Alaska, Fairbanks • Bill Holm publishes influential *Northwest Coast Indian Art: An Analysis of Form*	
1967	• First major exhibition on Native history and culture by Aboriginal curators shown at the Indians of Canada Pavilion of Expo 67, Montreal World's Fair, alongside newly commissioned contemporary Native art • Canadian Inuit artist Kenojuak Ashevak awarded the Order of Canada	
1968		• US Congress passes American Indian Civil Rights Act • American Indian Movement (AIM) founded by Dennis Banks and Russell Means
1969		• N. Scott Momaday (Kiowa) is awarded the Pulitzer Prize for Fiction • At the Haida Village of Masset, Robert Davidson erects the first new totem pole to be carved since the nineteenth century
1970	Ksan Art School and Cultural Centre established, Hazelton, British Columbia Six Nations Iroquois Confederacy petitions US courts for the return of wampum belts held in New York State Museums	
1971		Alaska Native Claims Settlement Act awards 44 million acres and $962 million to Indigenous people of Alaska

	ARTISTIC	CULTURAL/POLITICAL
1972	• Sarain Stump founds the Ind[ian]art Project, Saskatchewan Indian Cultural College • Salteaux artist Robert Houle helps to establish Manitou College, La Macaza, Quebec	
1973		AIM occupation of Wounded Knee on Pine Ridge Reservation, South Dakota, and siege by FBI
1974	Inuit artist Pitseolak Ashoona elected to the Royal Canadian Academy of Arts	
1975	Woodland Cultural Centre Museum, Brantford, Ontario, initiates annual exhibition of contemporary Native art	
1976	Bill Reid's monumental sculpture "Raven and the First Men," unveiled at the new Museum of Anthropology, University of British Columbia	Saskatchewan Indian Federated College is first Native-controlled college in Canada
1977		First Inuit Circumpolar conference, Barrow, Alaska
1978		American Indian Religious Freedom Act signed and incorporated into US law
1980		U'mista Cultural Centre opens in Alert Bay, British Columbia
1981		Sealaska Corporation (established as a result of the 1971 Alaska Native Claims Settlement Act) founds the Sealaska Heritage Group
1985	Inuit artist Jessie Ooknark awarded the Order of Canada	
1988		Indian Gaming Regulatory Act permits establishment of gambling facilities on Indian land in the United States
1989		US legislation authorizes establishment of the National Museum of the American Indian
1990	• US Government passes the Indian Arts and Crafts Act • First solo show for an Inuit graphic artist, *Pudio: Thirty Years of Drawing*, at the National Gallery of Canada	• US Government passes Native American Graves Protection and Repatriation Act • Elija Harper (Cree) stops ratification of the Meech Lake Accord in the Manitoba legislature • Mohawk protests over the building of a golf course on a burial ground at Oka and Kahnawake, Quebec, escalates into a summer-long confrontation with the Canadian army
1991		Brooklyn Museum repatriates 13 Zuni War Gods (*Ahayu: Da*)

	ARTISTIC	CULTURAL/POLITICAL
1992		• Ashíwí Awam Museum and Heritage Center founded at Zuni Pueblo • Elizabeth Sackler establishes the American Indian Ritual Object Repatriation Foundation
1992	• "Land/Spirit/Power," National Gallery of Canada • "Indigena," Canadian Museum of Civilization • "The Submuloc Show/Columbus Wos" organized by Atlatl	• Assembly of First Nations and the Canadian Museums Association accept report of Canada's Task Force on Museums and First Peoples, establishing guidelines for partnership and repatriation • Columbus Quincentennial marked by major exhibitions of Native Art
1995	The works of Plains Cree artist Edward Poitras represent Canada at the Venice Biennale in an exhibition curated by Gerald McMaster, also Plains Cree	
1996		Canada, British Columbia, and the Nisga'a Tribal Council initial the Delgamuukw Agreement in Principle, the future basis for the first modern-day treaty in British Columbia
1999	Eiteljorg Museum of American Indians and Western Art establishes the Eiteljorg Fellowship for Native American Fine Art	Nunavut Act and Nunavut Land Claims Agreement Act creates the new Inuit-governed territory of Nunavut
2001	Blackfoot architect Douglas Cardinal awarded Governor General's Award in Canada	
2003	• National Gallery of Canada incorporates Aboriginal art into Canadian art galleries with "Art of this Land' • Canadian Museum of Civilization opens First People's Hall	
2004	• The Biennale of Sydney features Jimmie Durham's *Still Life with Stone and Car* in front of the iconic Sydney Opera House • The National Museum of the American Indian opens its doors on the National Mall in Washington, DC	
2005	• James Luna presents *Emendatio* at the Venice Beinnale, sponsored by the National Museum of the American Indian • Carl Beam awarded Governor General's Award	

	ARTISTIC	CULTURAL/POLITICAL
2006	*Norval Morrisseau: Shaman Artist*, first retrospective of an Aboriginal artist, shown at National Gallery of Canada	
2007	Daphne Odjig awarded Governor General's Award	
2011	Nisga'a Museum opens; Aanischaaukamikw Cree Cultural Institute Opens	
2012	Gerald McMaster co-curates the 18th Biennale of Sydney	Idle No More Movement in Canada organizes protests against Aboriginal living conditions, proposed federal legislation to terminate Indian Act, environmental protections

NATIVE NORTH AMERICAN ART

AN INTRODUCTION TO THE INDIGENOUS ARTS OF NORTH AMERICA

1

Native North American art, after more than five centuries of contact and colonialism, is extraordinarily rich and diverse. Today, Native artists, male and female, trained in their communities and in professional art schools, and living in cities and on reserves, work in a broad range of media, conceptual modes, and expressive styles. At the beginning of the twenty-first century, James Luna (b. 1950) might have been creating his installation and performance work *Chapel for Pablo Tac* for presentation by the National Museum of the American Indian at the 2005 Venice Biennale (fig. 1.1). Honoring the memory of a twelve-year-old boy from Luna's Puyukitchum (Luiseño) community who was sent from California to Rome in 1804 to be trained as a priest, the piece reflects on the similarities that link Christianity with the Indigenous spirituality that Tac's future missionary activity was expected to eradicate. At the same time Odawa artist Yvonne Walker Keshick might have been at work in her Michigan studio inserting porcupine quills into birch bark to form a pictorial composition. Her work takes an art form invented by her ancestors for the nineteenth-century curio trade to a new level of conception, skill, and artistry (fig. 1.2). And as they worked, Dempsey Bob (b. 1948), a Tahltan-Tlingit artist from British Columbia, might be carving a mask in traditional Tlingit style that will be used at a community potlatch. Equally, he might be using the Tlingit formline style to create a modern sculpture in cast bronze that will be appreciated as a work of art by visitors to a large urban art museum (fig. 1.3).

These three moments of art-making, chosen from many possible examples, encompass realms of the ceremonial and the commercial, the sacred and the secular, the personal and the political. An Odawa woman's consummate skill in quillwork captures her inner vision and imaginative reworking of the materials and imagery of the natural world for those who see it in a home or a museum. When used in a potlatch, a Northwest coast mask makes an important statement about the location of political power by displaying publicly the image of a nonhuman being from whom its owners inherited valuable powers and prerogatives. Equally, it can provide aesthetic pleasure as a wall-mounted work in a museum or private collection. In the hands of Native North American artists, more recent forms of artistic expression such as performance, video, and installation have become powerful tools of historical revisionism and cultural critique that challenge and change the place of Native people in the art world and contemporary society.

The vitality of Native North American art today is evidence of an extraordinary story of survival. A century ago, most non-Natives (and some Native

◄ 1.1 James Luna, b. 1950 (Puyukitchum/Luiseño), *Chapel for Pablo Tac*, 2005. Image Courtesy National Museum of the American Indian (26/7735). Photo by Katherine Fogden.

Luna's installation was one of two he created as part of his "Emendatio" project for the Venice Biennale in 2005. Emendation, or improving accuracy, was also a goal for Pablo Tac. During his missionary training in Rome during the 1830s, he recorded the Luiseño way of life and language in a manuscript intended to correct the misunderstandings of outsiders—a task continued by contemporary artists such as Luna.

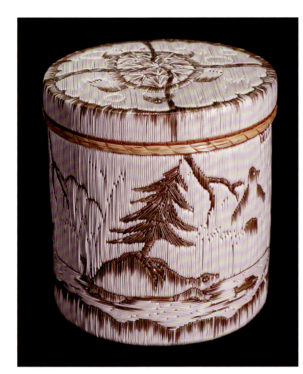

▲ **1.2** Yvonne Walker Keshick (Binaakwike, Falling Leaves Woman), b. 1946 (Odawa/Ojibwe), *Four Directions Box*, birch bark, porcupine quills, thread. Private Collection.

Both Indigenous spirituality and the contemporary environmental movement hold that all living things are interconnected. Keshick links animals, plants, earth, and sky with four lines that radiate from a great turtle on the lid. They read as the four directions, branches of one great tree, and the energizing power of lightning. "This box," she writes, "symbolizes the past, present, and future of all things."

people as well) had become convinced that Aboriginal arts and cultures would soon disappear. Yet today these arts are thriving and receiving renewed attention within Aboriginal communities and from non-Native students, art lovers, and international museums. As the following chapters will demonstrate, the visual arts have long played a critical role as carriers of culture within Native North American societies and are today among the most eloquent and forceful articulations of contemporary identities and struggles for sovereignty.

ART HISTORY AND NATIVE ART: THE CHALLENGE OF INCLUSION

This book introduces readers to the richness of Native North American visual arts in all their temporal depth and regional diversity. It also serves to make readers aware of the problems we now recognize in the ways these arts have been represented in museums and scholarly writing and how contemporary writers—Indigenous and non-Indigenous—are revising those histories. As art historians, we approach this enormously challenging task in the belief that the wide-ranging historical overview is a useful exercise, even though it must always be highly selective and can never be definitive. It encourages us to look for both unity and diversity, to recognize the many shared beliefs and practices revealed in these arts at the same time that we savor the distinctiveness of local and regional artistic traditions. The temporal dimension of the historical survey complements this spatial breadth as it reveals both change and continuity.

Yet the survey, like all forms of narrative, shapes the story it tells. Aboriginal conceptions of time are often organized around principles of cyclical renewal rather than linear unfolding. Western traditions of historical narrative that privilege moments of change are appropriate to a history of Native North American art in the sense that much of the story of this art over the past five centuries tells of successive visual responses to crises such as epidemics, forced removals from homelands, repressive colonial regimes, religious conversion, and contact with foreign cultures and their arts. It is also, however, a story of the enduring strength of traditions. The many moments of transformation, rupture, and renewal in art traditions recounted in this book reveal the importance of visual arts in maintaining and transmitting spiritual, social, political, and economic systems. These arts are, then, important contributors to Aboriginal people's success in resisting assimilation and maintaining their active presence in their lands. Anishinaabe literary theorist Gerald Vizenor has termed this achievement "survivance," a word that combines "survival" and "resistance." For Vizenor, it signifies "more than survival, more than endurance or mere response; the stories of survivance are an active presence."[1]

Aboriginal oral traditions and Western scholarship account differently for the origin of the world and the human presence in it. Stories of creation are as various as the peoples of North America, although those of neighboring peoples often share common features. They are "histories" in the sense that they are chronological, eventful narratives that explain the origins of present realities. But they are posited on a different notion of authority, that of inherited, transmitted truth that has the force of moral explanation, rather than that of scientifically verifiable fact that has no moral force. In discussing the art of each region, we provide an example of Indigenous knowledge about creation and a summary of Western archaeological knowledge in order to suggest that Western and Indigenous knowledge offer coexistent and different paths to truths that are complementary rather than contradictory.

Western scholars characteristically divide their historical narratives into two large epochs: before and after European contact. This fundamentally Eurocentric periodization is largely determined by the kinds of recordkeeping Europeans introduced; postcontact history can make use of written texts, depictions, photographs, and films, while precontact history relies on archaeological evidence and Aboriginal oral traditions themselves. Yet the notion of the "prehistoric" is misleading, for it implies a clear dividing line between eras of "history" and "before history." It appears to deny the momentous changes and developments that occurred prior to 1492. Archaeological sources make clear that during the thousands of years that preceded the arrival of Europeans, the cultures of Indigenous people changed and adapted many times to new features of the environment and contacts with other peoples. Although also Eurocentric, the term "precontact" is preferable to "prehistoric."

All surveys are, of course, arbitrary in their selection of examples. In a book such as this, where strict limitations on length and illustration are imposed, we have been able to write only briefly about some artistic traditions and have had to omit many others of great interest and beauty. In choosing specific examples and traditions to illustrate our thematic and regional discussions, we have inevitably been influenced by the state of the literature in the field as well as by the areas of our own scholarship and research. Although this literature has grown rapidly in recent years, as indicated by the bibliography at the end of the book, much more study is needed, particularly by Native authors able to offer multiple Indigenous perspectives on the role of visual art within their civilizations.

Our choices have also been guided by our belief in the importance of addressing Native North American arts in terms of a specific set of issues.

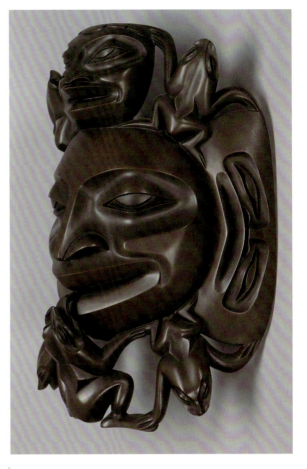

▲ **1.3** Dempsey Bob, b. 1948 (Tahltan), *The Messenger*, 2000. Cast bronze, 47.4 × 36.6 × 25.7 cm MOA ID# 2648/1. Photograph by Jessica Bushey. Courtesy the artist and UBC Museum of Anthropology, Vancouver, Canada.

"Our art has to evolve, otherwise it will die," Dempsey Bob affirms. His mastery of the technically demanding medium of cast bronze follows in his ancestral tradition of openness to innovation and an eclectic use of different media. In this mask, created as a sculpture rather than for use, the lively frogs represent transformation and communication, as they do on traditional Northwest Coast rattles.

Some of these—such as the role art plays in the expression of political power, group identity, cosmological beliefs, and the presentation of the individual self—are long-standing concerns of art-historical work. Others, such as the impact of gender, colonialism, and touristic commodification on the production of art, have been advanced by several developments within the discipline of art history that occurred during the last three decades of the twentieth century, notably "new" art history, the social history of art, and advocacy for the broadening of art history's scope from "fine arts" to "visual culture." Alongside these trends, awareness of the profound changes offered by globalization has stimulated scholars to consider the ways that transnational circulations of objects, ideas, and people have shaped artistic development not only in the present but also in earlier historical periods.

Intercultural exchanges—or "entanglements," in anthropologist Nicholas Thomas's phrase—have a particular relevance to the arts of colonized peoples. Native North American art histories are no exception. But long before the arrival of Europeans, the desire for exotic objects and materials for ceremonial and personal use had stimulated trade in raw materials and finished works of art across vast distances of the North American continent. Technologies, ideas, and beliefs traveled together with traders and their wares, as is clear from the dissemination of artistic imagery and ideas across vast distances of the continent—the kinship between the temple mounds of Pre-Columbian Mexico and the Mississippian earth mounds of the Southeastern United States (see chapter 3), or the animal imagery associated with shamanistic practices from Siberia to the Northwest Coast and the high Arctic are but two examples (chapters 5 and 6).

The arrival of Europeans in the sixteenth and seventeenth centuries brought about much more violent and traumatic forms of cross-cultural encounter and resulted in more profound challenges to existing Aboriginal concepts and styles of art. The impact of contact on cultural and artistic traditions varied at different times and in different places. Trade, invasion, and colonization began in the sixteenth century in the Southwest and Southeast and in the seventeenth century in the Northeast. On the Northwest Coast, sustained contacts did not occur until the late eighteenth century, while in most parts of the West and North they began only in the nineteenth century. In each region artistic exchanges and collecting histories reflected the particular understandings of art and cultural hierarchy that prevailed at the time among the peoples involved. Historian Richard White coined the term "middle ground" to describe the new intercultural forms of diplomacy, ritual, and art that emerged in the Great Lakes in response to the new patterns of trade, warfare, displacement, and cultural mixing.[2] Following White, we might think of all of North America during the five centuries since Columbus as a metaphorical middle ground, a space of negotiation of social, political, and aesthetic values and ideas that is often reflected with particular vividness in postcontact arts.

Modes of Appreciation: Curiosity, Specimen, Art

An art history is always contingent on a corpus of known works, however accidental their survival and however arbitrary (from the producers' vantage points) the reasons they were prized by collectors. We need to understand the

criteria applied by collectors in different times and places in order to assess the fragmentary ways in which these collections represent Indigenous traditions. The kinds of objects collected and the information that accompanied them depend, first of all, on the values current among collectors in a given period. Thus, although a seventeenth-century Jesuit missionary is likely to have destroyed masks or amulets surrendered by his converts, these are exactly the kinds of things a late nineteenth-century museum collector on the Northwest Coast would most have wanted to preserve (fig. 6.14). Because European contact with Indigenous peoples across the continent occurred in different centuries, the nature of the collections made also varies regionally. In writing the history of Native North American art, then, it is important to be aware of which paradigm of collecting, study, and appreciation was used in forming a collection or writing a description. Such awareness also allows us to recognize the gaps and silences that have been produced by the histories of encounter, collection, and representation.

We realize, first of all, the incompleteness of the archaeological record as a representative sample of visual aesthetic expression. Since organic materials survive only in unusual circumstances, whole categories of visual art—almost everything made of wood, fiber, or hide—can only be guessed at or reconstructed on the basis of depictions preserved within surviving artworks. Most of what exists today from the precontact period is either architectural or is made of stone, metal, or pottery (fig. 1.4). Apart from these objects, a relatively small number of artworks from the first three centuries of European contact have been preserved. They are complemented by descriptions and sketches by explorers, missionaries, and travelers of the things people made, used, and wore.

The generalized concept of the exotic object as a "curiosity"—something that excited wonder and interest because of its craftsmanship, its use of unfamiliar materials, or because its forms appeared strange or grotesque to Europeans—governed the collecting of Native North American art from the sixteenth through the early nineteenth centuries. The seventeenth-century curiosity cabinet of an English cleric and traveler named John Bargrave was representative of the eclectic composition of these collections. Along with several rare North American Aboriginal items, it included antique Roman cameos, an anatomical model of a human eye, a preserved chameleon, and "the mummified finger of a Frenchman."[3] The story behind the acquisition of a beautiful set of Cree quilled ornaments from northern Ontario dating to about 1670—the earliest known examples—is equally marvelous (fig. 1.5). Bargrave tells us in his handwritten catalogue that he was given them by a British sailor just returned from one of the first voyages into Hudson Bay as a token of the man's gratitude to Bargrave for having ransomed him a few years earlier from North African pirates.

▲ **1.4** Archaic Period Woodland artist, Michigan, Notched ovate bannerstone, 2000–1000 BCE. Banded slate, H. 12.7 cm, W. 14 cm. Detroit Institute of Arts, Courtesy Bridgeman Art Library International © Dirk Bakker.

Banner stones deposited in graves as gifts to the dead for use in the next world often display extraordinary workmanship and aesthetic sensibility. With consummate skill and judgment, the maker of this spear weight created a highly refined form and revealed the symmetrical pattern lying at the heart of the stone.

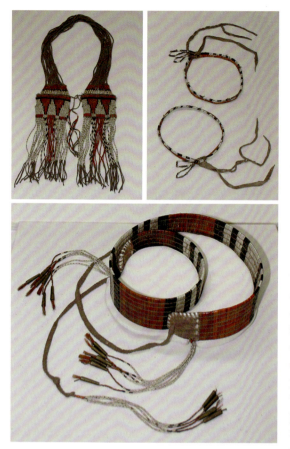

▲ **1.5** James Bay Cree artist, Set of quilled ornaments, 1662–76. L. 88 cm; belt, L. 82 cm; garters, L. 27 cm. Courtesy Dean and Chapter of Canterbury Cathedral.

Collected on the voyage of one of the first Hudson Bay company ships to reach James Bay, these ornaments were in an English cabinet of curiosities by 1676. They are probably the earliest extant postcontact objects from the Eastern Subarctic. The neck ornament, belt, and armbands testify to sophisticated techniques of quillworking and a cultural value for fine ornaments that were established at the time of contact.

The earliest postcontact objects from the East date to the sixteenth century and were originally preserved in such curiosity collections. Most, unfortunately, are not nearly as well identified as the Cree ornaments in Bargrave's collection, and only rarely can we determine their specific dates or communities of origin. Not only did Europeans misunderstand Native linguistic, cultural, and political affiliations, but what little information they did record has all too often been lost as collections were confiscated in wars, sold on the art market, or donated to museums.

During the eighteenth century, a more systematic approach to collecting information and artifacts was introduced by the philosophical historians of the Enlightenment. They took a particular interest in North American Indigenous peoples as archetypal "noble savages," and their more rigorous studies encouraged the better documented and more comprehensive collections made toward the end of the century along the Northwest Coast. The early collections made among Plains and Subarctic peoples during the first half of the nineteenth century also benefitted from this more systematic approach, although the notions of curiosity and the romance of the noble savage also lingered. Both the eclecticism of late eighteenth-century collecting and its more "scientific" modes of classification are seen in a view of Sir Ashton Lever's large private museum in London, where many of the Northwest Coast items collected by Captain Cook were first displayed (fig. 1.6).

The establishment of anthropology as an academic discipline during the second half of the nineteenth century resulted in the introduction of new modes of classification and material culture study borrowed from the prestigious field of natural history (fig. 1.7). Native-made objects came to be regarded as specimens that could be studied scientifically to reveal information about the technological development, belief systems, and practices of their makers. Ethnological collectors assembled huge quantities of Native North American material in museums newly built to receive them. They studied such collections in order to demonstrate the ways in which human arts, technologies, and societies had evolved progressively through time from the "primitive" (as represented by the Indigenous) to the "civilized" (as embodied by the European). Like their contemporaries, early anthropologists also accepted the widespread view that Indigenous arts and cultures inevitably became corrupted and weakened by contact with Europeans and were doomed to vanish as modernization proceeded. Such evolutionist studies were used to support laws and policies designed by the American and Canadian governments to assimilate Indigenous peoples into settler societies and erase their languages and cultures. Around the turn of the twentieth century, anthropologist Franz Boas

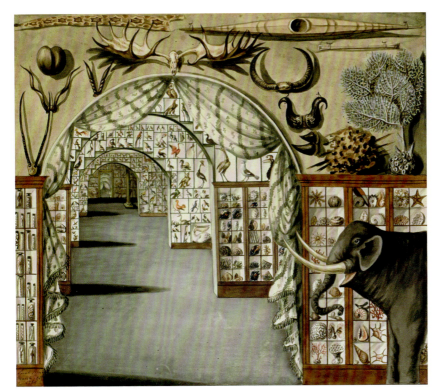

◀ **1.6** Sarah Stone, *Perspective View of Sir Ashton Lever's Museum, London*, 1785. Watercolor. Courtesy of Mitchell Library, State Library of New South Wales, Sydney, Australia.

The dense but carefully ordered displays of natural and artificial curiosities displayed in this private museum located near London's Leicester Square are recorded in the watercolor he commissioned from the young artist Sarah Stone. An Inuit kayak is visible high on the wall, and Lever's collection also included many of the artifacts collected by Captain Cook on the Northwest Coast of North America and in the Pacific.

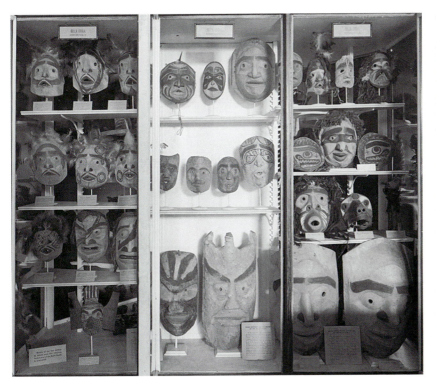

◀ **1.7** Installation of Nuxalk (Bella Coola) masks, American Museum of Natural History, New York, 1905. Image #386, American Museum of Natural History, Library.

During the late nineteenth and early twentieth centuries, ethnographic museums used a taxonomic display style borrowed from natural history museums, as seen in this view of the permanent exhibitions installed by Franz Boas at the American Museum of Natural History. Such grid-like arrangements fostered systematic processes of comparison intended to yield information about human historical development, cultural differentiation, and diffusion.

developed an approach to the study of Indigenous cultures that contrasted in important ways with that of the cultural evolutionists. His more relativistic view presented cultures as dynamic and changing, and formed by unique sets of factors that are historical and local. He instilled in the many students he trained at Columbia University rigorous and comprehensive methods for the documentation of Indigenous cultures and fostered a particular interest in their arts.

In both the United States and Canada, the work of documenting "disappearing" Indian cultures was sponsored by a network of research institutions such as the Bureau of American Ethnology at the Smithsonian Institution. The comprehensiveness of the "salvage" paradigm—the saving of the "last remnants" of authentic Indian culture—that informed their collecting activities is suggested by one dramatic but representative example: between 1879 and 1885 the Smithsonian collected over 6,500 pottery vessels made by Pueblo women from Acoma and Zuni, villages of just a few hundred inhabitants.[4] Stripping communities of the objects that supported their domestic, political, and spiritual life and could serve as models for young artists compounded the loss of artistic and ritual continuity that was being engineered during the same years by the forcible removal of many Aboriginal children to boarding and residential schools to become "civilized."

The collections of artifacts and documentation amassed during the late nineteenth and early twentieth centuries thus present us with a number of paradoxes. Many contain inaccuracies and gaps, yet they also preserve much that might otherwise have been permanently lost. Although historically implicated in oppressive assimilationist regimes, such collections offer today a precious resource for cultural renewal. In the contexts of their own historical era, furthermore, many early ethnographers, like Boas, were liberal and humane people who worked to counter poverty and cultural erasure and to preserve the knowledge of their Indigenous "informants." As Dakota scholar Philip Deloria has written, salvage anthropology was based on a fundamental contradiction, for "salvage workers are required to believe in both disappearing culture and the existence of informants knowledgeable enough about that culture to convey worthwhile information."[5] We should read these ethnographic sources critically, attending both to what they contain and what they distort or omit. Not only outsiders, but Indigenous people too, are today assessing the degree to which ethnographic texts have defined their identities. One of the sharpest critiques is offered by Tlingit/Aleut artist Nicholas Galanin in his sculptural self-portrait, *What Have We Become, Vol. 5* (fig. 1.8). His likeness is "carved" of the pages of *Under Mount St. Elias: The History and Culture*

▲ **1.8** Nicholas Galanin, b. 1979 (Tlingit/Aleut), *What Have We Become, Vol. 5*, 2009. 5 × 9 × 4 in. Courtesy Nicholas Galanin.

In carving his self-portrait out of the pages of an ethnographic study of his own people—literally remaking this "definitive" work in his own image—Galanin reclaims and transforms the knowledge the anthropologist, and through her the Bureau of American Ethnology, had acquired from the Tlingit.

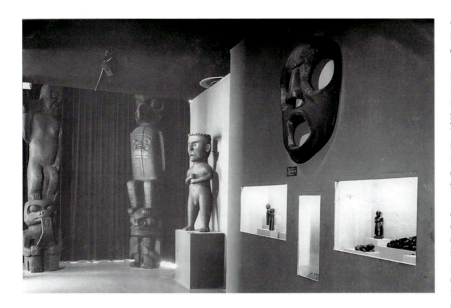

The innovative modernist installations at the 1941 MoMA show set the pattern of art museum display up to the present. Individual "masterpieces" were isolated against luxurious expanses of wall space with a minimum of label text. The intent of such displays is the promotion of intense visual experiences of the objects' formal and expressive qualities rather than of their specific cultural meanings.

of the Yakutat Tlingit, a classic ethnographic study of his own ancestral culture written in the mid-twentieth century by respected anthropologist Frederica de Laguna, a student of Boas.

Like Boas, many early ethnologists were interested in "art," but the concepts widely accepted during their own period have proved problematic for Indigenous artistic traditions in a number of ways. The influential aesthetic theory formulated in the eighteenth century by Immanuel Kant maintained that the creative freedom of the artist was curtailed when objects had to serve functional purposes and that the highest intellectual and aesthetic achievements were therefore to be found in the "fine" arts of painting and sculpture. Because much Native North American artistic expression occurs in the making of "useful" items such as pots, clothing, or weapons, these items were assigned to the categories of applied art or craft, which were long thought to be inferior. It was not until the beginning of the twentieth century, when a number of European modernist artists began to promote the formal virtues of African and Oceanic sculpture, that Western art collectors began to view Indigenous arts as fine art. Native North American masks and other art forms soon attracted similar appreciation. The artists, critics, and collectors who advocated a break with the European academic tradition found inspiration and validation in the apparent resemblances of "primitive" art forms to their own radical formal experiments. Landmark exhibitions in Canada and the United States in 1927, 1931, 1939, and 1941 displayed Northwest Coast masks, Pueblo pottery, and other objects in large urban galleries and art museums for the first time (figs. 1.9 and 2.8).

Unlike ethnographic collectors, the promoters of "primitive art" deemed necessary only a minimal understanding of the objects' original uses and meanings. In North America, promoters were also motivated by a nationalist desire to break away from the dominance of European cultural

influences. The painters Georgia O'Keeffe (1887–1986) and Emily Carr (1871–1945) and New York abstract expressionists Jackson Pollock (1912–56) and Barnett Newman (1905–70), among others, appropriated images of the Southwestern *katsina* and Northwest Coast totem pole to satisfy a desire for imagined primeval wholeness and to sever their own neo-colonial dependency on European art.[6] European artists who fled to the United States during World War II felt an affinity between their Surrealist interests in dreams and the emphasis on visionary experience of Native North American religions (fig. 1.10). As we discuss in chapter 7, a number of pioneering Indigenous painters and sculptors further complicated this movement by adopting modernist genres and styles to serve their own needs for self-expression and cultural preservation.

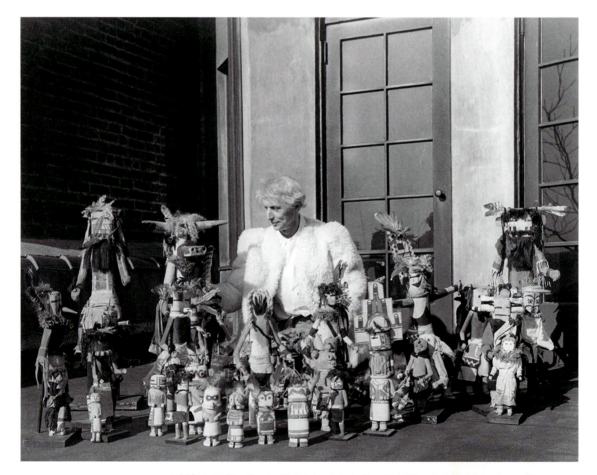

▲ **1.10** Artist Max Ernst with *katsina* dolls in New York City, photograph by James Thrall Soby, spring 1942. Digital Image © The Museum of Modern Art/Licensed by SCALA/Art Resource, NY.

European artists arriving in the United States during World War II became fascinated by the Native art they found in New York's ethnographic museums. They were particularly eager to collect *katsina* dolls, Alaskan masks, and other genres that appealed to their interest in dream experience and strange—to them—juxtapositions of materials and forms.

OBJECT IN FOCUS
The National Museum of the American Indian

On the morning of September 21, 2004, a remarkable sight greeted visitors to Washington D.C.'s Mall, the mile-long strip of grass running from the Capitol building to the obelisk of the Washington Monument that is bordered by many national museums. A vast crowd of 80,000 people facing the Capitol filled the space as far as the eye could see. Most were Indigenous people who had come from North, Central, and South America to celebrate the opening of the newest Smithsonian museum, the National Museum of the American Indian, or NMAI (fig. 1.11). This extraordinary gathering—the largest assembly of Indigenous peoples since European contact—was evidence of the importance attributed to the event. For most, the NMAI offered a powerful promise: to transform the damaging stereotypes of Native North American heritage, history, society, and contemporary life to which conventional museums had so centrally contributed.[7]

The NMAI was created on paper in 1989 when the United States Congress passed Public Law 101-185, the National Museum of the American Indian Act, which provided for the establishment of a new Smithsonian museum that would be a "living memorial to Native Americans and their traditions." As prescribed by the law, this museum, unlike comparable museums, would be directed and administered by Native North Americans themselves. The back story to the creation of the NMAI suggests the full extent of this transformative promise, for the stimulus for its establishment was the transfer to the Smithsonian of the collections of New York's Museum of the American Indian (MAI), an enormous collection of the Indigenous art

and material culture from the Americas. That institution had been the creation of George Gustav Heye (1874–1957), a wealthy New York businessman who first encountered Native American art in 1903 as a young engineer working in the Southwest. Collecting Native North American art became a lifelong obsession; during the following decades he used his wealth to buy up major collections from North America and Europe and to employ ethnologists to venture "into the field" to sweep up everything they could find in Indigenous communities. When the collection outgrew his private home, Heye recreated it as a public museum opened in 1922 on upper Broadway in Manhattan. For the next sixty-five years the museum and its vast storage building in the Bronx attracted school children, scholars, and artists, but its out-of-the-way location kept visitor numbers low. By the 1980s its displays (installed in the typological style—in which objects are grouped by type—typical of early twentieth-century anthropology museums), had become out-of-date and increasingly controversial. When the museum's financial problems converged with the growing pressure from Native Americans to create a site of self-representation in the national capital, the NMAI was born. Since Heye had left his museum to the state of New York, the NMAI also provided for the establishment of the George Gustav Heye Center in New York's financial district, where portions of the collection are always on view. Visitors to this building—a mid-nineteenth-century customs house built in French Empire style and adorned with murals celebrating the triumph of trade and commerce—are usefully reminded of the history of Native North American economic exploitation and dispossession that created the conditions for the formation not only of Heye's but many other museum collections as well.

The NMAI's new building on the Washington Mall and its innovative Cultural Resources Center in suburban Maryland (designed to store and study the vast collections according to Indigenous protocols of preservation and access) are, in contrast, examples of the dramatic museological innovations of its Native American conceptualizers. The Mall building was designed by Blackfoot architect Douglas Cardinal in the organic flowing style he had first created for the Canadian Museum of Civilization in Canada's national capital region. The curving forms of its layered stories evoke the topographies of land, just as the plants and water features that surround the museum reference Indigenous knowledge and ideals of harmony with the land. Inside the building, during NMAI's first decade, three major installations devoted to cosmology (Our Universe), identity (Our Lives), and history (Our

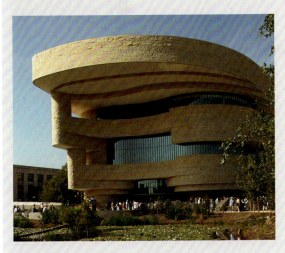

▲ **1.11** National Museum of the American Indian, Washington, D.C. Photo by Michael Ventura/Alamy.

(cont.)

(cont.)

Peoples) greeted visitors. Each consisted of a central exploration of the theme incorporating vibrant installations and works by contemporary artists and thirteen modular exhibits created by specific Indigenous communities working with the museum's professional staff. The stress on contemporary lives and beliefs in these exhibits frustrated some critics who had hoped to see more of the museum's great historic collections on view; yet such exhibits spoke eloquently to the felt need to emphasize survival and contemporaneity. At the time of writing, a new set of exhibitions is being planned to replace them; these will undoubtedly open up new issues. The NMAI, in its first decade, however, began the gargantuan task of dismantling and revising a centuries-long history by which Native North American histories, cultures, and arts had been presented from the perspectives of outsiders, often distorting and silencing the issues most pertinent to Native North Americans themselves.

Expanding Art History's Inclusivity and Defining "Art"

During the last decades of the twentieth century, three movements within art history began to develop the discipline's capacity to better represent and narrate artistic traditions that had been marginalized by its Eurocentric biases. Beginning in the 1970s, the "new art history" worked to reveal and undo the hierarchies of race, class, and gender embedded in the classic narratives and canons of Western art history. These approaches, in turn, encouraged an expansion of art history's scope from the traditional "fine arts" of painting, sculpture, graphic arts, and architecture to a broader field of "visual culture" that includes crafts, commercial and popular arts, film, photography, video, electronic media, and performance. Such a scope favors not only the ritual arts, performances, and popular and touristic arts that Aboriginal people have used as channels of artistic expression, but also critical analysis of stereotypes of Aboriginal people that have long circulated in the popular media.

A third interrelated development has been a renewed emphasis on the social history of art and the role of art forms in shaping social interactions among people. Art historians have always been interested in how the meanings of art objects change as they move through time and space into new contexts of use and viewing. In a 1986 essay, anthropologist Igor Kopytoff urged the value of tracing an object's "cultural biography" in order to understand how its meaning changed as it moved through different contexts. Scholars of Native North American art today attend to these changes as collected works move from their original ritual or social contexts to become marketable collectables, scientific specimens, or works of art (see chapter 5, Object in Focus box and fig. 5.20). Such studies have potential affinities, too, with theories of the active and autonomous agency of works of art advanced by Alfred Gell and other anthropologists. Such theories resonate in interesting ways with Indigenous North American intellectual traditions, which affirm that some material objects can harbor qualities of personhood and spiritual power.[8]

New art history, visual studies, and the social history of art have been further amplified by the emergence of the more global perspective generally referred to as "world art history." This further attempt to broaden art history's scope fosters interest in the diverse ways that visual aesthetic

expression is conceptualized and its history recorded in different parts of the world. The "world" perspective is most clearly adapted to contemporary Native North American artists, who today show their work at biennial exhibitions held from Germany to Australia, engaging not only with Western traditions but also with a global community of other Indigenous and non-Western artists and critics. Although the historic arts of Indigenous peoples have received relatively less attention within world art history than those of the so-called Great Civilizations such as China or India, they stand to benefit from the future expansion of this approach.

The definition of "art" is highly unstable, changing from one culture and time period to another. It is thus important to have a working definition of the way we use the term "art" in this book. In relation to historical (generally pre-twentieth-century) objects, where acts of classification are retroactive, this volume uses the term "art" to refer to a work whose form is elaborated to enhance its visual and material qualities and its rhetorical power. The impulse and the capacity to elaborate form appear to be universal in human beings, as Boas eloquently argued at the beginning of the twentieth century.[9] His stress on the importance of practiced skill in achieving the control over materials and technologies, the regularities of form and pattern, and the expressive inventions that evoke aesthetic responses is an essential corollary to his definition—and is well illustrated by the work of the three artists with whom we opened this introduction. The capacity for making art is also *useful*; an artfully made object will draw and hold the eye (fig. 1.12). Skill, virtuosity, and elaboration, therefore, confer what anthropologist Warren D'Azevedo has termed "affective" power on an object, a capacity that can be exploited to focus attention on persons or things of importance, or to enhance the memorability or ritual efficacy of an occasion (fig. 1.13).

However carefully we distinguish certain objects or performances as "art" (and, by implication, relegate others to the realm of "nonart"), we inevitably enter a cross-cultural morass. As a judgment made in relation to historical objects, the distinction imposes a Western dichotomy on things made by people who do not make the same categorical distinctions and whose own criteria for evaluating objects have often differed considerably. In relation to modern and contemporary Native art, the use of Western categories is less problematic, for many contemporary artists were trained in Western art schools and work in full awareness of the discourses and

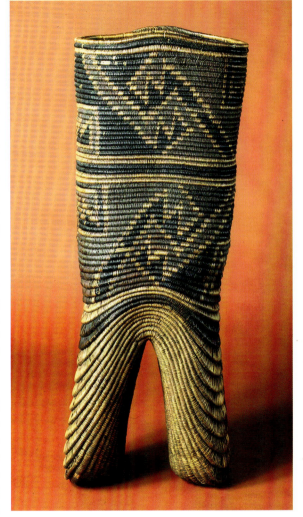

▲ **1.12** Anasazi artist, Mogui Canyon, Utah, Bi-lobed basket, c. 1200 CE, plant fibers. Courtesy University of Pennsylvania Museum of Archaeology & Anthropology #150615.

Basketry is perhaps the oldest indigenous American art; in many regions artists have produced works of enduring use and beauty out of coiled, twined, and wrapped plant fibers. Although objects made of organic materials do not usually survive from the precontact period, the dry desert climate has allowed this fine basket to last for 800 years.

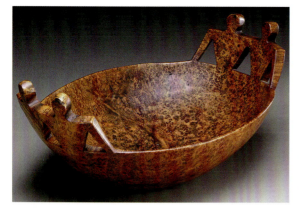

▲ **1.13** Anishinaabe artist, Feast bowl, nineteenth century. Ash wood, 48.3 × 33.3 × 21 cm. Detroit Institute of Arts, Courtesy Bridgeman Art Library International.

In the Great Lakes region, individuals brought beautifully carved bowls to communal feasts. Often carved from the tight-grained and durable wood burl, their rims sometimes display stylized animal motifs that transformed the bowl into the body of an animal of special spiritual significance to its owner. The representation of human figures on bowls is less common; here they extended out from the slanting sides of the bowl, creating a dramatic visual tension.

debates current in New York, Santa Fe, Vancouver, or Toronto—although they often contest aspects of the integrated system of scholarship, collecting, museum display, and market value that James Clifford has called the Western "art and culture system."[10]

When speaking of historical Native objects, the statement is often made that Native languages have no exact equivalent for the post-Renaissance Western term "art." The implication of this statement—that Native artists in the past were unreflexive about their own art-making and lacked clear criteria of value or aesthetic quality—is manifestly untrue, as scholars have repeatedly demonstrated.[11] Though specific criteria vary, Native North Americans, like people everywhere, value the visual pleasure afforded by things made well and imaginatively. They also value many of the same attributes that make up the Western notion of "art," such as skill in the handling of materials, the practiced manipulation of established stylistic conventions, and individual powers of invention and conceptualization. There is also ample evidence, however, that in Native traditions the purely material and visual features of an object are not necessarily the most important in establishing its relative value, as they have come to be in the West. Other qualities or associations, not knowable from a strictly visual inspection, may be more important. These may include soundness of construction to ensure functional utility, or ritual correctness in the gathering of raw materials, or powers that inhere because of the object's original conception in a dream experience, or the number of times it was used in a ceremony.

In the past, Western-trained scholars have tended to dismiss the Indigenous intellectual traditions that lie behind such modes of evaluation. Yet the deep knowledge that makers of objects carry in their heads and hands is a fundamental way of knowing the complexities of an object's material being. Such knowledge, sometimes termed "ethnoscience" by outsiders, is based on the close observation, experimentation, and transmission through Indigenous systems of apprenticeship and teaching by untold generations of makers. It is also tied to a deep knowledge of the land and its life forms. To a Native artist, some of this knowledge may simply be regarded as part of what it means to be an adult with the skills and experience necessary to make one's way in the world. For a Pueblo potter, for example, it may entail knowing exactly where to find clay with exactly the right properties, what tempering material to choose to achieve the desired result when firing the vessel, how to make paints from Rocky Mountain bee weed, how to stack pots for firing in an outdoor kiln, or which kind of manure to use to feed the fire in order to get the desired color—all activities that may look natural and simple, but that are based on a thousand years of expertise (see chapter 2). In many parts of North America, the losses of such forms of Indigenous knowledge that occurred when Aboriginal children were separated from their families and taken to distant boarding schools have been

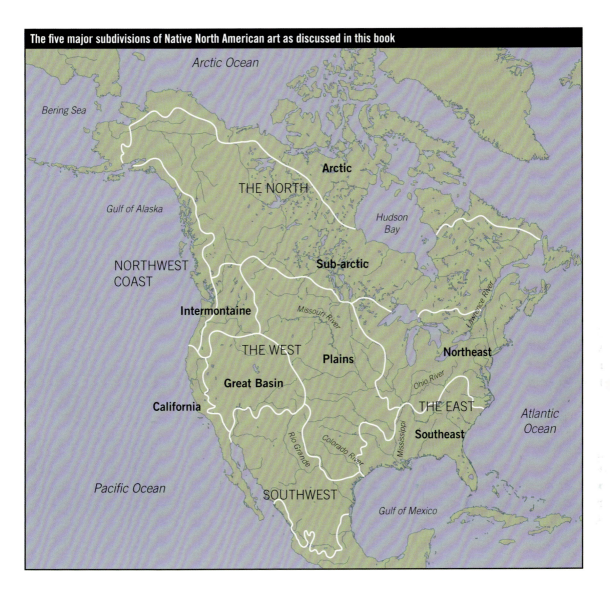

The five major subdivisions of Native North American art as discussed in this book

Arctic Ocean

Bering Sea

Arctic

THE NORTH

Gulf of Alaska

Hudson Bay

NORTHWEST COAST

Sub-arctic

Intermontaine

Missouri River

St. Lawrence River

THE WEST

Plains

Northeast

Great Basin

Ohio River

California

THE EAST

Atlantic Ocean

Southeast

Rio Grande

Colorado River

Mississippi

Pacific Ocean

SOUTHWEST

Gulf of Mexico

severe, but in many places successful projects of recovery have been under way in recent years.

In the next five chapters, devoted to the historical arts of the major regions of the continent—the Southwest, the East, the West, the Northwest Coast, and the North—we regularly interrupt our chronological accounts with examples of modern and contemporary art. We do this to intervene in the outmoded narrative that authentic Native North American arts have been "lost" or are in unstoppable decline. These contemporary works open a dialogue with today's Aboriginal communities, whose members affirm both the continuities that their artistic traditions manifest against all historical odds, as well as the authenticity—and universality—of processes of aesthetic and technical innovation. Whether historic or contemporary, works made by Aboriginal artists offer insights into particular philosophies and historical experiences that are especially valuable because, until recently,

we had so few written sources authored by Native people. As Mohawk historian Deborah Doxtator has written: "Visual metaphors impart meanings that sometimes do not have words to describe them."[12]

COLONIAL LEGACIES

We have already noted the ways in which Western interests and tastes determined what was collected and preserved after contact and that the majority of the objects surviving today were selected because they appealed to Western collectors' criteria of value and beauty. These histories also provide insight into ethical questions that arise today in relation to the ownership and display of many Native objects, because these problems are often linked to the circumstances in which objects were collected. In the next section we look in more detail at contemporary debates around three issues that are direct legacies of the colonial imposition of Western concepts and systems of art and culture: rights of ownership and modes of display, production for the market, and definitions of what is authentic and who is an Indigenous person.

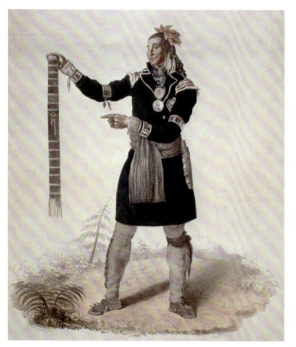

▲ **1.14** Edward Chatfield, *Nicholas Vincent Tsawanhanhi, Principal Christian Chief, and Captain of the Huron Indians*, 1825. Handcolored lithograph, 33.1 × 45.8 cm. Photo no. C-38948, Library and Archives Canada.

This image shows the Grand Chief of the Wendat nation when he was presented to King George III in London on April 7, 1825. To defend Wendat lands against incursions from settlers, he displays the wampum belt as evidence of the political agreement they had made with the British. Woven of purple and white shell wampum beads, it displays the image of a tomahawk, a symbol of war and a reminder that the historic alliance and promises of mutual support are still binding.

Ownership and Public Display

In the past, collectors rarely respected the ritual purposes for which many Native objects were made. Some of the finest pieces of art were made as burial offerings intended to accompany the dead into the next world. Many Aboriginal people believe these should now be returned to the earth, regardless of whether they were scientifically excavated or plundered by grave robbers. Other objects have been carefully conserved by Native people over many generations because of their inherent medicine power, their importance in ceremony, or as historical record (fig. 1.14). Woven belts of shell wampum beads, for example, were made for diplomatic exchange during the early contact period in the Northeast and Great Lakes. These were given to outsiders and some remained in their communities, passed on from generation to generation along with their detailed meanings, in order to maintain a record of important diplomatic agreements. Some were sold from these communities.[13]

Although some of these objects have never left Native hands, a great many were given or sold to ethnologists during the early decades of the twentieth century because of poverty or as a last hope for their preservation at a time when many Native people despaired of the survival of their cultures. Still others were stolen, seized illegally, or sold by people who had no right to do so. The last and largest category of historical art available for study and appreciation consists of nonsacred and nonceremonial objects. (The distinction is often hard to make because the sacred/secular dichotomy is another Western overlay on Indigenous modes of thinking.) These

were acquired by Western collectors, mostly through trade, purchase, or as gifts but also by violence and theft.

Native communities are today emerging from the dark days of official assimilationism, and many are requesting the return of certain museum objects. In recognition of their moral rights and past injustices, laws and official policies adopted in the United States and Canada in the early 1990s require repatriation to the legitimate descendants of the original owners of objects that are sacred, illegally acquired, found in burials, or belong to a category that the American law terms "objects of cultural patrimony."[14] These often go on display in community centers or museums from which they can be removed for use in ceremonies or for study by artists.

An early and influential example of repatriation resulting from effective Aboriginal activism occurred in the 1980s, when major museums in Ottawa, Toronto, and New York returned an important collection of Kwakwaka'wakw (Kwakiutl) coppers, masks, rattles, boxes, blankets, and whistles that had been illegally confiscated by a Canadian Indian agent at a great potlatch held in 1921 by Chief Daniel Cranmer. In 1885, the Canadian government had banned the holding of potlatches, key ceremonies that affirm and renew the political and social order of Northwest Coast communities. Many people had defied this ban, but in 1921 a local Indian agent decided to make an object lesson of Daniel Cranmer's potlatch. He arrested forty-five people, most of high rank, and released them from jail sentences only on condition that they surrender all their potlatch masks and other objects (some 450 items), which were then sold or placed in distant museums.

The Kwakwaka'wakw never forgot this loss and in the late 1960s began to lobby actively for the return of their treasures, using a number of strategies, including the making of two widely circulated documentary films. The National Museum of Canada responded first, agreeing to return its holdings on condition that an appropriate building be constructed to house them. The portion returned to the people of Alert Bay is now displayed in the U'mista Cultural Centre (fig. 1.15). Chief Cranmer's daughter, Gloria Cranmer Webster, an anthropologist who was the first director of the Centre, explains the meaning of its name. "In earlier days, people were sometimes taken captive by raiding parties. When they were returned to their homes, either through payment of ransom or by a retaliatory raid, they were said to have 'u'mista.' Our old people said that the return of the collection was like an u'mista—our treasures were coming home from captivity in a strange place."[15]

The U'mista Cultural Centre is not, however, a museum and the new ways in which it has chosen to display the objects demonstrate the belief in the importance of affirming Indigenous historical memory as part of the recovery from the colonial era. The returned objects are displayed in the open rather than behind glass, and in the order in which they would appear at a potlatch rather than in conventional typological groupings. They are accompanied, as James Clifford has observed, by texts that do not give their original uses and symbolism but record the memories of specific community members, speaking directly of their recent history of captivity and return.[16]

▶ **1.15** Kwakwaka'wakw masks at the U'mista Cultural Centre, Alert Bay, British Columbia. Photograph by Aaron Glass, 2003.

The repatriated masks and other regalia seized from Chief Dan Cranmer's potlatch are displayed around the sides of a room built in the shape of a traditional Northwest Coast big house. Installed in the open, they are accompanied by text panels that commemorate their illegal seizure and the active campaign waged by community members for their return.

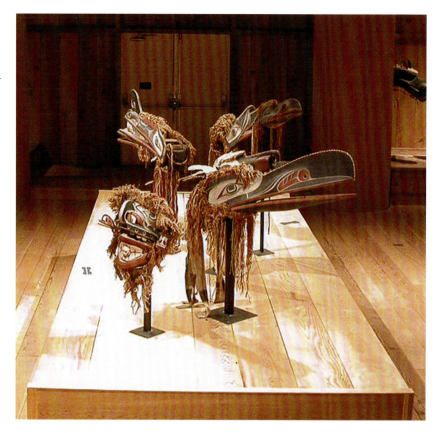

Across North America, Native representatives have also requested that certain kinds of objects be permanently removed from display and, in some cases, that photographs of such objects and related ceremonies not be reproduced. These requests are motivated both by beliefs in the inherent powers of such objects to cause harm to casual viewers and by a desire to maintain the privacy of ceremonies and rituals that were intended to be seen by knowledgeable people able to conduct them correctly, effectively, and respectfully. The Hopi Cultural Preservation Society in Arizona, for example, has put in place research protocols to address past "thefts" of information about sacred rituals such as the Snake and Antelope Ceremony, or "Snake Dance." This ceremony has attracted intense attention from outsiders fascinated by what they regarded as a quintessential primitive ritual. For the Hopi, it is a centrally important rite that invokes the rain that is vital to human subsistence in the arid Hopi lands. It is one example of many sacred rituals that have, as the Hopi write, "been exposed to others out of context and without Hopi permission," and the community has sought to prevent the unsanctioned exposure of objects and images. For this reason, too, no images of Iroquois *Ga'goh'sah* (medicine, or "False Face" masks) are reproduced in this book, although these masks, which represent forest spirits assigned by the Creator to lend their healing powers to human beings, were featured throughout the twentieth century as a major form of Iroquois "art" in art and anthropology exhibitions and publications. For more on such issues, see the Issue in Focus box.

ISSUE IN FOCUS
"Who Owns Native Culture?"

The question of "Who owns Native culture?" was posed by anthropologist Michael F. Brown in a thought-provoking book that examines the complex ethical issues raised by the circulation of objects and cultural knowledge.[17] Ownership and the restitution of objects illegally or improperly obtained often intersect with other equally important issues that arise from different definitions of the sacred and the power associated with tangible and intangible Native heritage. In a volume that surveys Native Art, such issues command attention; we address them here and elsewhere in this book.

The enactment of The Native American Graves Protection and Repatriation Act (NAGPRA) in the United States in 1990 and the 1992 Canadian *Report of the Task Force on Museums and First Peoples* established legal and policy guidelines for—as NAGPRA puts it—the repatriation of "funerary objects, sacred objects, and objects of cultural patrimony." Both have opened new dialogues not only about ownership but also about the proper treatment of sacred objects and knowledge in museums. They have led to the return of human remains and items of material culture as well as to remarkable collaborations between museums and Native peoples.

Most readers are unaware that Native North American efforts to recover items of central cultural importance began over a century ago when Haudenosaunee representatives sought the return of wampum belts sold to museums by people without the authority to do so.[18] More recently, but before NAGPRA, the Brooklyn Museum, the Smithsonian, and other museums repatriated to Zuni Pueblo their *ahayu:da* (sacred effigies also known as "War Gods"). Zuni people believe these should not be on display in museums, for the proper role of *ahayu:da* is to guard the world from high atop sacred hilltop shrines, where they eventually decompose.[19]

Both the Zuni and Hopi believe that the details of private religious ceremonies divulged to anthropologists and other outsiders in earlier generations should now be accessible only to tribal members—and often only to specific people such as elders or those initiated into particular religious societies. Some have asked archives and museums—including those with a legal mandate to be accessible to all—to limit access to photos, objects, recordings, and documents that they believe to be culturally sensitive. As Brown reminds us, "sorting out the unhappy legacies of the past will require years of discussion and pragmatic compromise."[20]

We offer two examples illustrating how complex and singular each case is. The first concerns replicas of sacred sandpaintings made by Navajo ritual practitioners

working collaboratively several generations ago to keep knowledge alive and promote cross-cultural understanding. The Wheelwright Museum in Santa Fe was founded in 1937 as The Museum of Navajo Ceremonial Art by philanthropist Mary Cabot Wheelwright in collaboration with renowned chanter Hosteen Klah (see p. 41, this chapter). It owns many replicas of sandpaintings, as well as recordings and texts used in ritual. In recent decades, advisors from the Navajo Nation Cultural Center have asked that only Navajo ceremonial practitioners be allowed access to certain records of sacred knowledge. Today, contemporary practitioners can learn the lengthy ceremonial songs (see chapter 2) by listening to recordings deposited at the museum by Klah and other early twentieth-century holy men. When the museum opened, the walls of its hogan-shaped structure displayed large replicas of sandpaintings painted by museum staff under direction from Navajo practitioners. Some fifty years later, the museum's Navajo advisors asked for the return of some of these to

▲ **1.16** Replica of sandpainting of four female supernaturals, the Long Bodies, from the Mountain Chant, originally painted by Paul Jones of the Wheelwright Museum. Based on published sources. Displayed at the Walmart in Gallup, New Mexico, photo J. C. Berlo, 2009.

(cont.)

(cont.)

the community. Surprisingly, for some years in the early twenty-first century these six-by-six-foot replicas hung in the Walmart Supercenter in Gallup—the largest place to shop on the edge of the reservation (fig. 1.16). While some might consider this to be an indigenization of corporate spaces, it could equally be seen as a co-optation of local interests by corporate marketing.

A second example concerns the contrast between the legal "harvesting" of archaeological objects by Yup'ik people in Alaska and the different local customs for the handling of archaeological heritage in other Northern communities. About 1,400 Yup'ik live in two villages on St Lawrence Island, in the Bering Sea, where a wealth of marine animals, including walruses, have supported human habitation for over 2,000 years. As archaeological finds show, over the centuries the Yup'ik and their ancestors have worked tons of walrus ivory into artifacts ranging from prosaic tools to elegant sculptures desired by collectors (fig. 5.10). St Lawrence Island Yup'ik see the excavation of archaeological sites as a subsistence activity. Archaeologist Julie Hollowell's account of their relationships to and knowledge of land suggests the broader context of this practice: "The right to continue to practice a subsistence lifestyle occupies a focal place in the ongoing struggles for Native sovereignty that St Lawrence Islanders share with other Alaska Natives and with Inuit across the circumpolar regions as well as with Indigenous peoples worldwide."[21]

In general, state and federal laws regulate the excavation and sale of ancient objects. But marketing their excavated artifacts by St Lawrence Islanders is not illegal. The Native Corporations on the island hold full title to their lands, and their regulations allow only "shareholders" (i.e., local Yup'ik themselves) to dig up and sell ancient materials. Outside buyers ranging from shop owners, to wealthy collectors, to Native artists buy everything from ancient tools, to so-called fossil ivory, to rare art objects. Exhibition catalogues from distant cities serve both as guides to what collectors value and evidence of what has come out of the ground.[22]

Elsewhere in Alaska, another Native community has taken a different approach to their ancient patrimony. Alutiiq people on Afognak Island (not far from where the 1,500-year old stone lamp in fig. 5.13 was discovered) have been collaborating with archaeologists to understand the deep history of their people. In a project called *Light the Past, Spark the Future, Dig Afognak*, graduate students in archaeology teach Alutiiq youth about archaeological methods, while elders teach spiritual values. In 1996, an ancient stone lamp was lit for the first time in centuries to mark the opening of Spirit Camp, where youthful campers explored both of these realms. About her community's collaboration with archaeologists, Ruth Alice Olsen Dawson, former president of the Afognak Native Corporation said, "scientific research has helped me find my Native heart."[23]

These examples suggest the many local traditions and responses that make the application of one national policy a complex and challenging process. They also illustrate the ongoing need for mutually respectful and creative processes as discussions about archaeology, repatriation and a host of other issues continue to unfold in future years.

It is also important to note, finally, that the singling out of *visual* arts in this discussion reflects a privileging of the visual sense that has characterized Western cultures for much of their history.[24] One of the effects of Western domination of Native North American cultures has been to devalue the importance of expressive forms such as oratory or dance that have traditionally been valued as highly—if not more highly—than works of visual art within Native societies. Many contemporary Native writers and artists are working to restore a balance and integration among art forms more typical of their historical cultures, and they often work in more than one expressive medium, or collaborate with writers, dancers, and dramatists.[25] Native artists are thus part of a contemporary process of debate and critique in which the boundaries that separate art from non-art, visual art from music, dance performance and other arts, fine art from other forms of visual culture, and the graphic and plastic arts from print culture and new electronic technologies are being called into question. As these explorations proceed, they will also, undoubtedly, bring new insights to the understanding of historical aesthetic expression.

Commodification and Authenticity

Despite their differences, the art and artifact paradigms of collecting shared a common assumption about the nature of authenticity in Native North American art. Both defined those objects that dated back to the early period of contact and displayed a minimum of European influence as the most interesting and valuable. This definition of authenticity is part of a widespread tendency to romanticize the past of Native peoples at the expense of their present, and such judgments carry important implications. Although the image of the Native man as "noble savage" or of a Native woman as "Indian princess" may appear to express unqualified admiration for Native culture, such images can also crowd out, in a damaging way, the possibility of engagement with the modern lives, problems, and accomplishments of contemporary Native people—in art as in everything else (fig. 1.17). Such stereotypes, furthermore, are based on early but enduring fantasies about Indigenous culture and society that have little or no basis in fact. The critique of stereotypes has been a central theme of modern and contemporary Native artists (fig. 1.18).

In more recent studies of Native North American art, the definition of authenticity has been reevaluated in relation to the commodification of Native art and issues of stylistic hybridity, and particularly in relation to art forms produced for the souvenir market during the late nineteenth and twentieth centuries. Nineteenth-century tourists sought out sites that offered sublime

▲ **1.17** Left: Poster for Buffalo Bill's Wild West show. Color lithograph. Courtesy of Buffalo Bill Historical Center, Cody, Wyoming, U.S.A.; Gift of George Fronval, through the courtesy of Nick Eggenhofer, Cody, Wyoming. 1.69.48.

"Buffalo Bill" Cody's immensely popular Wild West show toured North America and Europe between 1883 and 1913. The reenactments and posters seen by hundreds of thousands of people fixed in the popular imagination the stereotype of the Indian as a stoic figure in a feathered war bonnet. The reenactments of hunting and warfare that they staged provided for many of these men a welcome relief from the poverty and confinement to reservations Plains peoples endured during these years.

▲ **1.18** Right: Horace Poolaw, 1906–84 (Kiowa), *Horace Poolaw, Aerial Photographer, and Gus Palmer, Gunner, Mac Dill Air Base, Tampa, Florida*, c. 1944. Gelatine silver print, 31.1 × 23.8 cm. © The Horace Poolaw Family/Horace Poolaw.

During his two years in the U.S. Army Air Corps during World War II, Poolaw taught aerial photography. In this slyly humorous image, the photographer plays on stereotypes about the noble Indian warrior of the Plains photographically recording an image of twentieth-century warfare.

▶ **1.19** Unknown photographer, Ye Olde Curiosity Shop, early twentieth century. Postcard. Courtesy University of Washington Libraries, Special Collections, CUR540.

This postcard for Seattle's popular tourist shop, established in 1899, makes evident the enduring contexts of natural history and curiosity in which native North American objects were presented. In the jumble of wares, it would have been hard for buyers to distinguish quality. The totem poles, for example, are crudely carved and nontraditional while the finely woven Chilkat blanket over the doorway would undoubtedly have been worn at a potlatch by a high-ranking chief.

experiences of nature, among which Niagara Falls was preeminent. During the middle decades of the century, visitors eagerly bought finely made examples of the beadwork, moosehair embroidery, and other arts of Haudenosaunee (Iroquois), Wendat (Huron), and Anishinaabe (Ojibwe and Odawa) artists. By the end of the nineteenth century these productions had extended across the continent. As Jonathan Batkin has written, "curio dealers and Native North American craftspeople had collaborated to invent and market objects that had no purpose but to satiate a nearly irrational desire to own Indian artifacts." J. E. Standley's "Ye Old Curiosity Shop" in Seattle, Washington, exemplifies the marketing of Indian curios in the early twentieth century and the way that it confused the issue of authenticity (fig. 1.19). Crowded with basketry, jewelry, natural history specimens, ivory carvings, and other items then classified under the rubric of "curios," this emporium sold its wares to anthropologists, serious collectors, and casual tourists alike. Some were replicas carved by Native entrepreneurs from drawings in Franz Boas's *The Social Organization and the Secret Societies of the Kwakiutl Indians* (1897) a mere ten years after this pioneering anthropologist published his important treatise on Kwakiutl culture. Other items for sale were ivory carvings made by Inupiaq and Yup'ik men (see chapter 5) sold to Standley through middlemen in Barrow, Nome, or Juneau. As Kate Duncan has demonstrated, pieces from this shop ended up both in the parlors of middle-class collectors, where they were displayed as souvenirs of interesting travels and vacations, and in major museums such as the Horniman Museum in London and New York's Museum of the American Indian (now the National Museum of the American Indian).

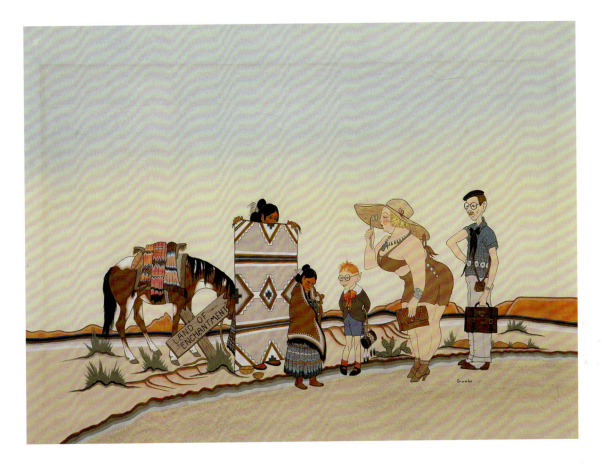

Souvenir production and the economic needs that lay behind it were long deplored by scholars and art connoisseurs, but they are now recognized both as important stimuli for creativity and cultural preservation and as sites of active Aboriginal intervention in the stereotypes circulated through popular art and performance. A satirical painting by Woody Crumbo foregrounds the discomforting dimensions of intercultural exchange. Its title, *Land of Enchantment*, is the state motto of New Mexico, which had become a major tourist destination by the 1940s when the drawing was made. Crumbo turns the table on the usual stereotypes by placing a Navajo woman and her daughter in the foreground, presenting a rug for the inspection of a white tourist family (fig. 1.20). The battered and crooked wooden sign, "Land of Enchantment," suggests that from the Native perspective, the days of enchantment are long gone.

▲ **1.20** Woody Crumbo, 1912–89 (Potawatomi), *Land of Enchantment*, 1946. Watercolor, 17.5 × 23 in. Gift of Clark Field, 1946.45.4. © 2014 The Philbrook Museum of Art, Inc., Tulsa, Oklahoma, courtesy Minisa Crumbo Halsey.

In Crumbo's satirical painting, each family member is a caricature, from the goofy freckled child, to the fleshy mother bursting out of her revealing play clothes, to the camera-toting father wearing a bohemian beret and holding a briefcase. The Indian crafts they are buying look absurd against their outlandish clothes. As they examine a Navajo rug, the weaver peeks shyly from behind her textile, while her daughter looks down sadly. Even the horse, bearing more weavings, has a dejected cast.

Who Is an Indian? Clan, Community, Political Structure, and Art

Particular forms of social organization and subsistence strategies are closely tied to the kinds of objects people make and their choices of medium and scale. In groups where populations are small, for example, the distribution of power tends to be relatively egalitarian and the systems of leadership more informal. The autonomous power of each individual is recognized and expressed in a range of different artistic contexts, often centering on

and policies that derive from outmoded racial theories, patrilineal bias, or geographical segregation.[26] Contemporary critical thought about identity, in contrast, stresses the importance of an individual's subjectivity—of the identity developed as a result of personal and family history. Yet legal definitions continue to place many Native people in invidious positions.[27] The subject remains a painful and difficult issue for many Aboriginal people, and it is regularly addressed in the work of contemporary artists (fig. 8.5).

SPIRITUAL PRACTICES AND THE MAKING OF ART

Identity is not only—or even primarily—a matter of legal definition. On a more profound level, it is constructed from the way an individual understands his or her relationship to place, to community, and to the cosmos. Contemporary Aboriginal people are heirs to unique knowledge systems that have developed out of thousands of years of living, dreaming, and thinking about the lands, waters, plants, animals, seasons, and skies of the North American continent. These epistemological systems explain the fundamental structures of the cosmos, the interrelationship of humans and other beings, the nature of spirit and power, and of life and death. They have provided the basis for the development of specific ritual practices that make human beings effective in the most critical of activities—hunting, growing crops, creating families, working in offices or factories, curing disease, making war, and accomplishing the journey through this world to the next. The unique worldviews of Native North Americans have been amplified over the centuries by encounters with other spiritual systems, and particularly with Christianity, which many Native people have accepted either in place of, or alongside, traditional ones.

Since the second half of the nineteenth century, the U.S. and Canadian governments have collaborated directly with Christian missionaries as part of a formal policy of directed assimilation. For more than a century both governments used their power to remove tens of thousands of Native children from their families to residential and boarding schools, mostly run by missionaries. There it was expected that they would, within a single generation, become Christian and "civilized," and that their ties to Aboriginal languages and cultures would finally be severed.[28] The effect of these schools is evident in remarks made in the 1930s by a Native graduate of a U.S. boarding school, the Hampton Institute: "What does the Indian of today care about his art? Or about some ancient tool that a scientist might uncover? That time is past, and should be kept there. Personally, I wouldn't give up the experiences I have had for all the old-time ceremonies and 'Indian culture.'"[29]

Schools did accomplish some of their educational goals and—often unintentionally—set a number of pioneering Aboriginal artists on the path to careers as professional artists. Yet for many, such benefits have been far outweighed by other issues: the anguish of separation experienced by parents and children, the abuse that was common in the schools, and the legacy

of family breakdown and cultural rupture they caused.[30] The orderly transmission from one generation to the next of Native languages, traditional beliefs, practices, and arts was radically disrupted. In 2009, the Canadian government at last issued a formal apology for the residential school system, offered compensation to victims, and established a Truth and Reconciliation commission to reveal the full extent of the damage and help them heal. As Indigenous peoples struggle to repair the losses, many museums are seeking ways to use their collections of Indigenous art and material culture to support their efforts.

The combination of missionary activity and Western schooling drew many people away from traditional spiritual practices and resulted in new forms of religious syncretism. The very brief account of Indigenous worldview to which we now turn is, then, an abstraction that describes neither the many individual combinations of belief and practice that have resulted from the history of contact and directed assimilation nor any one traditional worldview. Rather, it attempts to point out some broad historical patterns of worldview that underlie and link the rich diversity of contemporary Aboriginal life—and that also link the spiritual systems of Native North Americans with those of Indigenous peoples in Mesoamerica and South America, Siberia, and the Pacific Rim with whom they have many ties of history and blood. These shared beliefs concern the nature and location of "spirit," the fundamental structures of space and time, the concept of power (including that of "medicine"), the value of visionary experience, the role of shamans, and the importance of feasting and gift giving in the validation of blessings received from spirit protectors.

The Map of the Cosmos

A fundamental feature of a worldview is the way it "maps" space. Native North American cosmologies divide the universe into distinct spatial zones associated with different orders of power. A supplicant's proper orientation in relation to these zones is vital to the efficacy of ritual. Because space is experienced in relation to specific configurations of land, sky, and water, the specifics of cosmology in each region reflect and reflect *upon* particular environments and ecologies. In the Plains and Woodlands, for example, cosmic space is subdivided into three zones: sky, the earth's surface, and the realms beneath earth and water. Earthly space is also conceived of as circular, divided into quadrants identified with the four cardinal directions and with winds that blow from these directions bringing the changes of season. On the Northwest Coast, in contrast, the significant spatial zones define a water realm of sea or river, a coastal zone where human settlements are located, and a realm of forests and mountains. Everywhere in North America the zones of earth, water, and sky are also linked by a central, vertical axis that provides a path of orientation along which human prayers can travel between realms of power. This axis is visualized in various ways: as a great tree, an offering pole, or a path along which smoke travels from a central hearth through the smoke hole above it (figs. 1.22 and 1.23).

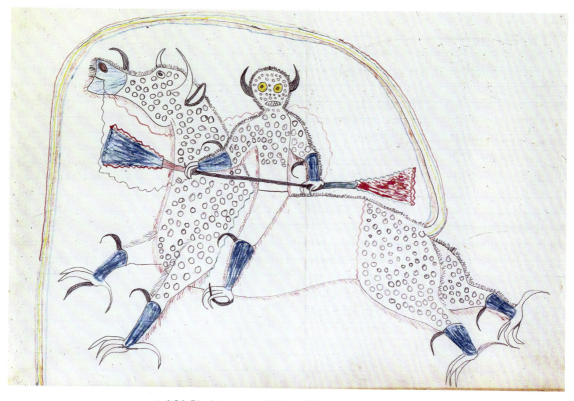

▲ **1.24** Black Hawk, c. 1832–c. 1889 (Sans Arc Lakota), *Dream or Vision of Himself Changed to a Destroyer and Riding a Buffalo Eagle*, 1880–81. Pencil, colored pencil, and ink on paper, 9 ½ × 15 ½ in. T0614 Gift of Eugene V. and Clare E. Thaw, Thaw Collection, Fenimore Art Museum, Cooperstown, New York, Photograph by John Bigelow Taylor, NYC.

For the Lakota and other peoples of the Great Plains, Thunder Beings are powerful supernatural creatures who appear to supplicants in vision quests. They often combine attributes of eagle, horse, and buffalo, all sacred animals. Here a horned and taloned figure rides a similarly endowed beast. Both steed and rider are covered with small dots, representing hail, and are connected to each other by lines of energy. The beast's tail forms a rainbow through which the figures travel. Black Hawk's vivid image of his vision conveys the potency of these awesome sky dwellers.

expressed through the songs and dances performed on ceremonial occasions. Today, some of these representational practices continue in the regalia worn at powwows, traditional dances, and potlatches and in more private ritual contexts.

Shamanism

All Native societies recognized that certain individuals were exceptionally receptive to visionary experience, allowing them to be in touch with powerful spirit protectors. These individuals, or shamans, could be of either sex, though they have most often been men. They could put their powers at the service of other people to heal, to guide a hunter, or for other constructive purposes. Oral history and sacred stories account for the existence of evil in the world by explaining how such powers can also be used destructively.

According to Mircea Eliade's influential formulation, shamanism has diffused over a large portion of the globe during thousands of years from a place of origin in central Asia. Shamanism is associated with a specific complex of beliefs, including the distinctive patterns of cosmological mapping discussed earlier, particularly the notion of a world axis that opens a channel of communication between zones of power. Shamans have commonly used drumming to induce trance states, and public performances involving visual and dramatic arts to relate their experiences of out-of-body travel. Distinctive dress, amulets, and masks display the images of their power beings, among which the bear is especially prominent across northern North America. A specific iconography associated with shamanism is derived from these beliefs and practices. It features such motifs as skeletal markings to represent the liminal state the shaman occupies between life and death; the marking of the joints, which are points of entry and exit for the soul; and hollowed-out or projecting eyes that signify the shaman's extrahuman powers of sight (fig. 1.25).[32]

One of the distinctive features of Native North American art is that shamanism and its typical iconography provide the fundamental metaphors that convey notions of power in a wide variety of contexts. Esther Pasztory has made a useful distinction between "shamanistic" societies, where the shaman is a central authority figure, and others in which individuals wielding power display "shamanic traits" but are not actually shamans. Shamanic traits, for example, mark the art and practice of Pueblo men's societies and Haudenosaunee healing societies.[33] Among Northwest Coast peoples, high-ranking individuals, whose authority is primarily political, display shamanic motifs on their ceremonial dress and masks, and the shamanistic trance is reenacted in the initiation rituals of the Hamatsa society into which members of the highest ranking families are inducted (see chapter 6).

▲ **1.25** Dorset artist, Dorset culture (Prehistoric Inuit), Canada, Shaman's tube, c. 500 CE. Ivory. Canadian Museum of History, NiHf-4:115, IMG2013-0146-0002-Dm.
Shamanic practice and shamanic art are both concerned with transformation. In this small item used in medicine rituals, the tube has a human face, but out of its head spring two walruses who interlock their tusks, perhaps in struggle or in assistance.

SOCIAL PRACTICES AND THE MAKING OF ART

Although no hard line can be drawn between spiritual and social practices in Native North American art, some forms of ritual are designed to ensure the transmission of customs, laws, and traditions that ensure the cohesion

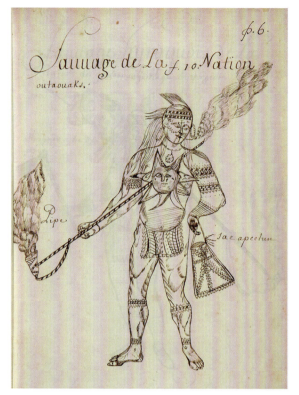

▲ 1.27 Attributed to Louis Nicolas (1675–1703), *Man of the Outaouak Nation*, c. 1700. Page from the *Codex Canadiensis*, 8 ½ × 13 ¼ in. Courtesy Gilcrease Museum, Tulsa, Oklahoma.

Jesuit missionary Louis Nicolas made 180 images of the plants, animals, and Aboriginal people he saw during eleven years of missionary work in New France between 1664 and 1675. In this drawing, an Odawa (Ottawa) man displays a tattooed image of the sun, signaling power acquired through visionary experience. He holds a tobacco bag in his left hand and a long calumet pipe in his right, and wears quilled head, leg, and arm bands.

"Creativity Is Our Tradition":
Innovations and Retentions

We have borrowed this subheading from the title of a path-breaking book about contemporary Native art, for it is applicable to the entire long history of Aboriginal art.[36] As the next five chapters will demonstrate, for thousands of years before contact Indigenous artists of North America used materials from distant sources in their art. Later, trade goods from European sources were welcomed by Aboriginal people who responded with tremendous creativity to the new textures, colors, techniques, and objects that began to circulate after contact. Manufactured materials added new possibilities for richness and diversity of self-display. Like artists everywhere, Native artists were eager to experiment with new materials, iconographies, and techniques, and to incorporate them in their own repertoire. They were also proud to wear and use items made by outsiders. A photo taken at a Tlingit potlatch in Sitka, Alaska, in 1904 is a visual encyclopedia of the diverse materials that Northwest Coast women were using in their art by the turn of the twentieth century (fig. 1.28). Tlingit access to all of these foreign goods through commerce in furs and fish sparked a creative explosion in women's textile arts. Wearing the products of their cosmopolitan artistry, the ranking participants of this Northwest Coast society make an emphatic statement about their status, wealth, power, and ability to assimilate goods and ideas from both distant and neighboring worlds.[37]

For many years Westerners looked at such images as examples of the "degeneration" or "corruption" of Native arts because of the incorporation of imagery and materials from elsewhere. All Native North American art should, however, be thought of as sets of objects that are in a perpetual dialogue with other objects and their makers. When glass beads were first introduced, for example, they were incorporated into preexisting Indigenous systems that valued light-reflective materials such as shell and quartz crystal. The new beads were similarly named with words that identified them as gifts from the spirit world. Frank Speck reported, for example, that the Innu (Naskapi) of the Labrador Peninsula termed glass beads "eyes of the *manito*," or spirit.[38] Numerous other examples will be discussed in this book.

When the explorer Prince Maximilian of Wied (1781–1867) and the artist Karl Bodmer traveled up the Missouri River in 1833 and 1834, they explored lands on the Northern Plains that very few non-Indians had seen. Yet long-distance trade goods were already an accepted part of Mandan and Blackfeet societies. In 1738, a French trader saw evidence of

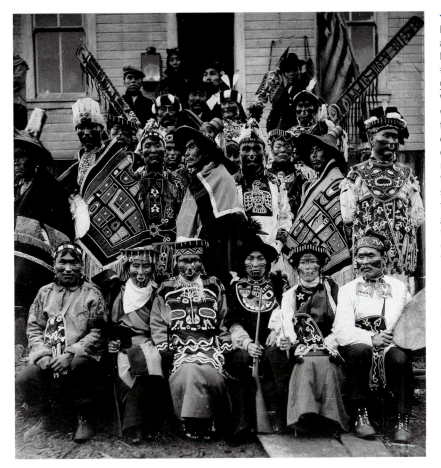

◀ **1.28** Photo of Tlingit Indians in ceremonial finery at a potlatch, Sitka, Alaska, December 9, 1904. Image #328740, American Museum of Natural History, Library.

Wearing Chilkat blankets woven by Tlingit women, trade cloth cloaks, and ermine-skin coats modeled on Russian and American military officers' garments, the people pictured here show how the creative transformation of diverse goods produced a striking visual display of wealth and cosmopolitanism. Much of the floral beadwork was learned from Northern Athapaskan women upriver. Most of the faces are stamped and painted with ephemeral tattoo-like images.

a lively exchange between the sedentary Mandan in their villages on the river and other Indigenous groups. This trade included goods of European manufacture acquired from French and British traders in New France, as Canada was then called. At Fort McKenzie in August 1833, Prince Maximilian was surely surprised when high-ranking Blackfeet chiefs distributed gifts to his party that included a British officer's scarlet coat given to the Blackfeet in a previous intercultural encounter. In his diaries, the Prince recorded his distress at seeing the chiefs wearing such overcoats and European hats as finery.[39] Bodmer deliberately omitted any such "tainted" influence from his portraits of the Mandan and Blackfeet, yet he unwittingly painted one man wearing a Navajo trade blanket as well as a neck pendant of trade silver, both of which were prized by Indians across the Plains (figs. 1.29 and 2.23). In their fascination with new types of cloth and styles of clothing, Native North Americans demonstrated the same human interest in ideas about dress as did French enthusiasts for imported Japanese and Chinese wares during the eighteenth century, or the Victorians for textiles from India and other distant places in the nineteenth century.

Value judgments based on a Eurocentric, patriarchal approach to art history color much of the writing on Native art before 1970. Male arts were often valorized as sacred and individualistic, growing out of a personal visionary experience, while women's arts—such as weaving, basketry, and beadwork—were characterized as quotidian, secular "craft." Too often, items made by women and used in daily life—coiled baskets, beaded moccasins, woven blankets—were not seen to be connected to spiritual or political power, while men's carvings or paintings were. This reflects the bias of the Western observer on two levels. European observers tended to privilege the art associated with political, military, and ceremonial life most similar to their own and which seemed to them attributable to Native men. European concepts of art, furthermore, have been grounded in the assumption that artists take inert raw materials and make them into meaningful human creations. Finally, the European classification divides art forms into separate realms of the sacred and the secular. These concepts are alien to Native worldviews which are founded on the notion that all artistic creation involves the utilization of materials in which power may reside, including wood, stones, grasses, and pigments. When human beings undertake to transform these powerful materials for another purpose, they engage in relationships of reciprocity with nonhuman powers. This is no less true of a woman gathering sweet grass for a basket than for a man taking wood for a mask from a living tree.

Ethnographic evidence, when closely scrutinized, makes it clear that both male and female artists gain inspiration for their work in dreams and visions. Interviewing renowned Ojibwe beadworker Maggie Wilson in the 1930s, anthropologist Ruth Landes reported that she "devotes herself incessantly to this form of embroidery, and receives visions in connection with it, just as a man would receive visions in connection with hunting, divining, or war" (fig. 1.31).[43] In women's textile arts of the Great Lakes region there are, thus, intimate connections among perfection in a skill, the conceptualization of design, and the possession of extrahuman powers. Outstanding talents and achievements are understood to be evidence of extraordinary power. As discussed in chapter 2, a finely woven Navajo blanket, made by a woman, projects *hozho* (beauty and harmony) into the world as does a finely constructed sandpainting made by a male healer (figs. 2.21 and 2.23).

While gender roles may seem to have been strictly defined in pre-twentieth-century Native life and art, they could also be transgressed under certain conditions. In general, men painted the narrative or visionary scenes on Plains tipis and kept the historical records or winter counts. Yet individual circumstances existed where women transgressed these boundaries—one Blackfoot woman painted her husband's war experiences on his tipi because she was such a good artist, and several Southern Plains women were entrusted with the keeping of a pictorial calendar count by a male relative. In Native North American societies, artistic and technical knowledge is a form of property or privilege, which can be transferred from one individual to another as a gift or through a financial transaction. If an uncle sees fit to bestow such property on his niece, her rights of ownership abrogate the "rules" of gender that usually define artistic practice. Power associated with shamanism can transcend gender rules, too. Transsexuals commonly practiced the art of the "other" gender. A famous example of this was the Zuni potter We'wha

(1849–96), who was born a man but by inclination was a woman, both in terms of dress and artistry.[44]

Shamans sometimes have physical characteristics that distinguish them from others. A famous Navajo medicine man, Hosteen Klah (1867–1937), practiced both the male art of sandpainting and the female art of weaving, having great powers in both realms. Klah was both left-handed and a hermaphrodite. In Navajo thought, a *nádleehí*—one who combines the physical attributes and/or talents of both genders—is a person honored by the gods. Klah did not attend school but apprenticed with a succession of ritual experts. The great aptitude for memorization he demonstrated from childhood allowed him to learn the arduous visual and aural details for the necessary completion of ceremonies that could last many nights. It was said that, by age ten, he was able to choreograph all the complex components of the Hail Chant learned from his uncle.[45]

As a young man, Klah also showed interest in both male and female realms, and mastered the female arts of spinning, carding, and weaving wool. He built his own looms on a much larger scale than was customary for weaving an ordinary Navajo blanket or rug (fig 2.20). He demonstrated weaving at the World Columbian Exposition in Chicago in 1892–3 and sandpainting at the Century of Progress International Exposition in Chicago in 1934. Klah was an expert weaver; in 1919, he was among the first to make textiles as large as ten square feet depicting the supernaturals ordinarily seen only in ephemeral sandpaintings (fig. 2.21). The reproduction of such designs was considered dangerous since the ritual process requires that the paintings made of crushed minerals and pollens be destroyed as part of the ceremony. But Hosteen Klah flourished both as a healer and a weaver and taught his nieces to weave sandpainting designs with no ill effects befalling any of them. His work is a good example of the way in which a superior artist who has spiritual powers can transgress the gender roles of his culture, transforming the arts of that culture in the process.

In most regions, gender roles in art production have relaxed considerably within the last fifty years. There are male potters in the Southwest, female wood-carvers on the Northwest coast, and male beadworkers in many regions. Contemporary artists freely take inspiration from both male and female realms in style, materials, and iconography. In Colleen Cutschall's series of paintings *Voice in the Blood*, the tiny hatchings and densely dotted patterns of her brushwork are a homage to the quillwork and beadwork patterns of her female ancestors. Like beadwork artist Ida Claymore a century ago (fig. 1.30), Cutschall draws upon the pictorial narratives found in male graphic arts on the Great Plains (see chapter 4).[46] Contemporary artists who are gay or transgendered draw strength from the artists of the past such as We'wha and Klah, who were able to transgress gender norms. Kent Monkman draws both on these models and on his comprehensive knowledge of Western art history to intervene in historical settler representations of Native North Americans (see Artist in Focus box). His paintings and ambitious multimedia works—which we discuss further in chapter 8—use gender, sexuality, and eroticism as sites for provocative, tricksterish reversals of the colonial power relations we have discussed in this chapter and which continue to inform many aspects of contemporary visual culture.

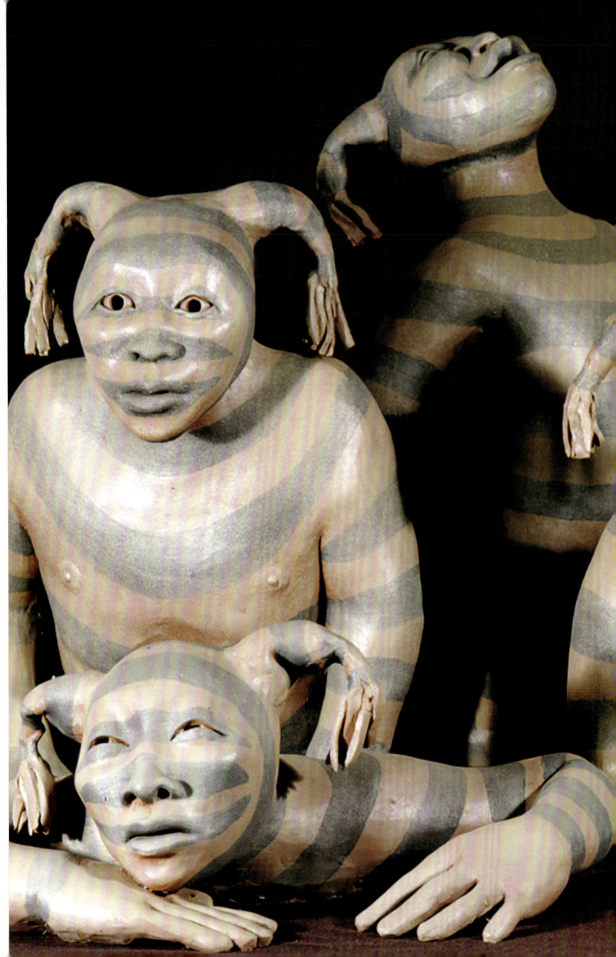

THE SOUTHWEST

Four black-and-white-striped clowns, made of clay but looking uncannily alive, push themselves upward (fig. 2.1). The artist, potter Roxanne Swentzell of Santa Clara Pueblo, has captured them in the moment of emergence from the earth. "The four *koshares* [clowns] symbolize the four directions," she says. "They're the ones who came out of the earth first and brought the rest of the people to the surface. My message is, 'remember where you came from.'"[1]

This modern image encapsulates several fundamental features of Indigenous ritual that still flourish in the Southwest. Humankind's emergence from the earth is often reenacted in public performance in which sacred figures emerge from a hole in the roof of the *kiva*, the subterranean enclosure characteristic of Pueblo religious architecture. Moreover, public religious performance is constantly reaffirmed as being central to the cycle of life. In the Pueblo worldview, human beings have a spiritual obligation to replay the ancient act of emergence, and to don masks and special garments to impersonate and personify the spiritual forces of the world (including the *koshares*—buffoons who remind people of their flaws and shortcomings).

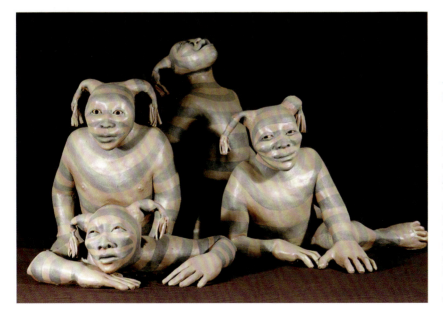

◀ **2.1** Roxanne Swentzell, b. 1962 (Santa Clara Pueblo), *The Emergence of the Clowns*, 1988. Fired clay, pigments, H. 17.8 × 33 cm. Courtesy Heard Museum, Phoenix, Arizona and the artist; photographer Craig Smith.

The sacred clowns who appear at many Pueblo festivals are here modeled in clay. Such figures emerge from the world beneath the earth to teach people through humor and bad example the proper way of being in the world.

THE SOUTHWEST AS A REGION

The Southwest encompasses diverse ecological zones—from the arid Sonoran desert of Southern Arizona and New Mexico to the expansive plateau and pine-clad mountain peaks of the northern regions of these two states and the southern parts of Colorado and Utah. The Southwest is home to several cultures whose artistic legacies have been exceptionally well preserved, precisely because of the aridity of the climate (fig. 1.12). This region is noteworthy for its 3,000-year record of continuous cultural history. While change is a constant factor anywhere, there is also great longevity of ritual, architecture, and the arts, especially in the Pueblo cultures of northern New Mexico and Arizona.

The principal ancient cultures are the Hohokam of Southern Arizona, the Mimbres/Mogollon of Southwestern New Mexico, and the Ancestral Puebloans of the "Four Corners" region—where the states of Arizona, New Mexico, Colorado, and Utah converge (see Map next page). All of these people were agriculturalists who coaxed corn, beans, and squash from the dry earth, petitioning the spirits and the clouds for rain. Although they were farmers, many were urban as well, living in communities of several hundred to several thousand, while traveling on a regular basis to farm fields beyond the limits of the community. All were part of a vast trade network that extended to the Gulf of California in the west, to Central Mexico in the south, and to the Great Plains to the north and east. Religious ideologies and iconographies were widely shared (and modified to local needs) across these regions. Today, for simplicity's sake, we tend to refer to these as discrete "cultures," but in fact they should be seen as no more than patterns of cultural practice—patterns that today we discern from building types and artifact styles. Within each of these regional patterns of material culture, there were many variations.

These cultural traditions evolved over many centuries and much of their ancient heritage is alive today in the Indigenous cultures that remain so strong in this region. The O'odham (or Pima and Papago) of Southern Arizona are heirs to the traditions of the ancient Hohokam. The Pueblo peoples at Hopi, Zuni, Acoma, and the Rio Grande Pueblos are so named because the sixteenth-century Spanish explorers, impressed at the urban nature of their settlements, characterized them by the word "pueblo," the Spanish term for town or city. These peoples are descended from the ancient Anasazi. Increasingly archaeologists prefer the term "Ancestral Puebloan" for these Anasazi ancestors. We use both terms in this chapter so that the reader will recognize that these are the same peoples who are always called Anasazi in the older literature, but we favor "Ancestral Puebloan." These ancient inhabitants have been joined over the past 500 years by the relative "newcomers" to the Southwest—the Navajo and Apache, whose long migrations from Northwest Canada and interior Alaska brought them to the Southwest in the thirteenth to fifteenth centuries. They, in turn, absorbed and reinterpreted aspects of Indigenous Southwestern artistic and religious practice, creating new hybrid arts and cultural traditions. Finally, the Spanish, who in the seventeenth and eighteenth centuries wrought profound changes in the cultural landscape, and the other "Anglos" who subsequently settled in the Southwest brought further changes.

Locations of Archaeological regions and sites discussed in this book

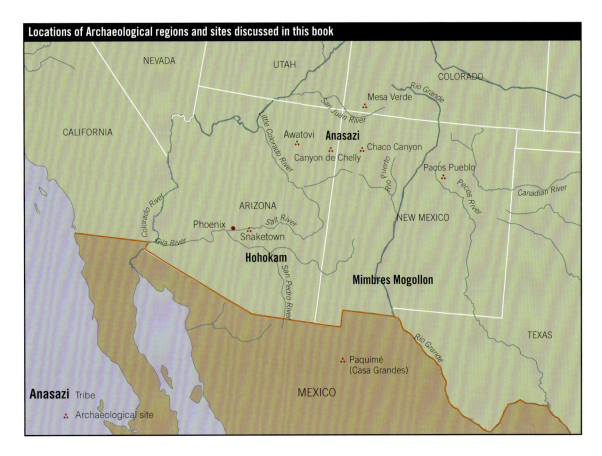

Locations of Southwestern peoples and sites discussed in this book

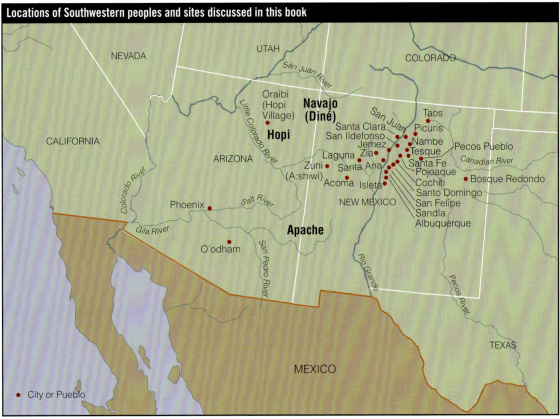

Pueblo peoples' own historical narratives stress migration as an important feature of their early existence. The Zuni (sometimes today called A: shiwi) talk about a "Search for the Middle Place" that took them on a quest in various directions in search of the ideal homeland. The archaeological record corroborates this, for over the past two millennia there has been much movement of peoples throughout the Southwest. And of course, in the postcontact period, some of the migrations were imposed by the will of outsiders, as we shall see.

Often in the history of art and culture we make the mistake of narrating a story of continuous development of a tradition that moves progressively toward an ever better and improved way of doing things. Yet here, as in many parts of the world, the archaeological and ethnohistorical record tells a different story. Notably, the people who lived in this region a thousand years ago lived in communities whose scale was more vast and whose architecture was more ambitious even than the impressive multilevel towns their descendants have built in the past nine centuries. Some of the finest ancient achievements in architecture and the arts occurred during relatively brief periods of social stability, punctuated by times of ideological change and conflict, cultural reorganization and migration in search of more reliable water sources, better land, and safer living conditions. The huge, multistorey apartment complexes at Chaco Canyon and the complex system of irrigation practiced by the Hohokam have had no parallels in recent centuries.

The small villages that survive today (see fig. 2.13) have preserved many ancient traditions and have modified them as a result of 500 years of acculturation to European ways. And while aspects of modern Pueblo culture usefully illuminate the past, the social organization of ancient societies, especially at places like Chaco Canyon, was far more complex than that of their modern descendants (a phenomenon true of the chiefdoms and confederacies of the East as well; see chapter 3).

Despite a thousand years of tumultuous history involving drought, warfare, invasion, slavery, pestilence, and multiple colonizing forces, the persistence of tradition in the Southwest is remarkable. The Hopi village of Oraibi, for example, has been occupied for over a millennium. While this may be a common occurrence in European or Asian cities, no other community in North America can lay claim to this distinction. It is a duration of time that is impressive in a country whose modern political history has endured less than 250 years.

THE ANCIENT WORLD: ANASAZI, MIMBRES, HOHOKAM

"Anasazi" is a Navajo word that translates as "enemy ancestors." Many Anasazi ruins are on Navajo land, and it is understandable that the modern inhabitants would have coined a term for the makers of such remarkable architectural ruins, which they recognized were not made by their own forebears. We do not know what these ancient peoples called themselves; presumably there were scores of different, specific names used within the multitude of communities whose ruins dot the Southwestern landscape. The Anasazi, or Ancestral Puebloans, were the ancestors of modern Hopi, Zuni,

and other Pueblo peoples, and the Hopi name for them is *Hisatsinom*. Their achievements in the arts ranged from monumental architecture to ceramic technology, to painting on walls of vessels and houses, to work in shell, bone, and fiber. Most of their perishable arts have disappeared, but historical and modern arts of performance and visual display, combined with a handful of well-preserved textiles, suggest that Ancestral Puebloan people had remarkable traditions in these realms. But it is by their formidable achievements in architecture and painted pottery that they are best known to the world.

Ancestral Puebloan Architecture, Ritual, and Worldview

The original permanent architectural form used by Ancestral Puebloan people and their neighbors was a modest-looking semisubterranean structure known as a pit house. The key features of a pit house included supporting wooden posts, an entrance hole in the roof, and walls and ceilings of sticks and dried adobe mud plaster. The *sipapu*, a hole in the floor, served as a symbol of the opening into the underworld from which the first people emerged.

In the centuries after 900 C.E., social and demographic factors led to a specifically Anasazi development. The rather humble circular form, combined with small rectangular rooms, became the building blocks for the most ambitious architectural constructions ever conceived in Aboriginal North America: the great apartment complexes and "cliff palaces" that, by 1100 C.E., dotted the landscape of the Four Corners region (see Map 1).

Many of these ancient structures were oriented in relation to the heavens and the underworld and were constructed with sophisticated knowledge of passive solar heating, as well as an appreciation for the cooling properties of stone walls. At sites like Mesa Verde's Cliff Palace (fig. 2.2), the low winter sun enters the pueblo and warms the stone and adobe structures, which then give off reflected heat. In contrast, the summer sun is too high to shine in on the buildings constructed within the cliff's overhang, and the shady stone structure provides welcome relief from the dazzling heat of the valley floor and mesa top.

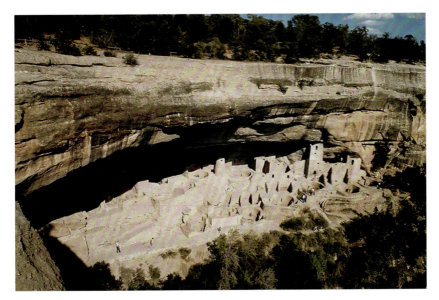

◀ **2.2** Interior view of Cliff Palace, Mesa Verde, Ancestral Puebloan culture, Colorado c. 1250 C.E. Photo by Janet Catherine Berlo.

Enclosed within natural spacious concavities in the rock mesas, the cliff dwellings at Mesa Verde offer protection from both hot and cold weather. Cliff Palace, the largest, had over 200 rooms, and two dozen kivas.

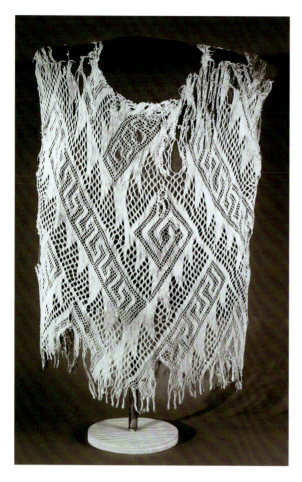

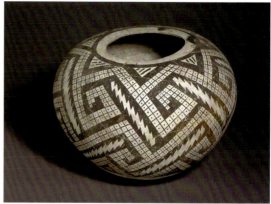

◄ **2.4** Left: Salado artist, Tunic from Tonto Ruins, Arizona, 1400–1500 C.E. Cotton fiber. Courtesy Arizona State Museum, University of Arizona.

In southeastern Arizona, Hohokam, Mimbres, and Ancestral Puebloan traditions joined to produce a late regional cultural variant called the Salado culture. Best known for polychrome pottery, they also produced technically complex garments.

▲ **2.5** Right: Ancestral Puebloan artist, Seed jar, c. 1150 C.E. Fired clay, pigment. Courtesy Saint Louis Art Museum, funds given by the Children's Art Festival 175:1981.

The painter of this vessel methodically constructed her design by making angular forms, crosshatching them, and painting individual black dots in each square of the checkerboard. She painted black sawtooth patterns on the edges of the angles, yet we read the white spaces between the sawtooth borders as lightning forms. The interplay of positive and negative space forms complex patterns.

"Basketmaker Culture" has long been used by archaeologists to describe the ancient Pueblo peoples who lived in the Four Corners region from 100 B.C.E. to 700 C.E. (Although evidence for weaving in the Southwest and Great Basin is now known to be far older than previously believed—as much as 9,400 years old.) Yucca fibers, other plant materials, and even strands of hair were coiled and twined into baskets, clothing, sandals, and other useful forms. Sometimes these were painted with geometric designs, while in other instances geometric patterns were formed by alternating different-colored plant materials in the weaving process (fig. 1.12). Some baskets were coated with pitch or resin to make watertight containers, though among Pueblo peoples these were generally replaced by fine pottery after 700 C.E.

Both Mimbres pottery and ancient murals provide some hint at the extraordinary achievements of the makers of ancient clothing. Arid conditions in the Southwest have allowed for the survival of some spectacular archaeological textiles. Clothing in the ancient Southwest ranged from feather and fur garments to woven, twined, and netted ones. In a technique used all over the ancient world called "sprang," the maker uses her fingers to cross and recross vertical fibers, somewhat like the traditional string game called "Cat's Cradle" (fig. 2.4). The resulting geometric patterns recall those on ancient pottery paintings (fig. 2.5).

The superbly crafted baskets and pottery made in the Anasazi area were the beginning of an unbroken tradition that persists today. In recent centuries, both pottery and basketry consistently have been the work of women in Pueblo culture (with some exceptions in the painting and manufacture of pots since the early twentieth century). It seems likely that in ancient times these arts were under the purview of female artists as well. Much scientific experimentation went into the development of these two arts over scores of generations. Women determined which roots and grasses would endure processing without excessive fading and cracking. Ecological, practical, and aesthetic considerations merged in ancient fiber arts, as artists ingeniously combined materials of different properties to serve particular functions: strength for a carrying basket or sandals, aesthetics for a gift basket or a basket placed in a burial, water tightness for a food basket.

Ancestral Puebloan Pottery

The making of fired clay pottery is a hard-won technical skill developed over hundreds of years of constant experimentation. Two periods stand out as the high points of pottery making, one ancient and one modern: the era from 1000–1250 C.E. when Ancestral Puebloan women and their Mimbres neighbors were making finely crafted vessels (figs. 2.5, 2.6, and 2.7); and the modern era of Pueblo pottery since the late nineteenth century, best seen in works from Zuni (fig. 2.17), Acoma, San Ildefonso (fig. 2.18), and Santa Clara (fig. 8.15). In Ancestral Puebloan pottery (especially in late precontact times, after the fall of Chaco), there were many regional polychrome traditions, some of which developed directly into historic polychrome pottery, like that made at Hopi. But the black-on-white tradition was both the most widespread and the most enduring style, from its roots in the ninth century to its decline in the thirteenth. As in modern Pueblo pottery, ancient pottery was characterized by regional as well as individual diversity. The Ancestral Puebloan potter was not only a master of the elegant vessel form, she also devised brilliant abstract designs out of a simple decorative vocabulary. Often this was done with negative painting, as in the seed jar, where black paint defines the negative

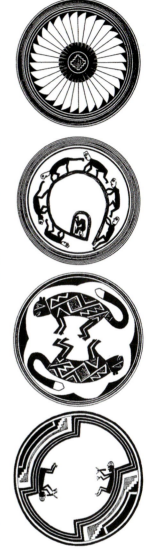

▲ **2.6** Drawing of Mimbres pottery designs, c. 1100 C.E. Drawings after J. Walter Fewkes, Designs on Prehistoric Pottery from the Mimbres Valley, New Mexico: Smithsonian Miscellaneous Collections 74, 6 (Washington, DC, 1924, figs. 3 and 120; Fewkes, Additional Designs on Prehistoric Mimbres Pottery: Smithsonian Miscellaneous Collection 76, 8 (Washington, DC, 1924), fig. 12; and Fewkes, Archaeology of the Lower Mimbres Valley, New Mexico: Smithsonian Miscellanous Collection 63, 10 (Washington, DC, 1914), fig. 14.

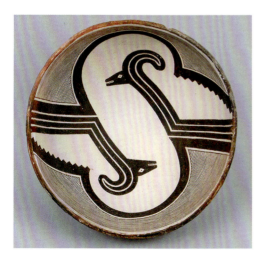

◀ **2.7** Mimbres artist, Mattocks Ruin, southern New Mexico, Black-on-white bowl, c. 1100 C.E. Clay and pigments. Courtesy Maxwell Museum of Anthropology, University of New Mexico.

Semiabstract bighorn sheep rotate around the interior of this bowl. Mimbres artists often experimented with rotational symmetry in which a two- or four-part design swirls around the concave surface of the bowl.

OBJECT IN FOCUS
Mimbres Pottery Designs: Trajectories and Transformations

Mimbres designs, while not as ubiquitous as Northwest Coast totem poles or Plains war bonnets as emblems of Indianness, have been widely appropriated both into fine art and popular culture. Since its first popularity at the beginning of the twentieth century, Mimbres pottery's black and white palette, bold graphic qualities, and mix of abstraction and representation have been repeatedly celebrated, exhibited, appropriated, and replicated. Tracing these histories, we reveal the "cultural biography" (see p. 14) of a Native American art form as it moves across time and cultural boundaries.

Smithsonian archeologist Jesse Fewkes first drew attention to Mimbres pottery in his 1914 publication. Harriet Cosgrove's meticulous drawings of more than 700 bowls she and Cornelius Cosgrove excavated during the 1920s became the source for most borrowings of Mimbres-style imagery.[5] Bowls were exhibited in the *Exposition of Indian Tribal Arts* in New York (1931) and at the San Francisco Golden Gate International Exposition (1939), and the Santa Fe Railway introduced a line of Mimbreño china on its deluxe Super Chief line. Mimbres bowls were displayed in the innovative plexiglass display cases of the blockbuster *Indian Art of the United States* at the Museum of Modern Art (1941), and Mimbres graphic designs were painted on the walls to signal their value as a source for modern design.

Pueblo artists were also exploring their relevance for a modern Indigenous artistic practice during these years. The feather designs that Julian Martinez painted on San Ildefonso polychrome and on black-on-black ware in the 1920s and 1930s came from illustrations of Mimbres pots he had seen in Santa Fe. On a black ware plate made by Maria and painted by Julian around 1930, two mountain lions radiate around the bowl's interior, exactly copying a Mimbres bowl that had appeared in a 1924 Smithsonian publication (fig. 2.6.). Hopi painter Fred Kabotie (fig. 2.14) won a Guggenheim Fellowship in 1945 to study Mimbres imagery, and in 1949 he published a portfolio, *Designs from the Ancient Mimbreños with a Hopi Interpretation*. In the 1960s, Acoma potter Lucy Lewis examined books on Mimbres design as she painted fine-line designs on her award-winning vessels, and mid-twentieth century Pueblo painters Tony Da (son of Maria and Julian Martinez) and Joe Herrera also found Mimbres designs to be a wellspring of inspiration. In the 1980s, Mimbres pottery inspired Anishinaabe artist Carl Beam to use the hemispheric bowl form as a pictorial and narrative space that could address contemporary political issues.

In each case, although in different ways, Mimbres art demonstrated the merging of abstraction and figuration still highly relevant to the Modernist eye. Just as some Pueblo potters talk about using temper from ground-up ancient potsherds as a means of incorporating the work of the ancestors into their vessels, so too did all of these artists conduct a dialogue with ancestral painters.

In the 1970s and 1980s, as historic Native arts achieved record prices at auctions, large-scale looting of Mimbres sites provided materials for an insatiable art market. In 1984–85, a major exhibit entitled *Mimbres Pottery: Ancient Art of the American Southwest*, traveled to seven American cities, including the Metropolitan Museum in New York, assuring a "blue-chip"

▲ **2.8** Installation of Mimbres pottery, *Indian Art of the United States* exhibit, Museum of Modern Art, 1941. Courtesy Museum of Modern Art.

status for this art form. As happens in any world art traditions, the high auction prices and passions of collectors stimulated the production of fakes. Because vessels with figural images command the highest prices, conservators began to notice that forgers had added figures to bowls ornamented with geometric designs around the edges.

"High art" phenomena produce accompanying echoes in popular culture. In the 1980s, Mimbres designs appeared on potholders, aprons, t-shirts, and greeting cards. In 2004, the United States Postal Service issued a 37 cent Mimbres stamp as part of its Native Art Series (fig. 2.7). A new generation of potters has also found inspiration in these designs. At Acoma Pueblo, Charmae Shields Natseway (b. 1958) draws delicate Mimbres-inspired figures on small lidded boxes and pyramidal vessels. Work by Cochiti artist Diego Romero (b. 1964) is influenced equally by Mimbres bowls, ancient Greek painted vessels, and cartoon illustration. His hip postmodern versions of Southwestern pottery have entered international museum collections. Providing a wry and witty commentary on Native life in the era of greed, substance abuse, pollution, and casino gaming, Romero's work demonstrates the continuing appeal of the Mimbres style after more than a millennium.

space, giving the illusion of white painting on a black background (fig. 2.5). This method of creating surface design by painting the negative spaces to delineate form was reused almost a thousand years later in San Ildefonso black-on-black ware (fig. 2.18). Potters made a number of different vessel forms, including mugs with handles, bowls, wide-shouldered water jars called *ollas*, seed jars, and animal effigy forms.

An Animated Universe: Mimbres Painted Bowls

During the same decades that Ancestral Puebloan potters were perfecting their fine-line geometric painting, their Mimbres neighbors devised another sort of container as the vehicle for their expressive painting tradition: the hemispheric bowl. Named after the Mimbres Mountains in Southwestern New Mexico that were their home, Mimbres was one branch of the larger Mogollon culture that extended into Northern Mexico.

While pottery was made in the Mimbres region for over 500 years—from 600 C.E. to 1150 C.E.—the high point of the tradition occurred in the eleventh and early twelfth centuries, leading this to be called the "Classic Mimbres" period. Most Mimbres pots are hard-coiled bowls that were smoothed and shaped, and then painted with black and white slips before firing (see Object in Focus box). Only the interior hemisphere of the bowl was painted. Over 10,000 of these bowls are known, and they display a vast iconographic lexicon (figs. 2.6 and 2.7). Some feature geometric designs and fine-line painting reminiscent of Anasazi pottery painting; others push the boundaries of abstraction, reducing animal imagery to its sparest recognizable form. Others provide a window into a world that indicates that Mimbres people held beliefs similar to those of their Mesoamerican neighbors far to the south. They may have been exposed to these ideas through the intervening presence of the town of Paquimé (see later discussion). Mimbres also shared beliefs with their closer Hohokam and Anasazi neighbors. But, of the three major Southwestern pottery painting traditions that existed before 1200 C.E., only the Mimbres created a complex representational iconographic vocabulary that expressed their relationship to the world of nature and the supernatural.

Recognizable animals, such as mountain sheep (fig. 2.7), bats, fish, and rabbits, appear on Mimbres pots, as do composite mythological beings

such as horned water serpents and humans in transformational guise. The characteristic black-and-white-striped clowns known from historical Pueblo ritual (fig. 2.1) make their first appearance on Mimbres vessels and are among evidence that suggests that, after the great migrations of the twelfth and thirteenth centuries, some aspects of Mimbres culture were absorbed into Pueblo culture.

Most of these bowls have been found in burials interred beneath the floors of simple one-storey apartment complexes. Usually inverted over the head of the buried individual, the bowls are sometimes stacked in groups of three or four. Most were ritually punctured or "killed" before burial, at the very bottom of the bowl where the first tiny coil was shaped to form the vessel. Barbara Moulard has demonstrated that "ethnographic analogy" (illuminating some features of the archaeological past by analogy with related historical cultures) can be used to shed light upon the meaning of these unusual painted bowls and their placement in graves.[6] Modern Pueblo people describe the sky as a dome that rests upon the earth like an inverted bowl, a dome that can be pierced to allow passage between different worlds. The essential Pueblo idea, discussed in the beginning of this chapter, about human emergence from a hole in the ground onto the surface of the earth, restates this idea of permeating the boundaries between worlds. By placing their elegantly painted and pierced "domes" over the heads of the dead, the Mimbres people may well have been expressing their ideas about the emergence of the honored dead into the spirit world, just as modern Pueblo people often speak of the transformation of the dead into spirit beings and clouds in the dome of the sky.

Hohokam Art and Culture

Around the same time as the Ancestral Pueblo and Mimbres fluorescence, further south and west near present-day Phoenix, Arizona, there developed a civilization known as the Hohokam. Its building program was on a more modest scale than the multistoreyed Anasazi architecture; Hohokam people built earthen platform mounds and pit houses. The more subterranean focus to their architecture may have reflected their more extreme environment. Living in the exceptionally dry Sonoran desert, they devised a complex series of irrigation canals to channel the water that came down from the nearby mountains. This feat of hydraulic engineering was one of their greatest achievements. The existence of ball courts at most Hohokam sites, including a 200-foot-long ball court at Snaketown, is evidence of participation in a ceremonial realm derived from Central Mexico. Hohokam people had extensive trade networks both north and south. In the arts, particularly noteworthy are their stone paint palettes in human and animal effigy form, as well as their shell jewelry and textiles, both of which they exported to neighboring peoples. Using whole clam shells imported from the Gulf of California, Hohokam jewelry makers fashioned one-piece bracelets featuring figural and geometric designs. In some instances, they used fruit acids to etch designs into shell jewelry or overlaid chips of turquoise and other minerals as surface design.

Hohokam pottery contrasts with both Mimbres and Ancestral Puebloan traditions. It was fired in an oxygen-rich environment, which allowed the

potters to produce bold red-painted vessels, rather than the reduction firing that produced the black on white designs of other ancient pottery (fig. 2.9). Hohokam pottery may have been a specialized industry, made in a limited number of villages and exported to surrounding regions. As art historian Barbara Moulard has characterized it, "the approach of the Hohokam ceramic painter seems to have been in aesthetic opposition to that of the Pueblo and Mogollon artisans, who mostly produced ordered compositions of balanced, banded fine-line and geometric components. The painterly style of the Hohokam artists was achieved using a loaded brush to form quickly rendered calligraphic patterns and motifs."[7]

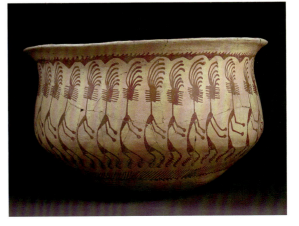

▲ **2.9** Hohokam artist, Sacaton red-on-buff cauldron, c. 950–1150 C.E. H: 10 ¼ × Diam.: 18 ½ in. Private collection, © Billy Famous, Inc.

A line of dancers encircles this large vessel. They wear feathered headgear and rhythmically stamp out a beat by means of the moth cocoon rattles around their legs.

Paquimé: Crossroads of Cultures, 1250–1450 C.E.

After the fall of Chaco (c. 1125 C.E.) power shifted, as did populations. These were the decades of the great migrations that so many Pueblo oral histories recount. By 1250 C.E., Paquimé, the largest and most powerful urban center of the ancient Southwest, emerged more than 600 kilometers to the south, at the border between Pueblo and Mesoamerican worlds, in what is today the Mexican state of Chihuahua.

Mesoamerica (literally Middle America) is the name for those parts of Mexico and the northern countries of Central America where, in the three millennia before the coming of the Spanish in the sixteenth century, a range of cultures came to power. Some were true polities, and even empires (such as the Aztec empire in the fourteenth to sixteenth century), with highly stratified societies ranging from slaves to kings. Advanced calendrical and writing systems and complex trade networks were also characteristic of Mesoamerican societies. Scholars have long recognized that there were strong ties, and cross-cultural exchanges in ideologies as well as material goods between the Greater Southwest and Mesoamerica; modern borders that serve to separate people have sometimes obscured the fact that in ancient times as well as today, Indigenous cultures of these regions hold many features in common.

Paquimé (called Casas Grandes in the older literature, for its location in the fertile Casas Grandes River Valley) was perhaps built by descendants of the Mimbres and exhibited features of two great culture regions. Mesoamerican traits such as ball courts and pyramids existed alongside Great House architecture of Ancient Puebloans. Copper, shell, textiles, turquoise, and, perhaps most important, macaw feathers were exchanged here.

At Acoma and Zuni Pueblos, origin stories tell of people who, in ancient times, split apart, some moving north to found their communities. Others traveled far to the south, where they raised parrots and macaws.[8] Macaws are important in the ideologies of both Puebloan and Mesoamerican peoples; these long-lived birds not only produce vibrantly colored feathers, but they can mimic human speech. Tropical scarlet macaws were raised in pens built into the architecture at Paquimé, as well as ritually sacrificed and buried there. In Pueblo belief, macaws are associated with the south, the sun, and

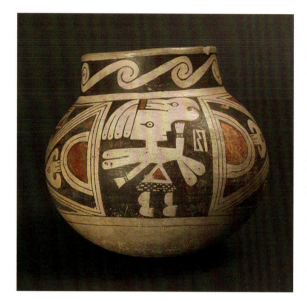

▲ **2.10** Unknown Paquimé artist, Ramos polychrome jar depicting human wearing macaw headdress, c. 1280–1450 C.E. Courtesy Museum of Indian Arts and Culture/ Laboratory of Anthropology, 22017/11.

Paquimé pottery painters synthesized the visual vocabularies of diverse regions, producing bold, innovative, and often asymmetrical designs that combine abstraction and figuration.

powerful spiritual forces. Macaws and their feathers appear frequently on painted pottery at Paquimé (fig. 2.10). The boldly painted jars made there in the late thirteenth to fourteenth centuries represent yet another of the great pottery painting traditions of the Southwest.

FROM THE LATE PRECONTACT TO THE COLONIAL ERA TO THE MODERN PUEBLOS

In the twelfth century, a severe drought occurred in the Anasazi region that may have triggered the collapse of the complex economy centered at Chaco Canyon and elsewhere. During this time of sociopolitical and cultural reconfiguration, many sites were abandoned, and new, smaller, regional centers arose. An even more widespread drought in the late thirteenth century led to large-scale migrations into the better watered Rio Grande River Valley and the Mogollon Rim country. In the west, the communities of Hopi, Acoma, and Zuni began to grow; the Hopi town of Awatovi, on Antelope Mesa, for example, had been in existence for centuries, but by the thirteenth to fifteenth centuries there was a great acceleration in building and in mural painting (fig. 2.11). The references to ancient migrations in search of a proper homeland in most Pueblo oral histories may be cultural memories of the migrations that occurred during the late precontact period.[9]

It is a tribute to the strength and tenacity of Pueblo people that they have survived in order to flourish in the twenty-first century, for the history of the European entry into the Pueblo world was a history of death, pestilence, and destruction. The handful of small villages along the Rio Grande River, the Western New Mexican villages of Zuni and Acoma, and the Hopi villages in Northern Arizona are all that remains today of the vast Pueblo world of the sixteenth century. Some 150 towns flourished when the Spaniard Francisco Vasquez de Coronado (c. 1510– c. 1554) and his men set forth from Mexico in 1540 in search of the rumored golden cities of the north. Over just a few months, they gave the Pueblos a taste of the pillaging, slavery, and murder that would take hold in earnest some decades later. From 1581 to 1680, Franciscan friars organized the cultural conquest of what came to be called "The Kingdom of New Mexico."[10] People were forced to repudiate their traditional religion and all its icons. Ceremonial masks and other regalia were seized and burned. Crosses and churches were erected, *kivas* destroyed. Using a technique that had been successful in gaining control over the Aztec world, the new political authorities consolidated dispersed populations into fewer, larger villages. Due to warfare and smallpox epidemics (as well as the periodic droughts which were a constant problem of this arid region), the Pueblo population was reduced from approximately 60,000 at the beginning of the seventeenth century to fewer than 10,000 at the beginning

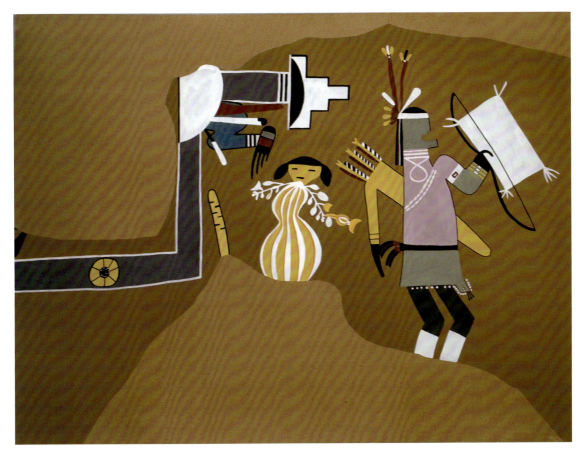

▲ **2.11** Reproduction of kiva mural, Awatovi village, Antelope Mesa, Arizona, c. 1400 C.E., Hopi. © President and Fellows of Harvard College, Peabody Museum of Archaeology and Ethnology, PM 39-97-10/22978D.1 (digital file# 98800075).

Awatovi, a large Hopi town inhabited from the sixth through seventeenth centuries, had many rooms with multiple layers of painted plaster. Room 529, a detail of which is depicted here, had fifteen layers of painted plaster, while others had as many as one hundred. Here, a warrior figure faces to the right, while a personified squash with the coiled hair buns of an unmarried girl seems to emerge from a kiva.

of the nineteenth. Friars tried to supplant Indigenous ritual dramas with theatrical liturgies concerning Jesus, Mary, the saints, and public performances commemorating the battles of the Moors and the Christians. (Even today, at some Pueblos, the *Matachines* dance, which derives from the Dance of the Moors and the Christians, may be enacted one day, and an ancient animal masquerade performed the next.)

This stranglehold on Pueblo society abated for a few years when in 1680 the Pueblos banded together to overthrow the Spanish, successfully driving them out of New Mexico for twelve years. Churches and crosses were burned and *kivas* reconsecrated. In the eighteenth century, traditional Pueblo religion was driven underground. The privacy that surrounds ritual activities in most Pueblos today is the result of a turbulent history in which secrecy was the only successful strategy for survival. For that reason, most Pueblos do not permit photography of sacred dances; nor do they believe that ceremonial regalia should be considered as "art" for consumption by

outsiders. For this reason, this publication includes no photographs of Pueblo masks or performances (though such photographs were routinely taken in the nineteenth century), but rather a painting produced by a Hopi artist (see fig. 2.14).

Pecos Pueblo: An Intercultural Zone

Pecos Pueblo is one of the most thoroughly documented archeological sites in the Southwest (fig. 2.12). Mostly abandoned by the early nineteenth century, Pecos was a center of cultural encounter for over a millennium. Architecture, material remains, and historic documents shed light on issues of trade, warfare, domination, rebellion, reconquest, and the eventual abandonment of the town.

Founded around 800 c.e., Pecos had access eastward to the river systems that extended into the southern Plains, as well as south along the Pecos

▶ **2.12** Reconstruction drawings of Pecos Pueblo, sixteenth and seventeenth centuries. © Lawrence Ormsby, www.ormsbythickstun.com

The upper drawing reconstructs the sixteenth-century North Pueblo compound, while the lower drawing depicts the massive church constructed in the early seventeenth century, with the adjacent living and working areas for the Franciscan clergy.

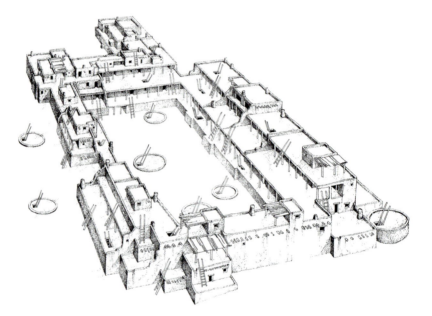

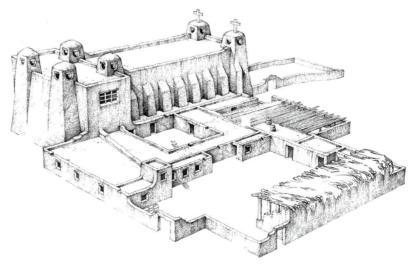

River and west to the Pueblos along the Rio Grande. Ancient trade goods found at Pecos included shells from the Pacific and the Gulf of Mexico, flint artifacts, pottery, and shell beads. By 1400, there were multiroom and multistorey apartment complexes like those at Acoma and Taos, but here made mainly of cut stone. In the 1540s, Coronado and his men found a prosperous community—over 2,000 people living in four-storey apartment complexes that had more than 1,000 rooms and twenty-six kivas. Impressed, they remarked that its buildings were "the greatest and best of these provinces." Substantial amounts of corn, chili peppers, and beans were stored at this vibrant trade center, and buffalo hides from the southern Plains were exchanged for Pueblo goods such as cotton textiles, pottery, and turquoise.

At Pecos today, one can see the footprint of the ancient multistorey Pueblo and the thick walls of the early seventeenth-century mission church. The reconstruction drawing demonstrates what a substantial building the North Pueblo was. The ground floor of the sixteenth-century Pueblo consisted mainly of storage rooms, while the second, third, and fourth floors contained apartments. The need for protection against enemies is evident in the small number of external doors and windows. In times of defence against marauding Apaches and Comanches (or later, Spaniards), the ladders—here as at other Pueblo communities—could be drawn up. Pecos residents resisted the first armed entry of Spanish soldiers in 1591 but allowed Franciscans to dedicate a small mission-convent in 1617/18. This was followed shortly by the construction of the largest church in all of Northern New Spain to accommodate the large Native population, built by Pueblo workmen under the direction of the Franciscan Father Juarez. An adjacent one-storey building that contained the priests' quarters, stables, and workshops was destroyed during the Pueblo Revolt of 1680, but it was replaced in 1717 with a smaller structure. Following the Revolt, Pueblo people built subterranean *kivas* in the quarters of the Catholic priests to reassert their own traditions, using adobe bricks salvaged from the burned church.

Pecos retained its importance as a trading center following colonization. During the seventeenth and eighteenth centuries, it was the site of vast trade fairs drawing Natives and non-Natives from all over the Southwest and the southern Plains, as well as traders from as far as Mexico and St Louis. Pecos pottery has been found in Kansas, and fragments of Chinese porcelain were excavated at Pecos itself, perhaps brought from Mexico City by Spanish settlers.

The last few Indigenous inhabitants left Pecos around 1840, their numbers having been reduced to fewer than twenty individuals. They moved to nearby Jemez Pueblo. In 1999, their descendants reburied the bones of their ancestors that had been removed during archaeological excavations in the twentieth century. In a remarkable public procession, the descendants carried two items emblematic of their historic relationship to their conquerors: the ceremonial cane of authority bestowed upon the Native Governor of Pecos by King Philip the Third of Spain in 1620, and a staff that was a gift from President Lincoln in the 1860s. These tangible expressions of power

with adobe-colored stucco) and modern homes. Yet the oldest part of the settlement, with its flat dance plaza, remains the ceremonial heart of the community. Even those who live far from their ancestral communities return to the dance plaza for festival occasions, to reaffirm their connections to the Pueblo world.

In September 1879, ethnologist Frank Hamilton Cushing (1857–1900) first laid eyes on the village of Zuni. His description remains one of the most evocative ever published:

> Below and beyond me was suddenly revealed a great red and yellow sand plain. It merged into long stretches of gray, indistinct hill-lands in the western distance, distorted by mirages and sand-clouds. [. . .] to the rock mountain, a thousand feet high and at least two miles in length along its flat top, which showed, even in the distance, fanciful chiselings by wind, sand, and weather. . . . But I did not realize that this hill, so strange and picturesque, was a city of the habitations of men, until I saw, on the topmost terrace, little specks of black and red moving about against the sky. It seemed still a little island of mesas, one upon the other, smaller and smaller, reared from a sea of sand, in mock rivalry of the surrounding mesas of Nature's rearing. [. . .]
>
> Imagine numberless long, box-shaped adobe ranches, connected with one another in extended rows and squares, with others, less and less numerous, piled up upon them lengthwise and crosswise, in two, three, even six stories, each receding from the one below it like the steps of a broken stairflight—as it were, a gigantic, pyramidal mud honey-comb with far outstretching base— and you can gain a fair conception of the architecture of Zuni.
>
> Everywhere this structure bristled with ladder-poles, chimneys, and rafters. The ladders were heavy and long, with carved slab cross-pieces at the tops, and leaned at all angles against roofs. The chimneys looked more like huge bamboo-joints than anything else I can compare them with, for they were made of bottomless earthen pots, set one upon the other and cemented together with mud, so that they stood up, like many-lobed oriental spires, from every roof top.[12]

While the colonial mission churches are, in some Pueblos, the tallest structures today, it is the dance plaza that is the focus of the architectural and ritual environment, for it is in the public space of the dance plaza that human beings demonstrate the reciprocity between their world and the spirit world (figs. 2.14 and 2.15). Pueblo people say that the elemental forces of nature, including plants, animals, and aspects of the weather, are embodied in supernatural beings known as "kachinas" or, in the preferred terminology today, *katsinam* (singular: *katsina*). Human beings, too, upon their deaths, join the world of the *katsinam*. These ancestors and other spirit beings retain a proprietary influence upon the affairs of the living, and they are made manifest through the public performance in masks and specialized clothing by male members of various religious societies. Indeed, the Zuni phrase for such an activity (which in English we would call "impersonating the gods") is "they allow the god to become a living person."[13] In other words, through religious and artistic activity, spiritual force is transformed into an incarnation that human beings can recognize.

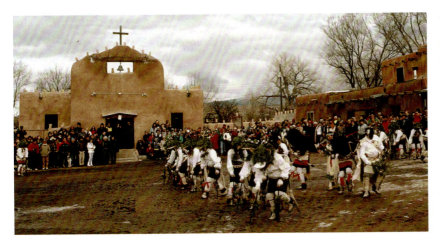

◀ **2.15** Tewa deer dancers, Tesuque Pueblo, New Mexico, December 1991. Photo by Janet Catherine Berlo.

In a midwinter performance, males of all ages wear white leggings, kilts, and deer antlers adorned with feathers and fresh pine boughs. With blackened faces, they dance in a long line, crouched with canes in their hands, mimicking the motions of these four-legged animals.

Within the Pueblo world, ritual knowledge is owned by particular families, clans, and specialized ceremonial organizations, whose interlocking responsibilities map out the ceremonial year and keep the world in balance. While only men don the masks that allow the gods to become manifest, Pueblo women do dance (although unmasked) as the manifestation of certain spiritual principles as well. They wear finely woven textiles, wooden headgear, and dance with painted dance wands.

Barton Wright has succinctly described Pueblo ritual performance as

> an integrating force for the villages in that it offers some form of participation for everyone either as audience, contributor, or performer. It combines the dramatic presentation of theatre with the entertainment of comedy and burlesque, the solemnity of prayer and sacred ritual interspersed with popular song and contemporary humor. It is both theater and church with the emphasis on the process of the ritual rather than the result. The dancers are the prayer and the audience the contrapuntal support.[14]

Each Pueblo has its own view of the origins and meaning of the *katsinam* (and in some, like the northeasterly communities of Taos and Picuris, these spirit figures are not prominent). The well-studied Zuni system provides some insights into Pueblo views about their spiritual world and artistic representations of it. The Zuni says that many come from a location called "Kachina Village" (beneath a lake to the west of Zuni), which is also the source for game animals such as deer, mountain sheep, and antelope. These spiritual protectors are fundamental to all aspects of fertility—human procreation, rain, agricultural abundance, and success in hunting. According to Zuni belief, men who have been initiated and their wives will, after death, join the spirits at Kachina Village and take part in dancing and festival activity for all eternity.[15]

Among the Hopi, the complex annual ceremonial cycle is divided into the season, from February to July, when *katsinam* appear in the human world, and the season, from August through January, when they do not. At *Powamuya*, in February, people petition for the return of *katsinam* to the human community. Gifts are bestowed upon the children. Girls receive dolls called *tihu* (plural, *tithu*) that represent *katsinam*, as well as baskets and

Although most late nineteenth-century *tithu* were simple painted effigies, today many of those made for the art market are richly adorned with additional materials, including feathers, turquoise, cloth, and rawhide. The twentieth century also brought an increased realism of pose, with "action figures" mounted on a wooden base and caught midstep in a dance pose.

Pueblo Pottery

Hundreds of thousands of Pueblo pots can be found in museums and private collections. Thousands more are offered for sale in Indian Pueblos and galleries worldwide. Historic pots by legendary potters, such as Maria Martinez of San Ildefonso or Nampeyo of Hopi, fetch auction prices of five figures, as do ancient pots made by their ancestors. The study of Pueblo pottery offers insight into scientific processes, traditional worldview, and ever-adaptable modern socioeconomic processes as well.

The details of pottery production differ from village to village, depending on clay, tempering additives, and the surface decoration of the vessels. Here, we offer only a few hints of the enormous technical complexity of this art. For most Pueblo potters, prayer precedes all work. Despite her later role as chemist and firing expert, at the start of the process a Pueblo potter is a daughter of Mother Earth, asking "Clay Woman" for the use of her bodily material. Traditionally, at some Pueblos only women could harvest the clay from Mother Earth. At Zuni, for example, men were customarily prohibited from going to the clay sources at Corn Mountain. (Yet gender classifications are flexible, as discussed in chapter 1; in the late nineteenth century at Zuni, We'wha, who was biologically male yet dressed as a woman and excelled at women's arts, gathered clay with women.[20])

Choosing the clay is a crucial part of the process, for all subsequent decisions rest on its initial selection. Clays vary widely in their chemical structure, requiring different tempering materials, variable methods of working the clay in its wet state, and alterations in the mode of polishing and firing. Some potters experiment widely with clays from different sources, noting variability in shrinkage, color, and durability. Contemporary San Ildefonso potter Barbara Gonzales (b. 1947), who is Maria and Julian Martinez's eldest great-grandchild, says, "I have looked over almost every inch of our reservation and gathered many different colors of clays. Some I haven't tried yet, but I like having lots of clays, and I know where there are lots more."[21]

Refining the raw chunks of newly mined clay is arduous work. At Acoma, women may grind up large chunks of clay in a hand-crank grinder, and then further refine it by grinding it to powder on a *metate* (grinding stone). The powdered clay is then soaked in water so that any impurities can rise to the surface and be poured off. The clay dries on baking trays in the sun, and then is ground again, and screened through a fine wire mesh.[22]

Most clays require the addition of some nonplastic material so that the clay can withstand firing at high temperatures without cracking, and so the vessel will have a smooth surface. This material is called temper. (Only at Hopi Pueblo can some clays be worked without the addition of tempering material, for Hopi potters have discovered a pure, fine kaolin clay that is strong and resists shrinkage.)

Potters have understood the principles of tempering for well over a thousand years. Ancestral Puebloan women used a variety of sands and sandstones, and by 900 C.E. they had discovered that old potsherds—bits of previously fired, discarded pots—were also an excellent tempering material.[23] Potters would grind the broken bits of old pottery on their *metates*, just as they would grind corn for food. This use of potsherd temper is a tradition that continues today in some Pueblos. Not only is it scientifically sound practice, but it also provides an emotional link with the potters of the past.

After the temper has been added, the clay is mixed vigorously. Then the mixture must mature. Potters often make the analogy between processing clay for pots and processing flour into bread dough. Both require a practiced hand in the mixing of diverse elements, both require kneading, and both must be put aside to rest. The dough rises, and the clay cures. When it is leather hard, it is painted with a liquid clay called "slip" before firing. Whereas bread is baked in the round "beehive" ovens that stand outside many Pueblo homes, pottery is fired, in most instances, on the ground in an open-air firing. The ad hoc appearance of this technique is deceptive. In fact, an expert Pueblo potter is controlling many diverse factors when she fires her pots: the ambient temperature, the force of the wind, and the exact composition of the dried animal dung used in the firing process. All of these affect the outcome.

It is in the painting of pots (as well as in the technical excellence of their manufacture) that one sees most clearly the continuity of this thousand-year-old tradition. Certain motifs and geometric designs repeat, and reappear in different generations. Particular design elements and colors are characteristic of particular Pueblos: the black-on-black ware of San Ildefonso (fig. 2.18), the finely controlled use of delicate parallel lines to form dazzling geometric patterns at Acoma, and the graceful figural and geometric imagery of Zuni Pueblo (fig. 2.17). Many potters today find inspiration in Anasazi and Mimbres iconography (see Object in Focus box).

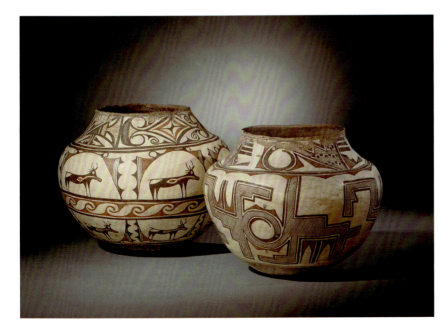

◀ **2.17** She-we-na (Zuni Pueblo). Water jars, late nineteenth to early twentieth century. Ceramic and pigment, 12 ¼ × 15 in. (31.0 × 38.0 cm). Brooklyn Museum, Museum Expedition 1904, Museum Collection Fund, 04.297.5249.

Water jars with a bulbous form are characteristic of Zuni pottery. The women who fashion and paint such jars generally divide them into separate fields for painting, the design on the body of the vessel differing from that on the neck. The jar on the left features the "deer in his house" motif in two registers on the body. On the right, the abstract scroll and angular stepped designs have variously been interpreted as rainbirds or rattlesnakes.

(cont.)

The Treaty of Bosque Redondo in 1868 established the limits of the Navajo Reservation, and returning Navajo were guaranteed "annuities" from the U.S. government from 1868 to 1878. Such reparations included 15,000 sheep and goats, and about 60,000 pounds of "Germantown" yarn, from the mills in Germantown, Pennsylvania, that produced finely spun and brightly dyed three-ply yarns. The use of this commercial yarn gave rise to the virtuoso textiles known as "eye dazzlers" because of the saturated colors and fine detail that weavers could achieve with their use.[31]

The textile illustrated here was a direct result of those annuity payments, and it can be firmly dated as well (fig. 2.23). The eleven colors of three-ply Germantown yarn used to such dazzling effect in this *sarape* (wearing blanket) were the same eleven colors of wool offered as treaty payments in just one specific year—1870—though such payments extended from 1868 to 1878.[32] It stands to reason that a weaver who does not have to raise and shear the sheep, card and spin the wool, and then dye multiple colors (all of which accounts for about 75 percent of the time involved in making a Navajo textile) can devote herself to complex color play and pattern, as is evidenced in this extraordinary work of art.

During the subsequent reservation era, sheep of many different breeds became part of the Navajo stock. Some breeds gave wool that was greasy and difficult to process. By the 1920s, the quality of much locally produced wool was poor, and for many it was prohibitively expensive to buy commercial yarns.

In the following decade, another catastrophic injustice was perpetrated on the Navajo: the U.S. government livestock reduction program purchased or killed hundreds of thousands of sheep and goats to remedy overgrazing. The program deprived women of their wool, their wealth, and their livelihood. Elderly Navajo people still talk about this with great bitterness; some even call it an "animal holocaust."[33] Since 1972, when the number of Churros on the reservation were estimated at fewer than 500, the Navajo Sheep Project has worked to reestablish herds. Internationally acclaimed weaver D. Y. Begay says, "I raise Churro sheep, especially the black sheep, for the color . . . and the fiber itself is very clean, greaseless, very easy to clean, wash, card, and spin. It's very beautiful to spin Churro wool, and the fiber tends to be long, and that's very nice for spinning."[34] Today, of course, materials from international sources are available through the local trading post, the Walmart in Gallup, and the internet. As Navajo people still affirm, "Sheep is Life!"[35]

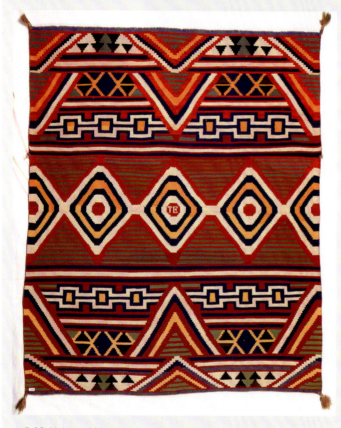

▲ **2.23** Unknown Navajo artist, Sarape, 1870–1. Handspun wool, 63 × 52 in. Copyright University of Colorado Museum of Natural History.

Navajo weaving has evolved through many stages and styles in the past 200 years, but little is known of the art form before then. Traditionally, small girls learned at their mothers', aunts', or older sisters' looms, and some of them were already weaving at the age of just four or five. The Navajo matrilocal residence pattern lent continuity to the passing on of this artistic legacy, for

generations of daughters and sisters tended to stay in the same area. Today it is far more common for a woman to take up weaving as an adult.

Early nineteenth-century textiles were relatively plain, striped wearing blankets. Throughout the nineteenth century, successive phases of the so-called chief's blanket display a graphic boldness and simplicity, conjoining stripes, cross patterns, and diamond forms. These blankets were widely traded throughout the Southwest and the Great Plains. Many nineteenth-century drawings by Cheyenne and Kiowa artists, for example, depict men wearing such fine robes. The earliest visual record may be a watercolor by Swiss artist Karl Bodmer who recorded a man on the Northern Plains wearing a First Phase Chief's blanket (fig. 1.29).

Navajo weavers have always been eclectic. Nineteenth-century wearing blankets evince a startlingly cosmopolitan use of materials—from cotton raised by the neighboring Pueblos, to the rare use of imported silks, or the common use of European wools. Weavers unraveled Mexican textiles to make use of rich scarlet fibers saturated with the cochineal and lac dyes that Mexican dyers made from mollusks and insects. And, like other weavers throughout the Americas, they readily adopted aniline dyes from Europe directly after their invention in the 1850s.[36] As discussed in the Materials in Focus box, in their use of commercial Germantown yarns starting in the 1860s, weavers often balanced complementary colors, such as red and green, or outlined colors with narrow bands, causing the vivid hues to oscillate in the viewer's eye (fig. 2.23). By the late 1890s, Anglo trading-post owners encouraged weavers to draw upon intricately patterned Persian carpet designs in order to make their rugs more marketable in late-Victorian households in the Midwest and New England. Out of this grew the proliferation of regional styles recognizable today, including Teec Nos Pos, Two Grey Hills, and Ganado.[37] During this era, most weavers also adapted their textiles for use as floor rugs rather than wearing blankets.

It would be a mistake to assume that the Navajo weaver passively submitted to these successive strata of outside influences. On the contrary, central to Navajo philosophy is the idea of change, transformation, and renewal.[38] This allows the Navajo artist to creatively incorporate many diverse realms into her work. Weaving can be a spiritual practice, as well as a paradigm for womanhood. It is a means for creating beauty and projecting it into the world. The universe itself was woven on an enormous loom by the mythic female ancestor, Spider Woman, out of the sacred materials of the cosmos. Spider Woman taught Changing Woman, one of the most important Navajo supernaturals, how to weave.

Changing Woman provides the model for the Navajo aesthetic of transformation. She is, in essence, Mother Earth, clothing herself anew in vegetation each spring. Displaying their evocative love of rich aesthetic patterns both in textile and in story, Navajo people say that when she was discovered on a sacred mountaintop by First Man and First Woman, Changing Woman wore the same cosmic materials from which Spider Woman wove the universe. Her cradleboard was made of rainbows and sunrays, with a curved rainbow arching over her face. She was swaddled in black, blue, yellow, and

all over my rugs. I want them on the walls to be looked at as art. When I start weaving, I want the excitement and the challenge that a painter would feel. I imagine myself sitting at an easel stroking the brush across the canvas.[43]

Apache and O'odham Baskets

Among the Apaches, basketry has long been the preeminent art form. Different Apache groups make many sorts of baskets, both twined and coiled. Jicarilla Apaches produce watertight basketry bottles coated with pine pitch and/or clay, while Western Apache bands make some of the most well-known types, including elaborately coiled shallow trays and *olla*-like storage jars (fig. 2.25). Women exploit the diverse plant materials of the Southwestern environment, including willow and cottonroot for the body of the container, and black devil's claw and red yucca root for decorative effects. The dynamic designs on Apache baskets include stars, interlocking geometric forms, mazes, and human and animal figures. Their neighbors to the south, the O'odham (called Papago in the older literature), use many similar designs. For over a hundred years the main outlet for basketry has been the commodity market, yet some baskets are still an important part of ritual. Apache burden baskets, for example, are sometimes still used to carry the gifts distributed in the Sunrise ceremony that marks a girl's coming of age.

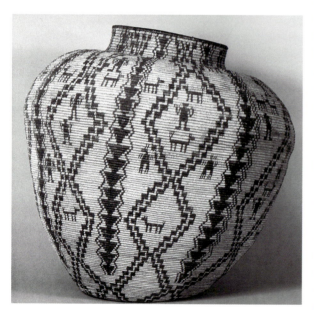

▲ **2.25** Unknown Western Apache artist, Basketry *olla*, late nineteenth century. Willow and devil's claw, H. 64.1, Diam. 72.4 cm. School for Advanced Research IAF.B301. Photograph by Addison Doty.

The large *olla* or jar-shaped basket is characteristic of Western Apache fiber arts. Human and animal forms are often woven among the geometric designs.

Navajo and Pueblo Jewelry

The making of silver jewelry—cast, beaten, stamped, or worked by hand in other ways—is another example of the innovative genius of Southwestern artists. Their ability to forge a new art form out of a variety of external models and materials formed the basis for the explosion of jewelry making as a major medium in the twentieth century.

For well over a thousand years, Pueblo people have fashioned fine ornaments out of semiprecious stones and shell. Native silverworking was added to this in the mid-nineteenth century. In the 1850s, Atsidi Sani (c. 1828–c. 1918) was the first Navajo to learn smithing from a Mexican blacksmith, making bridles and other sorts of ironwork. Some years later he began experimenting in a new material, silver, and eventually taught his sons and other Navajo men. Fine horse equipment and bells made out of hammered silver coins were among the objects that nineteenth-century silversmiths made. They also cast silver in sand, clay, or rock molds to make bracelets, buckles, bridles, and other goods. By the late nineteenth century, Navajo silversmiths were setting turquoise stones in silver.

The fine necklaces and concha belts that are so characteristic of twentieth- and twenty-first-century Southwestern jewelry had their genesis at the time. The famous "squash blossom necklace" is a standard jewelry form made by Navajo silversmiths, sometimes incorporating prodigious amounts of turquoise as well as silver into its design.

Before the opulence of the modern squash blossom necklace, an older form existed that synthesized Indigenous and Christian symbols (fig. 2.26).

At Zuni Pueblo, silversmithing grew out of blacksmithing technology. Navajo silversmiths taught Zuni blacksmiths how to work this new metal. In the early years of the twentieth century, the increase in tourism stimulated a commercialization of Native silverwork and opened up vast new markets for Pueblo and Navajo silversmiths. Since the beginning of the twentieth century, Navajo and Pueblo jewelry has become central to the idea of what Indian art is, and jewelry making as a performance for tourists has become closely associated with the idea of the Indian Southwest. Writing to the proprietor of the Hubbell Trading Post in 1905, a representative of the Fred Harvey Company remarked, "A silversmith is quite the attraction and, as I wrote to you, I would like to have one."[44] He needed a silversmith not only to demonstrate the making of Indian jewelry but to lend an air of authenticity and to promote sales at the "Indian Department," the new emporium at the Alvarado Hotel in Albuquerque. In the 1940s, at Maisel's Indian Trading Post, in Albuquerque, the innovative tourist draw was the glass floor that allowed visitors to watch Indian craftsmen hand-finishing silver jewelry in the basement. What tourists did not see, however, was the vast factory employing nearly 100 smiths. Jonathan Batkin has written about the sophisticated mechanized processes underpinning Native-made jewelry there:

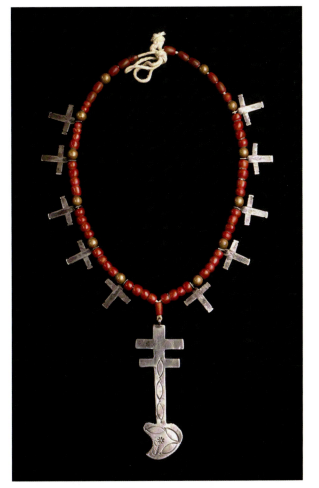

▲ **2.26** Unknown Navajo or Pueblo artist, Cross and dragonfly necklace, c. 1880. Coin, silver, brass, and beads, L 33 cm. School for Advanced Research, Catalog Number IAF.S853. Photograph by Addison Doty.

The dragonfly is an ancient Pueblo symbol associated with water. When Spanish friars introduced the Christian cross in the sixteenth century, one version with two crossbars, called the patriarchal cross, became associated with the dragonfly of Pueblo cosmology. The large central cross growing from a heart is a local adaptation of the Catholic symbol of Christ's crucifix and Sacred Heart. This item was in the family of Lorencita Pino of Tesuque Pueblo for four generations before it was sold to a Santa Fe museum in 1964.

Maisel's purchased commercially produced silver, both coin and sterling, and in the form of sheets and wire, from Handy and Harman in Los Angeles. Among the shop's machinery were at least two rolling mills, one of

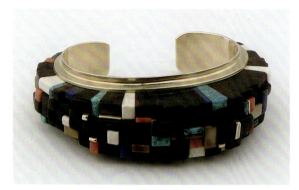

▲ **2.27** Charles Loloma, 1921–91 (Hopi), Cuff bracelet, 1982. Gold, jet, ironwood, turquoise, lapis lazuli, ivory, and coral, 2½ × 3⅛ in. National Museum of the American Indian, Catalogue No. 25/6307; photo by Ernest Amoroso; courtesy Georgia Loloma.

The asymmetrical raised stones of this opulent bracelet recall the landscape of the Hopi mesas that the artist loved.

which was a triple-geared, hand-operated mill, and the other an electric mill. Workers used these to reduce the thickness of sheet silver and to roll out sheets from melted scraps and filings collected in the shop. All machinery was kept concealed from public view, and all of it was operated by Indian workmen.[45]

Buyers of Southwest Indian jewelry in the 1940s surely never pictured the Indian workshop where their items were "handcrafted" as a machine shop.

In response to the overmechanization of this craft and the selling of cheap replicas made overseas, many Native jewelers of the last fifty years have sought to use fine materials, to maintain quality, and to demand a fair price for their work by educating the public about their artistry. There are recognized tribal styles as well as much individual variation within these styles. For example, at Santo Domingo Pueblo, jewelry makers have long specialized in shell and turquoise mosaic. Zuni is known for cluster work, in which numerous stones (often turquoise) are placed in bezels set close together, and for channel inlay, in which small turquoise tiles are cemented singly into channels in silver, and then polished to form a nearly seamless surface. Starting in the 1940s, Hopi jewelers began to develop a distinctive style of overlay, using cutouts of sheet silver soldered to a silver base and then tooled.

Southwestern jewelry took a new direction in the late 1960s, with the modernist work of Charles Loloma, who declared, "the craftsman must make a revision of his own work. He must find new ways of doing things. New forms can come out of Indian backgrounds."[46] Intrigued with ancient Egyptian jewelry he saw on display in Paris, Loloma experimented with stacking, amassing, and setting stones in clusters, forming turquoise, jet, ironwood, fossilized ivory, coral, and lapis into abstract mosaics (fig. 2.27). Loloma's work achieved widespread acclaim and opened up the field for others to broaden the scope of their experimentation, using gold and other "non-Native" materials, and to develop a recognizable following among serious collectors.

Today the making and marketing of jewelry is one of the economic mainstays of Indigenous life in the Southwest. While many craftspeople work in the same way that four generations of their ancestors have, some younger Pueblo and Navajo jewelers take inspiration not only from ancestral traditions but from global market trends. In doing this they follow the

lead of the distinguished artists of the Southwest who have looked at world art for generations and synthesized the sophisticated styles of the modern global world with the deep creativity of their own Indigenous traditions (fig. 2.28).

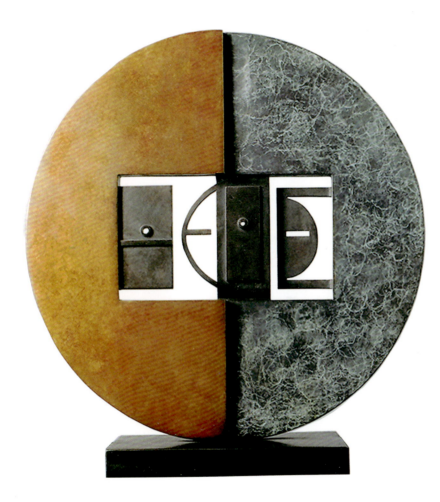

◀ **2.28** Dan Namingha, b. 1950 (Hopi-Tewa), *Duality*, 1997. Bronze (edition of 6), 51 ½ × 48 ½ × 17 ¾ in. Courtesy Niman Fine Art.

The dualities of life are represented in this abstract bronze sculpture. The rust-colored patina on the left recalls the desert landscape of the Southwest, while the blue patina on the right invokes water. In rectangular openings at the center, the artist has offered just a glimpse of abstract *katsina* imagery—a minimal and respectful gesture toward representing the sacred. The rectangular openings allow the viewer to see through the geometric forms to what lies beyond.

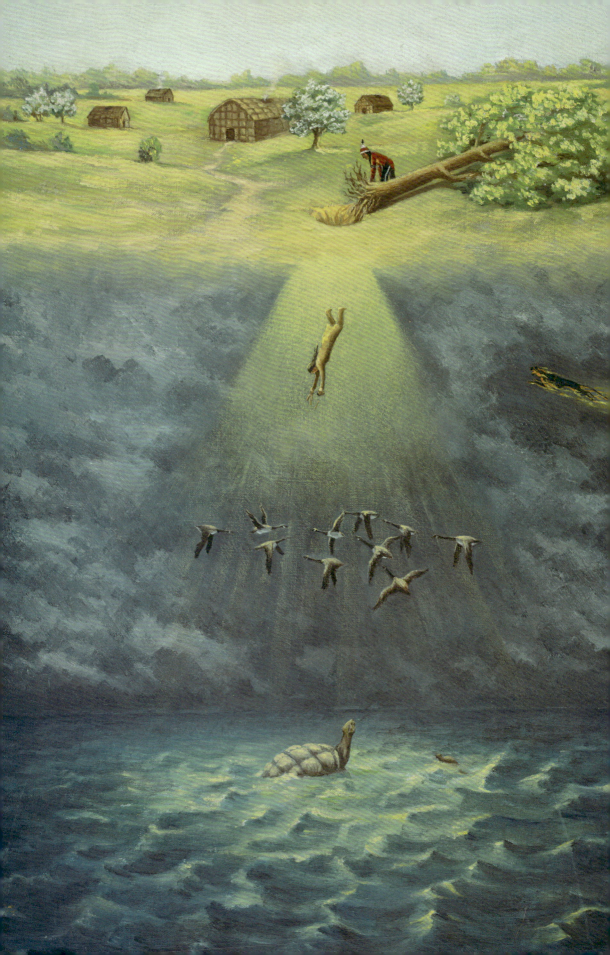

THE EAST

"Neh nih Che yonh en ja seh"—"When the world was new"—begins the Haudenosaunee (Iroquois) teller of the story of the creation. He tells of Sky Woman, who, pushed from the land of the sky people through a hole opened up by the uprooting of the great tree of light, was borne on the wings of birds to a safe landing on the back of a great turtle (fig. 3.1). He tells how muskrat brought up a clod of earth from beneath the waters, and how the clod expanded as she walked around until it became the earth we know. He tells of the birth of a daughter to Sky Woman, and how she, in turn, became the mother of twins. One, Good Mind, created human beings and the things that would be useful to them, but at every pass he had to counter the actions of his twin, Bad Mind, who went about unleashing negative and destructive things. In the story the existence of evil—although it remains ultimately inexplicable—can be traced to an initial act against nature. Seneca elder Jesse Cornplanter (1889–1957) recounts that Sky Woman's daughter, just before the twins' birth

> was so surprised to hear them talking while still within her. One was saying for them to come out by the nearest way while the other kept saying to come to the world in the proper way; so after a while they were born—the first came out as in the usual manner while the other came out through her arm-pit, which caused her death.[1]

This origin story powerfully expresses the challenge of moral choice and alerts the listener to central themes of Haudenosaunee traditional teaching, the dangers of antisocial conduct, and the need for vigilance in maintaining order and peace.

THE EAST AS A REGION

The Haudenosaunee Confederacy that united much of New York State and adjacent parts of the Northeast from the fifteenth to the end of the eighteenth century was the most recent of a series of powerful political chiefdoms and confederacies that have arisen in the eastern half of the North American continent over the past 2,000 years (fig. 3.2). This dynamic history of complex political organization has been overshadowed by the more popular and romantic image of the Eastern Indian as nineteenth-century novelist James Fenimore Cooper's Uncas—a lone hunter in the forest on the edge of extermination. However, in

◀ **3.1** Ernest Smith, 1907–75 (Seneca [Iroquois]), *Sky Woman*, 1936. Oil on canvas. Courtesy of the Rochester Museum & Science Center.

This painting, showing the fall of Sky Woman to earth, or "Turtle Island," is part of a larger corpus of paintings begun by the artist in the 1930s as part of a Works Progress Administration project. Using a westernized pictorial genre, Smith freshly visualized the traditional world of the Haudenosaunee, fusing oral and ceremonial traditions with archaeological and historical research. The village of longhouses in which the people of the Skyworld live, for example, brings to life the schematic drawings made by early-contact period European observers.

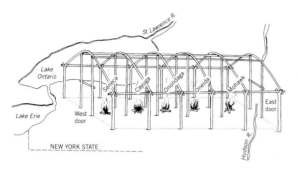

▲ **3.2** Conceptual map of the Iroquois Confederacy as a longhouse. Diagram after R. Easton and P. Nabokov, *Native American Architecture* (Oxford, 1989). © 1990 Robert Easton and Peter Nabokov. Used by permission of Oxford University Press.

The traditional Haudenosaunee dwelling is the longhouse, a structure up to 400 feet long. Made of poles sheathed in sheets of elm bark, longhouses sheltered a number of families of the same lineage. As shown in this drawing, the Haudenosaunee Confederacy itself is metaphorically expressed as a longhouse. It shelters five related peoples (six after the Tuscarora joined in 1722–3) and is guarded by the Seneca and the Mohawk, the keepers of the Western and Eastern Doors.

order to appreciate the region's artistic traditions, it is important to adjust this picture. During the past two millennia, at least as many Eastern Native Americans have lived in settled communities with complex and sophisticated political and religious institutions as have lived in small nomadic hunting bands. Many important forms of visual art and architecture have developed in this context. This chapter will also stress the role that visual art has played in negotiating cultural values as Indigenous ways of life were repeatedly disrupted—a process that began much earlier in the East than in most other parts of the continent. In the United States today, as a result of enforced removals during the nineteenth century, more Woodlands people live west of the Mississippi than in their ancient Eastern homelands. The continuities of artistic style and imagery that continue to link peoples separated by thousands of years and thousands of miles are all the more remarkable given the profound impacts of missionization, epidemics, and displacements that began, in some places, five centuries ago.

As a region, the East is bounded on its western side by the Mississippi valley and, on the east, by the Atlantic Ocean (see map 3, p. 87). It extends north from the Gulf of Mexico to the boreal forests that extend north from the Great Lakes and the Ottawa and St Lawrence Rivers. Anthropologists have termed the East "the Woodlands" because of the trees that originally covered much of the land, providing the inhabitants with nuts, plant foods, deer, beaver, and other game animals. Equally important to Native history, however, have been the sea coasts that are rich in fish and marine life, and the fertile river flood plains that were easily cultivated before the introduction of metal tools. Within this huge geographic area, of course, variations of climate, ecology, language, and history have created distinct regions. The major division is into the Northeast and the Southeast, which are differentiated primarily by the greater reliance on agriculture in the south and attendant differences in ceremonial and political life.

Eastern North America is relatively homogeneous linguistically in comparison with other parts of the continent. Most Woodlands peoples speak languages belonging to three large language families: Algonkian and Iroquoian in the Northeast and Muskogean in the Southeast; in the western Great Lakes, there are also smaller groups of Siouan speakers. Historically, a second vitally important unifying factor has been the ancient trade routes that have linked the Great Lakes with the Gulf Coast, the Mississippi Valley with Florida, and Mesoamerica with all of these regions. Over these routes came new food crops, exotic materials for the making of art, and—of equal importance—spiritual, political, and artistic concepts.

Precontact Art Traditions: Archaic, Woodland, and Mississippian Civilizations

Archaeologists date the first occupancy of eastern North America to big-game hunters who lived in the region from about 14,000 to 10,000 years ago. This Paleo-Indian phase was followed by an era known as the Archaic, a long period that lasted until about 1,000 B.C.E., during which Woodlands peoples lived by

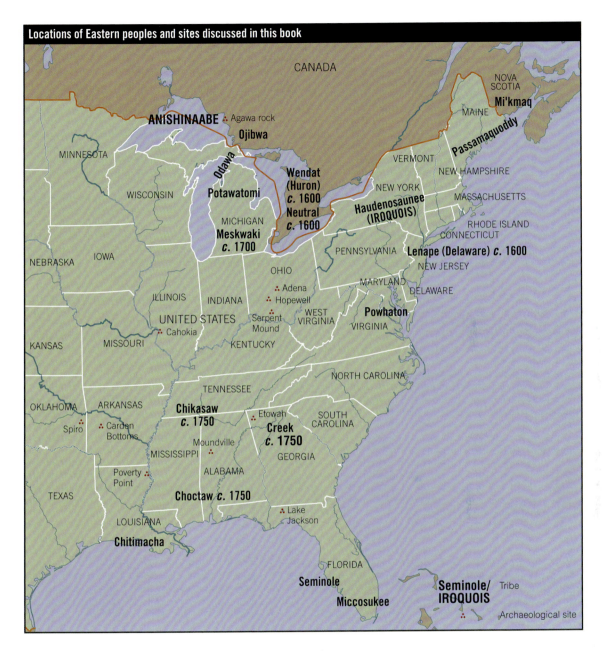

Locations of Eastern peoples and sites discussed in this book

hunting and gathering. They developed many of their characteristic spiritual and ceremonial practices, such as the ritual preparation of the dead and the placement of red ochre, rattles, and smoking pipes in graves.

The Archaic Period

The first appearances of the visually elaborated objects that we call "art" occur during the Archaic Period. More than a thousand graves were found, for example, at Indian Knoll, Kentucky (used between 5,000 and 4,000 years ago). Many contained exquisitely wrought bannerstones, objects that were used to weight *atlatls*, or launching sticks for spears (fig. 1.4). Yet few of these bannerstones show signs of use; many are carved with exceptional artistry out of exotic imported stones, exploiting their natural colors, patterns, and striations to afford maximum visual pleasure. Other Archaic Period burials

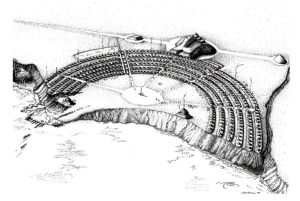

▲ **3.3** Reconstruction of ceremonial enclosure, Poverty Point, Louisiana, c. 1500 B.C.E. Pen and ink drawing by Jon Gibson.

The Poverty Point site in northeast Louisiana is oriented toward a bluff overlooking the Mississippi flood plain. It is made up of six concentric C-shape earthen embankments, the largest measuring nearly 4,000 feet across. When this site was in use 3,500 years ago, small houses were built on the tops of the ridges, facing a central thirty-seven-acre plaza that served the surrounding region as the site of public festivals and ceremonies.

contain oversized spear points made of cold-beaten Great Lakes copper, a metal which, though lustrous and beautiful, is too soft to make an effective weapon. Such objects were clearly not intended for use; David Penney has termed them "sumptuary implements" that "may have been thought of as effigies of tools rather than as utilitarian objects."[2] Their primary value lay in their symbolic and aesthetic worth rather than in their tool-like efficiency.

The Archaic Period also saw the beginning of a 5,000-year-long tradition of building large-scale earthworks for use as burial sites and ceremonial centers. Between about 1800 and 500 B.C.E. (the time of Stonehenge in England and the Olmec civilization in Mexico), Native Americans at Poverty Point, Louisiana, in the lower Mississippi Valley, built an immense town and ceremonial center formed of six concentric embankments measuring three quarters of a mile across, totaling seven miles in length, and inhabited by as many as 1,000 people (fig. 3.3). The largest settlement in North America—including Mexico—it was an achievement comparable to other great building projects of the ancient world. Poverty Point demanded a sustained investment of human labor and organizational skill, as well as the cultural will to sustain the effort over many centuries.[3] The Great Lakes copper, Missouri lead ore, and the special kinds of stones imported from all over the Southeast that have been found at Poverty Point also testify to the beginnings of a taste for exotic goods that would become a constant feature of Woodlands cultures for 2,500 years. Its builders left tiny, finely carved stone beads and pendants depicting owls, falcons, and humans that evidence new traditions of effigy carving.

The Woodland Period

The Archaic was followed by the long Woodland Period (300 B.C.E.–1000 C.E., usually subdivided into Early, Middle, and Late Periods), which produced some of the most dynamic political and artistic achievements of Native North American history. Early Woodland cultures constructed large-scale embankments and burial mounds and created fine works of art in different media, including pottery, which became established during this era. The Adena culture (1100 B.C.E. to 200 C.E.) is known from its principal site in southern Ohio as well as from about 500 other related sites in the central Woodlands. Adena people produced a variety of artistic genres, among which is a distinctive type of stone tablet that may have been used to stamp designs on textiles or to decorate walls (fig. 3.4). From the Adena site also comes a large stone pipe in the shape of a man wearing large ear spools and a feather bustle that resemble Mesoamerican items (fig. 3.5). In these two examples of Adena art can be seen aesthetic approaches that remained fundamental to Woodlands art for nearly 2,000 years. The linear designs engraved on the tablets produce an optical oscillation of figure and ground similar to that experienced when viewing historic-period ribbonwork appliqué (fig. 3.24). The rounded, organic forms and relatively naturalistic approach to representation of the Adena pipe are equally suggestive of historic period art, and they recall the styles of

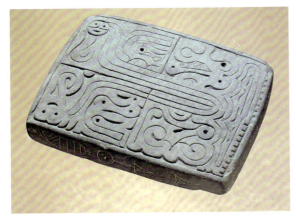

▲ **3.4** Adena Culture, Sparks Mound, Clinton County, Ohio, *Wilmington Tablet*, 400 B.C.E.–1 C.E. Sandstone, width: 12.4 cm. Courtesy The Ohio Historical Association, Image # AL05310.

About fifteen small stone tablets have been found at Adena sites, a few still retaining traces of paint. Archaeologists speculate that they may have been used to stamp designs on the body, cloth, hide, or walls. The flowing curvilinear patterns delineate stylized animals, birds, and faces. They suggest the antiquity of Eastern artistic traditions that invoke the power of other-than-human persons.

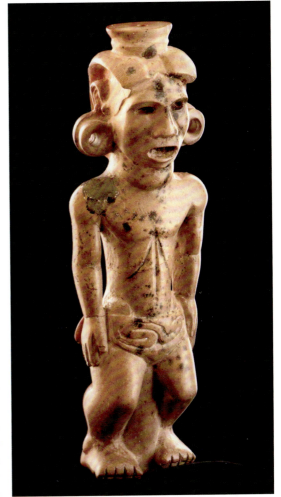

▲ **3.5** Adena Culture, from the Adena Mound, Ross County, Ohio, Human effigy pipe, 100 B.C.E.–100 C.E. Pipestone, height: 20 cm. Courtesy The Ohio Historical Association, Image # OM1289_793634_01.

The high status of this man of the ancient Adena culture is demonstrated by his elaborate dress, including large ear spools, a headdress, and a kilt with a feathered bustle at the back. The figure may represent the heroic ancestor of a living ruler with whom a relationship was maintained through ritual offerings of smoke.

the figures carved on pipes and other objects many centuries later.

During the Early Woodland Period there was also a new focus on mound building dedicated specifically to highly elaborate burials. These developments, though widespread throughout the East, reached a particular intensity in the central Ohio River Valley between about 1 and 350 C.E. at the Middle Woodland Period sites of the Hopewell culture. Hopewell mound complexes are marked by a geometric precision of design and construction. In them, Hopewell people placed an unprecedented quantity of offerings of luxury goods and works of art whose artistic quality still impresses and moves the modern viewer. Hopewell artists cut sheets of mica and copper imported from the Appalachian Mountains and Lake Superior into plaques shaped as birds, animals, and the human figure, head, and hand (fig. 3.6). They engraved ceramic pots and bones with intricate curvilinear drawings of humans and animals which are directly related to those on the Adena tablets, and they carved wonderfully lifelike stone platform pipes in the shapes of birds, frogs, beavers, and other animals (fig. 3.7). They placed in graves elaborate breastplates and animal effigy headdresses of beaten copper, and they piled up treasures of shell and copper jewelry. All this and more was offered only to the deceased of the elite class, implying a hierarchical social structure that contrasts with the Archaic Period. Robert Silverberg has written eloquently of the "stunning vigor" of Ohio Hopewell: "To envelop a corpse from head to feet in pearls, to weigh it down in many pounds of copper, to surround it with masterpieces of sculpture and pottery, and then to bury everything under tons of earth—this betokens a kind of cultural energy that numbs and awes those who follow after."[4]

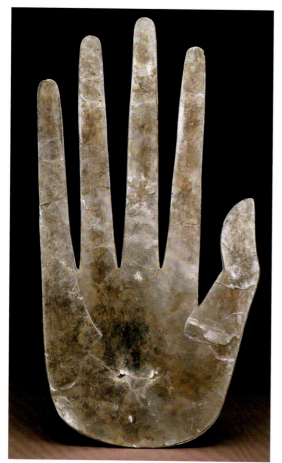

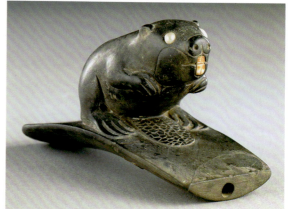

▲ **3.7** Havana Culture artist, Bedford Mound, Pike County, Illinois, Beaver effigy platform pipe, Middle Woodland period, 100 B.C.E.–200 C.E. Pipestone, river pearl, bone, 4.5 × 11.6 cm. Gilcrease Museum, Tulsa OK Courtesy Bridgeman Art Library International © Dirk Bakker.

In the visual language of Woodlands art, inlays of light-reflective materials signify the spiritual nature of the image. The artist who made this pipe achieved a sense of lifelike presence through a judicious use of naturalism and a skillful modulation of the transitions from flat engraving (the tail), to low relief (the feet), to the fully rounded three-dimensionality of the body.

▲ **3.6** Hopewell artist, Ohio Hopewell Culture, Mound 25, Hopewell site, Ron County, Ohio, Mica ornament in the shape of a hand, Middle Woodland Period, 200 B.C.E.–400 C.E. Sheet mica. Ohio Historical Society, Courtesy Bridgeman Art Library International © Dirk Bakker.

This famous example of Hopewell artistry is one of the most moving and eloquent representations of the human hand in world art history. It was placed in an elite grave together with other mica effigies, shell and river pearl ornaments, and objects of copper, stone, and bone. The holes that perforate the palm suggest it was worn as a pendant. The hand motif may have represented both an ancestral relic and a symbol of the potency and creativity of the empowered human being.

Ohio Hopewell were not an isolated people; rather they participated in a network of exchange—called the "Hopewell interaction sphere"—which stretched from Ontario to Florida. The desire for exotic luxury goods such as Great Lakes copper, Gulf Coast shell, Rocky Mountain grizzly bear teeth, obsidian from Yellowstone Park, Florida alligator and shark teeth, and Appalachian mica found in the burial sites of the participants in this exchange network can be compared to the late medieval spice trade that drove European merchants to push beyond the Mediterranean, around Africa, and across the Atlantic. Although each Middle Woodland Period culture was distinctive, the desire for trade goods across the East during the first four centuries C.E. ensured the transmission of similar artistic concepts and cultural inventions throughout the region.

Activity at the great Hopewellian mound complexes tailed off rather suddenly after about 350 C.E., and by 500 C.E. they were completely deserted. The phenomenon of sudden abandonment after centuries of cultural activity is a familiar pattern in the precontact Americas, one that scholars usually attribute to the exhaustion of critical resources through human overuse, often exacerbated by climate changes. Narratives of "abandonment" and "disappearance" are deceptive, however, when they imply that the peoples and their belief systems simply vanished without a trace. Although earthwork building ceased, the makers and their intellectual cultures survived in new locations. The cosmological principles and spiritual beliefs of the Woodlands Period continue to inform later

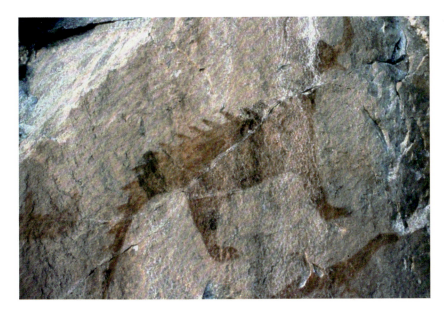

Painted on a sheer rock surface, these images honor beings whose powers control the often turbulent waters dangerous to people traveling by canoe. The large central image represents the Misshipeshu, or Underwater Panther, whose long tail whips up the waters but whose copper scales can provide wealth and power. In the 1960s, pioneering Anishinaabe artist Norval Morrisseau was inspired by this painting to renew representation of this being in the new medium of acrylic paintings.

cultures. The traces of Hopewell are everywhere to be seen in the historical arts and cultures of the East.

Woodland Period worldview is revealed not only in burial practices but also in its visual iconography. Both pre- and postcontact Eastern cultures attribute primary cosmic power to sky beings imagined as predatory, raptorial birds resembling falcons and eagles and to horned, long-tailed earth and water beings that combine the traits of amphibians and land animals. Such a being, with two pairs of curved horns, a reptilian skin, a panther-like body, and a long tail, was represented by a Hopewell sculptor almost 1,500 years ago;[5] an almost identical supernatural was represented in rock paintings and woven and embroidered bags dating to the eighteenth and nineteenth centuries (fig. 3.8). Many other artistic conventions found in historic Woodlands and Plains art also occur in Hopewell-related works, such as the representations of a bear by its clawed paw print or a raptor by its taloned claw. The cosmological symbols of the circle and the cross of the four directions are found both in the large-scale geometries of the mounds and the small-scale designs of individual ornaments.

Some archeologists now speculate that, on occasion, mound building might also have been a response to observations of the heavens. For many years the most famous single earthwork of the Hopewell phase was thought to be the Serpent Mound at Locust Grove, Ohio, but a new carbon date of 1070 C.E. has raised the possibility that this great earthwork actually belonged to the next great era of Woodlands history, the Mississippian Period, which began about 900 C.E. (fig. 3.9). The Serpent Mound is anomalous both in form and in function. It contains no burials and is designed as an oval enclosure (the "head") and a long twisting, sinuous embankment that are together nearly a quarter of a mile long. One archaeologist, noticing that the new dates coincide with two dramatic mid-eleventh-century astronomical events—the light effects from the supernova produced by

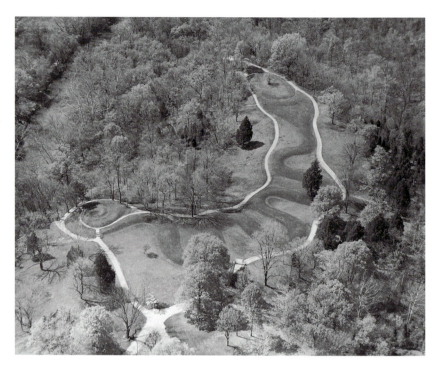

▶ **3.9** Fort Ancient Culture (attributed), Adams County, Ohio, Aerial View of Great Serpent Mound, c. 1000 C.E., photographed by Tom Root, c. 1960–80. Courtesy The Ohio Historical Association, Image #AL01026.

The Great Serpent Mound in southwestern Ohio, although probably a late addition to the famous mound complexes of the Ohio region, is—as the largest serpent effigy in the world—the most famous. Its sinuous lines seem to have been suggested by the topography of the land. The mound contains no burials or artifacts, and its orientation suggests a relationship to astrological observations.

the Crab nebula in 1054 C.E. and the sighting of Halley's comet in 1066 C.E.— has speculated that the "Serpent Mound" may actually reflect an image of the comet.[6]

Eastern Woodlands people probably first began to cultivate indigenous plants during the Late Archaic Period (3000–1000 B.C.E.), but agriculture remained relatively unimportant to subsistence until the Middle and Late Woodland periods when the economic basis of social life shifted to the intensive cultivation of corn. Originally domesticated in Mexico, corn permitted population growth and density capable of supporting some of the most ambitious building projects ever undertaken in the Americas. In the centuries before the arrival of Europeans the rich agricultural lands of the Mississippi Valley may have supported as many as four million people and the eastern seaboard and adjacent areas, two million.[7]

Mississippian Art and Culture

Building on the conceptual legacy of the Archaic and Woodland era peoples, and probably stimulated by renewed contacts with Mesoamerica, the Mississippians carried mound building, ceremonialism, and creativity in the visual arts to new levels (fig. 3.10). During the Mississippian Period between about 900 C.E. and 1600 C.E., the centers of power and influence in Eastern North America shifted southward. Major Mississippian towns include Cahokia, Illinois (near modern-day St Louis); Spiro (on the Arkansas River in northeastern Oklahoma); Etowah, Georgia (near modern Atlanta); and Moundville in northern Alabama. Each was a ceremonial center for a large area of surrounding countryside whose inhabitants paid tribute to a

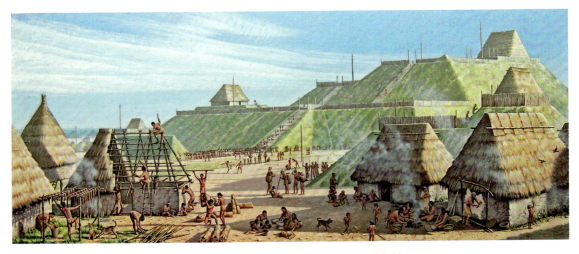

▲ **3.10** Artist's conception of Cahokia. Painting by Michael Hampshire, courtesy Cahokia Mounds State Historic Site.

This artist's rendering helps us to imagine the great site of Cahokia during the centuries when it was inhabited by thousands of people. At times of ritual and ceremony the large plazas were filled with people wearing rich dress and ornaments, while at other times, as seen here, people went about their daily lives. The style of rectangular house with thatched roof depicted here was described by early Spanish and French explorers in the Southeast.

ruling class. The concentrated wealth of the élite was directly expressed in its art and architecture. The major Mississippian sites are typically located at strategic points at the confluence of rivers or on the boundaries between two ecological zones. Here people could exploit the rich soil of the flood plains at the same time that they controlled trade between regions possessing different kinds of resources. Most towns were surrounded by defensive high stockades, for warfare and warrior cults are distinguishing features of the Mississippian Period.

Many features of Mississippian art and architecture are clearly derived from Woodland Period cultures, such as the shapes of many of the mounds, the use of conch shell and copper as important artistic media, and the wearing of ear spools and other forms of body decoration. Like their predecessors, too, the worldview of the Mississippians was structured according to a three-tiered universe inhabited by powers specific to the realms of below-earth, earth, and sky. This structure expressed itself visually in the continuing prominence of images of raptorial birds and great serpentine monsters in Mississippian art.

But new conceptual and artistic ideas—many recognizably of Mesoamerican origin—amplify and reconfigure these elements. Politically, socially, and spiritually, these include more centralized structures of authority in which classes of rulers and priests acted as intermediaries to the spirit world for the common people. There is much evidence that the Mississippians regarded the sun as a representative of the ultimate spiritual power from which both political authority and sustenance flowed. The chiefdom of the Natchez, a Mississippian people who survived into the contact period (though reduced in size and power and altered by the adoption of

refugees from other depopulated Mississippian chiefdoms), was described in some detail by late seventeenth-century European missionaries and explorers. The Natchez were divided into distinct social classes, the highest of which were the "Suns." The ruler was called the Great Sun and was regarded as a god. On ceremonial occasions his subjects carried him to avoid the contamination of contact with the earth, a ritual avoidance that explains the meaning of the litters found at many Mississippian sites. Such practices parallel characteristics of systems of divine kingship in other parts of the world, such as Mesoamerica, Europe, Africa, and Asia.

It is probable that the Mississippians expressed their beliefs in the sun and its powers through annual ritual celebrations, as have their direct descendants in historic times. The sun imagery central to Mississippian iconography was also a feature of contemporary Mexican ritual systems, notably those of the Aztec. Other images, such as the feathered serpent (resembling the Aztec Quetzalcoatl), and the long-nosed "gods" carved on ear spools and other objects, provide further evidence of commonalities between Mississippian and Mesoamerican cultures. Most strikingly, however, the principal mounds built by the Mississippians are flat topped and slope sided—Mexican in all but their lack of stone cladding. In both regions, temples, mortuaries, and houses for important people were built on top of the mounds. They were constructed of wattle and daub (a lattice of sticks covered with a mixture of clay and mud) and roofed with thatch like the houses of historic Southeastern peoples such as the Creeks and Seminoles. Although all these parallels are highly suggestive, no Mexican objects have been found at Mississippian sites (or vice versa). Exchanges between the two regions probably occurred through trade, possibly conducted by aristocratic merchants like the Aztec *pochteca*—men who were well enough versed in matters of political power, warfare, and ritual to have been effective transmitters not only of goods but also of key cultural concepts and ideology.

Like Hopewell and other Middle Woodlands communities, Mississippian chiefdoms were linked through trade and cultural exchange that promoted the diffusion of similar art forms and images over a wide area. Mississippian mounds, however, differed in their primary purposes. Some sites, like Spiro, on the border of Oklahoma and Arkansas, were primarily ceremonial centers serving a large number of satellite towns, and their mounds contained great numbers of rich burials. Others, like Cahokia, were residential metropolises; its mounds and plazas served for the staging of public ceremonials and contain few burials (fig. 3.10). Despite this diversity, the arts found across the Southeast have so many common iconographic features that they have all been associated with a shared religious and political ideology referred to in the literature as the "Southeastern Ceremonial Complex." This art includes elaborate imagery engraved on shell gorgets (large disk-shaped neck pendants), ceremonial conch shell drinking cups,[8] embossed copper plaques, and other objects that together reveal much about Mississippian beliefs and ritual practices. Some figures are depicted holding distinctively shaped maces or scepters as emblems of power that are faithful representations of stone and copper maces found at Mississippian

sites (fig. 3.11). A four-directional cross surrounded by a sun image, found on many shell gorgets, represents a map of the cosmos as the Mississippians understood it. Other images, such as hands with eyes inscribed in the center or men lavishly costumed with elaborate headdresses, aprons, and ornaments, probably make reference to divine ancestors.

A ritual-artistic balancing of the powers that govern the upper world (the sun, sacred fire, thunderers, and the falcon) and the underworld (water, the cougar, the rattlesnake, and the piasa—a composite being with an animal body, wings, a long tail, and horns that is ancestral to the Underwater Panther) structures this iconographic system. Human beings intervene to entreat and manipulate the protective powers conferred by the beings of both upper and lower realms.[9] There is also visual evidence of specific cults that seem to offer direct links to the later warrior societies of the Great Plains. James Brown has identified a widespread set of images showing men with distinctive forked eye markings and feathered costumes with fragments of cloth costumes displaying feather patterns that have been found at Spiro. He has argued convincingly that these images represent a warrior dance performed by members of a cult who impersonated the falcon, also identified with the Morning Star deity.[10] Related to these images are shell masks with lighting-like thunderbolt lines extending from the eyes that were the principal objects contained in sacred war bundles (fig. 4.3).

Through comparison with the traditional beliefs of the historic Kansa, Omaha, Osage, and other peoples who were probable descendants of the Mississippians, Brown summarizes the complementary powers of these beings of the upper and lower worlds: "Morning Star represents the capacity for rebirth; the Great Serpent exercises discretion over the timing of death. Each controls aspects of fertility: Morning Star controls the generation of human life and the Serpent/puma the generation of plant and animal life."[11]

Another key element of Mississippian ritual practice (and of divine kingship systems in general) was the veneration of relics of high-ranking ancestors. Archaeological remains from mortuaries reveal that the bodies of the dead were prepared for burial in highly specific ways that may have

COPPER BREAST PLATE
PLT 1, MOUND 3
BURIAL # 17

▲ **3.11** Fort Walton Culture artist, Lake Jackson site, Florida, Breastplate, 1300–1400 c.e. Copper. Courtesy Florida Department of State, Division of Historical Resources.

This drawing depicts one of fourteen copper breastplates from elite burials found in mounds near Tallahassee, Florida, at the southernmost extension of the Southeastern Ceremonial Complex. Probably made at Cahokia, it depicts a Falcon Dancer holding a mace in one hand and a severed head in the other. His elaborate headdress and long-nosed maskette, columnella pendant, beads, and apron would have had specific associations with powers of the upper and underworlds.

involved the removal of body parts. A type of effigy pot particularly common at sites in Alabama takes the shape of a human head with closed eyes, and often displays tattoo markings or other sacred symbols. These head effigy pots are now thought to represent relics of honored leaders or ancestors. The most common form of decoration on the fine pottery produced by the Mississippians was the spiral, a motif whose symbolic meanings may be related to the circular and cyclical concepts of time and the associated patterns of ritual movement of historic Woodlands peoples (fig. 3.12).

Among the greatest of all Mississippian works are sculptural renderings of human beings in pottery and stone. Pottery made for ritual purposes took a multitude of shapes, including shallow bowls, high-necked vases, and effigy pots in the forms of animals and humans. A sixteenth-century painting made in the Virginia colony by John White (active 1585–93) shows a mortuary house with the dead prepared for burial. Presiding over this scene is a statue, probably of an ancestor, which resembles those found at some Mississippian sites. A number of large pipes made of flint clay

▶ **3.12** Caddoan artist, Carden Bottoms, Yell County, Arkansas, Water vessel, 1500–1700. 18.90 × 13.30 cm. Photo © Dirk Bakker. St Louis Art Museum, courtesy The Bridgeman Art Library International.

The Caddo, whose homelands lie in the Red River region at the boundaries of Louisiana, Oklahoma, Texas, and Arkansas, were the westernmost Mississippian peoples. Caddoan pots are today recognized as the outstanding Mississippian ceramic tradition. Their shapes correspond to the organic volumes of gourds while their engraved designs recall basketry, shell engraving, and other Mississippian and historic arts. Caddoan ceramics are today being revived in the fine work of Jereldine Redcorn (b. 1939).

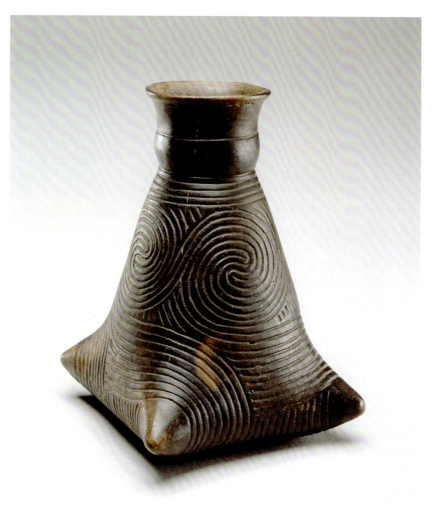

also take figural form. Although long interpreted as portraying persons of high rank, a key group of these sculptures has been reinterpreted by Kent Reilly as representing a sequence of moments in the Morning Star myth. The elaborate dress and ornaments of a high-ranking man that adorn the "Resting Warrior" figure, he suggests, establish his identity as the great supernatural hero (fig. 3.13). The artists who made these sculptures captured with immediacy and naturalness the expressive quality of the human figure at a moment of intense inner concentration that precedes action, an artistic problem that has challenged sculptors worldwide—and that lies, for example, at the heart of Michelangelo's (1475–1564) almost contemporaneous *David*.

With an estimated population of 20,000 and an area of six square miles, Cahokia was, at its height, the largest city in North America. It originally contained over 120 mounds, the biggest of which, Monk's Mound, is the largest earthen mound ever constructed in the Americas and, perhaps, the

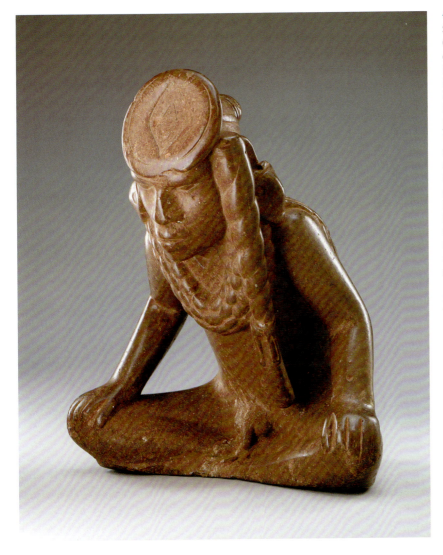

◀ **3.13** Mississippian artist, Spiro site, Leffore County, Oklahoma, *Resting Warrior* effigy pipe, 1200–1320 c.e. Bauxite, 27.5 × 23 cm. Detroit Institute of Arts / Photo © Dirk Bakker / The Bridgeman Art Library International.

This figure, which probably represents a Caddoan chief, comes from a workshop located in Southeastern Illinois and was made over a century before it was placed in the burial of an elite man at Spiro, Oklahoma. The figure is shown in a trance state and wears a copper headdress, ermine-skin cape, massive shell-bead necklace, and ear ornaments. Similar objects have been found at Mississippian sites.

world. Over a period of three centuries, its builders deposited twenty-two million cubic feet of earth to create a mound measuring 1,080 by 710 feet at its base and rising to a height of 100 feet. The great mounds at Cahokia, as at earlier Woodlands sites, may have been used to make astronomical observations that helped to determine the agricultural calendar. Monk's Mound is aligned with the position of the sun at the equinoxes. From the wealth of finely made ornaments and rich clothing depicted on the works of art found at Cahokia and other great Mississippian centers, we can imagine the colorful spectacles presented by the crowds that gathered at times of festival and the elaborately costumed teams of high-ranking men who played ritual ball games in their plazas. Cahokia thrived for four centuries—the same length of time that has passed in North America since the first European settlers arrived at Quebec City, Plymouth, and Jamestown—before it was abandoned just before 1500. Its decline may have been brought about by a similar combination of resource exhaustion and climate change that had probably led to the abandonment of the Middle-Woodland Period mounds.

THE SOUTHEAST: THE CATACLYSM OF CONTACT

The Mississippian chiefdoms maintained their power and dynamism for about five centuries, into the period of the European invasion of North America. Like Cahokia, however, the major sites were probably abandoned shortly before Europeans arrived, perhaps because they could no longer support previous population densities. We stress again that in the Southeast, as in the Southwest around the same time, the people who abandoned the great mound centers did not vanish but moved elsewhere. At the turn of the twentieth century there were still, for example, a few speakers of the Natchez language living among the Cherokee, who had absorbed their eighteenth-century forebears.[12]

The diseases, religions, and economic systems introduced by Europeans were far more serious threats to the survival of precontact Native cultures and languages than the earlier readjustments and relocations caused by environmental changes. The cataclysm of contact began almost a century earlier in the Southeast than the Northeast. One of the first and most extensive European expeditions, led by Hernando de Soto, traveled through the Southeast from northern Florida to the Mississippi River in search of gold between 1539 and 1543. Its members observed several thriving late Mississippian chiefdoms, engaged in violent battle with some of them, and everywhere introduced the germs that were the cause of the ultimate destruction of the Native polities. Over the next century and a half, the Aboriginal population of the Southeast was reduced, according to some estimates, by nearly 80 percent. Historians, searching for a word that can even begin to capture the magnitude of this disaster, have rightly termed it a holocaust, though one that was, at its inception, unintended.

It is impossible to trace the history of art in the East without stopping to try to conceive of the effects of such a loss. The survivors, pressed from

every side, their numbers reduced beyond their ability to maintain their former social and ceremonial institutions, formed new alliances and re-combined into new peoples, blending formerly localized cultural and artistic traditions. The historic-period Creeks, Muskogulges, Chickasaws, and Choctaws are confederations of remnant Mississippian peoples. Many memories of Mississippian heritage are preserved in the oral traditions and visual designs of these peoples, and the great mounds often remained the sites of ritual observance. Visual arts also preserve cultural memory. A type of nineteenth-century sash, for example, displays the same spiral motif as a Caddoan pot made several centuries earlier (figs. 3.12 and 3.14). And in the Choctaw creation story, the Nanih Waiya mound (in the present state of Mississippi) is identified with the Great Mother and source of life, and it remains the site of the modern Green Corn Ceremony.

Although we cannot assume that practices of more recent centuries repro-duce those of the precontact Mississippian societies, they are clearly descended

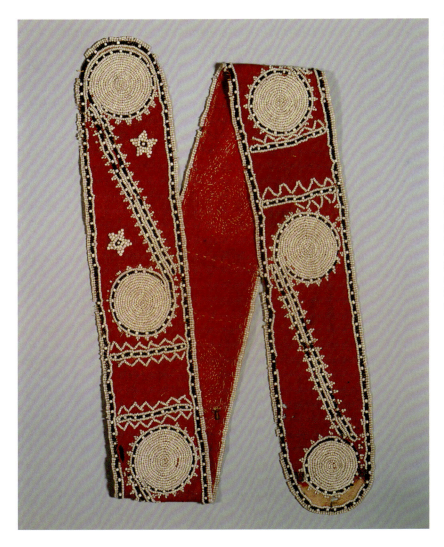

◀ 3.14 Choctaw artist, Mississippi, Beaded sash, before 1812. Stroud cloth, beads, 128.7 × 9.5 cm. Denver Art Museum Collection: Purchase from Maynard Dixon, 1939.3. Photograph © Denver Art Museum.

The spiral or scroll designs common on Mississippian pottery continued into the historic period. This sash also evidences the love of red stroud among eastern peoples and the use of white-glass beads as an analog for white shell. The five-pointed stars, derived from the United States flag, probably translate older iconographic references to cosmic bodies into a new visual system.

in important ways from those ancient systems of belief and ritual. For historic-period Southeastern peoples the Green Corn Ceremony (*boskita* or the "busk" in modern Muscogulge[13] languages and English) has been the culminating rite of the yearly calendar. Occurring at the full moon in July or August, it is both a thanksgiving for the harvest and a rite of renewal. Its central event is the extinguishing of the central fire of the chiefdom, conceived as kindled directly from the sun, and of all the other individual town and household fires. These fires burn at the center point of a cross formed of four logs laid at right angles to each other—a living embodiment of the cross and sun-circle motif that is so common in Mississippian art. The extinguishing of the fires is followed by days of ritual preparation, including the drinking of the purifying "black drink," which sixteenth-century French artists depicted as having been drunk from conch shell cups. At the end of this period new fires are lit from embers carried from the chiefdom's central fire, and the green corn is roasted as a symbol of renewal and new life—a ritual guarantee, too, of the continuing power of the sun.

A Continuum of Basketry: Chitimacha Traditionalism and Beyond

Archaeological evidence from Spiro shows that the Mississippians buried the bones of their dead in rectangular lidded baskets woven of river cane in two continuous layers, one inside the other. A similar burial practice using the same type of basket was still in use among the Chitimacha of southern Louisiana in the nineteenth century. Other archaeological finds near their reserve in Charenton establish a history for this type of basketry that goes back 3,000 years. The modern Chitimacha community comprises the descendants of one of the four groups whose confederacy, numbering 20,000 people, dominated the lower Mississippi delta at the time of contact. The early French explorers described their typically Mississippian social structure of nobles and commoners; an economy based on corn cultivation, fishing, and hunting; lively dances and elaborate ceremonials; and art forms that included elaborate tattooing of the body. In the 1750s Jean-Bernard Bossu witnessed burial rituals in which their finely woven baskets were used: "Each family gathers at the cemetery and weeps as it visits the boxes containing the bones of its ancestors. After leaving the cemetery, the Indians indulge in a great feast. . . . In the early part of November they have an important holiday called the feast of the dead or the feast of souls."

By the late nineteenth century, however, disease and warfare with successive European colonizers had reduced the Chitimacha to a half dozen families. Their traditional language had been replaced by Cajun French and only one woman, Clara Darden, still practiced the ancient art of basketry (fig. 3.15). Encouraged by a neighboring white woman, Mary Bradford, Darden embarked on a remarkable project to weave all the basketry designs she knew.[14] With consummate skill, she cut river canes, split and peeled them, and then dried and dyed some of them red and black. Plaiting them together with undyed splints in an unusual diagonal weaving technique, she created seventy-two different baskets and provided their names to Bradford. Some, such as Alligator Guts and Worm Tracks, evidence Indigenous Chitimacha knowledge of the natural world. Others, such as "Up

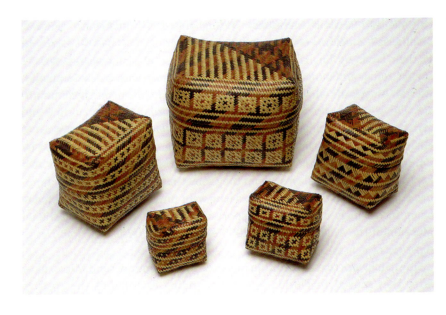

◀ **3.15** Clara Darden, c. 1829–1910 (Chitimacha), Nested covered baskets, 1904. Woodsplints, dye. Hampton University Museum, Hampton, Va./photo Scott Wolff, Virginia Beach, Va. (04.1696.2-04.1696.12).

The enthusiasm for collecting Native American basketry around the turn of the twentieth century provided the context within which Chitimacha in Louisiana promoted basketry traditions whose motifs and forms undoubtedly have roots in the precontact Southeast. This nested set, made for the 1904 St Louis Exposition, called forth a virtuoso display of technical skill and artistic design.

Across and Down" or "Something Around," speak of the weaver's technical knowledge and evoke the rhythm and movement of her hands. When Darden's baskets were exhibited at the St Louis World's Fair in 1904, they were much admired, although she never received the individual recognition her work merited. She did, however, pass her knowledge on to her descendants, Melissa, Scarlett, and John Paul Darden. Members of a community now growing and prospering through revenues from the tribe's casino, they are the most recent practitioners of an art that extends back in time for more than a thousand years.

The Darden family's baskets have been the impetus for works in other media as well. Photographer and mixed-media artist Sarah Sense (Chitimacha, b. 1980, fig. 8.13) has gained acclaim for her innovative photos, which take basket-weaving methods in a new direction. She writes:

> After researching the history of Chitimacha basketweaving, I was inspired to continue the traditions of my ancestors. In 2004, the chairman of the Chitimacha Tribe of Louisiana gave me permission to use nontraditional material in weaving our basket patterns, and since then I have incorporated photographic images into my work . . . Most recent bodies of work are photos woven over photo silkscreen prints.[15]

Sense's photographs, many of which measure four by six feet, reproduce the elegant geometries of Chitimacha basketry on a grand scale.

Reconfiguring Southeastern Arts: Seminole and Miccosukee Textiles

Elsewhere in the Southeast during the historic period, the merging of culturally diverse peoples into new tribal groups, together with intermarriages with whites and African Americans, have contributed to the development of new

gorgets imported from the Gulf of Mexico; cylindrical red catlinite beads from Minnesota; a wealth of Great Lakes copper formed into sheets, a rattler, beads, and coils of wire; pottery, some containing remnants of food; beaver skins and woven cedar bark mats (only fragments of which survive); turtle-shell rattles; numerous trade brass kettles; a great array of imported multicolored glass beads; and a wampum belt made of tubular white glass trade beads. The list testifies equally to the continuation of the ancient trade with the South and West and to the new vectors of trade directed at Montreal and the Atlantic Coast.[18]

The persistence, after a thousand years, of the same symbolic language of materials—red stone, white shell, shiny metal—that characterized Adena and Hopewell burials, is particularly striking (figs. 3.17 and 3.18). George Hamell has termed the early-contact-period commerce between Indians and

▶ **3.17** Virginia Algonkian Artist, Deerskin robe *(Powhattan's Mantle)*, before 1638. Hide, marginella shell, L. 213 cm. Courtesy Ashmolean Museum, University of Oxford.

This famous robe entered the curiosity collection assembled by the royal gardener and botanist John Tradescant through the agency of British colonists at Jamestown, Virginia. It may come from the temple treasure of the great chief Powhattan, father of Pocahontas. Its central image of a human figure flanked by two animals is widespread in the East, as is the use of shining white shell as a spiritually empowered ritual-artistic medium.

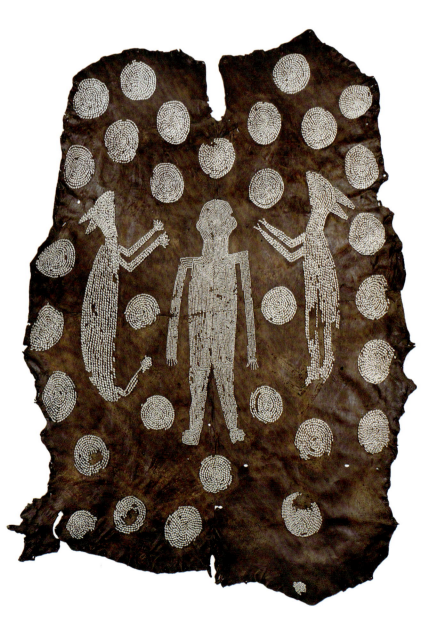

Europeans a "trade in metaphors," motivated on the Native side not—as the Europeans believed— by an economic rationale similar to their own, but by an Indigenous system of value based on the symbolic and spiritual qualities attached to certain classes of materials. He uses numerous travelers' reports to show that, during the first phase of contact, Native peoples classified the European invaders with the under(water) world beings from whom humans acquire gifts of crystals, copper, and shell—all medicine substances with life-giving, healing properties. Many of the gifts offered by Europeans—mirrors, glass beads, trade silver, and other metals—have similar physical properties: they are white, bright, reflective, and transparent. In the precontact- and early contact-period Woodlands, the aesthetic qualities of these materials thus carried strong moral associations of introspection, self-knowledge, and understanding. Hamell's argument that glass beads first "entered Native thought" as analogs of crystal not only explains why the most common burial offerings found in seventeenth-century graves are glass beads and white-shell wampum beads but also suggests why glass beads have remained a privileged artistic medium among the interrelated peoples of the Woodlands, Plains, and Subarctic. Native artists, of course, quickly understood that glass beads were European manufactures and not supernatural gifts, but their initial manner of integration into Native visual cultures undoubtedly carried ancient and enduring concepts and aesthetic values over to the new medium.

Arts of the "Middle Ground"

Historian Richard White, building on Hamell's thesis, argues that the need to acquire suitable ceremonial gifts was the most important motivation for the Native trade with Europeans during the seventeenth century.[19] One of the major gift-giving obligations was, as we have seen, to the dead, and the Feast of the Dead emerges as one of the most important stimuli for the production of art during the early contact period. Although only the durable components of these gifts survive in archaeological contexts—shell, stone, pottery, and glass—we know from the descriptions in early European texts that the prepared gifts would also have engaged the skills of the hide tanner and painter, the embroiderer in porcupine quills and moosehair, the weaver, and the wood carver. The enormous quantities of gifts needed required the investment of a great deal of cultural energy not only to acquire trade goods but also to produce the quantities of artistically worked offerings.

◀ **3.18** Northeastern Woodland artist, War club, 1620–80. Hardwood, brass, iron, copper, and shell inlay, L. 24 in. T0794. Gift of Eugene V. and Clare E. Thaw, Thaw Collection, Fenimore Art Museum, Cooperstown, New York. Photograph by Richard Walker.

Lieutenant John King, a seventeenth-century settler in western Massachusetts, acquired this club, possibly from a New England Algonkian warrior. Its imagery and decoration are unusually rich, including shell inlay, a handle carved as an animal's head, and what may be a self-portrait of the owner's elaborately tattooed face on one side.

The dead could make no exchange for these gifts, but among the living, gift-giving was, as ethnohistorians have stressed, a vital means of resolving conflicts and furthering social cohesion. During the seventeenth century, warfare increased dramatically among Great Lakes peoples as a result of the pressures that colonists exerted on Native peoples to move west and because of competition among Native nations for control of the trade with Europeans. The Neutral, again, exemplify a widespread pattern. They, like their neighbors the Wendat, were attacked, defeated, and dispersed by the Haudenosaunee confederacy in the middle of the seventeenth century. As already noted, in numerous cases such historical episodes, though violent and bloody, can be understood as leading not so much to total "extinction" as to the radical recombination of cultural groups. Individual captives were adopted into existing communities to replace family members who had been lost to disease or warfare. In some cases whole groups were taken in; 500 Wendat, for example, joined the Seneca after the Haudenosaunee attacks of 1648–49. In many other cases, groups of refugees fled west, joined forces with other refugees, and formed new villages in the central Great Lakes. Wendat and other Iroquoians from the eastern Great Lakes mingled, for example, with Odawa (Ottawa), Ojibwa, and Potawatomi—three groups who speak closely related Algonkian languages and refer to themselves collectively as Anishinaabeg.

What must have happened to local stylistic traditions during this century or more of turmoil and cultural mixing? The adoption practices that were so important during this era when disease and warfare had depleted populations were not only crucial in the restoration of communities but must have had a considerable impact on artistic traditions. Adopted captives assumed the names of deceased family members, married, and became full members of the adopting community, suggesting that during the early contact period eastern Native peoples held very different concepts of race and nationality from those imposed under colonialism. Western notions, in contrast, became increasingly essentialist, holding race and national identity to be an irreducible and unchangeable core of individual identity. Although we have inherited the related notion that art styles, like cultural traits, are fixed expressions of identity, scholars today understand the relationships among ethnicity, nationality, and art style as more fluid and more subject to individual negotiation. In today's processes of cultural renewal and reconfiguration, as in those of the past, artists may consciously retain or restore traditional artistic motifs, styles, and practices from more than one source as suits their specific purposes and creative contexts.

Works of art collected early in the contact period tend to be poorly documented. As discussed in the introduction to this book, scholars must rely on a small but precious corpus of objects that has survived from seventeenth- and eighteenth-century curiosity cabinets to identify their communities of origin (fig. 3.17). Even in relatively well-documented examples, we rarely know the specific place of origin or they were made

by a member of the group living there, acquired in a gift exchange from another community, or made by an adopted person trained in the art traditions of a quite different locale.[20] In the Great Lakes region, for example, it has proved almost impossible to identify a pair of porcupine-quill-embroidered moccasins or a moosehair-embroidered belt as Seneca rather than Mohawk, or even as Haudenosaunee rather than Anishinaabe. But it is also possible that the clarity we seek eludes us for good reasons—not only because the tremendous amount of long-distance travel, mixing, and recombination of cultural groups during the seventeenth and eighteenth centuries led to an unprecedented exchange of artistic ideas, but also because it is probable that narrow stylistic distinctions had little meaning for the makers themselves. The importance of this point is even greater because early-contact-period objects have been regarded as benchmarks of authenticity in Eastern Native American art. In contrast, during the nineteenth and twentieth centuries, when confinement to reserves does seem to have resulted in the development of more clearly definable local styles, the objects produced have been regarded as less authentically "Indian" because of the greater European and North American influence they display.

White noted that "the accounts of early ethnologists who studied these tribes and codified them are full of internal contradictions because they sought to freeze what was, in fact, a world in flux."[21] As he also demonstrates, ancient practices of gift exchange, including artistically worked objects associated with peacemaking and diplomacy, assumed a new importance (fig. 3.20). White's concept of the seventeenth- and eighteenth-century Great Lakes as a "middle ground" of intra-Indian and Indian-European negotiation is central to the understanding of the visual forms associated with three ritual complexes: the calumet ceremony, wampum exchanges, and the *Midewiwin* or Grand Medicine Society. While the rituals surrounding the calumet and wampum were tools for forging bonds between human communities, Midewiwin rituals are directed primarily at the spiritual realm.

As a ritual act, the burning of aromatic plants—including the smoking of tobacco in pipes originating among the Plains Pawnee and spreading as far east as the Haudenosaunee during the seventeenth century—functions as a means of offering smoke to nonhuman beings in order to invoke their blessings on human activities. The term "calumet" refers to the long stems attached to pipes used in ceremonies associated with the making of alliances or other important social interactions. During the early contact period, the calumet ceremony was a highly effective means for making peace among warring groups. The joining of the long stem to the pipe bowl expresses fundamental cosmological principles of complementarity and unity. The bowl, made of finely carved stone, wood, or red catlinite, symbolizes the earth with its feminine regenerative powers (fig. 4.13). The stem, decorated with porcupine quills, paint, eagle feathers, and other materials, symbolizes the male energizing powers of the sky world.

OBJECT IN FOCUS
The Assiginack Canoe

Like the full-sized canoes that carried the Northern Wood-lands peoples over long distances to hunt, trade, and make war, this finely made model canoe is crafted of birch bark, sewn with spruce root, sealed along the seams with spruce gum, and painted with colorful designs (fig. 3.20). More unusually for such models, it carries six wooden figures, each adorned with elaborate face paint and feathered hair ornaments The canoe and figures were made by Jean-Baptiste Assiginack (1768?–1866), one of the most promi-nent and respected Anishinaabe men of the first half of the nineteenth century. In 1823, in recognition of his loyal service, achievements, and influence, the British pre-sented Chief Assiginack with a silver medal and armbands during the annual distribution of treaty "presents" to its Anishinaabe allies. In return, Assiginack presented this model canoe together with other gifts that, in his words, showed "the ingenuity of our Indian brethren." He requested that the canoe be sent on to Lord Dalhousie, the governor general of British North America.

Over three feet long, made of birch bark and painted with elaborate geometric designs, it retains six of the original seven carved wooden figures. They are clothed in fitted woolen leggings, breechclouts, cross-chest bandolier straps, garters, and moccasins that were made by Assiginack's wife. Each is individualized by its facial features and face and body painting designs. A birchbark label that remained associated with the canoe confirms that each figure represents a spe-cific warrior who fought for the British during the War of 1812: Mookomanish or Little Knife, "an eminent war chief"; Blackbird, "a very distinguished orator"; Clap of Thunder at Night, "a great war chief" known "for his accuracy in foretelling events by his dreams"; Esh-guoi-can-nai-Be, who as cook, performed "one of the most honour-able occupations"; Cub-Bear; and Bird of Day.

Today, we think of miniature birch-bark canoes as toys or souvenirs sold at roadside stands throughout the Great Lakes. Yet Assiginack was a noted war-rior who had been educated as a devout Catholic by Sulpician priests, fought in seven battles of the War of 1812, was commissioned to proclaim the peace in 1815 by carrying wampum and the pipe of peace throughout the region, and served as an official British interpreter for twelve years. Why would he have taken the time and trouble to make such

an object for presentation to a powerful colonial adminis-trator? As Anishinaabe historian Alan Corbiere's research reveals, the answer lies in the historical events that were unfolding during the 1820s and in the principles of reci-procity that inform Anishinaabe relationships with all other beings. In this context, two long-standing traditions con-verged, one involving artistic representation on a miniature scale and the other diplomatic gift exchanges.

By the early nineteenth century Woodlands' artists had been making canoe models to present to outsiders for over 150 years. They occur in some of the early curiosity cabi-nets, and very elaborate examples were sought as souve-nirs by European military officers during the second half of the eighteenth century. Assembled by Quebec nuns and their Aboriginal partners, they included carefully dressed dolls, sails, carved wooden dogs, and miniature imple-ments that reproduced with great precision the colorful spectacle of long-distance canoe travel through the vast rivers and lakes of the region. Before the photograph and the postcard, such a model could convey to distant viewers the colorful sights that delighted travelers.

The making of miniatures has attracted artists through-out human history because it provides both maker and viewer with an enhanced sense of understanding and control. We find pleasure in the virtuosity and skill re-quired to work on a reduced scale, and we give miniatures to children as toys that also educate. Spiritual practitio-ners make miniatures to capture the substance of a vision

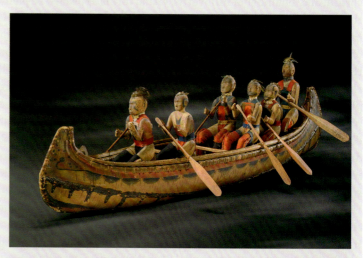

▲ 3.20 Jean Baptiste Assiginack and his wife, Canoe model with six warriors, 1815–27. Birch bark, white cedar, maple and bago wood, pine gum, red and black paint, fabric feathers, L. 94 cm. Canadian Museum of History, Accession number: III-M-10 a-n IMG2009-0063-0017-Dm.

or as offerings that accompany the dead on their journey to the afterworld. In 1823 Assiginack invoked the miniature for a different purpose. The European need for Native military alliances ended after the War of 1812, and by 1823 settler hunger for Aboriginal lands had already greatly intensified. Within a decade this pressure would cause Assiginack and other Odawa to move from northern Michigan to Manitoulin Island in Canada. In showing Lord Dalhousie the warriors who had fought so valiantly for the British cause and in making sure their names were recorded, he was reminding the British to honor the commitments they had made to protect Anishinaabe lands and to provide 1812 veterans with gifts—promises the British were already beginning to forget.

eighteenth centuries, the body was one of the most important sites of visual artistic expression (fig. 1.27). Historical accounts also make clear that elaborate dress was reserved for ritual performances and formal occasions such as political councils and trading missions. Assemblages of clothing and body decoration were primary vehicles for the display of the powers an individual acquired from guardian spirits through the vision quest, a rite that began at puberty and was widely practiced by men and women throughout the Woodlands (see chapter 1). The visual expression of these powers took many artistic forms, ranging from tattoos and body paintings to carved, embroidered, and painted depictions of guardian spirits and personal *dodems* (totemic ancestors) on clubs, pouches, and medicine bundle covers. As we have seen, the elaborate facial and body markings engraved, carved, and sculpted on Mississippian works of art demonstrate the antiquity of these practices.

Around 1700 when Jesuit missionary Louis Nicolas created his drawings of the people, plants, and animals he saw as a missionary at Lake Superior and western New York State, he included illustrations showing Indigenous people of different nations displaying on their bodies suns, serpents, thunderbirds, and geometric designs (fig. 1.27) Yet missionaries, who deplored both "nakedness" and "pagan" images, discouraged the continuation of many of these traditional arts of body decoration. By the beginning of the nineteenth century, tattooing had largely disappeared, in part also because of the prestige associated with the wearing of European shirts and coats that concealed the skin. The art of face painting has continued, evoked during the nineteenth century largely as an historical practice in diplomatic and performance contexts, and revived during the twentieth century in connection with the modern powwow movement. The hair, too, was the subject of careful grooming. In the East, most men shaved the head except for a long lock at the crown, while women allowed their hair to grow as long as possible and dressed it with beaded and quilled ornaments.

A man's garments consisted of tightly fitted hide or woolen leggings, a breech cloth (a rectangular garment drawn up between the legs with the top ends folded down over a sash), a blanket, and often a shirt made of printed calico (fig. 3.26). In the eastern Great Lakes, women wore leggings and moccasins with a knee-length, kilt-like skirt and a cloth overblouse. In the central and western Great Lakes, they wore the "strap dress," cut like a chemise and held up by shoulder straps. Over it, they wore two sleeves ending in wide

panels that were tied together back and front. The ornamentation of these and more recent garment types has been a fertile field for women's creative artistry since precontact times. With consummate skill, Woodlands women tanned the deerskins of which most precontact clothing was made, achieving a velvet softness and colors ranging from light brown to near black (fig. 4.5). Modern evidence from the Plains and Subarctic shows that the choices of woods burned to smoke the hides and the length of time the hide was exposed would have been carefully calculated to produce particular aromas and colors which were integral to the aesthetic impact of the finished product.[22] The precontact decorative repertoire for hide clothing included painted patterns of stripes and curvilinear designs executed with mineral pigments of black, white, and red that reminded some Europeans of lace. It also featured elaborate panels of porcupine-quill embroidery and, sometimes, the attachment of shell wampum beads (see Techniques in Focus box). The quills were colored with vegetable dyes that produced a brilliant scarlet that was the envy of Europeans, who regarded it as superior to the reds they could achieve (fig. 3.21).

▶ **3.21** Anishinaabe artist, Shoulder bag, c. 1760–84. Deer skin, moosehair, porcupine quills, metal cones, deer hair, 19 × 23 cm, strap (doubled) 54 × 3.5 cm. Collections du Musée d'Yverdon et région.

The great *manito* of the upper-world, the Thunderbird, whose cosmic battles with the under-earth beings energize the earth-world of human beings, appears on this fine bag probably collected by General Frederick Haldimand. It displays a virtuoso array of Indigenous needlework, tanning, and dyeing techniques, including embroidery in porcupine quills on the body of the bag and moosehair false embroidery on the strap.

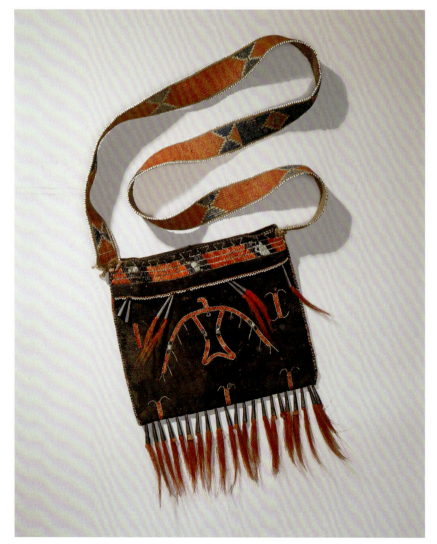

TECHNIQUES IN FOCUS
Quillwork and Beadwork

Porcupine quills might seem an unlikely artistic medium to those unfamiliar with their properties, but long before European contact, Native American women in the East and Plains discovered how quills could be used to embellish clothing, ceremonial items, weapons, and other goods. One porcupine can yield 30,000–40,000 quills with a wide range of sizes and lengths. When a quill is wet, it becomes soft and pliable and can be flattened from its natural hollow tubular shape by being pulled between the artist's teeth; its pointed end becomes a built-in needle

that the artist can insert easily into a hole made with an awl in birch bark or hide. The natural elasticity of the bark or hide causes the hole to close up as the drying quill stiffens and expands, securing it indefinitely.

Artists developed a large inventory of embroidery stitches and techniques of wrapping, weaving, plaiting, and sewing to create highly refined and intricate geometric and figurative motifs (fig. 3.22). Before manufactured thread became available, fine sinew threads served to stitch quills to the surface of a hide item, and for some artists it is a point of pride today to say that something is "sinew sewn." The artist might spot stitch flattened quills to the hide by folding them back and forth over two parallel rows of sinew thread. She might use two quills at once to give a plaited appearance, or use two of different colors to produce striped or diamond-shaped patterns. Clever variations would produce even more complex effects. Quills could also be woven on a bow-shaped loom into narrow bands that might be sewn on to a shirt, moccasin, or bag. As expert dyers, women used barks, roots, minerals, flower petals, berries, nuts, and mosses to produce a color palette that emphasized reds, oranges, yellows, whites, and blacks. After trade cloth became available, they might boil pieces of cloth with the quills in order to color

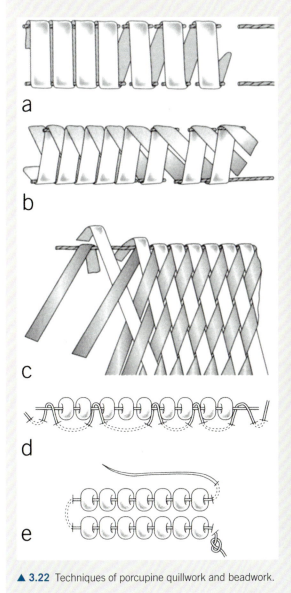

a

b

c

d

e

▲ 3.22 Techniques of porcupine quillwork and beadwork.

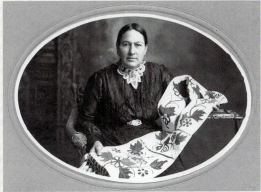

▲ 3.23 Photo of Sophia Smith (Minnesota Ojibwa) with a bandolier bag, 1890s. Collection III.40.74. Minnesota Historical Society.

The large, flamboyant bandolier bags made by Ojibwa women in the late nineteenth and early twentieth centuries were important commodities in the western Great Lakes trade. Exchanged for horses to the neighboring Sioux, they carried Great Lakes floral designs into the Central and Southern Plains. Worn across the shoulder singly or in pairs, with Western suits or garments of Native cut, they came to represent Native identity at annual treaty days and Anishnabe spirituality at *Midewiwin* ceremonies. Sophia Smith made this bag for the first Bishop of Minnesota.

(cont.)

(cont.)

them blue or green. In the mid-nineteenth century, the invention of chemical dyes further expanded the color palette available to quillworkers.

Glass beads were quickly adapted to preexisting quillwork techniques of weaving and embroidery, and new techniques were also invented. Beads were strung on thread and intertwined with wool yarn to enrich the patterns of finger woven sashes and garters, and they were woven on looms into large panels that served as bag fronts. During the second half of the nineteenth century, women began to appliqué strings of beads on bag fronts and other large surfaces, tacking them down at intervals to form the more curvilinear and naturalistic floral designs that appealed so strongly to both Aboriginal people and settlers (fig. 3.23).

Native people's long established traditions of connoisseurship in assessing the textures and colors of textiles lay behind their strong attraction to and highly selective appreciation of imported trade cloths. At the beginning of the eighteenth century, when high-quality red wool cloth from English mills became available, the Native demand was so great that it threatened to redirect trade from French Montreal to British Albany, in New York. Red stroud cloth, named for the town where it was manufactured, was another of the "analog" materials preferred during the early contact period; it was appreciated not only for its quality but also because its color resembled the red ochre that Indigenous North Americans have for millennia valued as a protective medicine and used as a paint.

The adoption of cloth gave rise to new techniques of ornamentation. Appliquéd silk ribbon came to replace paint, and beads came to replace porcupine quills. In the earliest ribbonwork broad ribbons were sewn to trade blankets rather crudely, forming stripes that imitated the painted patterns of hide robes. By the end of the eighteenth century Northeastern and Great Lakes women had invented a far more complex appliqué technique in which they cut and layered different colored ribbons to produce dense, optically active patterns that form wide borders on leggings, skirts, and blankets (fig. 3.24). Similarly, the early uses of glass beads evolved from a simple

▶ **3.24** Meskwaki artist, Iowa, Blanket with ribbon appliqué, c. 1880. Wool cloth, silk ribbon, German silver brooches, 142.9 × 156.8 cm. National Museum of the American Indian, Catalogue No. 14/1158; photo by David Heald.

The Mesquakie brought ribbonwork with them when they moved from the Great Lakes to Iowa in the mid-nineteenth century. Through precise layering of colors and balancing of the negative and positive spaces created by the cut patterns of the appliquéd ribbons, women created optical effects that are at once energized and stable. Contemporary artists comment that the colors and organic forms are spiritual and cosmological references to night and the plant world.

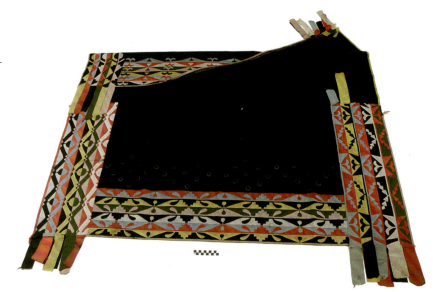

border of white beads that gives the same effect as the porcupine-quilled edging stitch, to the more complicated appliquéd and woven beadwork that began to appear at the beginning of the nineteenth century (fig. 3.25).[23] Despite the transformations of the materials used in Native clothing, however, the basic cut and disposition of garments changed very little until the first half of the nineteenth century. A fine outfit acquired by Lieutenant Andrew Foster around 1790 gives us a good idea of the richness of dress that had evolved by that period (fig. 3.26).

Hide moccasins are a notable exception to this pattern of adaptation of trade goods. Moccasins were one of the first forms of Native art to be commoditized for sale to non-Natives and remain one of the largest categories of Native art in museum collections. As early as 1708, for example, a French traveler reported that the Mi'kmaq were making a type of quill-decorated moccasin much admired by the French who "wish to procure them for display in their own Land."[24] Although glass beads and ribbon soon formed part of its decoration, commercially tanned leather did not replace Native-tanned hide until access to hunting ended and the laborious tanning process became uneconomical. The superior comfort and beauty of Indigenous cuts and designs for footwear have held their own against European shoes down to the present.

The French, Spanish, Americans, and British battled for control over eastern North America throughout the eighteenth and early nineteenth centuries. Once these struggles were resolved with the ending of the War of 1812, the pent-up desire for Native lands was unleashed, and a renewed period of displacement and radical disruption of Indigenous life began. The opening up of western New York State and the central and eastern Great Lakes to settlers resulted in rapid and massive appropriations of Native land. The Removals Policy adopted by the United States in 1830 forced most Eastern Indians to leave their ancient homelands and to move thousands of miles west to Indian Territories established in Kansas and Oklahoma. In the Southeast, the Five Civilized Tribes (Cherokee, Choctaw, Chickasaw, Creek, and Seminole), many of them peaceful and successful farmers and landholders, were compelled to abandon their homes to travel the long overland path west that has become known as the Trail of Tears. Of the almost 50,000 people forced to relocate during the 1830s, a third to a

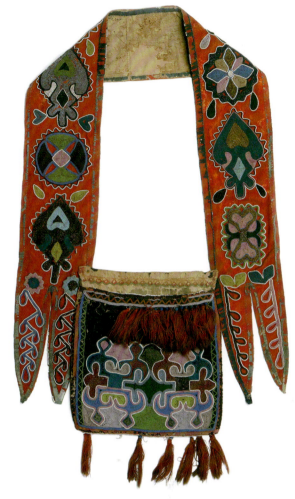

▲ **3.25** Delaware artist, Bandolier bag, c. 1850–70. Wool and beads, 39.4 × 37.5 cm, total length: 1,194 cm. Roberta Campbell Lawson Collection, gift of Mr. and Mrs. Edward C. Lawson, 1947.19.5. © 2014 The Philbrook Museum of Art, Inc., Tulsa, Oklahoma.

The bag was given to the Philbrook Museum by the granddaughter of its owner, Charles Journeycake (1817–94), the last principal hereditary chief of the Delaware. The bold, free-form blocks of color are typical of a beadwork style that developed in the early nineteenth century among the Southeastern peoples with whom the Delaware lived after their forced removal from their New Jersey homelands.

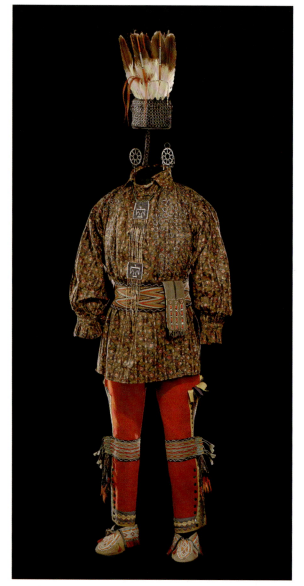

▲ **3.26** Anishinaabe artists, Man's outfit, c. 1790. Birchbark, cotton, linen, wool, feathers, silk, silver brooches, porcupine quills, horsehair, hide, sinew. National Museum of the American Indian Catalogue Nos. 24/2000-4; 24/2006, 24/2012, 24/20165, 24/2022, 24/2034; photo by Ernest Amoroso.

The collector of this outfit, British Lieutenant Andrew Foster, conducted diplomatic negotiations with Anishinaabe allies in the central Great Lakes during the 1790s. It was probably presented during a ritual adoption that confirmed the allies' mutual obligations. The rich assemblage of trade cloth, silver ornaments, silk ribbon, porcupine quill embroidery, and glass wampum beads typified eighteenth-century men's dress throughout the East.

half died from the starvation, exposure, and disease caused by the harsh conditions of the journey. The treaties negotiated by the British in Canada resulted in equivalent losses of lands and freedom and confinement to reserves that rapidly became inadequate to support their Native populations. The removals, the losses of traditional subsistence bases, the greatly intensified contacts with non-Native people, and the renewed era of intense Christian missionization led within decades to far more radical changes in genres and styles of art than had occurred during the preceding two centuries.

Yet even in their new homes in Kansas and Oklahoma, Native Americans have preserved artistic and ritual traditions they brought from their Eastern homelands (fig. 3.25). And those who stayed in their original territories, although increasingly surrounded by an alien settler culture, developed strategies that allowed them to accommodate new ways of life while also defending their cultural and political identities. A young Tuscarora artist named Dennis Cusick is a good example. The son of a leading Haudenosaunee family, Cusick worked alongside missionary James Young at the Mission School at the Seneca Reservation at Buffalo Creek, New York between 1820 and 1822. To showcase the success of Christian education, he decorated collection boxes used to raise money for the mission. On one he shows the schoolroom on the upper floor of the Young family's log house: Young leads the students in Christian prayer, but they wear traditional *gustoweh* headdresses in seeming affirmation that they have not forsaken their Indigenous identity. On another side of the box, girls wearing woolen dresses with traditional leggings and moccasins are taught to spin by female teachers (fig. 3.27). Cusick's work suggests a familiarity with the folk arts that would have circulated in the early nineteenth century, such as small trinket boxes painted by itinerant folk artists and schoolgirls. The world he depicts is literate and bicultural, and his own transcultural object deliberately blurs the distinction between the monolingual Seneca children whom schoolmaster Young sought to educate and convert, and more cosmopolitan, bilingual Natives such as Cusick. It is likely

▲ **3.27** Dennis Cusick, c. 1800–c. 1824 (Tuscarora), *Church Collection Box*, 1821–22. Watercolor on paper attached to wood. Used with permission, Franklin Trask Library, Andover Newton Theological School, Newton Center, Massachusetts.

The artist accurately depicts the specialized wheels for spinning wool and flax, the baskets overflowing with wool roving, and busy girls carding wool for spinning and winding yarn for knitting. Above are verses from the Old Testament including "She seeketh wool and flax and worketh willingly with her hands." At bottom is inscribed *Seneca Mission House, Nov. 15, 1821, Dennis Cusick, son of the chief, fecit* (Latin for "he made it"). Cusick's miniature masterpiece vividly captures the nineteenth-century ideal of feminine domestic industry.

that the Protestant churchgoers who dropped coins into this box saw its imagery as evidence of the success of Christian missions. They would not have known of the artist's distinguished parentage, or that he was the second generation in his family to read, write, and speak English. His skills were not the result of the missionary zeal of James Young's generation, but of the complex intercultural politics of the previous decades.

In the Bag: A Mini-History of Change Told Through Bags

The changes in Woodlands arts can be traced by looking at the developments of style, design, and iconography that occurred in bags, a large and important category of Woodlands artistry. The old examples of eastern bags preserved in early European curiosity collections are made of whole animal skins or hide cut into long rectangular pouches. Both types were worn folded over a belt (fig. 3.26). Painted on the body of the rectangular bags and woven into the netted quillwork panels attached to the bottom were images and geometric motifs representing important

manitos (spirit beings) such as the Sun or the Thunderbird. Similar images were woven into twined bags made to hold medicine bundles, in which were kept objects embodying powers conferred in dreams by the other-than-human persons.

During the eighteenth century Native artists invented a new type of square or rectangular bag attached to a bandolier strap worn diagonally across the chest (fig. 3.21). Although the style of these bags was copied from bags worn by European soldiers, eighteenth-century bandolier bags continued to display large central images of thunderbirds and underwater beings or abstract designs that expressed their protective powers. In the contact zone of the Great Lakes, other styles of bags also circulated, cut in different ways and decorated with other techniques such as appliquéd bands of quillwork woven on narrow bow looms. During the second and third quarters of the nineteenth century, with lightning rapidity, women in the Great Lakes region experimented creatively with all these bag designs, weaving decorative bands of glass beads instead of quills, replacing hide with fabric, and dyed deer hair with wool yarn (figs. 3.23 and 3.25).

The major innovation seen on bags (as on clothing and other art forms) was, however, the introduction of an entirely new type of floral imagery borrowed from the art of the European and North American immigrants. Evidence of the attraction floral designs had for Great Lakes Anishinaabek is found in the memoir of an early Southern Ontario pioneer, Catherine Parr Traill, who wrote of the visits paid to her in the 1830s by Ojibwa women from the neighboring Rice Lake community. One woman, Traill wrote, "fell in love with a gay chintz dressing-gown belonging to my husband, and though I resolutely refused to part with it, all the [women] in the wigwam by turns came to look at 'gown.'"[25] By the late nineteenth century Great Lakes Aboriginal women had replaced their geometric images and the clear representations of the other-than-human persons with floral compositions. In the middle of the century, bandolier bags made for Midewiwin ceremonies and formal occasions displayed large panels of floral motifs whose geometric stylizations were produced by the process of loom weaving. By the end of the century, however, they had again innovated a new beadwork appliqué technique that allowed them to create bold, curvilinear floral compositions that rank among the most splendid examples of floral art ever created (fig. 3.23).

During the early eighteenth century Ursuline nuns in Quebec had already introduced a commoditized production of small objects made of birch bark embroidered with flowers and genre scenes in dyed moosehair. The nuns sold these wares as souvenirs to the transient European population until the early 1800s when local Wendat artists began to take over the production (fig. 3.28). Although it has often been stated that the Quebec convents were the source of the floral designs spread across North America during the nineteenth century, there were, in fact, many possible separate introductions of floral imagery. Flowers are prominent in European fine and decorative arts; ubiquitous in textiles, ceramics, and interior decoration; and a frequent subject for painters. During the nineteenth century, the "cult of

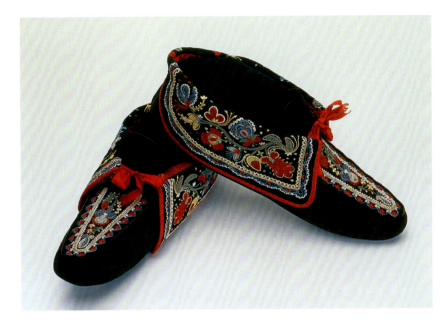

◀ 3.28 Wendat artist, possibly Marguerite Vincent Lawinonkie, Moccasins, 1847–53. Black-dyed skin, moosehair, cotton thread, silk lining, binding and ribbon, 9 ½ × 3 in. T0038. Gift of Eugene V. and Clare E. Thaw, Thaw Collection, Fenimore Art Museum, Cooperstown, New York. Photograph by John Bigelow Taylor, New York.

The pristine condition of these moccasins, acquired by Lord and Lady Elgin during Elgin's term as Governor General of Canada, allows us to appreciate the vibrant colors Wendat women used in their moosehair embroidery. As seen in this example, Wendat floral style became more naturalistic during the middle decades of the nineteenth century, in keeping with Victorian tastes and fashions.

flowers," as one anthropologist has termed it, gained even greater importance. One of the most striking aspects of the Indigenous arts that developed during the nineteenth century is the originality of the beadworkers' interpretations of floral designs. No example, whether in quillwork, beadwork, moosehair, or silk embroidery, is stylistically identical to a European prototype (fig. 3.28). Indeed, during the nineteenth century, articles in women's magazines showed European and North American readers how to imitate Native floral beadwork. For the Victorians, unlike most later Western textile artists, floral motifs were not empty of meaning. Rather, they regarded flowers as the epitome of the beauty of God's natural creation and as the essence of refinement and femininity. Missionaries, teaching needlework to Native women, would have urged the adoption of this imagery as an outer sign of Aboriginal people's acceptance of "civilization." Opposition to traditional Native spirituality was certainly an important stimulus for the promotion of floral motifs, yet these pressures do not seem sufficient to explain the enormous and enduring popularity of floral designs among Native artists. Although representations of flowers had not previously figured in Native textiles, vegetation is revered within Native spiritual systems as an essential part of the cycle of creation. Many plants are used as healing medicines and others—particularly berries—play an important role as ritual foods, symbolizing seasonal renewal and the food of the dead on their journey to the afterworld. Contemporary Métis painter Christi Belcourt explores such meanings through her re-evocation of the historical floral bead and silk embroidery made by her Anishinaabe ancestors, reproducing their textural aesthetic in floral compositions built up of tiny bead-like dots of paint (fig. 4.23). The prominence of berries in Native beadwork and quillwork should also be viewed in this context.

ARTIST IN FOCUS
Caroline Parker

Looking out at us from the daguerreotype in its ornate gold frame, Caroline Parker (c. 1826–1892) smiles, her gaze strong and direct (fig. 3.29). It is 1849 and she is twenty-three years old, posing for her portrait in the studio of an Albany, New York photographer. The fine outfit she wears is her own creation, made to represent the garments worn on ceremonial occasions by traditional Seneca. Her skirt, overblouse, ruffled collar, leggings, and handbag exhibit the refined sewing skills of an accomplished dressmaker. Although the fine bead embroidery is distinctively Seneca in style and motifs, her dress conforms to the general styles and feminine ideals of settler women of taste and modesty. After the sitting was finished, the outfit would be returned to Lewis Henry Morgan, the man who had commissioned it as part of the comprehensive collection of Haudenosaunee traditional arts he was assembling for the state of New York, and he would go on to commission engravings of her work to illustrate his book and reports on Haudenosaunee political, cultural, and artistic traditions.

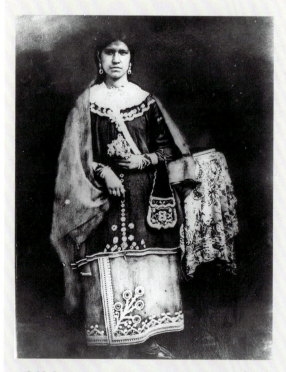

▲ 3.29 Daguerreotype of Caroline Parkert. Braun Research Library Collection, Autry National Center, Los Angeles; N.24963.

Caroline's parents, William and Elizabeth Parker, and her brother Eli were Morgan's chief collaborators in supplying the information that allowed him to write his foundational works of American anthropology. In return, they engaged him as an ally in resisting removal to the western Indian territories and in the legal battles the Tonawanda Seneca were waging against aggressive and unscrupulous land speculators. Prominent community leaders, the Parkers were Christian converts and also followers of the *Gaiwiio* or Longhouse way of life. William had accompanied Handsome Lake, the founder of this recodification of traditional Haudenosaunee spiritual beliefs and practices when the prophet settled at Tonawanda in 1809.

In the matrilineal system of the Haudenosaunee, Caroline's mother Elizabeth played an equally if not even more important spiritual and political role as a Clan Mother of the Tonawanda Seneca Wolf Clan. One of the Parkers' key strategies was the acquisition of Western education for their six sons and daughter. Caroline attended a Baptist missionary school, the Auburn Academy, and—most unusually and with Morgan's help—the State Normal School at Albany. As a teacher, holder of the name Jigonsaseh (the Peace Queen)—an important title at Tonawanda—and as a prominent figure at Tuscarora after her marriage to Chief John Mount Pleasant, she continued to play a strong female role in the matrilineal tradition of her ancestors. Together, as Parker's biographer Deborah Holler writes, the Mount Pleasants "became something of a nineteenth century power couple, jointly advocating for social, political and cultural progressive reforms."[26]

In Caroline Parker's hands, the arts of clothing and textiles became an effective way to mediate between Seneca traditions and the growing power of an aggressive and expansionist settler society. To Seneca eyes, her textile designs communicated central spiritual and moral values and traditional structures of leadership and social organization. To Victorian eyes, they testified to refined elegance and a civilized appreciation of nature at the same time that they appeared pleasantly exotic. The hem of the skirt Parker wears in the daguerreotype is, for example, bordered by motifs that reference Haudenosaunee cosmology and spiritual principles; the semicircular motifs represent the Skyworld and the projecting spirals the top of the Great Tree of Peace. The large central motif on the skirt front can be read either as this great central axis of the Haudenosaunee cosmos or as a branch of flowers. Other embroideries testify to Parker's mastery of what Morgan called the "art of flowering." On a tablecloth that he owned, she rendered the buds, flowers, and leaves with a

refined naturalism that was even more admired by Victorian viewers. The legacy of textile art that Caroline Parker has left was integral to her role as a cultural mediator who throughout her life sought to negotiate between settler and Indigenous worlds and to combat stereotypes of Indians as primitive and lazy.

Due in large part to Caroline Parker's legacy, the garments she created set the pattern for styles of Longhouse dress that have become classic. During the 1930s the illustrations in Morgan's publications and the garments she and other Tonawanda Seneca had made were used as models for the revival of traditional Iroquois fabric arts organized by the Rochester Museum of Science through a Depression-era Works Progress Administration project. These styles and designs remain current to this day.

Souvenir Arts

During the nineteenth century, the major stimulus for the production of ornamented dress accessories and domestic items was not Aboriginal use but the growing market for Native North American souvenirs. As a pioneering settler in Ontario during the 1830s, Catherine Parr Traill bought flower-decorated birchbark baskets made by the entrepreneurial Native artists who visited her. "Our parlour," she wrote, "is ornamented with several very pretty specimens of their ingenuity . . . which answer the purpose of note and letter-cases, flower-stands and work-baskets."[27] By the end of the century, the production of such art commodities had become vital to survival in many areas. Unable to rely on hunting, gathering, and cultivation for their subsistence and often resistant to official government policies designed to transform Native people into farmers, many Eastern peoples chose instead to rely on a more mixed economic base, one to which the travel and trade in which they had engaged for untold past centuries remained central. Between the 1830s and the 1930s, newly developed tourist and vacation sites became the destinations of Native travel. At spas, summer fairs, and coastal resorts along the Atlantic—and above all at Niagara Falls—they sold a wide variety of products, including birchbark objects embroidered in porcupine quills, beaded purses, pincushions, wall pockets and moccasins, dolls and model canoes, and ash-splint fancy baskets (figs. 1.2 and 8.17).

As our minihistory of bags demonstrated, this period was one of almost febrile creativity, stimulated by increasing exposure to the new art forms introduced by settlers as well as by economic need. The high regard in which Aboriginal needlework was held during the second half of the nineteenth century is evidenced by the remarkable number of settler women who display a Haudenosaunee beaded bag in the carte de visite portraits they commissioned from professional photographers.[28] Money earned from sales of these items and performances for tourists could also support political activism. Margaret Boyd (c. 1814–84), a renowned maker of quill-embroidered birchbark model canoes and other wares, was an Odawa from Harbor Springs, Michigan, a community that had resisted removal to the west and negotiated to remain in Michigan. In the 1870s she sold her highly priced quillwork and basketry in order to finance a trip

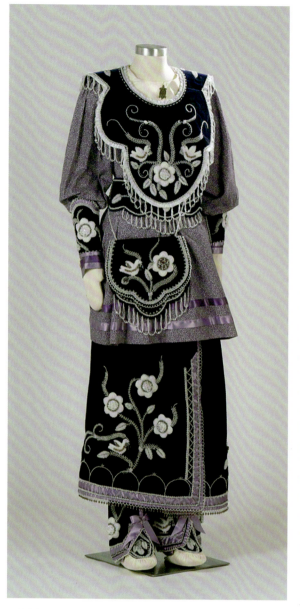

▲ **3.30** Samuel Thomas, b. 1964 (Cayuga) Haudenosaunee woman's outfit, 2001. *Courtesy the artist.*

Haudenosaunee women have worn this style of dress for Longhouse ceremonies and other celebrations since the nineteenth century. This is one of two outfits made by the *Ska-Ni-Kwat* ("We are of one mind") project, which Thomas organized to create a way for people of different faiths, races, and ages to work collaboratively through artistic creativity and beadwork.

to Washington, D.C. in order to bring her community's problems before the President of the United States.[29]

Toward the end of the century, however, the souvenir arts that had been so celebrated began to be dismissed as inauthentic. Both the salvage model of the professional ethnologists and the aesthetic preferences of modern art lovers for "primitive art" contributed to this change. Although demand and production decreased, the arts of beadwork, quillwork on bark, and basketry did not die out. As the turn of the new millennium, these arts are reaching new heights, as seen in the quillwork of Yvonne Keshick discussed at the beginning of this book and the basketry of Passamaquoddy Jeremy Frey, which will be discussed in chapter 8 (fig. 1.2, fig. 8.17). Like Chitimacha photographer Sarah Sense, contemporary Odawa artist Daphne Odjig, Lakota artist Colleen Cutschall, and Mohawk photographer Shelley Niro have paid tribute to the quillworkers and beadworkers who have provided models of artistic creativity on which they have built. These arts have also had unexpected global impacts. Cayuga beadworker Samuel Thomas (b. 1964), has devoted more than two decades to the perfecting of traditional Haudenosaunee beadwork techniques used both for ceremonial dress and for the production of art commodities during the nineteenth century. As the new millennium opened, Thomas was continuing to teach these arts to Native and non-Native people in North America. (fig. 3.30) He also became aware of striking similarities between traditional Haudenosaunee and east African beadwork techniques and that many of the African traditions had disappeared as a result of missionary suppression and the pressures of modernization. Traveling to Kenya, he collaborated with Munuve Mutisya, founder of the Akamba Peace Museum, and together they developed the Great Tree of Peace Project. Thomas learned traditional Kenyan beadwork techniques and taught them together with those of the Haudenosaunee. He brought together people in Kenya and North America to create a six-foot-tall beaded Tree of Peace that was partly inspired by a smaller

but equally innovative beaded tree made for sale as a table ornament in the late nineteenth century by a Haudenosaunee beadworker named Sophronia Thompson. The monumental beaded tree that Thomas and his collaborators made renewed the Haudenosaunee teaching of peace and unity and translated it into a global framework. Appropriately, it was exhibited at the United Nations art gallery in 2007.

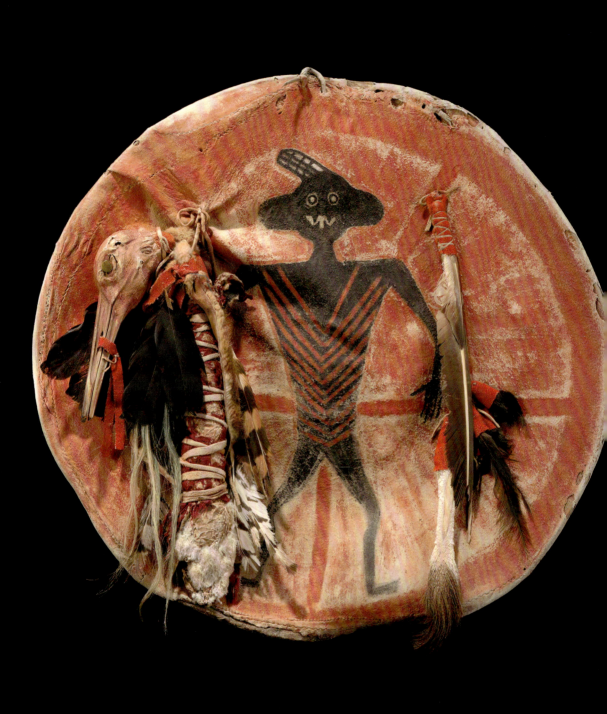

THE WEST

4

Lakota cosmology merges with modern physics in one sentence that describes the mystery of life: "*Taku skan skan*," rendered imperfectly into English as "something that moves moves." The phrase encapsulates the idea that the entire universe is in motion and infused with power and mystery.[1] On the Great Plains, as in other Native American traditions, one can only understand one's place as a human being by understanding how the cosmos has been generated. Life was created out of the primal rock that squeezed from within itself its own blue blood to make water and the dome of the heavens, and developed through the differentiation of earth and sky, sun and moon. Notably, the spatial and temporal ordering of the world was only completed when the Four Winds (represented in Lakota stories as four young brothers) established the cardinal directions and the division of time into day and night and the annual round of lunar months and seasons. As life developed, human beings and other-than-human beings each had roles to play, and, as elsewhere in North America, humans could draw upon the powers of the thunder, the hail, the wind, and the four-legged ones. Special power-beings sometimes came in visions and could be called upon to help in difficult situations (fig. 4.1).

Most outsiders do not think about such sophisticated cosmological concepts in considering the Native arts of the North American West. Instead, the image of the Plains Indian in fringed hide clothing and feather bonnet comes to mind, perhaps the most common stereotype of Indigenous America in the minds of people worldwide. Yet, in the long history of Native life in the West, this image belongs to a relatively brief period, lasting only from about 1700 to 1870 C.E. At the beginning of this era, wild herds of horses, introduced by the Spanish to the Americas less than two centuries before, had migrated north. They became available to peoples living at the western and southern margins of the tall grasslands long inhabited by the great, migrating herds of buffalo central to the economy and spirituality of Plains peoples. With horses and guns (acquired first from tribes further east engaged in the fur trade and later through direct trade with whites) Plains peoples were able to hunt buffalo in new, efficient ways.

The buffalo-hunting life was a rich and generous one, encouraging the development of a multitude of visual arts in skin, hide, quillwork, feather-work, painting, carving, and beadwork. These represent some of the fore-most achievements of Native art. The almost exclusive focus of outsiders on the male warrior societies and their associated arts reflects a particular fixation of romantic nineteenth-century travelers and twentieth-century

◀ **4.1** Arapoosh (Sore Belly), d. 1834 (Crow), War shield, c. 1820. Buckskin, rawhide, pigments, head of sandhill crane, stork feathers, deer tail, flannel, Diam.: 61.5 cm. National Museum of the American Indian, Catalogue No. 11/7680; photo by Ernest Amoroso.

Because shield designs were often given to men in vision quests or dreams, the rights of ownership of particular designs were strictly observed. Arapoosh, chief of the River Crow in the early nineteenth century, painted this visionary image of a skeletal moon spirit on his war shield. Parts of powerful animals complete the medicine of this important item of war equipment.

collectors and has distorted our understanding of Native arts as they were made and used over a far longer period and greater geographical range.

This chapter considers the arts of diverse cultures in the western half of North America, including the peoples of the Great Plains, the Intermontaine region (Plateau), and the Great Basin and California (see Map next page). The peoples of these regions and their arts suffered rapid alterations during Euro-American colonization and settlement. From the Spanish settlements in coastal California in the eighteenth century to the incursions on to the Great Plains by Euro-American and Euro-Canadians in the nineteenth century, many Indigenous peoples were removed from their homelands and either resettled on distant reservations or were forced to accept greatly reduced access to their ancestral lands. Intensive Christian missionizing led to the diminution of arts used for traditional ceremonial purposes. By the mid-nineteenth century, many of the arts being made were part of a larger intercultural exchange between whites and Natives.

This chapter is devoted principally to art on the Great Plains because it has been so central to the Euro-American image of the Indian. Focusing on neglected questions such as the importance of art as an expression of complementary gender roles in society, we will examine how these roles and artistic expressions have shifted in response to the new social realities of the last 125 years or so. We will also look at the various ways in which quillwork, beadwork, and fiber arts have been central to the expression of cultural values. The one-dimensional image of the warrior, looming so large in the Euro-American imagination, has not only crowded out discussion of these other arts but has also distorted our understanding of men's arts, which are not simply about military prowess. Moreover, it has left no room for an understanding of the complex intellectual underpinnings of Indigenous art and life such as the cosmological concerns and profound interest in history and timekeeping that underlie men's pictorial arts on the Great Plains.

THE WEST AS A REGION

The Great Plains

The Plains extends from the boundary of the Eastern Woodlands (just west of the Mississippi River) to the Rocky Mountains in the west. Stretching from Southern Canada and sweeping down to the Mexican border of Texas, this land was inhabited by more than two dozen different ethnic groups during the postcontact period, among them the Assiniboine, Plains Cree, Lakota, Crow, Mandan, Pawnee, Kiowa, Arapaho, and Cheyenne. Linguistic and archaeological evidence suggests that the historic cultures of the Great Plains grew out of prior ethnic configurations. Some, like the Shoshone and Comanche, arrived from the Great Basin to the west. It is also important to remember the continuities of Plains cultures with those of the East carried by migration and shared language. The Lakota and related Siouan peoples were pushed westward out of the Great Lakes region due to population pressures from other Native groups and settlers in the eighteenth century. They, in turn, squeezed out the Kiowa, who had lived in the region of the Black Hills of South Dakota in the eighteenth century. Other groups moved north

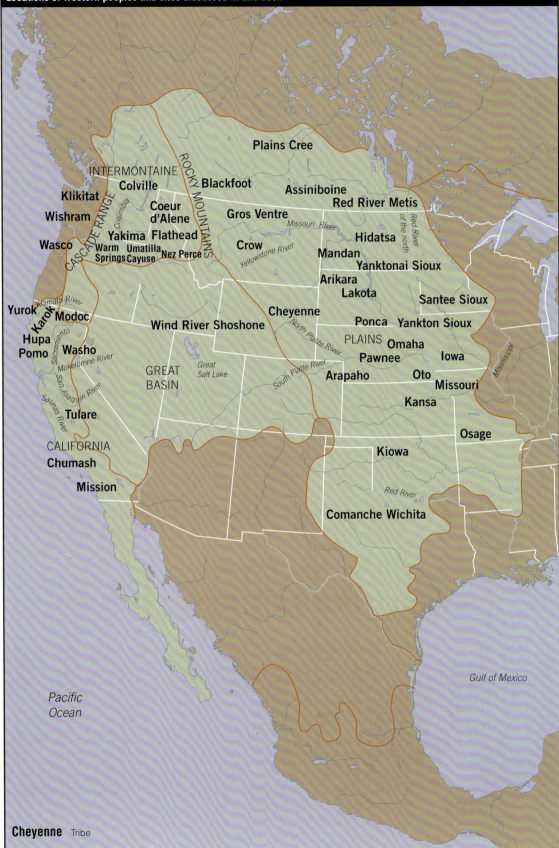

Plains Cree

INTERMONTAINE

Colville Blackfoot Assiniboine

Klikitat Red River Metis

Coeur
d'Alene Gros Ventre

Wishram

Yakima Flathead Hidatsa

Wasco Crow Mandan

Warm Umatilla Nez Perce Yanktonai Sioux
Springs Cayuse

Arikara

Lakota

Santee Sioux

Yurok Cheyenne Ponca Yankton Sioux

Modoc

Wind River Shoshone PLAINS Omaha

Hupa Pawnee Iowa

Pomo Washo

GREAT Great Arapaho Oto
BASIN Salt Lake Missouri

Kansa

Tulare

Osage

CALIFORNIA

Chumash Kiowa

Mission

Comanche Wichita

ROCKY MOUNTAINS

CASCADE RANGE

Karok

Columbia

Klamath River

Sacramento

Mokelumne River

San Joaquin River

Salinas River

Missouri River

Yellowstone River

North Platte River

South Platte River

Red River

Red River
of the north

Mississippi

Pacific
Ocean

Gulf of Mexico

Cheyenne Tribe

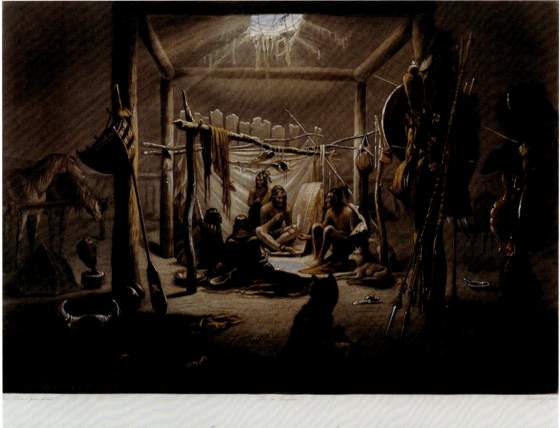

DAS INNERE DER HUTTE EINES MANDAN HÄUPTLINGS. INTÉRIEUR DE LA CABANE D'UN CHEF MANDAN.

THE INTERIOR OF THE HUT OF A MANDAN CHIEF

▲ 4.2 After Karl Bodmer, *The Interior of the Hut of a Mandan Chief*, 1834–36. Engraving with aquatint, hand-colored, 41.4 × 54 cm. Library of Congress, Prints and Photographs Division.

Bodmer's detailed depiction of the interior of an earth lodge shows the four posts and beams that support the slanting roof poles. A skylight allows for light, ventilation, and the drafting of the central fire. War paraphernalia hangs from the pole on the right, while a burden basket and oar rest against the pole at the left. Even dogs and horses can be kept snug against the harsh Northern Plains winter within the lodge. Early travelers to the plains remarked on the orderliness of the Mandan villages, where dozens of earth lodges surround spacious plazas.

and west on to the Plains from the great Mississippian cultures of the Southeast, bringing with them an influential legacy of concepts of leadership and symbolic expression. Some Plains languages, such as Blackfoot and Plains Cree, belong to the Algonkian family that predominates in the Northeast and the Eastern Subarctic (see chapters 3 and 5).

Some groups, like the Mandan and Hidatsa, have lived on the plains for more than a millennium, in semipermanent villages of spacious earth lodges (fig. 4.2). They had a mixed economy combining horticulture, hunting, and fishing. The Lakota, Crow, and others were true nomads, whose temporary camps followed the migrating herds of buffalo and other game animals across the grassy landscape. Even their architecture was eminently portable, consisting of painted hide lodges or tipis draped over sturdy poles (see fig. 4.11).

Archaeology reveals that most of the peoples of the Plains had been involved in extensive trade networks for centuries before the arrival of

Europeans: shells from California and the Gulf of Mexico, obsidian and flint from distant quarries, are found together with evidence of intellectual and artistic transmissions (fig. 4.3; see also chapter 3). On the Great Plains, as Ted Brasser has put it, "Mississippian cosmology was grafted on to the world-view and rituals of [the] northern buffalo hunter."[2]

The Spanish explorers who disrupted the Pueblo world in the Southwest (see chapter 2) also made brief early forays onto the Southern and Central Plains. They reported modes of life very much like those documented by nineteenth-century explorers and painters. Some communities, like the Wichita, were living in grass-lodge villages, while others lived in temporary encampments of dozens of tipis. Everywhere, great herds of buffalo traversed the landscape.

The Plateau, the Great Basin, and California

The Plateau or Intermontaine region is a 400-mile-wide area extending from the Cascade Mountains in Western Washington northward into Southern British Columbia, eastward into Idaho and Montana, and south to the California border. For centuries it has been the crossroads of many cultural traditions, and the art styles of this region show correspondences with those of neighboring peoples in all four directions. Some cultures along the Columbia River had much in common with coastal peoples, while others, further east, were more like their Plains neighbors, including reliance on the horse.

The ecological and cultural area called the Great Basin extends over much of Nevada, from the Sierra Nevada Mountains in California, north into Oregon, and east into Utah. In California and the Great Basin, many ethnic groups live in radically diverse ecological regions, ranging from the rich coastal areas of California to the harsher, more arid interior zone of Nevada. Hunting, fishing, and gathering were the main subsistence strategies here as well, and the arts of this region are rich in basketry, shell, and featherwork used in ceremonial life. Basketry has a special prominence; before the twentieth century, it was used in all aspects of daily life throughout the Intermontaine region, California, and the Great Basin. Men caught fish in basketry traps. Women harvested wild seeds using a woven seed beater and a burden basket. Roots were stored in large twined bags. Watertight baskets held liquids, and food was cooked in baskets. Babies were placed in basketry carriers, and various types of baskets were prominent in ceremonies ranging from birth, to marriage, to death. In addition to their Indigenous uses, by the end of the nineteenth century baskets from these regions were a fundamental part of the lively trade in touristic commodities; indeed, California baskets were among the most prized by the many serious collectors of that era.

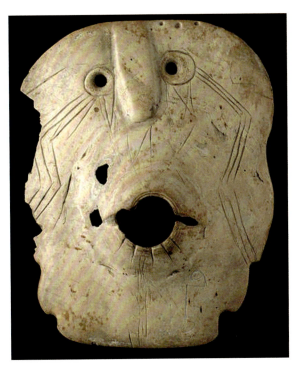

▲ **4.3** Prehistoric shell gorget, Calf Mound, Manitoba, c. 1500 C.E. Smithsonian Institution.

This shell pendant excavated from a Plains site in Manitoba features the forked eye motif that is ubiquitous in ancient Mississippian iconography.

Women's Arts

One of the unique features of Plains women's artistry was its organized communal structure. A Crow myth gives insight into Native beliefs about female artistic power and cooperation. It describes a woman who was warned by her fiancé that he would only marry her if she were powerful. He made the unreasonable demand that she tan a buffalo hide and embellish it with quillwork all in one day. As she cried in the woods, numerous animal helpers appeared. Female beavers and badgers staked the hide, while moles, mice, ants, and flies removed the flesh, dried it, and scraped it smooth (see Technique in Focus box). A porcupine offered its quills to the ants, who completed the quillwork.[4] This tale articulates through analogy with the animal world the ideal response of cooperation when faced with an ambitious artistic task. While individual hide paintings and quilled items reflected an individual woman's artistic inspiration, quillwork was undertaken as a sacred endeavor within the structure of women's artistic guilds. Large-scale tasks, such as making and raising a tipi, were often undertaken as a group, with specialists performing particular tasks.

TECHNIQUE IN FOCUS
Tanning a Hide

All across the Plains in the prereservation era, men would hunt and skin buffalo and other big game. Women would

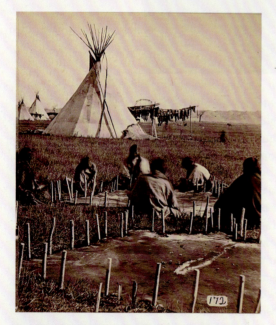

▲ **4.5** Women Working Buffalo Hides, c. 1880. Stereographic photo by Stanley Morrow (1843–1921). Courtesy National Anthropological Archives, Smithsonian Institution, NAA INV 09852400.

cook or dry the meat and process the skins for diverse uses. Thick strong hide would be used for tipis, moccasin soles, and parfleches (fig. 4.5). Softer, more flexible hides, especially deer and elk, would be used for clothing.

Figure 4.5 shows Northern Plains women along the Yellowstone River working communally on hides around 1880. The "green" or fresh hide would be staked out on the ground with sturdy wooden pegs, to keep it stretched as it was worked and dried. It took many hours of vigorous fleshing, scraping, and softening to ready the hide for the application of paint, quillwork, or beadwork. Tools were traditionally made of stone, bone, and antler, and good ones were handed down through generations. Anthropologist George Bird Grinnell was given a fleshing tool in the early twentieth century that had come down through five generations of Cheyenne women.[5] Nineteenth-century women were also ingenious at making tools of metal scrounged from rifles and machinery. The first task was to flesh the hide—remove bits of membrane, flesh, and tissue that remained after skinning the animal. The skin was washed and scraped repeatedly to work it to an even thickness. If making a garment, the object was to make the skin thin and supple through arduous and careful scraping.

Many different materials can be used to tan a hide, but most popular were brains and other organs that came from the animal itself. These provided the oils that helped to condition the hide and make it soft. Cheyenne craftswoman Mary Little Bear Inkanish (1877–1966) remembered the

elderly Shell Woman joking, at the end of the nineteenth century, "every hide should have brains enough to tan itself."[6] This was a clever way to help a young hide tanner remember the quantity of brain matter needed.

Yet Canadian Métis scholar Morgan Baillargeon, in his fieldwork with hide tanners since 1980, discovered that for many tanners spiritual reasons also motivated the use of brains as tanning agents. Traditions in many parts of North America maintain that the soul resides in the brain of the animal hunted. By reuniting brain and skin, the tanner restores life and power to the animal. Moreover, this power remains immanent in the object made from the skin.[7]

In some regions, smoke-tanned hide is especially valued. Rotten wood from spruce and fir stoked into hot coals is optimal for smoking hides. Smoke-tanned hides are far more water repellent, and the smoke adds both a pleasing color and fragrance. Particular woods may be chosen specifically to highlight the olfactory pleasure of the finished work, reminding us once again of the multisensory dimensions of Aboriginal arts. Even today, scent of smoke-tanned hide reminds many Aboriginal people of their grandparents' homes, and the old ways of doing things.

Plains women decorated their tanned hides in geometric and semiabstract designs which contrast with the narrative, figural designs painted by men (compare figs. 4.6 and 4.10). Women incised and painted abstract designs on their robes, dresses, tipi liners, and storage boxes. Porous buffalo bones, thin reeds, and even buffalo tails were used as brushes. Hematites, clays, carbonized materials, and plants provided natural pigments, and these media were later supplemented by the vivid commercial pigments obtained from traders. Chokecherry tree resin and boiled buffalo hoof jelly were used as fixatives.

While these practices diminished in many areas during the reservation era, Baillargeon found a wealth of knowledge remained in the Yukon, Northwest Territories, and Northern Alberta, even at the end of the twentieth century. He discovered that most tanners no longer follow traditional gender divisions of labor, believing that the most important thing is for the work itself to be kept alive. Many more men tan hides now than a century ago, and Aboriginal people all across North America are interested in preserving this knowledge of working with the animals and the land.

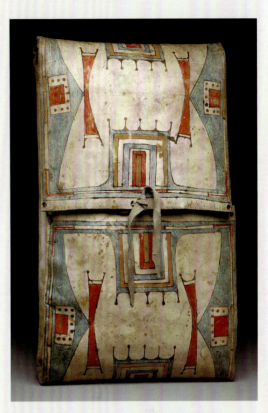

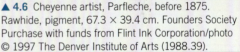 **4.6** Cheyenne artist, Parfleche, before 1875. Rawhide, pigment, 67.3 × 39.4 cm. Founders Society Purchase with funds from Flint Ink Corporation/photo © 1997 The Denver Institute of Arts (1988.39).

The French term *parer flèche* (to turn away arrows) describes the impenetrable properties of sturdy, Indian-made rawhide. The term came to refer to the large storage containers made by Plains women and painted with a variety of elegant abstract designs. This is a fine example of the delicacy of line characteristic of Cheyenne parfleche painting.

Some of the tasks associated with working skin and hide were highly specialized and conferred stature and wealth on the women who performed them. Among the Cheyenne, to belong to the guild in which women gained expertise in designing, constructing, and ornamenting a tipi was one of the highest female aspirations, even into the twentieth century. Membership in the tipi-makers' guild was a mark of special prestige, and Cheyenne mothers encouraged their daughters to strive for this honor.[8] Membership in the guild implied stamina, fortitude, and patience as well as artistic expertise. Because of the lavish feasts that were held, and the fees paid to expert designers, it also implied that a woman had achieved a respectable level of wealth.

The making of a tipi or lodge was recognized as so demanding a task that if a woman made one by herself—carrying out every step from tanning and sewing the skins, cutting the lodge poles, and producing all of the interior and exterior quill or beadwork—she was considered to be an exemplary individual. More often, tipi-making was a communal artistic undertaking. The intention to make a tipi was publicly announced and a feast would be held. A high-ranking member of the guild who was an experienced lodge maker would be responsible for the design and fit of the skins, arranging them and tacking them together before the other women completed the sewing. Other Plains groups had similar customs, even if they were not organized into formal guilds as were the Cheyenne. Crow women would commission an expert designer to lay out the tipi. This specialist in both architecture and tailoring, who would be paid for her services with four different types of property, supervised as many as twenty women who collaborated on sewing the skins. In payment for their services, the owner threw a lavish feast.

Blackfoot women made the largest tipis of the Great Plains, using up to twenty-eight skins and forty lodge poles. They, too, had regular work teams that would make new tipis in late spring.[9] Before calling together her collaborators, a woman would select and stockpile several dozen buffalo skins, numerous buffalo sinews from which to make threads, and a collection of awls. She would prepare a feast and announce her intentions to her colleagues. After the meal, the sinews would be distributed, and the day was spent splitting them to make thread. The following morning, expert needlewomen and a designer would commence laying out and sewing together the tipi. Other women would use knives to peel the bark and trim branch stubs from the assembled tree poles, cutting them to the desired diameter. When all work was completed, the poles were raised, and the new tipi was stretched upon them. The edges would be pinned to the ground and a fire would be lit inside the tipi to smoke the skins. This would keep them flexible throughout the repeated soakings and dryings afforded by the harsh weather on the Great Plains.

Tipi painting was, in general, a male art, as will be discussed later, although individual instances are known in which a particularly talented female artist might paint a narrative scene on her family's tipi. While a family might need a new tipi only once every second or third year, female artistry did not stop with the raising of new houses in the late spring. The process of making and adorning tipi liners, backrests, storage bags, and robes for the interior, as well as clothing for all daily and ceremonial occasions, continued throughout the year. Quillwork and beadwork were the main forms of artistic elaboration (fig. 3.22).

We know a great deal more about the meaning and social beliefs concerning quillwork on the Great Plains than in the other areas where this work was done. Quillwork was a sacred art form, the mastery of which gave grace and prestige to the artist. Lakota women teach that the supernatural known as Double Woman gave them the sacred art of quillwork, by appearing to a young woman in a dream; thereafter that young woman taught the art of quillwork to other women. Still practiced today, Lakota quillwork continues to be a sacred art. Because of its importance, the exchange of women's quillwork and beadwork was central to maintaining relations among neighboring

groups across Western North America. Through the exchange of these arts at intertribal gatherings and trading sites, artistic styles were disseminated across a wide area.

The anthropologist George Bird Grinnell, who lived among the Cheyenne in the 1890s, observed of quill- and beadwork: "This work women considered of high importance, and, when properly performed, quite as creditable as were bravery and success in war among men." He goes on to relate that, in meetings of the quillwork society, the assembled women recalled and described their previous fine works, "telling of the robes and other things that they had ornamented. This recital was formal in character, and among women closely paralleled the counting of coups by men."[10] The quintessential act of male bravery in warfare, in counting coup a warrior touched his opponent with a lance or coup stick, an act requiring courage, skill, and finesse. Grinnell's comparison tells us that in the Cheyenne worldview, women's fine artistic designs demand these traits as well. Confirmation that the view was widely shared and persists today comes from expert Crow beadworker Violet Birdinground of Wyola, Montana. "A good design," she told art historian Barbara Loeb, "is like counting coup" (fig. 4.7).[11] Beautifying the world by vowing to undertake an artistic project was an act of honor and devotion.

On the Great Plains, then, a woman's path to dignity, honor, and long life lay in the correct and skilled pursuit of the arts. As in many Amerindian traditions, the finished object was in some ways less important than the process of carrying it through in a ritually correct manner. For no other tribe do we have as complete a picture of traditional quillwork societies as we do for the Cheyenne. There were set procedures for a young Cheyenne woman to follow when she embarked upon her first major quillwork project. She began by making a public vow in front of the assembled guild, describing her intention to undertake an ambitious project. She then held a feast and requested aid from one of the more senior guild members, asking the older woman to draw in white clay a preliminary pattern of the intended design on the robe. All these steps show the seriousness with which women approached these arts.

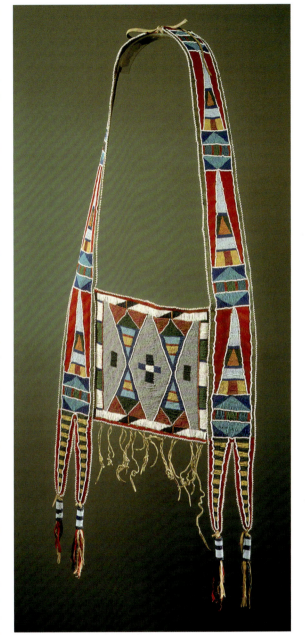

▲ 4.7 Crow artist, Beaded horse collar, c. 1890–1900. 96.5 × 37.5 cm. Denver Art Museum Collection: Purchase from Babitt Bros., 1936.81. Photograph © Denver Art Museum.

Classic Crow beadwork of the Reservation Era is defined by bold geometric designs of triangles and hourglasses in which pink, blue, and white are the predominant colors. Crow people recount that Old Man Coyote, who created their world, was the first to dress and ornament horses as beautifully as human beings would dress. For this reason, even today Crow horses are more beautifully ornamented than any other horses on the Plains. Every summer at Crow Fair, in Montana, horses and people display the finest beadwork of Crow women, some of which is modeled after classic nineteenth-century pieces such as this.

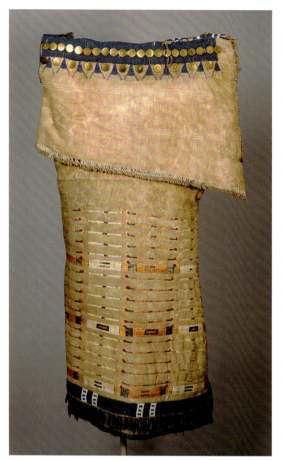

▲ 4.8 Unknown Upper Missouri River Region artist, Side-fold dress, 1800–25. Hide, quills, beads, brass buttons and other metal ornaments, wool, Pacific cowrie shells. Courtesy of the Peabody Museum of Archaeology and Ethnology, Harvard University, 99-12-10/53047, 60741043.

At the beginning of the nineteenth century, when trade goods were particularly costly, this dress adorned with European buttons, beads, and cloth may well have been made by a Native woman married to a trader, for she would have had ready access to such prized items.

Other groups shared some of these concepts and protocols. Both the Blackfeet and Lakota believe that quillwork in ancient times was divinely inspired. Among the Hidatsa, a young woman's increasing artistic skill was publicly recognized and rewarded by other women. Girls were given "honor marks": ornaments such as belts, bracelets, and rings for successful completion of artistic works.[12] Rattling Blanket Woman, a Lakota, recalled the year when, during the summer Sun Dance camp, she challenged other women to come and sit in a circle and recount their achievements.[13] Each woman was given a stick for every piece of work she had quilled. The women with the four highest tallies were seated in places of honor and served food before all the others. The tallies, or "quilling coups," were recorded on the tipi liner of the Red Council Lodge, along with the achievements in warfare of the males.

When beadwork was introduced, some of the same standards valued in quillwork were transferred to this new material. Around 1800, the new trade beads were such a prized commodity on the Great Plains that one horse might be exchanged for only 100 beads. But by the 1830s, traders on the Upper Missouri River were importing more than 1,500 pounds of beads annually from the American Fur Company in St Louis. Indian women quickly recognized beads' artistic potential in terms of individual design units. Often beads were used alongside quillwork for extra richness of ornamentation, but in many regions of the Great Plains, they came to replace quillwork by the mid-nineteenth century. Strong and durable, with a vivid range of nonfading colors, beads were easier to work with than quills, because they required no laborious preparation of the raw materials. Yet, like quills, beads could be used to form both small, discrete color areas and large monochromatic ones. Easily sewn to both hide and cloth, they could be used to outline a form or to ornament a fringe.

A side-fold dress that may have been collected by the Lewis and Clark Expedition (1804–6) reveals the ways in which women readily mixed old technologies and styles with new (fig. 4.8). This style of dress, worn during the eighteenth century, is made of two large animal hides, each of which forms a flap at the top, and it is traditionally adorned with bands of quillwork. Yet this early nineteenth-century example reveals the extent to which the Great Plains had become part of a world trade network even before the era of settlement. As Castle McLaughlin has written, "The dress is ornamented with an impressive array of rare and valuable trade goods that illustrate the scope of the emergent global political economy. Here on the central Plains, the woman who fashioned this garment was able to avail herself of blue and white glass beads from Italy, gilt brass buttons from the

British Isles, cowrie shells from the islands of the Indo-Pacific, and wool fabric from central Europe. All of these materials were introduced by English, French, and Spanish traders and militia, who competed fiercely for trade and military alliances with Indian people during the eighteenth century—well before Lewis and Clark set out across the continent."[14]

As Plains beadwork developed, distinctive regional differences in style, aesthetics, and technique came into being. Lakota beadwork since the late nineteenth century, for example, can usually be identified by a fully beaded background in one color (usually white or blue), crafted in bands of lazy stitch. Figural or geometric designs stand out vividly against this background (figs. 1.30 and 4.20). In contrast, much nineteenth-century Crow work is boldly graphic in pattern, favoring light blue, with large blocks of color outlined by thin stripes of white beads (fig. 4.7). Yet it is not always easy to label with confidence an artist's work as coming from a particular tribe. In previous centuries, as today, Plains peoples of different groups gathered in large summer camps for festive occasions. These were times for feasting and dancing, when artists could scrutinize the newest works of their peers from other bands or tribes. Innovative designs might be remembered, adapted, and transformed into a personal aesthetic statement. For example, an exceptional young boy's shirt probably made around 1870, and acquired from the Blackfeet, closely resembles the bold coloration of Assiniboine shirts and may represent a gift, or an idea borrowed from a beadworker from another tribe (fig. 4.9). Long-distance trade among different tribes was common, too, and raw materials such as hides and finished goods, including moccasins and bags, were exchanged. While intertribal marriages had always occurred, by the early twentieth century this became common, providing another avenue for artistic change.

Men's Arts

There are very few areas of Indigenous North America where art was concerned with the chronicling of recent historical events, or with the keeping of time in a linear sense. Yet on the Great Plains, a profound sense of

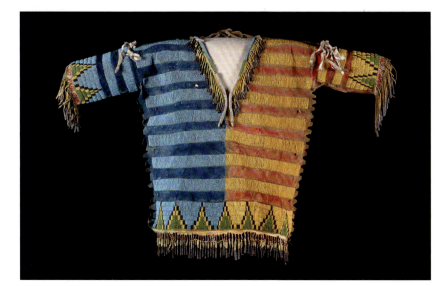

◀ **4.9** Unknown Blackfeet or Assiniboine artist, Boy's shirt, c. 1870. Buffalo hide, beads, porcupine quills, rabbit fur, tin cones, rope. T0065. Gift of Eugene V. and Clare E. Thaw, Thaw Collection, Fenimore Art Museum, Cooperstown, New York. Photograph by John Bigelow Taylor, NYC.

The maker of this shirt ensured that the young boy who wore it would be admired for his fine garment. The play of light blue and mustard yellow beaded stripes against the dark blue and red paint on the hide makes a bold visual statement.

history has long compelled men to illustrate important events in their lives. Images chipped or painted on rock faces served for centuries as a large-scale, public way of marking historical events and visionary experiences. Narrative scenes on buffalo-hide robes and tipis validated and memorialized a man's exploits in war or success in hunting (figs. 4.10 and 4.11). Or, as in the Great Lakes, they depicted images from dreams and visions. But spiritual encounters could not be divorced from military ones, for many warriors had visions that influenced their actions in war.

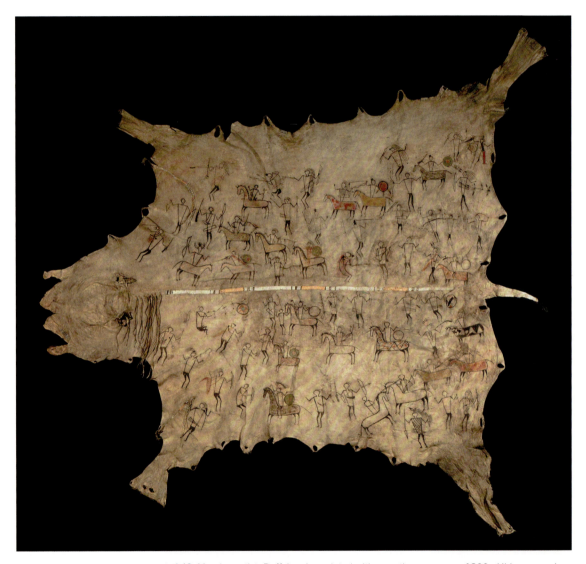

▲ **4.10** Mandan artist, Buffalo robe painted with narrative scenes, c. 1800. Hide, porcupine quills, and pigment. Courtesy of the Peabody Museum of Archaeology and Ethnology, Harvard University, 99-12-10/53121, 60740433.

The explorers Lewis and Clark collected this painted hide in 1804, in what is today North Dakota, and presented it to President Thomas Jefferson, under whose auspices they conducted their Western expedition. The Indigenous men's painting style of the Great Plains is well represented in this ambitious battle scene of some five dozen figures. Semiabstract pictographic men and horses range across the hide. With the help of painted robes like this, powerful warriors would recount the histories of their battles.

The River Crow chief Arapoosh is remembered both as a war leader and as a medicine man who used his powers to cause rain and hail to hamper his enemies. Edwin Denig, a fur trader on the Upper Missouri from 1833 to 1856, described him as one who "made no show of his medicine, no parade of sacrifices or smokings, no songs or ceremonies, but silently and alone he prayed to the thunder for assistance. . . . His great superiority over others consisted in decision, action, and an utter disregard for the safety of his own person."[15] Arapoosh's shield depicts a Thunder Being (fig. 4.1). All across the Northern Plains, Thunder Beings have revealed themselves to humans in vision quests—powerful supernaturals who *are* the thunder, lightning, wind, and hail of summer's powerful electrical storms (fig. 1.24).[16] Affixed to the shield are eagle, crow and hawk feathers, the tail of a black-tailed deer, and the head of a sandhill crane, indicating that his power came from both sky and earth realms.

In some nations, such as the Kiowa on the Southern Plains and the Lakota on the Northern Plains, recorded accounts extended beyond a particular individual's experiences. Family or band history was inscribed pictorially in "winter counts"—records of the most important events of a year, each distilled into one economical pictographic image which oral historians could use as a linchpin upon which to anchor their memories of all the other important events of the group. Some pictographic winter counts depict events that unfolded over many decades, or even centuries.

War exploits and autobiographical episodes were and still are sometimes painted on the exterior of tipis (fig. 4.11); alternatively, images from personal dreams or visions might embellish the tipi. Such imagery was very much the personal property of one individual who held the rights to the designs, although he might sell or bestow upon another individual the right to paint a particular pattern.[17] Such personal "copyright" also extended to paintings on shields. Although certain images recur on shields, each was a unique assemblage of painted images and power objects from the natural world, as Arapoosh's shield shows.

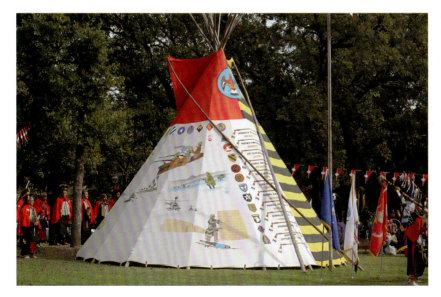

◀ **4.11** Sherman Chaddlesone (1947–2013), Jeff Yellowhair (b. 1956) and other members of the Black Leggings Warrior Society, (Kiowa), Tipi with Battle Pictures, 2008. Canvas, wooden poles, latex paint. Courtesy the Brooklyn Museum and the Black Leggings Warrior Society; photo © Susan Kennedy Zeller. Older versions of this tipi are known from nineteenth-century ledger drawings, and miniature replicas. The exploits of Kiowa warriors are kept up to date, with this version showing moments of Kiowa heroism in recent wars in the Middle East.

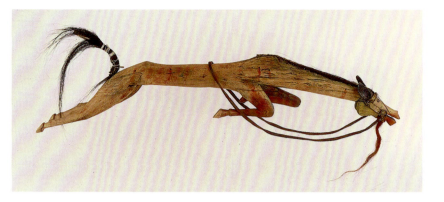

▶ **4.12** Lakota artist, Horse effigy dance stick, 1880s. Painted wood, leather, horsehair; L. 94.6 cm. South Dakota State Historical Society, Pierre, SD.

When a Plains warrior had his horse shot out from under him in battle, he might carve such an effigy in honor of his mount. The animal has red paint around its mouth and marking each of the wounds in its body. An enemy's scalp lock hangs from the bridle. Often carved as a kind of club, with a head at one end, and a large leg and hoof at the other, this example is unusual in its vigorous depiction of the entire lunging body of the horse.

Plains narrative painting of the early contact period is relatively flat and semiabstract in style (fig. 4.10). Humans are depicted as modified stick figures, and events and actions are illustrated through selective use of details, such as individual hairstyles and weapons, and activities such as hand-to-hand combat or horse capture. A man who wore a robe painted with these scenes was publicly displaying his own personal history and would use it as a visual aid in his autobiographical narrations. During the nineteenth century, the Indigenous pictographic style was modified as Plains artists encountered the visual materials circulated by traders and the pictures made by traveling painters such as George Catlin (fig. 4.4) and Karl Bodmer (figs. 1.29 and 4.2). The level of detail and illusionistic renderings in these works stimulated them to experiment with European conventions of perspective and details of portraiture, while new materials offered new possibilities as well.

Explorers and traders provided pencils and paper, as did military men and Indian agents at a later date. Some of these new materials were trade items or discards. It is not uncommon to see the lined pages of a ledger book, with its list of trading post supplies or military scores in marksmanship, drawn over with images of warfare and the hunt, similar to those that Plains artist had always painted on hides. For this reason, the genre has often been nicknamed "ledger book art," although many drawings included in that category were made in new sketchbooks and tablets (figs. 1.24, 4.15, and 4.16). While artists continued to record traditional scenes of horse capture and armed combat, they also used this genre to chronicle their rapidly changing lives, as will be discussed in the next section.

The sculptural traditions of the Plains have often been overlooked, yet they present compelling forms and have an ancient history, as archaeologically excavated buffalo effigies demonstrate.[18] War clubs carved of wood and antler combined utility and elegance, while the delicate faces of elk and birds often graced ceremonial whistles. Spoons and feast bowls were carved of wood or of steamed and bent horn. Among the best known of Plains sculptures are the handsome horse effigies that were carried in dance performances, and their streamlined forms and expressive quality of movement have greatly appealed to modern connoisseurs (fig. 4.12).

Plains carvers did some of their best work in catlinite, a soft stone that is easily worked. The most important source of this material, in use for more than three millennia, is now protected as Pipestone National Monument, in

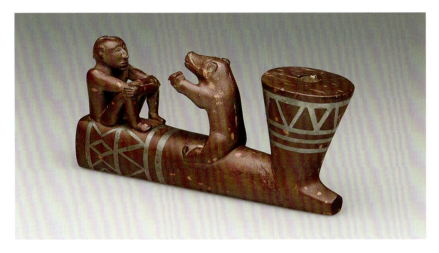

Pipe bowls such as this were attached to long wooden stems that were often carved and embellished with quillwork, beads, ribbons, and feathers.

southwestern Minnesota. Catlinite continues to be used by Native pipe makers who appreciate its deep oxblood color and the way it takes a fine polish. Catlinite is principally used for the bowls and shanks of pipes. Much like Haida argillite carving in the nineteenth century (fig. 6.26), catlinite carvings portray a range of imagery in miniature, from totemic animals, to portraits of individuals, to genre scenes, humor, and social commentary. In some cases, ceremonial beliefs and sacred stories are referenced, as is fitting for the bowl of an instrument for smoking sacred tobacco. A Pawnee pipe depicts a well-known story of a bear who transmits his sacred power to a boy (fig. 4.13). Both the bowl and shank of this pipe are inlaid with lead in geometric designs.

During the centuries before contact, Plains artists also created medicine wheels, monumental earthworks that we would today call land art. These giant, round solar symbols formed of boulders were probably used as ritual spaces. The antiquity of the circle as a sacred form is evidenced by the scores of medicine wheels dotting the landscape across the prairie, clustering most densely in the Canadian provinces of Alberta and Saskatchewan (fig. 4.14, right). While they are hard to date, some show evidence of usage going back more than 3,000 years, suggesting that in ancient times, as today, peoples of the Plains gathered in ceremonial performances to mark the summer solstice. To do this, they build a Sun Dance enclosure, a circle made of tree limbs and branches cut in a ceremonial manner, which defines the space in which the ceremony takes place and becomes a microcosm of the world itself (fig. 4.14, left).

All Plains people affirm that it is through ceremony that humans become "centered." In the Sun Dance of more recent times, humans celebrate their place in the universe, dance and sing, and fulfill vows they have made, and mortify their flesh in sacrificial rites. A small number of men make vows to pierce or cut their chest, back, or arm flesh. Though described by the first outsiders who saw it as "torture," this is perceived by the ritual performers as an affirmation of a profound unity among the powers of the world: man and his life's blood, the sun, and the Sun Dance pole that reaches from the interior of the earth up into the dome of the sky. The great ritual pole represents the axis at the center of the world, around which all ceremony revolves.

In all ritual performances, including the Sun Dance, visual display of fine clothing, horse trappings, and other art objects has been important. Both

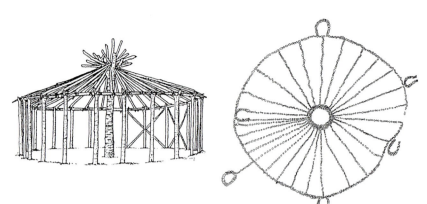

▶ **4.14** Comparative drawings of a Sun Dance enclosure and a medicine wheel. Drawing after Michael Coe, Dean Snow, and Elizabeth Benson, *Atlas of Ancient America* (Oxford, 1986), 65. Big Horn Medicine Wheel in Wyoming was built on a mountaintop, at an altitude of more than 9,600 feet. It may have served to mark the summer solstice and other astronomical sightings. Modern Sun Dance or medicine lodge enclosures are modeled on such ancient cosmograms.

men and women have ritual roles to play; male roles were generally more public and often involved impersonating game animals in a kind of ancient hunting magic. Aspects of this are seen in the *Okipa* of the Mandan, the *K'ado* of the Kiowa, and the *Massaum* ceremony of the Cheyenne, in all of which the fundamental importance of the buffalo to human life is affirmed. Some Plains performance attire was highly idiosyncratic, for it related to personal dreams, visions, and accomplishments. Other aspects could easily be deciphered, for male warrior societies across the Plains had recognizable codes of dress for different age grades and achievement levels, and men often wore such war regalia when participating in ritual performances, as they continue to do today.

Arts of Survival and Renewal

During the second half of the nineteenth century two cataclysmic developments altered the way of life that had supported Plains peoples and their arts for at least 200 years. After the American Civil War in the 1860s, exploration and settlement of the Great Plains rapidly increased, as did the escalation of U.S. military conflict with Plains peoples. In 1869 the transcontinental railroad was completed. Within fifteen years, the enormous herds of buffalo that had freely roamed the Plains were hunted to the brink of extinction, the railroad making possible their slaughter on a scale never before imagined. Within just a few years, the major source of food, clothing, and shelter for Plains peoples virtually disappeared, as simultaneously the people were being defeated militarily by the U.S. Army. Within a very short time, most were forcibly resettled on to reservations, their traditional ways of life fractured, especially for men. By the late nineteenth century, the old ways of warrior societies and seasonal migration were in tatters. People lived much more sedentary lives on reservations, dependent on the government for most of their food as well as materials for clothing and shelter.

Since at least the 1860s, warrior-artists had drawn pictorial histories in small books which they wore on their persons when going off to battle—in a miniaturization of their age-old convention of wrapping themselves in autobiographical hide robes (figs. 4.4 and 4.10). Some of these books were "captured" on the battlefield or taken from the bodies of dead warriors by white soldiers. Some army men had amicable relations with Indian scouts from friendly tribes and commissioned these scouts to make drawings.

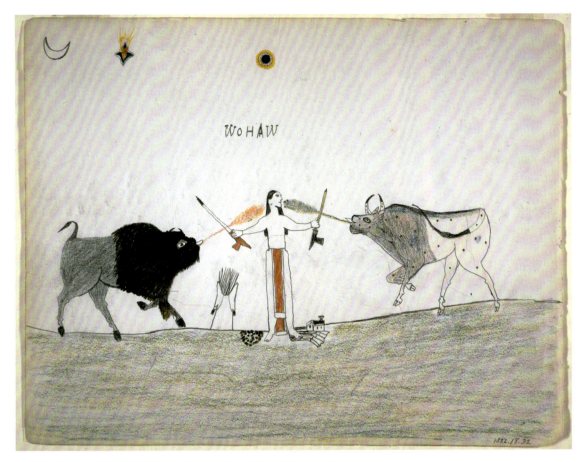

▲ **4.15** Wohaw, 1855–1924 (Kiowa), *Between Two Worlds*, 1876. Pencil and crayon on paper, 22.2 × 28.6 cm. Missouri Historical Society, St Louis. Accession number: 1882.18.32. In an unmistakable depiction of his acute ambivalence at being caught between two ways of life, this Fort Marion artist depicts himself holding out a peace pipe to two animals—a domesticated beef cow and a buffalo. One foot stands near a miniature buffalo herd and Kiowa tipi, but Wohaw's other foot is firmly planted in the tilled fields of a white settler's frame house. His actions are witnessed by the celestial bodies overhead. This image stands as the single most powerful metaphor and most poignant representation by a nineteenth-century Indian artist of the cultural schisms of the era.

Cheyenne and Arapaho scouts who worked for the U.S. Army at Fort Reno and Fort Supply in the 1880s, for example, made many such drawings.

Most well known of the late nineteenth-century graphic arts are the hundreds of drawings made by Cheyenne and Kiowa warriors incarcerated from 1875 to 1878 at Fort Marion, Florida, far from their Southern Plains homeland (fig. 4.15). As these men learned Euro-American pictorial conventions, their drawings became more detailed, utilizing perspective, overlapping, and sometimes a landscape setting. Such drawing also provide a powerful and eloquent chronicle of dispossession, as these formerly free warriors pictorially record the details of their imprisonment—the manual labor, the army dress, the daily classes, and Bible study. It was the work of these men, and the next generation of artists, including Silver Horn (see Artist in Focus box), who provided a bridge to twentieth-century painting on the Great Plains (figs. 4.16 and 7.7).

ARTIST IN FOCUS
Silver Horn: Chronicler of Kiowa Life

Silver Horn (Hau-gooah, 1860–1940), whose life span extended from the days of buffalo hunting to the start of World War II, was the most prolific and accomplished Plains artist of his generation. More than 1,000 works by him are known, spanning nearly fifty years and ranging from hide paintings and tipi liners to works on paper. As Candace Greene has noted, "Silver Horn's illustrations of ceremonies offer visual documentation that far exceeds the written records of these events and richly enhances the verbal knowledge still held within the Kiowa community."[19] Born to a prominent family, Silver Horn was nephew of the Kiowa chief Tohausen. His older brother was a warrior-artist sent into captivity at Fort Marion, Florida, in the 1870s. Himself a member of one of the warrior societies, Silver Horn later served in the first Indian troop of the U.S. Army at Fort Sill, Oklahoma.

The work illustrated here comes from one of the artist's earliest sets of drawings, consisting of seventy-five scenes of warfare, courtship, hunting, and ceremony made in a commercial drawing book. They were commissioned in 1883 by a man who had a ranch near Silver Horn's home. The drawings are rendered with great delicacy of line and a precise attention to detail. In this battle scene, the artist has drawn a robust yet somewhat disproportional horse, whose body is painted with dots and dashes, its tail tied up for war in red stroud cloth. Astride the horse, a high-ranking warrior carries a crooked lance and dragonfly shield. Each red-tipped feather on the lance and head-dress is carefully drawn, as are all the mechanics of the horse's bit and bridle. In the foreground, a Pawnee in a striped wool capote and ornate leggings topples over in a stylized pose of death, his firearm knocked from his hand. Details of the Springfield rifle, including its checkered butt and peep sight, are accurately rendered.

Silver Horn often followed the conventions of late-nineteenth-century warrior art: showing the action from right to left, using a horizontal format, and balancing abstraction against narrative detail in a predominantly flat picture plane. Yet his artistic innovations were legion. He provided fully realized visual depictions of Kiowa stories, and he kept detailed pictorial calendars that were far richer than those of his predecessors. He created several self-portraits and chronicled the life ways of Kiowa people during a changing time. Silver Horn collaborated with Smithsonian anthropologist James Mooney on recording Kiowa heraldry, participated in the peyote religion (properly known as The Native American Church), and in his old age was a keeper of one of the sacred medicine bundles of his tribe. Silver Horn was the first painting teacher of Stephen Mopope and James Auchiah, who gained fame in the 1920s and 1930s as members of the Kiowa Five (fig. 7.7).

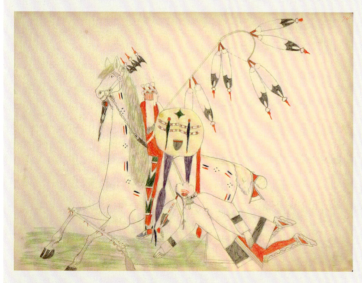

▲ 4.16 Silver Horn, 1860–1940 (Kiowa), *Mine-yock Kills a Pawnee*, 1883. Pencil and colored pencil on paper, 11 ¾ × 14 ¾ in. Nelson-Atkins Museum of Art, Gift of Mr. and Mrs. Dudley C. Brown, Accession numbers: 64.9/74. Photo: Tiffany Matson.

The Reservation Era of the late nineteenth and early twentieth centuries was a time of profound cultural upheaval for all Plains people. With these changes came radical ruptures in artistic traditions. Although the very foundations of culture were under attack, the reservation period was also a time of tremendous innovation and creativity. Men no longer needed the painted hide shirts that boasted of their war exploits, the sacred shields to protect them in battle, or the complex paraphernalia of the warrior societies.

They did continue to record their deeds and their changing ways of life in drawings and in paintings on canvas or muslin. In some of these works, the age-old practice of memorializing individual achievements in hunting and warfare continued. Others show an almost compulsive interest in documenting scenes of traditional life, as if the artists were all too aware of how fragile some of these traditions were and how rapidly they were changing.

The legacy of ledger drawings remains strong in Plains Indian painting of the last fifty years. Contemporary Lakota artist Arthur Amiotte, for example, has found in the arts of the Reservation Era a rich vein of iconography to mine in his collage series. Using visual quotations from Fort Marion drawings, family history, and Lakota ritual practices, he continues the venerable male tradition of pictorial autobiography, injecting it with contemporary wit and irony. He does so out of a conviction that most outsiders are fascinated by earlier, less acculturated arts and are ignorant of the complex lives led by Plains people in the years from 1880 to 1940. This was a time, for example, when Amiotte's great-grandfather, Standing Bear (1859–1933), who as a young warrior fought in the 1876 Battle of Little Big Horn, traveled in 1887 and 1889–90 to Europe with Buffalo Bill's Wild West show (fig. 1.17). There he met Louise Rieneck, an Austrian, married her, and brought her home to Manderson, South Dakota, where they raised three daughters according to Lakota and Viennese standards of comportment. In *The Visit* Amiotte mixes photos, drawings, and texts to tell part of this family's history during the Reservation Era (fig. 4.17). In a 1919 photo, Standing Bear, Louise, and two of their granddaughters are in front of their log cabin (a cabin that has been reconstructed with many of its original objects in the Plains Indian Museum at the Buffalo Bill Historical Center in Cody, Wyoming). Amiotte depicts Standing Bear dreaming his ancestors into the present, writing on the collage, "In an imaginary reunion, they dismount their steeds and appreciatively sit in the new horse-power machine belonging to a newer generation." To the left, Amiotte reproduces in miniature his own painting of Standing Bear at the end of his life, wearing his ceremonial regalia, the rights to which Amiotte himself was given by his grandmother, Christina Standing Bear, in the 1980s.

As discussed in chapter 3, the introduction of trade cloth, ribbon, and other manufactured goods modified traditional dress across North America in significant ways. When Karl Bodmer and Prince Maximilian traveled up the Missouri River in the 1830s, they saw Piegan and other people wearing dozens of brass and silver rings on their fingers, for example. Chinese vermilion, shipped out of Canton (today, Guangzhou) in the nineteenth century, was a staple of early traders' supplies. Both Prince Maximilian and George Catlin mention vermilion used in face and body painting, and Karl Bodmer gave packets of vermilion as gifts to some of the men he painted. Traders' inventories from St Louis in the 1830s indicate that this, along with vast amounts of beads, buttons, mirrors, and thimbles, was shipped upriver on steamboats to the trade forts on the Upper Missouri. The Lakota term *saiciye*, previously mentioned in chapter 1 as an expression of ritually correct dress (p. 34), literally means "to paint oneself red."

Calico fabric and men's tailored cloth coats also appeared early in the nineteenth century among the goods of traders and visiting delegations.

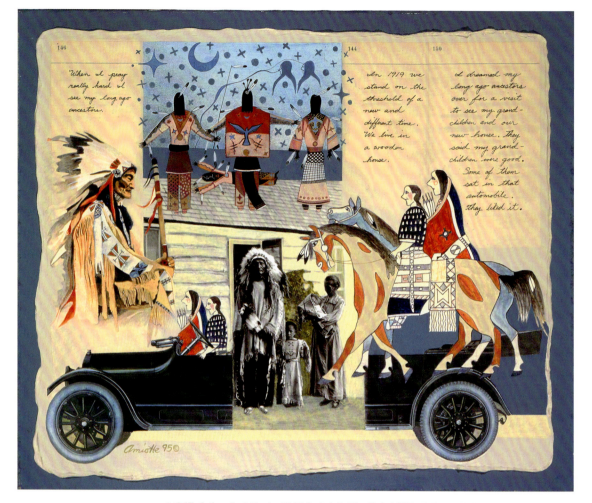

Within the collage, handwritten text reads:

"When I pray really hard I see my long ago ancestors."

"In 1919 we stand on the threshold of a new and different time. We live in a wooden house."

"I dreamed my long ago ancestors over for a visit to see my grand-children and our new house. They said my grand-children were good. Some of them sat in that automobile. They liked it."

▲ **4.17** Arthur Amiotte, b. 1942 (Lakota), *The Visit*, 1995. Collage. Buffalo Bill Historical Center, Cody, Wyoming, U.S.A.: Gift of George Fronval, through the courtesy of Nick Eggenhofer, Cody, Wyoming, 1.69.48.

An Indian couple on horseback, at right, arrives to inspect the fine touring car parked in front of the family in the central photo, that of the artist's great-grandfather Standing Bear. In a typical nineteenth-century Plains artistic convention of simultaneous visual narrative, the Lakota couple at right is repeated, seated in the touring car, inspecting the new style of "horsepower" belonging to Standing Bear. Part of the text reads, "In 1919 we stand on the threshold of a new and different time. We live in a wooden house." Above the central scene, standing on the roof of the house, are figures wearing Ghost Dance clothing and studying the sky for sacred portents.

They later formed an important part of treaty payments made to Indian nations by the U.S. Government. Such items so transformed traditional dress that army officer John Gregory Bourke wrote this about the visual impact of one of the last great Lakota Sun Dances in 1881:

> As the crier began to proclaim the orders of the day, the Indians once more closed in spontaneously around him, forming a great ring 50 or 60 yards in diameter, and 8 or 9 persons deep, and aggregating several thousand men, women, and children. The display was no less brilliant than fantastic. Some were on foot, many on ponies, and quite a number in American country vehicles. Nothing could be added in the way of dazzling colors. Calico shirts

in all the bright hues of the rainbow, leggings of cloth, canvas, and buckskin,
moccasins of buckskin, crusted with fine beadwork were worn by all, but
when it came to other garments no rule of uniformity seemed to apply.
Many of the men and women had wrapped themselves in dark blue blankets
with a central band of beadwork after the manner of medallions; others
gratified a more gorgeous trade by wearing the same covering of scarlet or of
scarlet and blue combined. A large fraction of the crowd moved serenely
conscious of the envy excited by their wonderfully fine blankets of Navajo
manufacture, while a much smaller number marched as proud as peacocks
in garments of pure American cut.[20]

Although pleasure in the colors and patterns of trade cloth was an important reason for changes in Plains clothing, it was the far more tragic circumstance of the near extermination of the buffalo by the time of Bourke's remarks that had already made the adoption of these materials a matter of necessity.

The Sun Dance was officially banned by the U.S. Government in 1883 as a part of the efforts to "civilize" the Indians, but it continued surreptitiously even after the ban. In the 1880s, as a replacement for the festive, nonceremonial aspects of the Sun Dance, summer celebrations on the fourth of July, the U.S. national holiday, began to be common. These summer festivals, as well as the development of the powwow as an intertribal dance competition, kept some aspects of traditional arts alive during some extremely harsh decades in which the impulse of the dominant society was to assimilate Indians and to encourage them to leave ancient cultural traditions behind. Today, the Sun Dance is practiced as an enduring symbol of traditional values and ideals.

An Indigenous response to the cultural holocaust occurring throughout the vast lands of the West at the end of the nineteenth century, a religious cult known as the Ghost Dance flowered briefly. Its immediate inspiration was a series of religious visions by Wovoka (1856–1932), a Paiute holy man. In 1889 he proclaimed that if Indian people lived peacefully, danced a new dance that he introduced called the Ghost Dance, and sang the Ghost Dance songs, their world would be transformed into an ideal place populated by buffalo herds and the ancestral dead. Most important, white people, their goods, and the troubles they had caused would disappear. This hopeful message spread across many Western tribes and was adapted according to the cultural practices of each group. Notably, the Ghost Dance movement also incorporated some features of Christianity, including recognition of a "Messiah." Hauntingly beautiful painted clothing incorporating many celestial and avian symbols was made for Ghost Dance participants. Among Arapaho adherents, the rejection of white men's goods dictated that the Ghost Dance shirts and dresses should be made from tanned deer skin (fig. 4.18). Most Lakota garments, in contrast, were made of painted muslin. In keeping with ancient beliefs in the protective power of visionary imagery, the Lakota believed that these shirts and dresses would render their wearers impervious to the bullets of white soldiers. But when the Seventh Cavalry of the U.S. Army gathered at Wounded Knee Creek in South Dakota in December of 1890 and massacred more than 200 Lakota participants in the

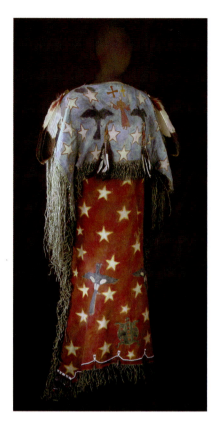

▲ **4.18** Arapaho artist, Ghost Dance dress, 1890s. Deerskin and pigments. Field Museum of Natural History, Accession number: #A113021C; photo by Diane Alexander White.

The iconography of Ghost Dance garments includes both four- and five-pointed stars, crescent moons, directional symbols, and many other symbols associated with the sky realm, such as eagles, magpies, and dragonflies. In this example, the colors evoke the American flag as well.

Ghost Dance, including unarmed women and children, this proved to be false. It was clear that such a Messianic movement—based on the idealism of peace, right living, and ecstatic dancing—could not stave off the brute force that backed up official U.S. policies of assimilation.

To many, December 1890 marked the true end of an era on the Great Plains. Yet cultural resistance, in the form of adherence to Native artistic practices, has persisted as an important element in the survival of Plains Indian cultures. Today, art remains a vital force in the life of the people. In some regions, even the Sun Dance is practiced once again, and people are making fine ceremonial garb for its observance. There has been a revival of quillwork, particularly among the Lakota. The annual Crow Fair in Montana provides expert beadworkers with an opportunity to wear and sell their finest dance accessories and horse paraphernalia. All across North America, the powwow remains an important venue for competitive dances and costume makers to exhibit and make money from their work, and to transmit artistic traditions to the next generation.

An Aesthetic of Excess

Among many tribes of the Plains and Plateau, an important feature of personal adornment is what we call an aesthetic of excess: a propensity to lavishly bead, decorate, and dress richly. We first noted this in Mato-tope's garments in the 1830s (fig. 4.4), but since the Reservation era, this has become something not just for chiefs but for many others as well, especially in gifts given to honor family members. Paradoxically, while the late nineteenth century witnessed the radical diminishing of traditional male arts, women's arts flourished during this time of adversity, a phenomenon that can be understood as a response to the many forces that were threatening Plains cultures. As Marsha Bol has pointed out, in the "enforced leisure" of reservation life, women had more time to devote to art, and the result was a tremendous blossoming of beadwork arts. Women's arts came to symbolize the ethnicity of the tribe, both for the people themselves and for outsiders, and such arts became, even more than before, a way of affirming the traditions of the group. In many regions, beadwork designs grew more complex, and items of clothing were lavishly covered with beads.

Women sometimes made seemingly impractical moccasins on which even the soles were beaded. Museum catalogues often state that these were made for the dead; in fact, they were made for the living as well. Mary Little Bear Inkanish remembered that her aunt had made such a pair for her in the 1890s, when she was small, and that it was a customary gift for a bride. Wealthy horse riders wore beaded-sole moccasins to indicate that they need not walk on the earth but would always be astride a mount.[21] The intention in all of these cases is to imply that the wearer is so honored or so wealthy that her feet need not touch the ground.

Fully beaded baby carriers are notable for the lavish artistry expended upon them. Different tribes not only have distinctive beadwork designs but

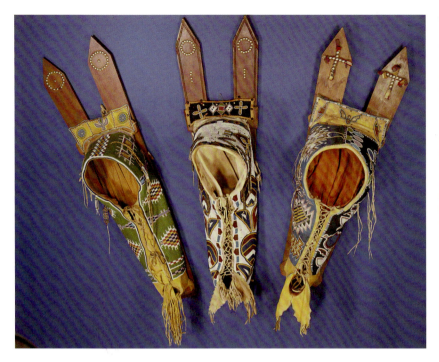

◄ 4.19 Kiowa artists, Three beaded cradles, c. 1900. Courtesy of the Haffenreffer Museum of Anthropology, Brown University.

Kiowa cradles are often beaded in both geometric and floral motifs in vivid colors, and usually are gifts bestowed upon a new baby by her female relatives. The artists of these masterworks are (left to right) Mrs. G. Qui-ah-tone, Hoy-Koy-Hoodle, and Tah-o-te. All were made in Oklahoma at the turn of the century.

also distinctive methods of cradle construction. The Kiowa and Cheyenne, for example, favor a V-shaped frame made of two long pieces of wood that extend well beyond the top of the beaded bag (fig. 4.19). These protect the baby's head if the cradle falls. The cradle could be worn like a backpack, or hung from a saddle, tipi pole, or tree. The cradleboard combines crib, carriage, and high chair, protecting babies not old enough to walk with the other children. Often a valued gift from a female relative, and embellished with designs that are personally as well as tribally distinctive, beaded cradleboards are among the most beautiful examples of the beadworker's art.

Among prosperous Lakota families, abundant esteem and affection are denoted by excessive beadwork. The *Hunka* ceremony marks a child who is designated to bear the lifelong burden of moral generosity toward others. Lakota stories say that when a man named Slow Buffalo first performed this ceremony, he told the young woman he had blessed that she must be an example to others, and she had special responsibility to the poor: "If such a child should ever come to your lodge, and if you should have but one piece of meat which you have already placed in your mouth, you should take it out and give it to her. You should be as generous as this!"[22] Individuals who have been so blessed are supposed to become a sort of moral aristocracy. Around the year 1921, Eva Roubideaux (b. 1909) and Albert Six Feathers (b. 1905) apparently had such an honoring ceremony (fig. 4.20). Each wears fully beaded garments, in which both figural and geometric designs are formed within a ground of white beads covering the whole garment. To wrap one's offspring in the beaded regalia of Lakota life was to afford them some protection against the many adversities they would face. This extravagant use of beads is not seen before the Reservation era.

▶ **4.20** Albert Six Feathers and Eva Roubideaux in beaded regalia for honoring ceremony, 1924. Gelatin dry plate photograph by Joseph Zimmerman (c. 1908–c. 1950). Department of Special Collections and University Archives, Marquette University Libraries, Joseph Zimmerman.

This photo was taken at Saint Francis Mission, Rosebud, South Dakota. In addition to the lavishly beaded garments worn by the people, the horse's halter and saddle blanket are decorated, and the cart is draped with more extravagantly beaded clothing and a fine Navajo trade blanket.

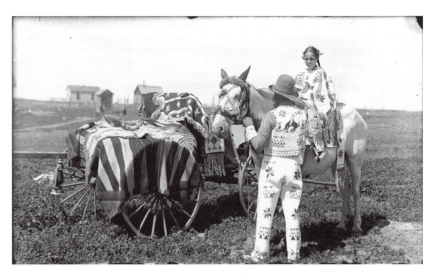

The penchant for allover beadwork extended to nontraditional items as well, reaching its peak in the early years of the twentieth century. Suitcases, handbags, and other manufactured items were lavishly beaded (fig. 1.30). Lakota artists were especially renowned for this, with particular families among the Cheyenne River Sioux and Standing Rock Reservations producing the finest pieces. While some of these intensively beaded bags were likely made as commissions and sold to outsiders, others were made as honoring gifts for local family use, like Ida Claymore's bag in figure 1.30. Historical battles, names, dates, American flag iconography—all were incorporated into the artistic vocabulary of the Plains beadworker.

The "aesthetics of excess" continues today, as anyone who has ever attended Crow Fair in Montana, or a powwow anywhere across North America, can attest. Plains beadwork artists continue both traditional and innovative styles of beadwork. Stethoscopes for doctors at the Indian Health Service, Nike athletic shoes for young sportsmen, marker holders for bingo-playing grandmothers—all are beaded in a dizzying array of traditional and contemporary patterns. Jamie Okuma's beaded high-fashion ankle boots are a cosmopolitan mix of Parisian and Native high fashion (fig. 4.21). As Lakota beadworkers are known to say, "If it doesn't move, bead it!"

Quillwork, too, has made a resurgence. While it was replaced by beadwork in many tribes by the mid-nineteenth century, it never completely died out among the Lakota. Alice New Holy Blue Legs (1925–2003) of Oglala, South Dakota, was central to keeping this technique alive. She taught her five daughters the painstaking processes that her grandmother, Quiver, had taught her as a child. She was awarded a National Heritage Fellowship in 1985 for her quillwork, and the New Holy family's quillwork was the subject of a documentary film that same year. Jo Esther Parshall (Cheyenne River Sioux) has made quilled clothes and horse regalia for many museums. Several contemporary doll makers, including Jamie Okuma (b. 1977, Luiseño/ Shoshone-Bannock) and Joyce Growing Thunder Fogarty (b. 1950, Assiniboine/Sioux), make dolls wearing ethnographically exact nineteenth-century dress, including quillwork fashioned on an exceedingly small scale.

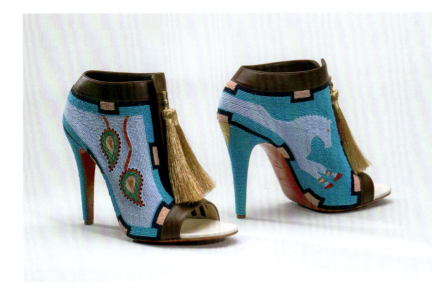

◀ **4.21** Jamie Okuma, b. 1977 (Shoshone), *Adaptation*, 2011. Commercial high heeled ankle boots, glass and 24k gold-plated beads, and polyester tassels, each shoe 6 ½ × 3 ³/₈ × 8 ½ in. The Nelson-Atkins Museum of Art, Purchase: The A. Keith Brodkin Fund for the Acquisition of Contemporary American Indian Art, 2001.42.A,B. Photo: Joshua Ferdinand.

Jamie Okuma's artistry ranges from dolls crafted with meticulous attention paid to the authenticity of their nineteenth-century quillwork and beadwork regalia to the most high fashion designer shoes beaded with traditional imagery. At the age of twenty-two, Okuma was the youngest artist ever to win a "Best of Show" medal in 2000 at the prestigious Santa Fe Indian Market.

Okuma won Best of Show ribbons at Santa Fe Indian Market in 2000, 2002, and 2012 for dolls that included finely quilled ornaments.

Métis Art: "The Flower Beadwork People"

For more than two centuries, the European desire for beaver pelts drove a small army of fur traders into the heartland of the North American continent. To acquire the quantities of pelts needed to make men's tall beaver hats fashionable in Europe and America, traders needed Indigenous hunters, and they, in turn, wanted the traders' supplies of guns, cloth, and other manufactured goods. Out of these complementary needs emerged new patterns of alliance and kinship—and a new people. The Métis (from the French word for "mixed") are the descendants of French, Scottish, and English fur traders and their Anishinaabe (primarily Cree and Ojibwe) wives. Their oldest and best-known community, the Red River Colony, was established during the 1820s at modern Winnipeg, Manitoba, and other Métis communities developed throughout central and western Canada and the United States.

Skilled in traditional quillwork and beadwork techniques, Métis women also had access to European and North American floral embroidery patterns and materials such as glass beads and silk thread. In the Red River Colony, and later in other places, the daughters of Métis families were taught needlework at missionary schools. Their creative melding of Indigenous hide tanning and embroidery techniques with European clothing styles and floral designs gave rise to distinctive new textile and clothing arts. Traveling widely as buffalo hunters, trappers, and traders, the Métis disseminated their finely made vests and frock coats, buckskin trousers, half-legging, bags, and pad saddles embellished with expert quillwork, beadwork, and silk embroidery (fig. 4.22). Sherry Farrell Racette's research, which greatly expands the corpus of Métis art and documents the lives and works of individual artists, also maps the continental reach of Métis art, which extended from the southern

(cont.)

woman wears many beaded necklaces—dark and light, long and short. At the bottom of her beaded yoke, pendant fringes of different types of beads and *Olivella* shells hang down over her belt. Her long earrings and the headdress that cascades over her forehead are both fashioned from beads, *Dentalium* shells, and Qing Dynasty Chinese coins. As she walked, all would be in motion, the coins on her forehead glinting in the sun and making soft musical sounds. These coins (which conveniently arrived with holes already made in them) were a part of the system of global trade that from the 1780s to the 1840s extended from Boston to the fur-trade ports of the Pacific Northwest to Canton, China; later, coins were brought by Chinese immigrants to the Northwest. At The Dalles, such global systems of trade intersected with interregional Native American ones. The *Dentalium* shells this young woman wears had been harvested by Nuu-chah-nulth people off Vancouver Island and traded far into the interior of North America.

The Wishham were a ranked society, with members ranging from slaves to commoners to chiefly families. Marriage among the wealthy involved payment from the bridegroom's family to that of the bride, and reciprocal feasts honored the new alliance between families. One of the ways that the prosperous indicated their wealth was by wearing *Dentalium* shells. Chiefs wore *Dentalium* head-dresses, and most people of rank wore these long shells through the pierced septums in their noses. Without such ornaments, Curtis was told, one "looked like a slave."

The object paired with the Curtis photo is a bridal head-dress in a museum collection (fig. 4.25). It consists of more than 300 pieces of *Dentalium*, and some three-dozen Chinese coins, as well as blue, maroon, and white trade beads. While we may admire the object on its own, seeing its use in Curtis's photograph and discovering its history leads us to understand its place in a complex system of wealth, gift exchange, and aesthetics. The wealth of the Wishham is now gone. In 1855, the governor of Washington Territory pressured them to sign a treaty that removed them to an arid region of central Oregon, away from their rich fisheries. The salmon fishing sites that had supported their ancestors for 11,000 years were destroyed when the Dalles Dam was completed in 1957, submerging ancient habitation sites.

Basketmaking is enjoying a renaissance in many regions, including the Intermontaine area. Descendants of Wishham and Yakama people, like many Native peoples across North America, take inspiration from historical photos and objects to re-create ceremonies and regalia, or to make works that honor and replicate the handiwork of their ancestors (fig. 4.27). One of the finest artists in this medium is Pat Courtney Gold, a Wasco woman who grew up on the Warm Springs Reservation in Oregon, but knew that her ancestors came from the same Columbia River area as the Wishham people discussed earlier. In 1992, she began to learn the ancestral Wasco techniques of twining, and within a decade became so proficient that her work has been honored with many awards. Gold says, "As a contemporary weaver, I have to be a botanist, a politician, an educator, and a computer specialist."[29] As a botanist, she needs to understand her materials and their properties, as well as how to protect their habitats. Politically, she is tireless in trying to educate government agencies charged with land management about the "weeds" they sometimes try to eradicate—the plant materials central to the weaver's craft. She teaches and mentors other weavers, as well as the general public. Trained as a mathematician, Gold uses her computer skills to maintain databases on museum collections of historic materials that are of inspiration to contemporary weavers.

THE FAR WEST: ARTS OF CALIFORNIA AND THE GREAT BASIN

In many communities across the Far West, the legacy of basketmaking has been handed down from mother to daughter for centuries—even millennia. In the Great Basin are found some of the most ancient examples of artistically worked fiber. For example, mats and bags dating from nearly

10,000 years ago have been found in Spirit Cave, in west-central Nevada. Made of split bulrushes, these items were both woven and twined, with feather decoration.[30] Other sites have yielded baskets and sandals of similar antiquity. When Sir Francis Drake (1540–96) sailed into the bay at Point Reyes, in northern California in 1579, a member of his expedition wrote in his journal that the local baskets were made "of Rushes like a deep boat, and so well wrought as to hold Water. They hang pieces of Pearl shells and sometimes Links of these Chains on the Brims . . . ; they are wrought with matted down of red Feathers in various Forms."[31] He describes the unparalleled Pomo ceremonial basket, into which red feathers from woodpecker crests were woven to richly ornament the flat or conical exterior (fig. 4.30).

Women of the Far West have used the knowledge they gained as gatherers of Indigenous plants for food and shelter in their work as basketmakers. They have always been among the most technologically proficient basketmakers in the world, excelling in a medium which favors rhythmic repetition of pattern, and complex schemes of rotational geometry, all of which were exploited to the maximum by the inhabitants of these areas (figs. 4.29 and 4.31). By the late nineteenth century, in each of these cases the primary destination for Native baskets was the curio trade. As one elderly basketmaker, Rosy Jacks, told anthropologist Lila O'Neale in 1930, "We made baskets every day. Only way to get clothes."[32]

By examining the baskets of four regions, in the next four subsections, we can understand different contexts for the making and use of such works. Chumash basketweavers of the early nineteenth century lived within the harsh Mission system imposed by the Spanish in coastal California (fig. 4.28). At the end of the nineteenth century, the Lower Klamath River region of California (including Karok, Yurok, Hupa, Wiyot, and other peoples) was an extraordinary basketmaking region. Unlike some objects in this book that can immediately be characterized as Lakota or Zuni, for example, many baskets in northern California were the products of mixed-race women who lived in multiethnic (though predominantly Native) communities and intermarried with each other and with non-Natives. Their work often assimilated stylistic features of different groups. Some baskets that museums have labeled as Karok or Yurok, for example, might better be called "Lower Klamath River region" (fig. 4.29). Further south, Pomo people, living in some six dozen autonomous villages in the mountainous areas of Sonoma and Mendocino Counties, produced some of the most strikingly beautiful baskets, often with intermixtures of feathers, plant materials, and shell beads (fig. 4.30). In each of these cases, traditional lifeways and habitats were radically disrupted in the nineteenth century, in

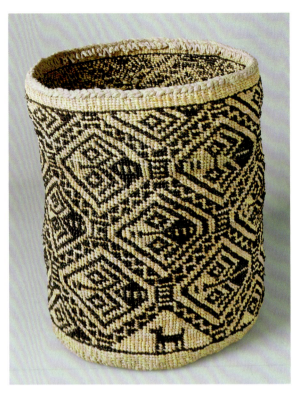

▲ **4.27** Pat Courtney Gold, b. 1939 (Wasco), *Honor the 1805 Wasco Weaver*, 2003. Sally bag, Hemp, cattail, raffia, dye, dogbane bark, 11 3/16 × 10 7/16 × 9 5/8 in. Courtesy Peabody Museum of Archaeology and Ethnology, Harvard University, Accession number: 2003.24.1.

Upon seeing the earliest known Wasco basket, possibly collected by Lewis and Clark in 1805, Gold was moved to replicate and build upon its designs. The abstract ancestral faces of the 200-year-old basket, which themselves replicate the faces carved in ancient rock art along the Columbia River, are changed slightly in Gold's basket, so that they smile, wink, and whistle.

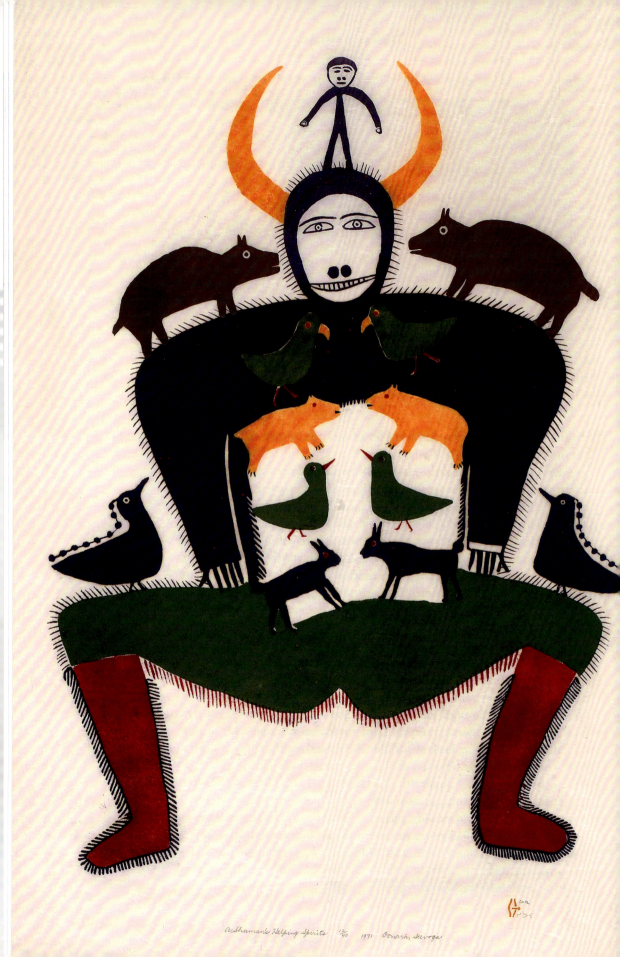

THE NORTH

<div style="text-align: right; font-size: 3em;">5</div>

A horned shaman, clad in fur garments, crouches in a dance position, hands on his hips. Perched on his legs, lap, torso, and shoulders are small birds and mammals. Astride his head stands a small spirit-helper in human form (fig. 5.1). Inuit artist Jessie Oonark has captured the essential bond that links the human world with that of spirits and animals. According to stories told in the Arctic, powerful earth-dwelling or sea-dwelling spirits have miniature animals that live on their bodies. These animals travel to the human world and allow themselves to be captured in the hunt, to sustain human life. Human beings have for thousands of years sought the cooperation of the animal spirits and honored them by wearing small amulets carved in their images.

Such ritual and artistic traditions reflect beliefs, common throughout the Arctic and Subarctic regions of the North, in relationships of reciprocity and respect that bind the animal and human populations to each other, and both to the land that nourishes them. Among the Dene, as a late nineteenth-century missionary pointed out, "a hunter returning home empty-handed would not say, 'I had no luck with bear or beaver,' but rather 'Bear or beaver did not want me.'"[1]

Such attitudes, fundamental to Northern ways of life, help to explain the purposes for which much visual art is made. Among both Arctic and Subarctic peoples the highest level of artistry has been committed to the ornamentation of clothing and equipment in order to please the animal spirits so that they will give themselves to the hunter and so that their protective powers can be transferred to humans. Northern artists have drawn upon a wealth of animal materials in fashioning visually appealing clothing, art, and utensils—including salmon skin, walrus intestine, musk-ox and moose hair, bird pelts, bone, antler, and ivory, as well as the more widely used hides of deer, caribou, and hare. Northern clothing arts demonstrate the remarkable patience, dexterity, and imagination of women in transforming a caribou hide, fifty yards of walrus intestine, or a hundred bird pelts into a garment of lasting use and beauty. Although these arts are practiced by relatively few people today as compared with a century ago, the last few decades have seen a renewal of many exacting techniques for preparing materials and sewing that had for some years been in decline.

The importance of hunting also helps to explain the centrality of shamanistic practices to Northern ritual-artistic expression. Specialist shamans engaged powerful helper spirits in order to communicate with beings that control the animals, for example, Sedna, the undersea mistress of the Arctic sea mammals, or the eastern subarctic Master of Caribou, who controls

◀ **5.1** Jessie Oonark, c. 1906–85 (Inuit), Baker Lake, Nunavut, Canada, *A Shaman's Helping Spirits*, 1971. Stone cut, stencil, 37 × 25 ¼ in. Canadian Museum of History, BL 1971-009, IMG2009-0184-0003-Dm; Public Trustee for Nunavut, Estate of Jessie Oonark.

In Oonark's work humans transform into animals or fly across the sky with their spirit helpers. She also draws old stories and legends, characteristically rendering forms in bold blocks of color, with a graphic artist's flair for the interplay of positive and negative space.

that, over time, the wearer's powers came to permeate his or her clothing and could be transferred with the garment to another wearer. The Western tendency to separate utilitarian from artistic concerns, and acts of aesthetic self-expression from those of ritual observance, hinders an understanding of the inextricable interconnectedness of these factors in the creation and visual elaboration of Subarctic clothing.

In the eastern and western Subarctic, clothing for the coldest weather consisted of double layers of furred caribou hide clothing—the inner layer worn with the fur side against the body to trap heat and the outer layer with the fur outside to shed water and snow. The dehaired caribou skin clothing worn in warmer weather until the twentieth century by both Eastern Cree and Dene was often elaborately decorated. Autumn is also the time of the caribou hunt when, as we will see, ornamented clothing had ritual importance. In the central Subarctic, Cree people used moose hide for clothing that might also be richly decorated. As in the eastern Subarctic, until the nineteenth century the primary decorative medium was painting with mineral pigments in a palette of red, black, and white.[8] Women also wove, netted, and embroidered dyed porcupine quills to further enrich the collars, shoulders, and cuffs of these coats.

Painted Coats of the Innu: Pleasing the Spirits of Caribou

The distinctive painting style used by the Labrador Innu (the eastern Cree group formerly known as the Naskapi) featured dense bands of parallel lines and the graceful, bilaterally symmetrical scroll motifs that anthropologist Frank Speck termed "double curves" (fig. 1.22). Artists used tools made of bone or antler, some of which had multiple prongs that allowed the artist to produce sets of evenly spaced parallel lines.[9] In a famous study carried out during the 1930s, as the hide painting tradition was ending, Speck reported Innu hunters' belief that "animals prefer to be killed by hunters whose clothing is decorated with designs" and that decoration also pleased the hunter's own inner "soul-spirit." In singing to game animals the hunter would say, "You and I wear the same covering and have the same mind and spiritual strength."[10] An Innu woman's painstaking painting of a caribou-skin summer coat was thus a ritual gesture of respect to the animal spirits and helped to ensure their continued cooperation. Although this principle is articulated particularly clearly in Speck's writing about the Innu, a similar concept probably lies behind traditions of decorated clothing across the North.

The fitted cut and flared skirt of the Innu hunters' painted hide coats is distinctive and differs considerably from other Subarctic clothing (fig. 5.3). Textile expert Dorothy Burnham confirmed the theory that this cut was influenced by gifts of European clothing made by the French to Native people early in the contact period. As time went on, changes in the cut of European men's coats were reflected in Innu clothing—with one significant exception. Burnham's careful analysis showed that the Innu retained the triangular gusset inserted into the back of the coat after flared styles had gone out of fashion and despite the fact that the insert served no functional purpose. She argued convincingly that this was because of its probable

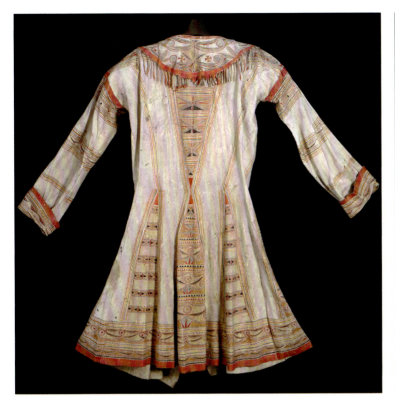

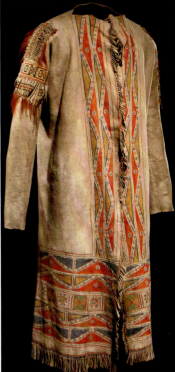

symbolic association with the spiritual being that controlled the animals: "This gusset, which is shaped like a mountain peak, was the symbolic centre of the coat's power and . . . represents the Magical Mountain where the Lord of the Caribou lived and from the fastnesses of which the caribou were released to give themselves to the hunter."[11] Her interpretation complements the explanation Ted Brasser offered for the designs painted on a type of square hide panel used by Innu shamans in rituals performed to the rising sun (fig. 1.22). These designs can be read as conceptual maps of the cosmic zones and spiritual forces that control the seasonal cycles of plant, animal, and human life.

The James Bay Cree: From Painted Geometries to Beaded Flowers

Moving west across the Subarctic, we find related painted clothing traditions. Cree peoples living around James Bay wore brightly painted moose-hide coats featuring bolder geometric patterns (fig. 5.4). It is reasonable to assume that similar beliefs and purposes informed their decoration.[12] Sherry Farrell Racette has located about thirty such coats that date to the late eighteenth and early nineteenth centuries, although few are documented. Made from a single large hide, these coats have a straight, unfitted cut, resembling the coats worn by nineteenth-century Anishinaabeg living around the Great Lakes—and also possibly those worn by Innu before the seventeenth century. A pair of fashion dolls dressed

▲ **5.3** Left: Innu (Naskapi) artist, Northern Quebec, Hunter's summer coat, c. 1805. Caribou skin, sinew, fish-egg paint. Royal Ontario Museum © ROM.

One of the most splendid of the 150 extant painted caribou-hide coats collected in Northern Quebec, this coat illustrates the skills in painting that Innu women put into making clothing that would please the spirits of animals who gave themselves to humans in the hunt.

▲ **5.4** Right: Cree artist, probably Muskegon (Swampy) Cree, northern Manitoba (SFR), *misko taky* (hide coat), early nineteenth century. Moose hide, paint, porcupine quills, hair, 125 × 160 cm. National Museum of the American Indian, Catalogue No. 17/6346; photo by Walter Larrimore.

About a dozen coats of this type, painted with bold geometric designs composed of triangles, circles, and hourglass shapes, are known from the eighteenth and early nineteenth centuries. The artist incised the designs with a sharp tool and then painted them with Native and imported paints. Made of a single thick moose hide and once trimmed with fur, such coats were worn in winter not only by Cree men but also by European fur traders.

to display the typical dress worn by Cree women gives a good idea of the richness of their dress around 1800. Their garments consisted of a hide strap dress (see chapter 3, p. 111–12), leggings, and robe painted with stripes, triangles, and circles; a beaded cloth hood; a wide belt of woven quillwork; and elaborate beaded and quilled chest ornaments (fig. 5.5).

Toward the middle of the nineteenth century, Cree women added floral designs to their decorative repertoire. Cath Oberholtzer's research shows that during the middle decades of the nineteenth century older traditions

▶ **5.5** Eeyou Istchee (James Bay Cree) artist, Dressed dolls, c. 1800. Imported dolls, hide, porcupine quills, paint, cloth, red ochre, beads, and commercially produced dolls, left, 33.5 × 33 cm. Permission of the Cuming Museum, London Copyright Southwark Council, inventory numbers C02337 and C02338.

The dolls in this unique set are of European manufacture and can be dated to 1770–90. Their miniature garments were made by Cree women, probably as a commission for a European curiosity cabinet. They are the only known examples of clothing worn at that time by James Bay Cree women and exactly match the written descriptions of mid-eighteenth-century fur traders.

of porcupine quill embroidery on hide were gradually replaced by glass bead embroidery on cloth. One of the most splendid Cree garments was a type of hood richly ornamented with wide, densely beaded borders of stylized floral designs and a thick hanging fringe of beads strung in the same striped patterns that appear on earlier quill-wrapped fringes (fig. 5.6). Women are recorded as having worn these hoods to church, but other information indicates that they also continued to function as beautiful garments made to please the spirits of animals. Edward Nemegus, who was born about 1867, recalled watching his grandmother "wearing her cap when watching beaver nets and at feasts, when his grandfather sang and drummed."[13]

The return of a fine beaded hood to the Cree Cultural Institute at Ouje Bougoumou in 2012 stimulated memories that further confirm that the ornamentation of women's as well as men's clothing was related to the life-sustaining activities of the hunt: Lily Pepabano recounted an anecdote told by her mother: "There was an elderly lady who made these hoods for members of the community. When one was completed, it was never brought indoors. . . . My mother said that her grandmother wore them while travelling. Even when she was old, she still walked everywhere when on a journey. When they arrived to where the camp was being made, she would walk to a small tree to hang her hood on it. It was only when they left camp again that she would wear it."[14]

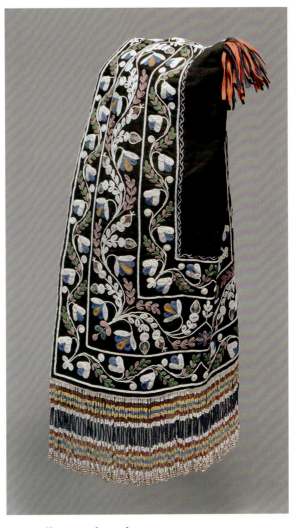

▲ **5.6** Eeyou Istchee (James Bay Cree) artist, Woman's hood, 1840–50. Wool, cotton, glass, 26 × 11 in. Metropolitan Museum of Art 2011.154.92.

This hood, collected by Lord Strathcona (1820–1914), displays the delicacy and continuous, flowing line typical of James Bay Cree floral beadwork. The characteristic separation of the floral motifs into three distinct zones may reflect in a general way the spatial (and cosmological) mapping found in the painted hide robes used by Cree shamans.

Dene Clothing for Protection and Beauty

The Dene peoples of the western Subarctic (known as the Athapaskans in Alaska) made caribou hide clothing of markedly different cut and decorative approach. The principal garments worn by both men and women were long-sleeved tunics and one-piece moccasin trousers. Mitts and hoods completed the outfit (see fig. 5.9). Dene women ornamented these carefully tailored garments with porcupine quills dyed with plant and berry juices. They wove or sewed the quills to form geometric designs and added fine, dense fringing, often threaded with silverberries and wrapped with porcupine quills. Judy Thompson has pointed out that the delicate ochre lines painted around the neck, wrists, seams, and hemline of many garments had practical uses as tailoring marks and waterproofing, and that, because they also seem to mark "vulnerable points" of the body, these ochre borders may also have afforded spiritual protection.[15] A type of quiver made by the Tanaina Dene of Alaska, which was painted in ochre with the images of the animals a hunter desired,

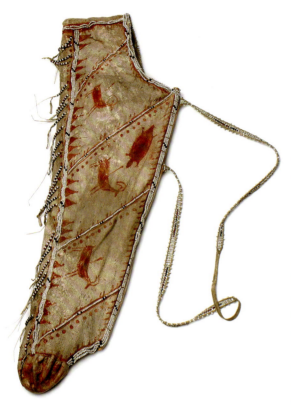

must have been made to honor and please them (fig. 5.7). Like Cree women, Dene artists made a range of ornaments using porcupine and bird quills, animal bones, antlers, teeth, and feathers to complement clothing ensembles. Individuals were buried with their finest ornaments, and there is considerable evidence that they played an important role as ritual offerings and in gift exchanges. One early source suggests that Dene people offered quilled ornaments to the spirits of those whom they had killed in war.

Among the most elaborate products of Dene textile artists were garments and ornaments made for young women to mark their ritual segregation from the community at the onset of puberty. This special dress and the other rituals observed at this time offer further insight into the high value placed on a woman's capacity to create rich ornaments for ritual and personal adornment. In traditional belief systems, the great power that manifests itself in women during menstruation (and especially at its first occurrence) can interfere with a hunter's success.

▲ **5.7** Tanaina (Dene) artist, Quiver, before 1841. Beads, unsmoked skin, red ochre, feathers. Musée d'ethnographie de Genève, MEG Inv. ETHAM K001564.

This is one of several Dene quivers dated to the first half of the nineteenth century that displays animals painted in red ochre. The ornamentation of hunting equipment with animal representations may have been a means of honoring the animal spirits. The use of symbolic abstract patterns for such purposes is, however, more typical of Dene art.

Women therefore segregated themselves from their communities monthly during their childbearing years and for a prolonged period at puberty. This initial period of seclusion was a time for perfecting the sewing skills a girl had started to acquire during childhood. In 1983 Mary Wilson recalled her own experience many decades earlier:

> *Then you are introduced to sewing—crafts like embroidering, sewing with porcupine quills, and beading . . . a very talented woman is chosen to start the first stitching. It seems like how you did during that time was the formation of your life as an adult . . . Nothing was written or read, everything was oral, but even today I still remember all that was told to me when I, too, had to go through that phase of life, when I stepped into womanhood.*[16]

Here as in other regions of North America where menstrual seclusion was practiced, the monthly periods of withdrawal provided opportunities for women to meditate and dream, to think creatively about ornamentation, and to work uninterrupted at sewing projects (see chapter 4, pp. 132–35).

An incident reported by Samuel Hearne (1745–92), one of the first Europeans to travel across the western Subarctic, provides still further evidence of the antiquity of clothing arts and their profound connection to female creativity. In 1772 Hearne came across a young Dene woman living on her own in the bush. Having escaped a Cree attack, she had lived for seven months through the long Subarctic winter, feeding, sheltering, and clothing herself. Hearne was most impressed, however, that, living all alone, she had exerted herself to make her clothing beautiful. "It is scarcely possible to conceive that a person in her forlorn situation could be so composed

as to contrive or execute anything not absolutely essential to her existence. Nevertheless, all her clothing, besides being calculated for real service, showed great taste, and no little variety of ornament."[17] Few incidents reveal so dramatically the differences between European and Native worldviews, or the importance of clothing as a vehicle of ritual-aesthetic expression in the lives of Subarctic people. The young Dene woman created beauty for herself and for a world animated by other nonhuman presences. She would also have been accustomed to taking advantage of solitude as an opportunity for artistic creativity.

The combined effect of women's clothing arts and the elaborate body decoration devised by wearers was vividly evoked in the inventory of the dress worn by young men of the Dene Slavey nation recorded by a German fur trader named Wentzel in 1807:

> [They] tie their hair, wear ornaments, such as feathers, beads in their ears, and paint or tattoo their faces. . . . Around their head, they wear a piece of beaver, otter or marten skin decorated with a bunch of feathers before and behind. . . . Their robes and capotes are ornamented with several bunches of leather strings garnished with porcupine quills of different colours, the ends of which are hung with beaver claws. About their neck they have a well-polished piece of caribou horn, which is white and bent around the neck; on their arms and wrists they tie bracelets and armbands made also of porcupine quills; around their waist they have also a porcupine quill belt curiously wrought and variegated with quills of different colours.[18]

Wentzel's presence in the North in the early nineteenth century, however, heralded the great changes that were soon to occur in the western Subarctic and that had already affected the eastern Cree as a result of the arrival of fur traders and missionaries. As elsewhere, Subarctic artists immediately saw the potential of the glass beads, trade cloth, and metal tools the traders offered. While traders actively encouraged the new taste for imported goods in order to ensure their own access to furs, they found the Dene to be extremely demanding customers who would trade only for certain qualities and colors. As elsewhere, traders adopted such strategies as presenting the most important hunters with full suits of clothes and "chief's coats."

Depictions of the tattooing mentioned by Wentzel, and the engraved designs found on weapons, amulets, and antler ladles and armbands made by Dene men during the early-contact period show abstract patterns of spurred lines, triangles, and hatching. Scattered but highly suggestive evidence links some of these designs with representations of animal spirits. One late nineteenth-century observer, for example, affirmed the "symbolical" meanings of certain stylized bone carvings and provided a drawing of one "intended to represent a beaver." "It will be remarked," he commented, "that the design is highly conventionalized. Yet even a child [of Dene parentage, of course] will recognize at once its significance."[19] Missionaries and other outsiders regarded tattooing and traditional body decoration as uncouth and "pagan," in part, perhaps, because they understood these sacred significations and were actively trying to discourage or suppress them. By the end of the nineteenth century they had largely succeeded.

During the second half of the nineteenth century the new floral design vocabulary introduced by fur traders and missionaries rapidly gained popularity, as it had a few decades earlier in the eastern Subarctic and Woodlands (fig. 4.22). The movement of Red River Métis from Manitoba into the region in the 1880s swelled the numbers of already resident Métis who were descended from unions between fur traders and Dene women. The newcomers brought with them a refined and highly accomplished floral style executed in silk embroidery and beadwork, and they introduced distinctive styles of bags (such as the eight-tabbed "octopus" bag) and tailored garments (such as a short, straight-cut man's jacket with a front opening and fringed shoulder panels). Another important development that had an impact on Indigenous artistic traditions was the establishment of schools by teaching orders of nuns. The Grey Nuns opened their first school at Fort Chipewyan in 1849. Here and at other institutions Aboriginal girls were given instruction in needlework and floral design.

It would be a mistake, however, to think of the transition to these new styles and object types as uniform or stylistically homogeneous. Artistic traditions changed most rapidly in areas close to fur trade forts; elsewhere, older types of objects and ways of making clothing remained unchanged for much longer. Distinctive regional beadwork styles replaced the regional styles of clothing and quillwork that preceded them; this stylistic specificity has become the subject of systematic art historical study by Kate Duncan, Judy Thompson, and others. Duncan's research has shown, for example, how Dene beadwork designs are built of a relatively small number of "core" motifs that are elaborated, multiplied, and recombined in a seemingly endless variety according to local preferences and historical patterns of development.

Dene also invented some entirely new object types that exploited the color and texture of trade cloth and beads. Although floral beadwork appears to contrast radically with earlier decorative styles, it continued to express aspects of traditional Subarctic worldviews and to fulfill traditional functions in Dene social and ritual life. From the Métis, the Dene adopted a type of dog blanket, densely decorated with floral designs. These blankets were made in sets to adorn the dog teams that pulled toboggans loaded with a family's equipment and furs along the trap lines and into trading posts (fig. 5.8). These seasonal gatherings were occasions for family hunting groups not only to trade but to come together for sociability and ceremony. The highpoint of Tlicho (Dogrib) visits to a trading post was the performance of the Tea Dance, a traditional round dance that remains the quintessential expression of the community's identity and unity. Tlicho elder Elizabeth Mackenzie emphasized the role that finely quilled and beaded clothing plays at times of gathering in enhancing and enriching the dance. Looking at a reproduction of a watercolor portrait of a finely dressed young Tlicho man made in 1826 by George Back during the first exploratory voyage to Tlicho territory, she commented: "That person dressed in good hide clothing . . . is shown as a young man. When he hears the drum and when he sees the people dancing, that person is going to want to dance. He's not going to think of the way he's dressed, the way that he appears, or of bad times. He is going to celebrate and join the dance."[20]

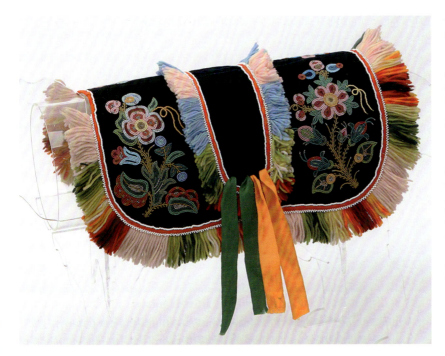

Gwich'in (Kuchin) artist, Great Slave Lake-MacKenzie River area, Dog blanket, before 1912. Velvet, seed and metal beads, L. 46.5 cm. McCord Museum of Canadian History, Accession number: ME966X.111.1.

The arrival of a dog team with its load of furs at a trading post was the occasion for a special visual display enlivened by the musical jingling of sleigh bells. Families stopped before reaching the fort to dress themselves, their dogs, and their carioles with ribbon streamers and gorgeously beaded clothing and trappings.

Though much has changed for Subarctic peoples since those first years of European contact, the importance of making beautiful clothing continues. When they ornament jackets, moccasins, and baby belts with floral beadwork, Dene textile artists pay tribute to husbands and family members and to the land and its gifts to humans. Today, contemporary Dene also work with museum curators to recover the knowledge of old styles of quilled hide clothing that went out of use in the early twentieth century. Between 2000 and 2002 the Gwich'in Social and Cultural Institute worked with museums to replicate a man's summer caribou skin outfit in the Canadian Museum of Civilization's collection.[21] Museum specialists contributed the patterns they had created from examples preserved in museums and Gwich'in experts shared their knowledge of how to prepare hides, silverberries, quills, and other materials. Together they made five new outfits, one for each of the five Gwich'in villages in the Northwest Territories of Canada (fig. 5.9).

As Ingrid Kritsch and Karen Wright-Fraser wrote, for contemporary Gwich'in, "these items represent a bygone era and have great historical, cultural and sometimes spiritual meaning."[22] Yet it is also important, when thinking about Dene and Athapaskan visual arts, to remember the broader ways in which these communities think about their own expressive culture. Working with a Tuchone elder who made small soapstone carvings, Julie Cruikshank reported the enfolding importance of story and narrative to which visual arts serve as adjuncts. Interviews with Mrs. Kitty Smith, she urged, "suggests that it is *spoken words* which are primary, and that material objects essentially provide illustrations for particularly meaningful stories."[23] Recalling a beadwork demonstration she had done at the University of Alaska museum, Athapaskan elder Poldine Carlo pointed out that although she had mastered beadwork, she had never mastered another very important

▲ **5.11** Old Bering Sea style, Alaska, Semiabstract engraved patterns on a harpoon head, c. 100–400 C.E. Smithsonian Institution.

harpoon heads, shafts, and winged counterweights. Sinuous designs in semiabstract style cover the surfaces of these objects, suggesting modern hunters' belief that animals allow themselves to be caught by beautiful implements is an idea of great antiquity (fig. 5.11).

At Ipiutak, a thriving community of several hundred households on the shore near Point Hope, Alaska, numerous carved and ornamented tools were found within the households, while burials of great hunters or shamans contained ceremonial replicas of tools; amulets of bears, walruses, and loons; and unusual interlocking chains carved from a single walrus-ivory tusk. The most famous work of art from Ipiutak is a multipart mask laboriously carved in ivory, on which low-relief animal heads are combined with the incised circles and curving lines that ornament so many tools and sculptures from the Norton tradition (fig. 5.12; see also the Issue in Focus box in chapter 1, "Who Owns Native Culture?"). Characteristic of Norton carving,

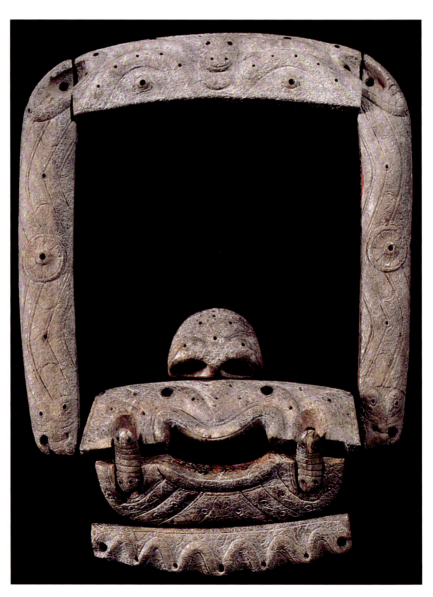

▶ **5.12** Ipiutak culture, Point Hope, Alaska, Burial mask, c. 100 C.E. Ivory. The Bridgeman Art Library International and Werner Forman Archive, American Museum of Natural History.

Numerous heads and eyes animate the mask. Even the down-turned mouth with jet inlays representing labrets (ornaments that pierce the lip) reads as an upside-down face. This ivory mask may have had wood or other perishable materials covering the cheeks and eyes of the wearer.

as exemplified by the Ipiutak mask, is what has been called its "polyiconic nature."[25] A seal's head morphs into another form; seemingly abstract designs emerge as stylized faces and heads. This is true of Dorset carving as well and persists in both Arctic and Northwest Coast carving styles to the present (figs. 1.25 and 6.7).

The Dorset people of the Canadian Central Arctic carved fewer items, and they were done with a rough, expressive naturalism in contrast to the luxurious elaboration of the Old Bering Sea peoples. The polar bear seems to have been the predominant animal in Dorset ideology; ivory carvings of swimming polar bears, with incising marking its skeletal structure (in a shamanic type of x-ray vision, perhaps), are found in diverse regions of the Canadian Arctic. More items of wood, antler, and stone carving occur here than in the Alaskan Arctic, including masks, articulated wooden figurines, birds, and horned men and objects covered with clusters of little faces. When we think of the skill needed to carve antler, ivory and stone without the benefit of metal tools, we can appreciate the strength of the artists' determination to bring forth these spirited beings from formless matter. As a lamp used to burn seal oil to bring warmth and light to a winter igloo found at Kachemak, Alaska, shows, even such a mundane object might harbor an animating spirit (fig. 5.13).

After 1000 C.E., another group of Eskimoan peoples, known as the Thule, emerged from the Bering Sea region and quickly spread from west to east across the Arctic. In the East, where Dorset people had been isolated from their Bering Sea relatives for as long as a millennium, the Thule immigrants quickly displaced or absorbed them. They also encountered and traded with the Norse who arrived in Greenland, Labrador, and possibly further west. A Thule artist's small figurine of a man wearing a long European coat and displaying a cross on his chest stands as an eloquent testimony to these first contacts between Europeans and Indigenous North Americans (fig. 5.14). Thule people were successful whale

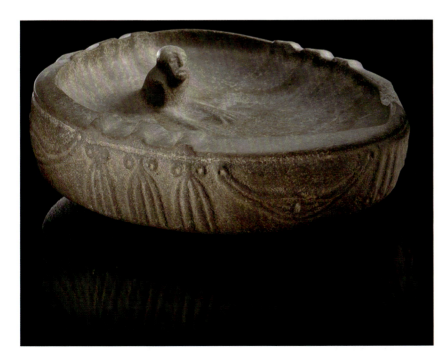

◀ **5.13** Cook Inlet, Kachemak, Alaska, Lamp, 500–1100 C.E. Stone, 42 × 37 × 15 cm. National Museum of the American Indian, Collected by Anderson Ankehl, Accession no: 04/9236, Photo by Ernesto Amoroso.

The Alutiiq (Pacific Eskimo) people who painstakingly carved this lamp lived in sod-covered plank houses with central stone fireplaces. Such a lamp could have been used in one of the work areas where they rendered oil and butchered meat during the cold of winter, or on one of the sitting and sleeping platforms where elders told stories about spirits such as this one, rising from the pool of seal oil that illuminated long winter nights.

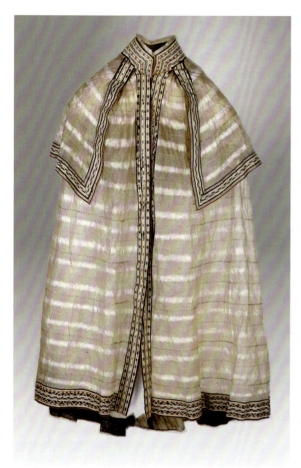

While such garments were refined and modified over the centuries, some of the most dramatic modifications took place in the late eighteenth and nineteenth centuries. When trade beads became available, women here, like those across lower regions of North America, adeptly incorporated them into a traditional repertoire. Beaded parkas became popular in the Hudson Bay region in the nineteenth century and remain so today (see Artist in Focus box, fig. 5.19). Lightweight fur-trimmed cloth parkas, or parka covers, called "Mother Hubbards" became popular in Alaska early in the twentieth century and are still worn. In the last few decades, fine work in skin and hide has been revived all across the north, as young women realized that a vast storehouse of technical knowledge was in danger of dying out with their grandmothers.

Among the most Ingenious uses of animal products for human clothing is the working of gutskin—the tough, dense inside layer of walrus or seal intestine—for waterproof garments (see Technique in Focus box). The Aleut are especially well known for their parkas made of gutskin, but these were made and worn by Siberian and Alaskan Eskimos as well. Extraordinarily flexible, and weighing just a few ounces, the gutskin parka or *qas'peq* could be worn over a regular fur parka when extra protection was needed. Constructed by seamstresses to protect their male relatives while hunting in icy waters, some gutskin parkas were made to be lashed to the opening of the kayak to form an impenetrable barrier protecting both the wearer and the boat's interior, even if the kayak rolled. Women would themselves wear gutskin parkas, not only for rain protection but also to protect their clothing while butchering animals. A late eighteenth-century innovation was the gutskin cape, tailored in the style of a Russian Navy officer's greatcoat (fig. 5.17). Heavy water-logged wool made these explorers miserable, but the innovative waterproof cape could be worn over their woolens. There was evidently a prodigious trade in such capes in the nineteenth century, reflecting the merging of an effective Indigenous technology with an introduced clothing form to produce an object widely traded and admired. Today, some Aleut, Yup'ik, and Iñupiaq women still work with gutskin.

Skin and hide clothing, like ancient ivory artifacts, signaled the importance of animals and their powers in the human realm. As Valerie Chausonnet has noted:

> *Animal skin, transformed into a second skin for humans by the work of the seamstresses, still maintained its animal identity. From the killing of an animal through the tanning, cutting, and sewing of its skin into a piece of clothing, the qualities and characteristics attributed to it in life were maintained and passed*

TECHNIQUE IN FOCUS
Working with Gutskin

In their exploration of the materials provided by animals for human use, Arctic seamstresses long ago learned that sea mammal intestines could be exploited for their waterproof and windproof properties. Intestines of the beluga whale and the walrus make the strongest rain garments, though bearded seal and walrus guts are used, too. In the photo, Yup'ik seamstress Frances Usugan grasps the yards of intestines—about fifty feet from one seal—she has cleaned and inflated into one continuous tube. Her next step will be to split the material into long strips, cutting carefully along the thicker side of the intestine, so that the seam can be sewn where the material is thick and stretchable. The seamstress distinguishes between *mingqeqluki,* "sewing with an overcast stitch," and the more specialized *iqerrluteng,* "sewing a waterproof seam."[31] The latter is sewn with two sinew threads, a running stitch, and a lining of coarse seashore grass inside the seam. Of this grass reinforcement, Theresa Moses observed, "We prepare *tapermat* [seashore grass] by removing the hard parts in the grass's center. When you come to the end of a piece of grass while stitching, you would add another piece of grass and let it continue, measuring it so it doesn't get too thick. The grasses in fall and those picked in spring, when the ground first thaws, are usually stronger."

Yup'ik women sometimes narrate in dance and song the making and use of a gutskin garment, and how it successfully protected its wearer, who brought home much good food while wearing it. Perhaps the nineteenth-century Aleut artist, too, shared her delight and her knowledge in a similar fashion (fig. 5.17).

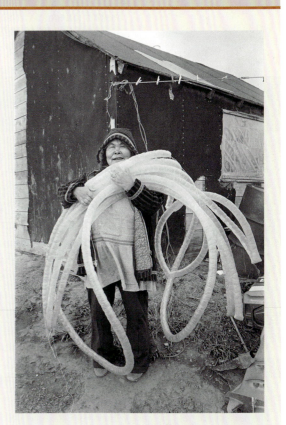

▲ **5.18** Frances Usugan with inflated seal gut, 1980. Tooksook Bay, Alaska. Photograph by James Barker.

on to the wearer of the finished garment. This important spiritual principle linked animals, hunters, and seamstresses together in an intricate and circular set of relationships.[32]

Male hunters procured the animals and female artists transformed them into clothing that was both physically and spiritually protective. Moreover, respect for the living animals also dictated respect for each of its component parts after death. Rita Pitka Blumenstein (b. 1936), a Yup'ik elder, artist, and healer, relates:

> *In respect for the fish and the seal, you use every bit of it: the head, the insides, the bones, and the skin of the fish. And then whatever we don't eat goes to the dogs. The bones go back to the river or the lake, wherever you caught it from. If they're from the ocean, you take them there. That will ensure more fish in the next years. If it's a seal, same way. The bladder goes back to the sea. The seals will come back. You bury the bones near the sea so you won't find them floating all over the beach. I appreciate very much the respect for things when I was*

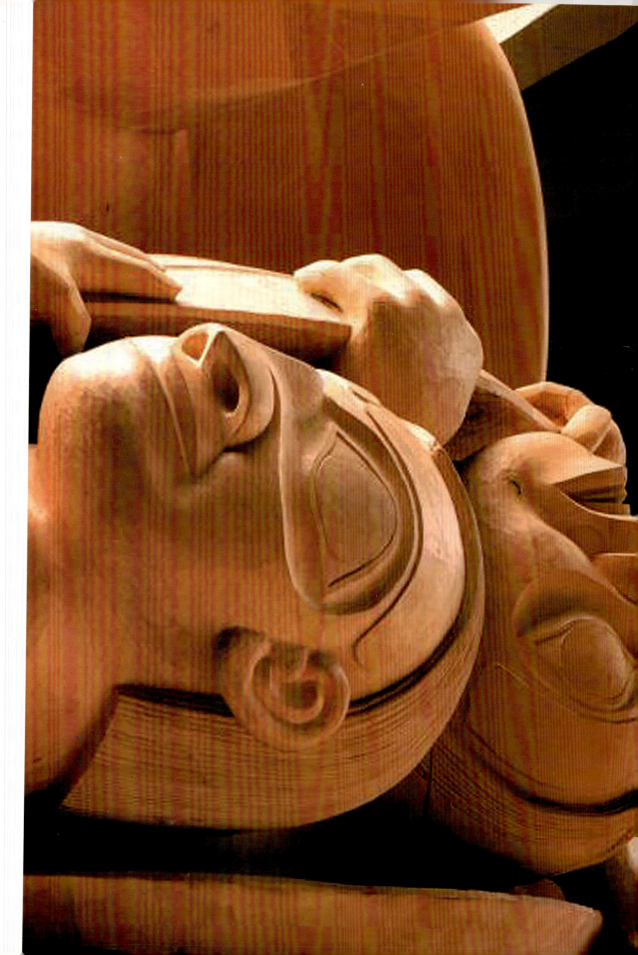

THE NORTHWEST COAST

6

Bill Reid's monumental sculpture *The Raven and the First Men* portrays the Haida culture hero Raven in the act of discovering the first human beings inside a clam shell (fig. 6.1). In a typically tricksterish act, Raven opens the shell and coaxes the little beings out into the world. In due course, to add to the interest of his experiment, Raven flings chitons[1] at the groins of these first men, and out of this encounter come the men and the women who are the ancestors of humankind. In Reid's representations of ancient Haida truth, people emerge, by virtue of Raven's curiosity, not, as in the Judeo-Christian tradition, into a perfect Eden which they must forfeit for their own sin of curiosity, but directly into the mixture of wonder, confusion, pleasure, and pain that characterizes life on earth. Reid has written evocatively of these first Haida and the world they made:

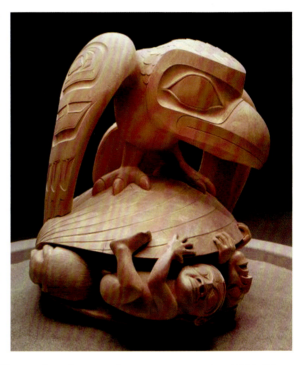

▲ **6.1** Bill Reid (1920–98), Haida, *The Raven and the First Men*, 1983. 1.9 × 1.9 m cedar. UBC Museum of Anthropology. Photo © Bill McLennan.

Reid used Northwest Coast formline style with equal versatility in the miniature scale of jewelry and the monumental scale of public sculpture. In one of his best known works, he exploited the expressive capacities of Haida art to imagine the emotional responses of the first humans as they emerged from a clam shell on to the surface of the earth.

> *No timid shell dwellers these, children of the wild coast, born between the sea and the land, to challenge the strength of the stormy North Pacific and wrest from it a rich livelihood. Their descendants would build on its beaches the strong, beautiful homes of the Haidas and embellish them with the powerful heraldic carvings that told of the legendary beginnings of the great families, all the heroes and heroines, the gallant beasts and monsters that shaped their world and their destinies. For many, many generations they grew and flourished, built and created, fought and destroyed, lived according to the changing seasons and the unchanging rituals of their rich and complex lives.*[2]

In Reid's masterpiece the central image is of the trickster, the "huge and cocky Raven squatting possessively over his prize," as Doris Shadbolt has described him.[3] It sets before us two key aspects of Northwest Coast worldview and art: a strong sense of the paradoxical nature of the human condition, and an awareness of the possibilities for transformation hidden within the mundane. The unanticipated and remarkable resurgence of traditional

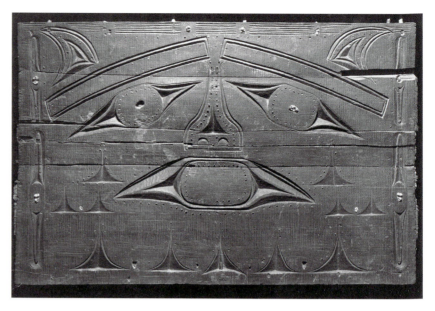

▶ **6.5** Makah artist, Ozette site, Washington, Side panel from a carved chest, sixteenth century. Western red cedar. Makah Museum, Neah Bay, Washington. Photo by Mike Short courtesy of Ruth Kirk.

The panel from a kerfed box found at Ozette represents the "archaic" relief carving style used by peoples of the central coast and Vancouver Island before the mid-nineteenth century. In this style, in contrast to that of the north, the eyebrows and mouth are more squared off, the ovoid of the iris more rounded, and the features are accented by deeply excavated triangle and crescent forms.

before contact. The site, known as Ozette, is on Washington's Olympic Peninsula, on the land of the Makah. Sometime around 1500 C.E., a mudslide covered part of a village, preserving from decay four plank houses and over 50,000 objects, including many made of perishable materials such as wood and basketry that would not ordinarily have survived. The larger carved objects from Ozette include wooden boxes, a large bowl carved in the effigy of a human being, whale-bone clubs, and weavings (fig. 6.5). They revealed the existence by 1500 (and undoubtedly many years prior to that) of an elaborate inventory of decorated objects on the south central coast and of highly refined artistic styles which varied within a single community, as they have in historic times, from abstract to naturalistic modes.[9] Archaeological research on the northern coast has also revealed the use of figurative effigies during the first millennium B.C.E., some depicting animals familiar from historic-period art and oral tradition, such as the raven. According to George MacDonald's archaeological research,[10] by about 1000 C.E., all the main stylistic elements and object types of historic northern art were already in place.

The Early Contact Period

European explorers began to visit the Northwest Coast during the late eighteenth century, two centuries after Native-European contact had begun on the Atlantic Coast. An active trade rapidly developed up and down the coast organized around the market for sea otter pelts, which the merchant captains could sell in China at enormous profit. Preservation of the oldest examples of postcontact art is owed to these explorers and traders, many of whom participated in the period vogue for the collecting of "curiosities." Some of the most important information comes from the systematic collections made by scientific expeditions like those of Captain James Cook (1778) and Captain Alejandro Malaspina (1791). Cook, who visited the Nuu-chah-nulth in 1778, made the single largest extant collection, now housed in several

European museums.[11] It contains examples of blankets (some of which may be Salish), hats, combs, rattles, carved wooden heads and masks (some of which may be Kwakwaka'wakw), whalebone clubs, and other weapons.

The resemblances between many of the Cook pieces collected on southern Vancouver Island and those uncovered at Ozette are striking, and they attest not only to the close cultural links between the Makah and the Nuu-chah-nulth but also to the stability of the arts and cultures of this region over more than three centuries. The strength of these traditions can be appreciated by imagining a parallel: a Makah explorer arriving in Siena in 1778 and finding people creating art in the mode of Renaissance artists like Donatello or Botticelli, rather than in the Rococco style that had developed. The early expeditions also left us sketches and watercolors that offer precious glimpses of house interiors and of the visual arts that enriched everyday life, such as figuratively carved houseposts, basketry, weaving, and finely carved wooden storage boxes. The collections and descriptions of the late eighteenth and early nineteenth centuries do not, however, present a complete record of the visual culture of the Northwest Coast because the traders were not normally present during the winter when the most important ceremonies took place, and most therefore missed the masked performances and displays of crest art presented at that time.

The trade in sea otter fur that lasted until about 1810, the commerce in land-based fur that went on until the end of that century, and increasing white settlement introduced into the life of the Northwest Coast a mixture of new conditions that rapidly destabilized cultural patterns of long standing. Most radically and most tragically, death from disease on a scale never before experienced affected all parts of the coast during the late eighteenth and the nineteenth centuries. Within a hundred years the population declined by over 80 percent, from an estimated 200,000 at contact to only 40,000 around 1900. It is hard to imagine, here as for other regions of North America, the sheer extent of the loss or its effects on the survivors. Disease killed many people who held cultural knowledge and who would normally have inherited important rank and privilege, leaving more distant relatives to succeed. At the same time, the fur trade made easier and faster the process of accumulating the goods needed to hold potlatches (the great feasts where a high-ranking or chiefly family's powers are publicly acknowledged). The cessation of warfare and the greater numbers of marriages between members of different nations also created new needs for the performance of rituals and related displays of art and cultural property that are necessary to the legitimation of wealth and status on the Northwest Coast. Together, these various factors probably led to more lavish and more frequent potlatches than had previously been held, fostering misconceptions and engendering hostility among white settlers. As we will see, potlatching soon came into such direct conflict with the Victorian values of the colonists that the Canadian and American governments sought to suppress it entirely, in Canada by the passage of a law in 1885 (see chapter 1).

Yet for much of the nineteenth century, trade and contact also created the conditions for an extraordinary artistic creativity in this region following a pattern seen elsewhere on the continent at similar historical

flowing contour whose width widens and narrows as it changes direction and encounters other lines. Subsidiary design areas are linked by a red "secondary formline," and a third infilling of negative spaces between the two formlines may be added and painted blue or blue-green. The tertiary lines are often carved out in shallow relief. Research by Bill McLennan also shows that a great deal of painting was done freehand.[15] Holm concluded that, even when an artist was making a three-dimensional object, such as a box, a spoon handle, or a totem pole, he first conceived of the design in two dimensions and then mentally "wrapped" it around the three-dimensional surface before carving it out in relief. It is particularly easy to visualize this process in relation to the design of decorated bowls and boxes used for feasts and for storing important possessions, which constitute one of the most important genres of Northwest Coast art. A box is constructed from a single plank into which wedge-shaped cuts, or kerfs, are made where the corners will occur. The plank is then steamed, bent at right angles, and sewn with spruce root along the open edge. In formline-style art, the two sides of a being may be displayed on opposite sides of a bowl or a box, or laid out as mirror images on a flat surface according to a characteristic convention known as "split representation" (fig. 6.22, far right).

The monotony that might result from the strict limitations that the formline style imposes on practitioners (who were, up until the twentieth century, men) is avoided by a number of other design strategies also identified by Holm. For example, although compositions are largely symmetrical, the Northwest Coast artist characteristically avoids both absolutely parallel lines and true concentricity in the placement of ovoids and other forms. He also calibrates nicely the curving shapes of his design units and formlines to fall between the extremes of angularity and curvilinearity. The formline style is a highly disciplined mode of graphic representation that eliminates all extraneous elements. Yet it also lends itself to subtle invention and variation. The hands of individual artists can be detected by attending to such details as the precise degree of off-centeredness with which the artist avoids an exact concentricity in the placement of the pupil within the eyeball, or in the subtle differences in the ways in which each artist proportions and contours his U-forms, ovoids, and formlines. The study of individual artists' styles is an area of expanding research among Northwest Coast artist and scholars.[16] Building on Bill Holm's work, Peter Macnair, Robin Wright, Bill McLennan, and Lyle Wilson have made signal contributions, clarifying the bodies of work that can be attributed to artists active in the late nineteenth and early twentieth centuries such as Charles and Isabella Edenshaw (see Artists in Focus box), Simeon Stilthda (ca. 1799–1889), John Gwaytihl (ca. 1820–1912), Tom Price (ca. 1860–1927), John Robson (1846–1924), Willie Seaweed (1873–1967), and Charlie James (1870–1956).

The limited number of basic design units also gives rise to a characteristic representational feature of Northwest Coast art. Because the same or similar design units are used for different body parts—a U-form for a fin or a tail, an ovoid for an eye or joint—the style lends itself to the creation of visual puns in which a particular form can be read simultaneously as

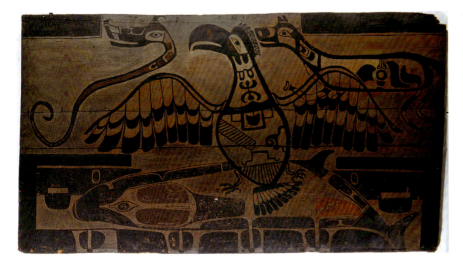

◀ **6.9** Nuu-chah-nulth artist, British Columbia, House screen, c. 1850. Wood, 298.5 × 173.1 cm. Image #3730, American Museum of Natural History, Library.

This famous screen, displayed at potlatches and other important occasions, contains a central image of Thunderbird catching Killer Whale, with Wolf and Lightning Snake in the upper corners. It represents an Opetchesaht (Nuu-chah-nulth) chief's crest story of an ancestor's encounter with a supernatural being while checking his salmon traps.

part of two different, overlapping images. Northwest Coast artists have exploited this capacity to the full, using it to play on fundamental philosophical perceptions of structural dualities, the deceptiveness of appearances, mythic processes of transformation, and the paradoxical coexistence of two truths at a single juncture of time and space.[17] The contemporary Haida artist Robert Davidson speaks of the explorations of fundamental cosmological principles that occur in the working out of formline compositions. He has described, for example, his conversations with apprentices while creating an important housefront painting: "All the time we were working on it, I stressed the importance of space, how one line relates to another line, or how the ovoid related to the U-shape, or how the ovoid relates to the space around it, and I talked about the balance, and how fragile things were"[18] (fig. 7.24).

The earliest objects that can firmly be identified as coming from the Kwakwaka'wakw and Nuxalk of the central coast were collected in the mid-nineteenth century, and these show an extensive use of the conventions of the formline style. Yet archaeological evidence suggests that the arts of the central province were formerly more like those of other Wakashan speakers such as the Nuu-chah-nulth. In two-dimensional painted designs this "archaic" style, which is still evident in Coast Salish and Nuu-chah-nulth art, displays tendencies toward elegant simplifications of form that can verge on abstraction (fig. 6.9). In many three-dimensional objects, this art displays more angular transitions of plane and a tendency to flatness that contrasts with the deeper relief characteristic of more northerly carving traditions. Although ovoids and U-forms are present in southern province art, their use is more limited and they tend to be realized as more regular geometric forms. Other characteristic linear motifs, such as crescent and "T" shapes, are, however, important design elements, incised into surfaces to define facial features and limbs and used decoratively in repeated groupings (fig. 6.5). In his analysis of northern coastal arts, Holm also identified "slits" and "resultant forms" that occur in between the main design units as important

▶ **6.25** Lawrence
Paul Yuxweluptun, b. 1957
(Cowichan-Okanagan),
*Scorched Earth, Clear-cut
Logging on Native Sovereign
Land, Shaman Coming to Fix*,
1991. Acrylic on canvas,
196.6 × 276.5 cm. National
Gallery of Canada, Accession
number: 36950 © Lawrence
Paul Yuxwelupton.

Yuxweluptun uses the formal
vocabulary of traditional
Northwest Coast painting in a
highly innovative way to make
contemporary works that
address such issues as the
appropriation of Native lands
and the despoiling of the
environment. In this painting,
whose bitterly ironic title
refers to destructive logging
practices, the figure of a
shaman is symbolized by the
wearing of a traditional
swaixwe mask.

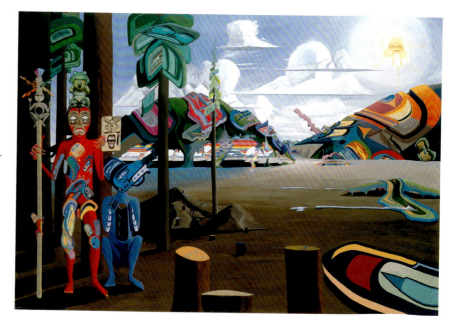

Some of these pipes depict Europeans and portions of their ships. Free-standing European figures were also made. Round and oval platters ornamented with floral motifs and compass work testify to the interest Haida artists took in foreign decorative arts, including the machine-pressed glass plates manufactured in Sandwich, Massachusetts, in the mid-nineteenth century that arrived on the New England sailing vessels. Ornamental gun fittings, carved wooden and meerschaum pipes, and sailor's scrimshaw all provided other points of departure for Haida artists.

After the 1860s, however, when the normal outlets for the visual representation of crest stories and other traditional images were closed off, the imagery of argillite carvings began to change further. Haida carvers continued to carve elaborate plates, platters, and candlesticks that imitate the contours of European china and metalwork, but they began to add figures from traditional Haida stories, many of which had not previously been depicted in a fully narrative manner. The popular story of the Bear Mother, for example, which tells of a woman kidnapped by a supernatural bear who bore twin half-bear children, is associated with a crest belonging to Tsimshian families. The story is represented on totem poles as a single figure, usually of a bear with some human attributes. Depictions of the story in argillite are much more explicit and expressive; in one figure the Bear Mother's pain as she nurses her half-bear children is vividly shown in the expression on her face.[43] Carvers also used argillite to make miniatures of totem poles and other ceremonial objects they could no longer carve at full size. These were avidly collected by the tourists who stopped at Haida Gwaii on the newly popular boat trips, but they also served important needs of the Haida themselves, keeping traditional stories and art styles alive. Indeed, one of the greatest carvers of the Victorian period, Charles Edenshaw, made some of his finest works in argillite (fig. 6.26). The legacy he and other late nineteenth-century artists left proved critical to the twentieth-century revival of Haida art.

ARTISTS IN FOCUS
Charles and Isabella Edenshaw

In 1885 a traditional marriage was celebrated at the Haida village of Massett between Qwii.aang and Da.a xiigang. After a second, Anglican ceremony, they became known as Isabella and Charles Edenshaw, two of the most famous names in the history of Northwest Coast art. Isabella (1858–1926) was an expert weaver of hats, baskets, and mats; Charles (1839–1920) painted flowing crest designs on his wife's hats and produced a corpus of works in argillite, wood, and silver that remain consummate examples of classic Haida art.

The lives and arts of Qwii.aang and Da.a xiigang illustrate the new relationships between traditional and modern art practices that artists working at the turn of the twentieth century were compelled to negotiate. On the one hand, the drastic decline of the Haida population caused by the epidemics of the 1860s destabilized Haida communities at the same time that the 1884 law prohibiting the potlatch removed the traditional ceremonial context for art. On the other hand, the new economic opportunities offered in the late nineteenth century by the arrival of the canneries, tourists, and ethnographic collectors created new outlets for traditional arts and crafts. The Edenshaws entered these new art worlds well trained in traditional arts. Charles's father, a famous canoe carver, died during his youth, while Isabella's parents and other relatives died during a smallpox outbreak when she was eight. Both were adopted into the household of Chief Albert Edward Edenshaw, an artist and leader of the Haida community at Massett (fig. 6.6).

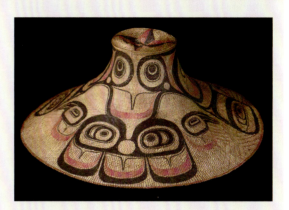

▲ **6.27** Isabella Edenshaw, c. 1858–1926 (Haida) and Charles Edenshaw, c. 1839–1920 (Haida), Clan hat, late nineteenth century. Cedar fiber and paint. Image 7954 courtesy of Royal BC Museum, BC Archives.

The Edenshaws entered the cash economy in various ways, traveling widely up and down the coast in the spring and summer. As their daughter, Florence Davidson (1896–1993), recalled, "What my mother wove all winter long she sold in June when we went to the mainland to work in the canneries. She sold her work at Cunningham's store in Port Essington. She used to get five dollars for a finely woven, painted hat. Mr. Cunningham paid her cash for her work and she bought our winter coats there."[44] Charles was unusual in being able to work full time as an artist. From Juneau and Ketchikan in Alaska to Victoria, British Columbia, he acquired commissions and sold his miniature totem poles, dishes, and platters in argillite and wood, his engraved silver bracelets, and his carved wooden masks and models. Like all great artists, the Edenshaws reinterpreted artistic traditions in individual ways. Charles painted a characteristic red and black four-pointed star on the top of Isabella's hats (fig. 6.27), and Isabella's "signature" is found in her characteristic use of four-ply twining—a four-strand braid finishing technique on the brim edge—and the raised concentric diamond pattern she wove on the brim.[45]

Charles used market arts and commissions as a way to preserve stories and oral traditions that could no longer be publically recited. He engraved on silver bracelets crest designs formerly worn as tattoos. He used the surfaces of argillite boxes and platters to give visual expression to Haida oral narrative, thus innovating a new pictorial use of formline design. Bill McLennan has pointed out the animation and liveliness of these scenes and the mastery with which Da.a xiigang combined negative with positive spaces

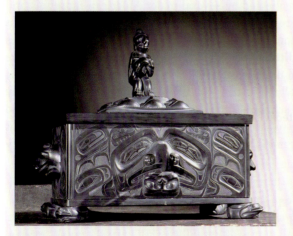

▲ **6.26** Attributed to Charles Edenshaw, 1839–1920 (Haida), Raven Transforming into Human Form while Standing on the Clam Shell with the First Humans Emerging. Argillite, 45.5 × 30 × 37 cm. Werner Forman Archive, The Bridgeman Art Library International.

(cont.)

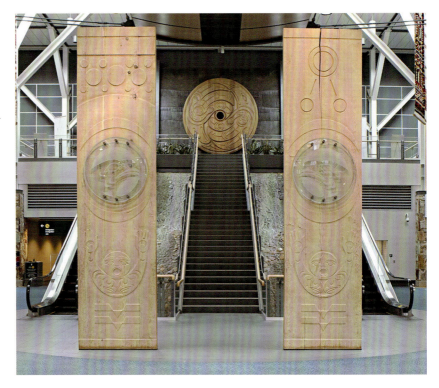

▶ **6.29** Susan Point, b. 1952 (Musqueam), Welcome area, Vancouver International Airport, *Flight* and *Welcome Figures*, 1995–6. Red cedar, glass. Photo Vancouver Airport Authority. Courtesy the artist.

On the reverse sides of the tall panels, two figures extend their arms in welcome to arriving passengers. The round glass and wooden disks are based on traditional Salish spindle whorls. The eagles on Point's glass and wooden whorls evoke the speed of flight.

public art commissions (fig. 6.29). Her installation for the international arrivals area of the Vancouver airport monumentalizes the form of the Salish weaver's spindle whorl and combines it with traditional welcome figures and four large suspended woven panels entitled *Out of the Silence* made by Krista Point, Robyn Sparrow, Debra Sparrow, Gina Grant, and Helen Callbreath. Their art offers the ritually correct first greeting to strangers arriving in the territories of their Musqueam First Nation. Point's work also suggests the changing relationship of gender to artistic genre since the second half of the twentieth century. Men and women have always collaborated in the creation of art on the Northwest Coast, as discussed earlier in relation to Chilkat blankets and the collaborations of Charles and Isabella Edenshaw. In the 1980s and 1990s, Robert Davidson created formline designs for the high-fashion clothing produced by Dorothy Grant (Haida, b. 1956). Until the second half of the twentieth century, however, the medium in which a male or a female artist worked was largely regulated by convention. Men carved and painted, while women wove and sewed. The Haida carver Freda Diesing (1925–2002) and the Gitksan artist and curator Doreen Jensen (1933–2009), both students at the 'Ksan school, were instrumental in redefining the roles of both men and women artists.

An important aspect of this renewal of tradition has been the necessary interconnection of visual art with the performative contexts of dance, song, narrative, and ceremony. Tlingit scholar Nora Dauenhauer has likened the museum display of masks and other items of ceremonial garb to "a movie without a soundtrack," for without the animating force of oratory and

performance, such objects are, in her view, lifeless.[47] A Chilkat robe, for example, must be seen draped around a human form, its full artistry revealed in the swaying motion of its fringes, its visual majesty gaining force when scores of these robes and hundreds of red and black button blankets are on view at once, has occurred at the biennial "Celebration" held in southeast Alaska since 1982 (figs. 6.11 and 6.22). Started by the Heritage Foundation of the Sealaska Corporation (the organization of the Native peoples of southeast Alaska, incorporated following the land claims settlements of the 1970s), "Celebration" is a public festival held in Alaska's capital to educate children about their heritage and to celebrate ancestral ways. As Celebration has grown in the last decades to a five-day event that includes cultural workshops, canoe races, dance contests, art shows, and a public march of thousands of participants through the streets of Juneau, it has also helped spark a reinvigoration of regalia-making among a younger generation. Its role is to "assure that the voice of the ancestors will continue to be heard through the songs sung by their descendants."[48]

The renewal of artistic traditions all along the Northwest Coast from Oregon to Alaska has been the work of countless community members and artists. It is a movement that insists that tradition can thrive at the core of modern life. Whether carver, jeweler, weaver, or high fashion designer, these artists embrace the modern—the topic of the next chapter—as they make use of Western genres and media, transgress older gender boundaries in the making of art, and participate in art markets while also making traditional works that equal or even surpass those of their illustrious forebears. As we will see in the next two chapters, however, in the process of renewal contemporary artists also draw on an ethnographic record created by outsiders to recover traditions interrupted by numerous forms of colonial suppression and intervention. The portrait Nicholas Galanin carved out of the pages of a major ethnography of his own Tlingit people reminds us that colonial histories of representation are inevitably intertwined with contemporary cultural expressions (fig. 1.8).

NATIVE ART FROM 1900 TO 1980: MODERNS AND MODERNISTS

7

In 1978, in a studio rented especially to accommodate the huge eight-by-twenty-seven-foot canvas, the Anishinaabe painter Daphne Odjig (b. 1919) completed what is arguably her masterwork, *The Indian in Transition* (fig. 7.1). Modernist in its flattened space, intertwined curvilinear forms, and expressive coloration, it nevertheless deviated from the high modernist modes of abstraction that were then current. Rather, it belonged to the unfashionable genre of history painting, forcefully recounting Aboriginal experiences of precolonial life, colonial oppression, and the dawning of a new postcolonial era. As Mohawk curator Lee Ann Martin has written of the work:

> The Indian in Transition *takes the viewer on an historical odyssey that begins before the arrival of Europeans, continues through the devastation and destruction of Aboriginal cultures, and ends on an expression of rejuvenation and hope. Odjig's story unfolds with the figure on the left playing the drum, which symbolizes strong Aboriginal cultural traditions, while overhead is a protective Thunderbird. Then a boat arrives filled with pale-skinned people. The boat's bow becomes a serpent, a bad omen in Anishnabe mythology.*
>
> *Next, Odjig depicts Aboriginal people trapped in a vortex of political, social, economic, and cultural change. Four ethereal figures rise above the fallen cross and broken drums against a background of a bureaucratic symbol of authority. To the right, a figure, protectively sheltering the sacred drum, struggles free, under the protection of the Thunderbird and the eye of Mother Earth depicted in the top left. Odjig ends the story as it began, with a message of hope and mutual understanding for the future.*[1]

◀ **7.1** Daphne Odjig, b. 1919 (Anishinaabe [Odawa]), *The Indian in Transition*, 1978. Acrylic on canvas, 240 cm. × 820 cm. Canadian Museum of History, III-M-15, IMG2008-0624-000-Dp1.

▲ **7.6** Angel DeCora, 1871–1919 (Ho-Chunk), Book cover for *Wigwam Stories*, 1902. Private collection.

of spatial illusion and mimetic representation that were antithetical to the avant-garde modernism of the day. In contrast, her work as a graphic designer was informed by the modernist approaches to design encouraged by the British Arts and Crafts movement (fig. 7.6). In the books she designed, she successfully combined William Morris's innovative approaches to typography and layout with the elegant geometries of Native American basketry. As Hutchison concludes, in both aspects of her work DeCora was able "to insert Indian characters into a Western artistic tradition" and to "suggest the value of the Native American artistic tradition."[19]

In Marshall Berman's sense, then, Angel DeCora was a modernist who "made herself at home" amid the turbulence and contradiction of ongoing processes of modernization. The small number of artists who received the kind of support that made De Cora's professional career possible gradually grew during the first half of the twentieth century. The dispersed yet coherent body of work they created redefined Native American arts as modern, living, and changing while remaining connected to Native American historical consciousness and aesthetic traditions.

The Southern Plains and the Kiowa Five

The Plains was perhaps the only region of North America where historical narrative had long been a part of Indigenous visual arts. The tradition of painting on paper that became established in the third quarter of the nineteenth century has a direct connection to some of the subsequent developments of easel painting. In the 1890s, Kiowa artists such as Ohettoint (1852–1934), who had been imprisoned at Fort Marion in the 1870s, his younger brother Silver Horn, and Arapaho artist Carl Sweezy (1879–1953) drew pictures for anthropologist James Mooney, who was endeavoring to record the rapidly disappearing aspects of Southern Plains cultures. Such men kept the pictorial impulse alive on the Great Plains and served as direct inspiration for the first generation of twentieth-century painters.

The prolific Kiowa artist Silver Horn influenced the next generation of Southern Plains painters (fig. 4.16). This group, known as the "Kiowa Five," included Silver Horn's nephew Stephen Mopope (1898–1974) (fig. 7.7), as well as Jack Hokeah (1900–69), Monroe Tsatoke (1904–37), Spencer Asah (1906–54), and James Auchiah (1906–74). The story of their careers as artists began in 1914, when Sister Olivia Taylor, a Choctaw, taught art to Hokeah, Asah, and Mopope at St Patrick's Mission School in Anadarko, Oklahoma. Her successor, Indian Agency teacher Susan Peters, gave informal art lessons to these young men for several years. She then contacted Professor Oscar Jacobson at the University of Oklahoma, and he

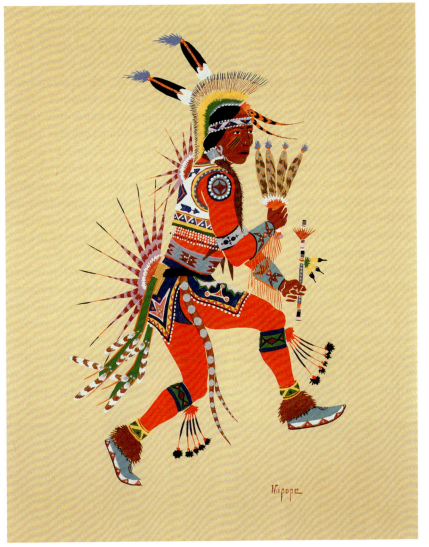

◀ 7.7 Stephen Mopope (1898–1974), Kiowa, *Flute Player*, pochoir print after original watercolor, 1929. Courtesy Vanesa Jennings and The Stapleton Collection, The Bridgeman Art Library International.

The young artists of the Kiowa Five were active as competitive dancers in Oklahoma. Many of their works, like this one, depict figures in dance positions.

agreed to set up classes for the five young men together with a sixth young Kiowa artist, Lois Smokey (1907–81), during 1927 and 1928. In order to prevent the "authenticity" of their art from being contaminated by Western art influences, Jacobson arranged special separate classes, a decision that today seems paternalistic and even racist, but that was then intended benevolently, as a way of preserving the qualities modernists admired in Native American arts.

The works of the Kiowa Five grew out of their traditional artistic heritage, synthesized with a modern, flat, decorative style similar to that later taught at the Santa Fe Indian School in the 1930s. They worked in gouache (opaque watercolor), thickly applied to fine watercolor paper. Through Jacobson's intercession, some three-dozen of their paintings circulated in an exhibition that toured the United States and Europe, culminating in a show at the 1929 International Folk Art Congress in Prague, Czechoslovakia. They also exhibited at the 1931 Exposition of Indian Tribal Art in

working with them on a mural project, and she presented a compelling model for younger female painters from the Pueblos, such as Pablita Velarde.[23]

Tsireh, Peña, and others turned out numerous variants of the scenes for which they were renowned—the sheer number of these early paintings is amazing, for they exist in the thousands. One might be sold to a tourist in the Pueblo for $3 if the artist needed quick cash; for a bit more to The Spanish and Indian Trading Company in Santa Fe, where many collectors and museums purchased paintings; or sold for $25 to $300 at *Avanyu*, the first New York gallery of Native art.

The event that was to consolidate Native painting as a larger movement was the establishment of a formal art program at the Santa Fe Indian School in 1932. The Studio School, as it was called, was designed for high-school-age students and was directed for its first five years by Dorothy Dunn (1903–92). A non-Native art teacher from Kansas who had studied at the Art Institute of Chicago, Dunn believed that there was an "authentically Indian" way to paint. She encouraged the students to draw inspiration from the great artistic traditions that were their heritage—abstract forms painted on pottery, figurative rock art, geometric beadwork, and basketry patterns. Purposely, Dunn did not offer technical lessons in perspectival drawing or color theory, preferring that the students' natural ability and memories of their cultural traditions form the basis for their work. Dunn's successor, Geronima Montoya (b. 1915), an artist and teacher from San Juan Pueblo, headed the school and its art program from 1937 to 1961 along the lines set down by Dunn.

In the literature written before the 1990s, the Studio School received a great deal of attention and credit, mostly due to the indefatigable Dunn, who assigned herself the central role in her writings from the 1930s through the 1960s, although she taught at the Studio for only five years. It is important to remember that Dunn's work with young Native students in Santa Fe came after fifteen years of steadily developing interest in Pueblo painting, both in the United States and abroad. Furthermore, during a time when the overriding impulse in the dominant culture was toward assimilation and the obliteration of Indian traditions, Dunn's teaching offered a supportive and relatively nonauthoritarian approach to Native art pedagogy. On the other hand, the Studio's art program also encouraged a decorative, two-dimensional approach and resulted in a large body of rather uniform genre scenes. Many of the students painted images of traditional life—Pueblo potters or ceremonial figures (fig. 2.14), Navajo social dances or horsemen, and animals in an idealized landscape. Some of these young students were undoubtedly homesick for these very events of daily life; others, like Pablita Velarde (Santa Clara Pueblo, 1918–2006), believed that these "memory paintings" would help preserve a way of life that was rapidly changing. In subsequent years the Studio School was criticized for contributing to the fossilization of Indian art within a narrow stylistic mold. For its era, however, it was a remarkable experiment that produced an entire generation of Indian artists who, in turn, served as role models for the next two generations. Some never swerved from the artistic path laid out in their student years at the Studio School. Others, as we shall see, went on to transform Indian art at mid-century into a more complex and varied artistic corpus.

The Display and Marketing of American Indian Art: Exhibitions, Mural Projects, and Competitions

The work pouring out of Oklahoma and New Mexico found a ready commercial market. Between 1930 and 1960 it was also championed in North America and Europe through a series of exhibits and publications which established it as the normative style for Indian painting. One of the most important shows was the Exposition of Indian Tribal Arts, which opened in New York in 1931 and toured the United States and Europe (see Object in Focus box). It provided the first large-scale exposure for the new Indian painting, which was critically acclaimed as an important new American art form. A few years later, the 1939 Golden Gate International Exposition in San Francisco featured Indian paintings alongside works in more traditional media and was seen by over a million visitors, spreading awareness of the new Indian art nationwide.[24]

OBJECT IN FOCUS
Book Cover of *Introduction to American Indian Art* (1931)

On December 1, 1931, The Exposition of Indian Tribal Arts opened at the Grand Central Art Galleries in New York. According to its organizers, it was "the first exhibition of American Indian art selected entirely with consideration of esthetic value." Awa Tsireh's *Koshares on Rainbow* graced the cover of volume one of the two-volume catalogue. It depicts the distinctive Pueblo striped clowns who straddle a rainbow emerging from stepped cloud forms (fig. 7.9; see also fig. 2.1). Two horned serpents undulate along the ground line; out of their tails grows a complex abstract design derived from painted motifs found on Pueblo pottery. The colors are the simple black, white, and rust red of local pottery and ancient mural painting.

Such clowns appear in Mimbres pottery as early as 1100 c.e. The horned serpents can be traced back even further, probably to a Mesoamerican origin. Yet Awa Tsireh and his peers were painting not for a local audience, but for a cosmopolitan, transcultural one. Successfully merging the symbolic vocabulary of Indigenous Pueblo art and the eclectic international styles of early modernism, this art mapped complex vectors of patronage and economics that extended from rural New Mexican villages, to Santa Fe, New York, and across the Atlantic as far as Venice and Prague.

In 1925 poet Alice Corbin Henderson shared with the readers of *The New York Times* her recollections of first seeing work by Awa Tsireh in the summer of 1917. She and her husband befriended him, bought his pictures, and entertained him in their Santa Fe home. "Awa Tsireh's drawings are, in their own field, as precise and sophisticated as a Persian miniature," Henderson wrote. "There is a precision and a surety, both in conception and in intimate

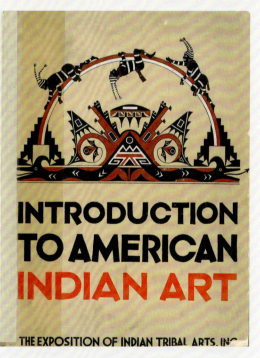

▲ **7.9** Book Cover of *Introduction to American Indian Art* (1931). Photo courtesy of the Peabody Essex Museum, Salem, Massachusetts.

detail, which marks his work as that of an artist who loves his medium." Her praise was remarkable for its lack of paternalism and she also recognized a crucial source for the young artist's work: "The technique that has produced

(cont.)

(cont.)

pottery designs as perfect as those of an Etruscan vase has gone into his training."[25] This was an important insight. Awa Tsireh was the son of an accomplished potter and he also came from the same village as world-famous ceramic artists Julian and Maria Martinez (fig. 2.18), who were making great strides in the shaping, painting, and selling of painted pots. The many critics who lauded the "self-taught" Pueblo painters of the 1920s were thus mistaken: a thousand-year tradition of Indigenous painting lay behind those brushstrokes.

The Exposition of Indian Tribal Arts was the largest touring exhibition of Native art in U.S. history before the 1970s and would today be termed a blockbuster. It included some 650 historical and contemporary objects, including more than forty watercolors, and versions of the show toured fifteen American cities during 1932. For its time, the catalogue was an influential and informative account of Native traditions in art, literature, dance, and more. Curators John Sloan and Oliver LaFarge urged a revision of the "curio concept" of American Indian art and sought to convince the American public that Indian art was "at once classic and modern," representing "thousands of years of development" on American, rather than European, soil.[26] Because of the success of the Exposition, Native works of art—both the new paintings of Kabotie and others and more traditional jewelry, pottery, and weaving—were exhibited as part of the official American Pavilion at the Venice Biennale of 1932.[27]

In 1941, the Museum of Modern Art in New York gave over its entire three floors to *Indian Art of the United States*, setting the definitive seal of art world approval on Native American art. Traditional works were presented in elegant and minimalist art museum installations (figs. 1.9 and 2.8), causing many viewers to consider such objects as art rather than ethnographic specimens for the first time. The new Indian painting was displayed conspicuously on the first floor of the museum, and the exhibit's director expressed the hope that "the downtown galleries will swing into line and accompany our exhibit with sales exhibits that should create a new steady market for Indian paintings in the east."[28] The museum display of easel paintings alongside pottery, beadwork, and silversmithing established the new work as continuous with "authentic" historic artistic traditions. None of these projects, however, positioned modern Native painting fully within the most prestigious Western category of "fine art." The language of presentation remained patronizing and retained elements of established installation conventions for Indian art that continued to evoke premodern modes of categorization.[29] In the context of art exhibitions, the paradigm linking Native art to folk art would have a particularly long life. At Expo 70, the World's Fair held in Osaka, Japan, where the art exhibit in the United States pavilion was devoted to so-called folk art, more than 50 percent of the objects shown were Native American.[30] The governments and foundations that underwrote these exhibitions were primarily motivated by economic development agendas, but their promotion of modern Indian art as folk art or interior decoration diluted efforts to have it seen as "fine art" with its higher monetary values.

Another important source of patronage for Native painters in the United States during the 1930s and 1940s was mural painting inspired by the populist Mexican muralist movement of the 1920s and, more specifically, by the murals being painted in the United States around 1930 by several of its founding figures, Diego Rivera (1886–1957) and José Clemente Orozco (1883–1949). The Works Progress Administration (WPA), a New Deal

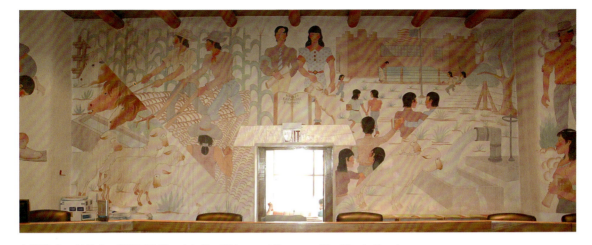

▲ **7.10** Gerald Nailor, 1917–52 (Navajo), *The History and Progress of the Navajo People*, 1942–3, Navajo Council House, Window Rock, Arizona. Photograph: Thomas Patin.

On the Northwest wall, the 1940s-era young man and woman painted above the door appear ready to stride into the modern world. Below them, "Navajo Educational Progress" is inscribed on an open book. Yet the corn stalk twining around the boy's arm and the sheep the girl touches are reminders of the traditional land-based foundations upon which their success rests.

program designed by the U.S. government to provide work for artists during the Great Depression of the 1930s, employed white, African American, and Native American artists to paint murals in public buildings such as schools, libraries, and post offices. Tonita Peña (fig. 7.8), several of the Kiowa Five (fig. 7.7), and Studio School graduates Pablita Velarde, Oscar Howe (fig. 7.12), and Gerald Nailor (fig. 7.10) received commissions to paint murals in the West and Southwest as well in the Department of the Interior building in Washington, D.C.[31] In western New York State, Seneca artist Earnest Smith also made paintings and murals intended to revive and preserve Haudenosaunee arts as part of a WPA-related project based at the Rochester Museum of Science (fig. 3.1).

Among these projects, Nailor's was one of the most ambitious. His cycle of frescos, *The History and Progress of the Navajo People*, covers the walls of the eight-sided hogan-shaped Navajo Nation Council Chamber in Window Rock, Arizona (fig. 7.10). Nearly life-size figures illustrate the community's economic movement from a hunting and gathering way of life to sheep herding, agriculture, silversmithing, and weaving; to its forced relocation to Bosque Redondo and its twentieth-century modernity. Even today, Navajo legislators deliberate while surrounded by this epic visual history of their nation.

The exhibits of 1931 to 1941 and the mural projects and other New Deal initiatives like the totem pole restoration projects organized in southern Alaska not only celebrated Native art but also fostered a notion of Indian art as essentially American. Commissioned during a time of war and extreme cultural destabilization in Europe, these projects affirmed the United States' Indigenous roots and asserted American independence from European cultural dominance. Yet in other contexts the benefits conferred by opportunities to exhibit work publicly could also constrain

▶ **7.11** Blackbear Bosin, 1921–80 (Kiowa/Comanche), *Prairie Fire*, c. 1953. Watercolor on paper, 51.4 × 84.1 cm. Museum purchase, 1953.7. © 2014 The Philbrook Museum of Art, Inc., Tulsa, Oklahoma; courtesy Nola Bosin Kimble Estate.

Bosin was a self-taught artist who attended St Patrick's Mission School in Anadarko, Oklahoma, where he was influenced by murals painted by the Kiowa Five. This, his most famous painting, exemplifies the hyperstylization of some of his work, especially between 1930 to 1960. The leaping antelope motif participates in an art deco or art moderne aesthetic.

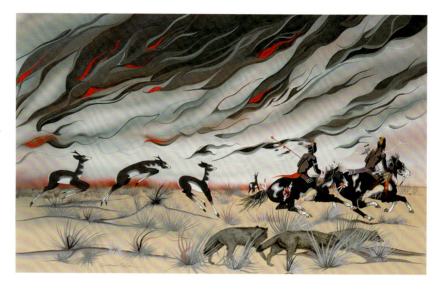

and frustrate artists who wished to innovate. The juried competitions and exhibitions held at the Philbrook Museum in Tulsa, Oklahoma, between 1946 and 1979 were a case in point. The Philbrook Annual Exhibition quickly became an important venue for the display of contemporary Native work, and artists from many tribes vied for acceptance as well as for cash prizes. The exhibits often traveled through the United States, Latin America, and as far as Europe, providing further exposure for the successful entries. Despite these benefits, by the mid-century the Philbrook shows had become a conservative force in the development of twentieth-century Native art because they imposed the conventional set of stylistic and iconographic criteria for what was admissible as "Indian painting." In this prestigious venue, romanticized images painted in the flat decorative style made popular during the 1920s and 1930s and perpetuated by artists such as Blackbear Bosin continued to be considered the epitome of modern Indian art (fig. 7.11).

MODERNS AND MODERNISTS AT THE MID-CENTURY

By about 1950, there was a growing feeling that this style had become a kind of artistic straitjacket. Across Native America, a growing number of artists, working independently of each other, began to engage directly with the conceptual and stylistic approaches of European and North American modernism, although reworking them to express Indigenous concerns and aesthetic traditions.

Pioneering Modernists: Howe, Herrera, and Houser

One of the best known graduates of the Studio School, the painter Oscar Howe, played an important role in forcing a reconsideration of what modern Indian art might be. After leaving the Studio, he achieved immediate recognition for his paintings of Sioux traditional dances and activities. In the WPA-sponsored mural he painted for the Carnegie Library in Mitchell, South

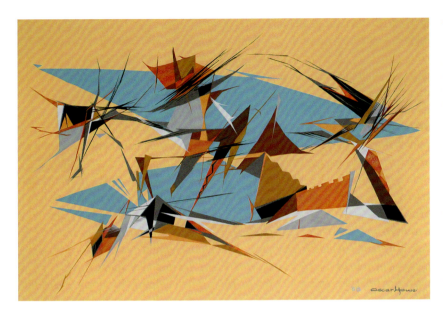

◄ **7.12** Oscar Howe, 1915–83 (Yankton Sioux), *Rider*, 1968. Casein. Courtesy University Art Galleries, University of South Dakota © 1968 Oscar Howe, reproduced by permission of Inge Maresh.

Howe's rigorous explorations of planar space helped to move Native American painting beyond a simple transcription of visual reality into a more complex examination of pictorialism and abstraction. This grew out of Native metaphysical concerns as well as European artistic experiments in cubism.

Dakota, in 1940, he combined the spareness and linearity of Studio style with Lakota symbolic geometries. After serving in Europe during World War II, Howe earned a BA and an MFA in painting and taught at the University of South Dakota. In the 1950s he began to work in a highly innovative modernist style (fig. 7.12). His figures of Sioux dancers, riders, and tableaus from mythic narratives convey explosive energy that fractures the picture plane into numerous facets and moves his work toward abstraction.

These paintings defied the sedate predictability of most Indian painting of the era. When Howe entered one of his works in the 1958 Philbrook Annual, it was rejected. He responded with a letter to the curator which we might characterize as the first manifesto of Indian modernism and artistic autonomy:

> Whoever said that my paintings are not in traditional Indian style has poor knowledge of Indian art indeed. There is much more to Indian art than pretty, stylized pictures. . . . Are we to be held back forever with one phase of Indian painting, with no right for individualism, dictated to as the Indian always has been, put on reservations and treated like a child, and only the White Man knows what is best for him? Now, even in Art, "You little child do what we think is best for you, nothing different." Well, I am not going to stand for it.[32]

Howe's protest caused the Philbrook to rethink its rigid categories, opening the competition to a wider range of works, and paving the way for institutional support for the individualism and fully realized modernisms of Indian art in the 1960s.

Howe vociferously rejected the label "neo-cubist" that his formal experiments suggested to many viewers. He argued that his artistic experiments were a logical outgrowth of the Sioux artistic and mythic tradition, and he referred to his multifaceted pictorial surfaces as a spider web linked to the

and large wood collages that make reference to his Grand Portage community's lands along the north shore of Lake Superior (fig. 7.2).

These examples make clear that during the middle decades of the twentieth century the Native engagement with twentieth-century art produced a number of modernisms rather than a single monolithic style. Each artist's oeuvre, furthermore, reveals a unique negotiation of particular Native identities, traditions, and modernist models. As Joseph Traugott has observed, the facile identification of Native American works with the particular styles of modern art they have appropriated "mask[s] the power of these images to transcend cultural boundaries" and "limit[s] this work by condescendingly appending them to the dominant tradition rather than viewing the work as a synthesis that transcends Euro-American cultural traditions."[36]

The Institute of American Indian Arts

The single most important institutional force in the development of modernist Native American art was the Institute of American Indian Arts (IAIA) in Santa Fe, founded in 1962 on the site of the Studio School. The groundwork for the new school was laid at a series of conferences and workshops funded by the Rockefeller Foundation. Held in Arizona between 1959 and 1962, the purpose of these discussions was to develop a more systematic approach to modern Indian art. The ethos of self-determination that was integral to the general consciousness of the 1960s clearly informed the formation of the IAIA. Native American educators designed the curriculum to incorporate Indigenous ways of teaching, and prominent Native artists formed the school's faculty. Allan Houser (fig. 7.13) and the painter Fritz Scholder (Luiseño, 1937–2005) (fig. 7.27) were among its most influential teachers, inculcating ideas of individual artistic freedom.

The IAIA trained many of the most notable American and Canadian Native artists of the 1960s, 1970s, and 1980s, for example, T. C. Cannon (Kiowa-Caddo, 1946–78, fig. 7.14), Marcus Amerman (Choctaw, b. 1959), Roxanne Swentzell (Santa Clara Pueblo, b. 1962, fig. 2.1), Hulleah Tsinhnahjinnie (Seminole-Muscogee-Navajo, b. 1954), and Marie Watt (Seneca, b. 1967, fig. 8.14) The new positioning of contemporary Native art that the IAIA achieved was signaled by an important exhibition that took place in 1972 at the National Collection of Fine Arts (now the Smithsonian American Art Museum) in Washington, D.C. Entitled *Two American Painters: Fritz Scholder and T. C. Cannon*, it exhibited the work of Scholder and his former student (figs. 7.27 and 7.14).[37] The title was a play on a landmark exhibit of high modernist abstract art held in 1965, *Three American Painters: Kenneth Noland, Jules Olitski, Frank Stella*.[38] It heralded the organizers' intention to situate contemporary American Indian art directly in the mainstream of American art. Both Scholder's expressionist style and Cannon's pop-art imagery were, however, deployed in order to reposition Native American painting as sharing the conceptual approaches of leading contemporary artists and questioning, through parody, the claim to quintessential American identity made by the earlier show's title. Both artists reclaimed

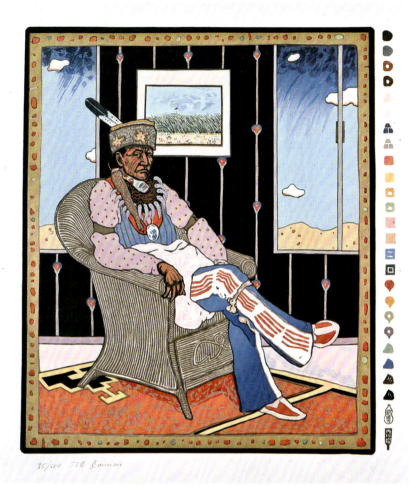

25/200 TC Cannon

◄ **7.14** T. C. Cannon, 1946–78 (Caddo/Kiowa/Choctaw), *Osage with Vincent van Gogh* or *Collector #5*, 1980. Woodcut, 65 × 51 cm. Courtesy Heard Museum, Phoenix, Arizona, and the Estate of T. C. Cannon.

In a woodcut version of a much larger oil and acrylic painting of the same name, an Osage man in late nineteenth-century tribal finery is seated in front of Vincent van Gogh's *Wheatfield*, a juxtaposition which subverts the expected ethnicities of who is the collector and who is the collected.

and subverted the stereotypical, pervasive images of "Indianness" familiar from the nineteenth-century paintings of Karl Bodmer and George Catlin, the photographs of Edward Curtis (1868–1952), and Hollywood movies. The feather-bonneted Plains warriors hold ice cream cones and wear sunglasses. In Cannon's *Osage with Vincent Van Gogh* (fig. 7.14), they hang reproductions of Van Gogh on the walls of their modern living rooms; in many of Scholder's paintings they live, destroyed by alcohol and poverty, on the street (fig. 8.10). The visual truth-telling and the use of irony and kitsch that marked the work in this show opened up a new phase of contemporary artistic representation that has continued to the present.

Figurative art, with its searching and often biting critique of the position of Native people in contemporary society was not the only focus chosen by the new Indian modernists. During the 1970s, Native artists in the United States and Canada used the more open definition of Native art to move in a number of different directions. In addition to George Morrison and Rita Letendre, mentioned at the beginning of this chapter, Robert Houle (Anishinaabe, b. 1947, fig. 8.4), Robert Markle (Mohawk, 1936–90),

▲ **7.16** Peter Pitseolak, 1902–73 (Inuit), Kinngait (Cape Dorset), Nunavut, photograph, 1942–3. Canadian Museum of History, 2000-215.

Pitseolak has been justly celebrated for his ability to capture with his camera the personalities of people in his family and community. This landscape view evidences his equally skillful compositional eye. It shows us his home community at a time when it still served primarily as a trading and administrative center for people whose lives continued to revolve around the rhythms of hunting on the land.

careers during the 1940s. Rather than exhibiting shared style, their work is interlinked conceptually as a set of responses to the social and political realities of their time. For this first generation of modern artists the production of visual art was a way to affirm and preserve cultural knowledge and to express personal responses to rapid modernization.

The career of Inuit photographer, carver, artist, and writer Peter Piseolak (1902–73) is exemplary, as is the story of how he took his first photograph in the 1930s, when a frightened tourist handed him a camera to take a picture of a polar bear. The new technology of photography challenged and fascinated Pitseolak. During the 1940s he taught himself to take and develop pictures in the igloo he used during the winter hunting season. When stone carving and printmaking workshops were set up in Cape Dorset, he embraced these media as well. In his corpus of more than 1,500 photographs are self-portraits in which he holds a camera or wears a dapper three-piece suit with a crest on the pocket as well as many views of Cape Dorset and its people, both Inuit and *Qallunaat* (non-Inuit) (fig. 7.16).

During these same years Gerald Tailfeathers in Alberta (Blood, 1925–75) and George Clutesi (Nuu-chah-nulth, 1905–88) and Judith Morgan (Gitk'san, b. 1930) in British Columbia chose painting as a medium for

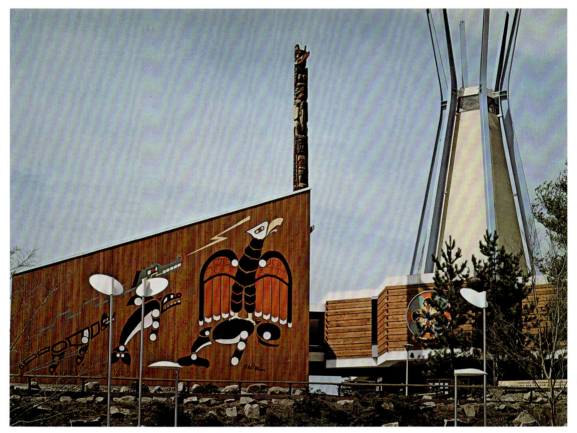

▲ **7.17** George Clutesi, 1905–88 (Nuu-chah-nulth), Exterior Mural of Killer Whale and Thunderbird, Expo 67 Indians of Canada Pavilion, Montreal, 1967. Photo © Bill Dutfield.

For the younger artists who made paintings and sculptures for the Expo 67 pavilion, Clutesi was a respected Elder. For two decades he had led the struggle to restore traditional arts and ceremonies repressed by official policies. His mural draws on depictions of the great supernatural beings displayed at potlatches on painted wooden dance screens and curtains. Their public display in 1967 was dramatic evidence of the change in the status of modern Native art that was in progress.

self-expression and recording community life. Clutesi had been drawn to art, traditional narrative, and performance as a youth, but it was not until his work as a fisherman was interrupted by an accident that he reengaged with these interests as a way of actively resisting the assimilationist program to which he had been subjected as a student at the Alberni residential school. Through radio broadcasts and the two books of Nuu-chah-nulth narratives that he wrote and illustrated with black-and-white ink drawings, Clutesi gave public affirmation to oral traditions and ceremonies that were still outlawed. As in the United States, prominent artists who sought to found a new and modern national artistic movement—Emily Carr (1871–1945) and Lawren Harris (1885–1970)—mentored him and facilitated the exhibition of his work in important venues.[42] By the time he was commissioned to create his large mural on the outside of the Indians of Canada Pavilion at the Montreal World's Fair in 1967, Clutesi had come to be regarded as a pioneering father figure by the young artists who participated alongside him (fig. 7.17).

▶ **7.18** Judith Morgan, b. 1930 (Gitksan), *Morning Mist*, 1940s. Image PDP00517 courtesy of Royal BC Museum, BC Archives, used with permission of the artist.

Attending the same Alberni, British Columbia residential school twenty-five years after George Clutesi, Morgan received encouragement for her desire to make art that recorded and affirmed continuing Northwest Coast traditions of art and ceremony. The swirling morning mists that ring the carved poles in this painting suggest both a heritage that has survived from the past and the dawning of a new era.

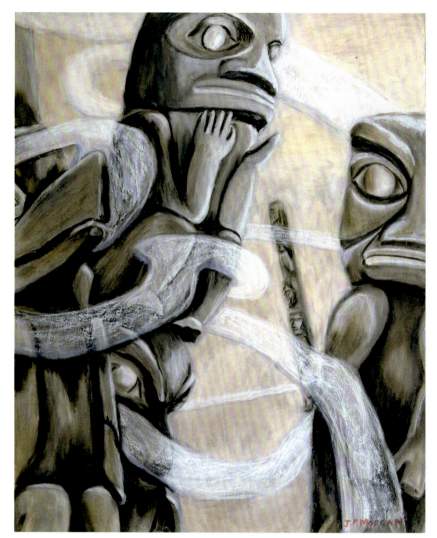

By the 1940s, when Judith Morgan made the 800-mile journey south from her home on the Skeena River in northern British Columbia to the same Alberni residential school Clutesi had attended, attitudes toward Aboriginal culture were slowly beginning to change. Morgan's interest in art was encouraged by her art teacher, and upon graduation the British Columbia Indian Art and Welfare Society awarded her funding to study the historical collections of the Provincial Museum in Victoria. Her paintings of the ceremonial life of the big houses record the resistance of the Gitksan to the government's ban on potlatching, while an image of monumental totem poles gradually disappearing in the mist seems to record the losses of traditional artistry that also resulted from this policy (fig. 7.18).

Gerald Tailfeathers first became interested in painting as a child in the 1930s during summers he spent at Montana's Glacier National Park, where members of his family shared Blackfoot traditions with tourists and posed for German portraitists Winold Reiss (1866–1953) and Carl Link (1887–1969).[43] Encouraged by his school principal and other early mentors,

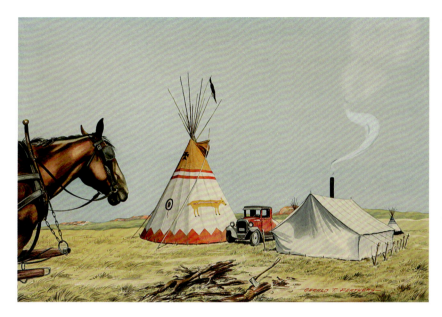

◀ 7.19 Gerald Tailfeathers, 1925–75 (Kainai), *Blood Camps*, 1956. Watercolor on paper. Courtesy The Glenbow Museum, 56.22.3.

Two different dwellings (the tipi and the settler's tent) and two modes of travel (the horse and the automobile) are juxtaposed here. Like artists on the Great Plains at the end of the nineteenth century, Tailfeathers used painting to record coexistent realities of early twentieth-century life. Unlike those artists, he adopts an illusionistic realism to reimagine the experiences of his grandparents' generation.

Tailfeathers won a scholarship to the Provincial Institute of Art and Technology in Calgary. After graduation, he continued to paint in his spare time while working at salaried jobs. He initially experimented with the flat figural style promoted at the Santa Fe Indian School, but he was ultimately drawn to the illusionistic style used by Charles Russell and Frederick Remington in their romantic and nostalgic scenes of the Old West. He gradually built a reputation as a painter of accomplished, historically accurate pictures of Blackfoot life that were grounded both in meticulous museum research and in oral traditions related by elders. During the 1950s his important commissions included a series of eighteen scenes of traditional Indian life painted for the Glenbow Museum in Calgary (fig. 7.19). Clutesi and Tailfeathers were active in Native political organizations, which were becoming reenergized during the 1950s. For all three artists, however, the making of modern art was itself inherently a political act. The styles they chose intervened in modernism's bias against figural representation. As modern, rather than modernist artists, their work presents compelling examples of the strength of Aboriginal survivance.

Inventing "Inuit Art"

In 1949, as Pitseolak, Clutesi, Morgan, and Tailfeathers were pursuing their artistic projects, the Canadian Guild of Handicrafts in Montreal opened an exhibition of small ivory and stone carvings made by "Eskimos" in the eastern Arctic. James Houston (1921–2005), a young artist who had come across these carvings during a summer sketching trip, had urged the Guild to organize the exhibition and sale. He was motivated both by his excitement about this "unknown" art—in actuality a production that began in the nineteenth century largely for trade to outsiders (see chapter 5)—and by his desire to help Inuit who were suffering economically from a drastic decline in the fur trade. At the Montreal show,

the carvings were snapped up by buyers imbued with the modernist taste for primitive art. Its success was repeated the following year, stimulating the Canadian government to establish arts and crafts programs and a centralized marketing system for carvings and other arts.

Houston was a highly effective promoter of the new Inuit carvings, presenting them as authentic products of people still living an ancient hunting life in a pristine natural environment. Today we see these art forms as innovative responses to processes of modernization, but the romantic mystification promulgated by Houston and others has persisted to the present day. The ambiguity that at first surrounded the status of modern Inuit carvings as "art" or "craft" was, however, more quickly resolved. Although the National Gallery of Canada's first exhibition of Inuit sculptures in 1952 suggested the folk art paradigm by including examples of basketry and fur clothing, an exhibition held the next year at London's Gimpel & Fils gallery displayed Inuit carvings as works of primitive art. The enthusiastic reception by collectors such as eminent British sculptor Henry Moore helped to confirm them as fine art.[44] As Nelson Graburn has argued, this redefinition was aided by the eager appropriation of Inuit work in Canada as an iconic national art form which soon followed.

The miniature scale of the first carvings to come out of the north was soon replaced by sculptures made on a larger scale. Inuit art's fine art status was also enhanced when managers of carving workshops urged artists to engrave their names on the bases of sculptures in the syllabic writing that had been introduced by missionaries—an important deviation from the anonymity of the makers of other "tribal" arts. During the 1950s, critics such as George Swinton (1917–2002) began to celebrate the individual styles of carvers. Swinton had made his first trip to the Arctic in 1957 at the behest of the Hudson Bay Company to evaluate the quality of the carvings that were being traded south through their fur trading posts. Like Houston, he was first drawn to Inuit art as providing a precious glimpse into the rapidly disappearing world of a people whose "simpler" way of life connected them to elemental realms of meaning lost to members of more complex modern societies. In the course of his many trips and sustained contacts with Inuit artists, however, Swinton came to understand that mid-twentieth-century Inuit art could be seen as a complex and highly distinctive negotiation of memory and tradition *within* modernity. "We thought that the factors that we knew—the data by which we 'defined' the Inuit—were definitive," he wrote. "The only factor that we now know to be definite is change."[45]

As an artist himself, Swinton wanted to understand how Inuit carvers conceptualized the phenomenon Westerners term "art." Based on his conversations with artists, he reported that the term carvers used for their sculptures was *sananguaq*, a term derived from words for "making" and "model, imitation, or likeness." Kenojuak (see fig. 7.20), one of the most famous graphic artists, added the comment, "we say it is from the real to the unreal." Swinton concluded that for the Inuit, art-making is concerned not in the first instance, with beauty, but with making "likenesses—real or imagined—that have their own small-size reality."[46]

In 1957, Houston conceived the idea of introducing printmaking to the Arctic, prompted by an Inuit artist who asked him how the printed wrappers of cigarette packages were produced. Houston introduced Japanese printmaking methods and materials to Cape Dorset. As Vorano has shown, the specific printmaking tradition Houston imported was that of the *sosaku hanga* movement—itself a Japanese analog to the modernist, and individualist, Arts and Crafts tradition.[47] The market success of Inuit prints repeated that of sculpture, although the production of prints was more rigorously organized. Cooperative print shops were established in several communities which have, since the 1960s, issued art prints annually in editions of fifty or fewer.

The oldest and most famous of these producers is the West Baffin Eskimo Cooperative at Kinngait (Cape Dorset), which has issued more than 2,000 different prints since 1959. Baker Lake, Ulukhaktok (Holman Island), Pangnirtung, Povungnituk, and Clyde River also ran print shops, although only Kinngait is producing annual print editions at this writing. All followed a similar process. At each center, large numbers of drawings made by local artists, usually in their homes, were bought by the co-ops, and staff members chose some for submission to the Canadian Eskimo Arts Council, which made the final selection. There are striking resemblances in both subject matter and graphic style between many of these drawings and the early prints made from them and the pictorial arts made in Alaska during the mid-twentieth century. Although these similarities have not been much remarked upon, they should not surprise us, since the artists shared many cultural and aesthetic traditions. In the context of mid-twentieth-century arts, however, the differences of media and genre have obscured the underlying similarities.

TECHNIQUES IN FOCUS
Inuit Stonecut Prints

When we think of Inuit prints today, we think first of stonecut prints. Yet when James Houston introduced printmaking to Kinngait in 1957 it was not obvious to the artists, working in cramped quarters with no specialized facilities, that this technique would come to be so closely identified with their graphic art. Norman Vorano's recounting of the moment of origin reveals Inuit artists' active welcome of new ways of making art:

> Printmaking in Cape Dorset, as the story goes, was "discovered" in 1957 when Osuitok Ipeelee, a respected hunter and an artist known for his carved walrus tusks, looked at the identical design on two cigarette packages and remarked that it must have been very tiresome for a person to repeatedly paint the same image. James Houston . . . was unable to satisfactorily explain the reproduction process used to print the packaging in the south. Instead, he tried to demonstrate the technique of intaglio printing by rubbing some lamp soot into the grooves of one of Ipeelee's incised walrus tusks. Houston carefully laid toilet tissue on the tusk and pulled a clear print. "We could do that" was Ipeelee's instant response.[48]

Canadian Arctic cooperatives have experimented with a wide range of printmaking techniques—stencil, woodcuts, linoleum block prints, copperplate engraving, etching, lithography, and serigraphy (silk screen). As in the history of Western art, artists develop affinities for particular techniques, and although some have different preferences, the stonecut print has come to prevail. It is appreciated by Inuit and by outside connoisseurs for the clarity and textural interest of the images that result.

(cont.)

(cont.)

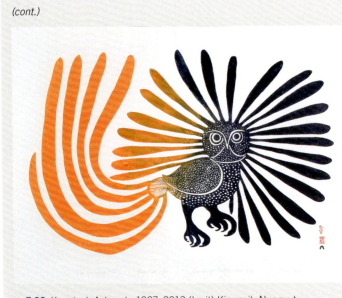

▲ **7.20** Kenojuak Ashevak, 1927–2013 (Inuit) Kinngait, Nunavut. *The Enchanted Owl*, 1960. Stone cut print. Canadian Museum of History, CD 1960-024ii, IMG2008-0935-0195-Dm and Dorset Fine Arts.

A stonecut is a relief technique, similar to the woodcut. The print begins with an artist's drawing. Artists often draw at home and then sell their drawings to the co-op. From these, some are selected to be made into prints by members of the co-op, including the printmakers. (Jean Blodgett estimated in 1991 that only one out of every hundred drawings became a print.) The printmaker transfers the drawing to the surface of a flat stone and then carves out the areas that will appear as blank space. The process is exacting, as it must leave the linear contours and solid areas intact as well as the fine detailing, texture, and pattern of the artist's drawing. The printmaker then carefully inks the stone with the different colors that have been chosen. A sheet of paper is laid on top and the raised areas are carefully rubbed by hand or with a small flat-surfaced tool. Fifty prints are normally pulled from one stone, and great care is taken to ensure that they are as identical as possible. As with any handmade production, however, tiny differences will always be present, and these enhance the interest of the production as a whole.

Printmaking is an inherently collaborative process, since the stone cutter and printer contribute to the realization of the artist's original concept. In the opinion of some artists at least, this collaboration results in an enhancement of the original drawing. Helga Goetz, who ran the Canadian government's Inuit art program during the 1970s, reported that "Pitseolak [Ashoona] . . . expressed a preference for the prints over her original drawings."[49] The collaborative nature of the process is acknowledged by the way they are signed, not only with the artist's name in writing but also with the stamp of the printmaker—often in Inuit syllabics—and the pictographic symbol of the co-op.

The story behind their development is one of fertile global exchange and technological mastery. Houston's trip to Japan in 1958–9 was critical. Rather than choosing to study the classical, highly refined pre-twentieth-century technology with its multiple printing stages and relatively greater degree of mechanization, he was drawn to the new *sōsaku hanga* (creative print) movement, which combined aspects of Western composition, subject matter, and color with traditional Asian printmaking techniques. The prints that resulted were bolder, with a more modern aesthetic, and fostered a more direct translation of original image to print. Houston brought back to Cape Dorset the expertise he had acquired during the five months he spent with master printmaker Uni'ichi Hiratsuka as well as samples of Japanese work. From there the new art was adopted by several other Arctic cooperatives.

During these decades, the subject matter of Inuit art depicted, by an overwhelming margin, the traditional Inuit hunting life, men's and women's domestic activities such as skin sewing, shamanistic rituals and experiences of transformation, and episodes from traditional oral narratives (fig. 5.1). Such scenes appealed to southern buyers as images of a timeless nomadic life. For the makers, as for late nineteenth-century graphic artists on the Great Plains, they served as arts of memory in a time of rapid change. Even in 1989, after the predominantly non-Native Eskimo Arts Council ceased to control the selection process, a strong preference for "traditional" life scenes kept Inuit prints lodged in an idyllic past. It was only gradually

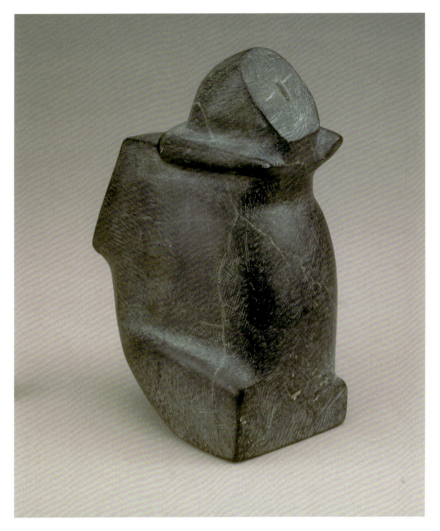

◀ **7.21** John Pangnark, 1920–80 (Inuit), Arviat, Nunavut, *Woman*, 1968. Stone, 15 × 6.5 × 9.5 cm. Canadian Museum of History, IV-C-3825, S98-3300.

John Pangnark was an Inuit hunter who lived off the land until he moved into a settled community in the late 1950s. He began to carve soon thereafter, focusing principally on single human figures that emerge organically from the rock that he worked.

that drawings that chronicled the modernity of Inuit life, increasingly reliant on clocks, airplanes, and camera-bearing tourists, were accepted for translation into prints. *Aeroplane* (1976) by Pudlo Pudlat (1916–92) was one of the first to find popular acceptance and it was reproduced on a Canadian postage stamp the year it was issued. There followed many witty and imaginative juxtapositions of traditional life and modern technology in Pudlo's work, which was featured every year in the Cape Dorset offerings. *Muskox in the City* (1979) depicted the huge hairy mammal perched in unlikely fashion atop a large building. Pudlo carefully observed a double-rotor Chinook helicopter and, with his pencil, imagined it airlifting a walrus, a polar bear, and his ever-present muskox, who dangles in the sky beneath the giant flying machine in *Imposed Migration* (1986).[50]

Individual Inuit artists have exhibited great diversity of style or, like Pudlo, strong personal preferences for particular subjects or methods. Pangnark revealed human figures embedded in stone by making only the most subtle modifications to the uncarved stone block (fig. 7.21).

▶ **7.22** Joe Talirunili, 1893–1976 (Inuit), Purivnituq, Nunavik, *Migration*, c. 1974. Canadian Museum of History, IV-B-1644 a-mm, S2001-3022.

Talirunili made numerous versions of this sculpture, whose title is misleading. It illustrates one of the most dangerous episodes of his early life. Returning by dogsled from his baptism, the artist and other travelers became stranded on an ice floe. Resourcefully, they made an *umiak*—a large boat—from their sleds and sealskins and managed to get to shore. The emotional intensity with which the artist depicts traditional hunting life has made Talirunili's carvings of boats among the best known works of Canadian Inuit art.

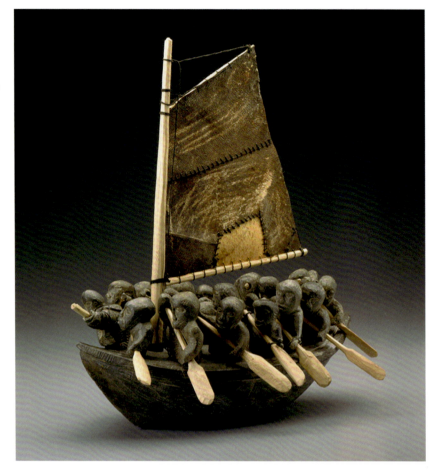

Sculptor Joe Talirunili (1893–1976) made multiple sculptures representing a dangerous journey he remembered from childhood (fig. 7.22). Pauta Saila (1916–2009) created images of powerful bears, the most important spirit helper of shamans. Karoo Ashevak (1940–74) was also drawn to themes of shamanistic transformation and created dream-like images of spirit travel that appealed strongly to the modernist interest in surrealism (fig. 7.23).

According to Nelson Graburn, in the mid-1950s when the Hudson Bay Company posts in the north began to buy carvings, many buyers strategically bought works only from the most successful trappers in order to ensure that the company would hold a monopoly on the skins as well. This tactic disenfranchised women from earning money through carving.[51] To this day, only a small number of women pursue active careers as carvers, although many have tried their hand at it and excelled. Only Ovilu Tunillie has achieved great fame (fig. 8.19). In contrast, women quickly emerged as prominent figures in the artistic communities that developed around the new cooperatives, benefitting, as had Navajo weavers and Pueblo potters, from the introduction of new markets and media. Across the Arctic, as seen in chapter 5, women have traditionally worked in fur, skin, basketry, and other soft materials while most carvers and mask makers were male.

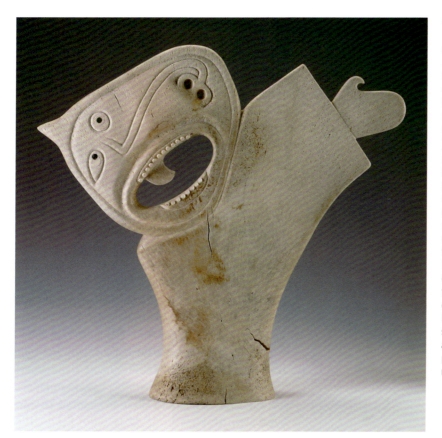

◀ **7.23** Karoo Ashevak, 1940–74 (Inuit) Taloyoak and Spence Bay, Nunavut. *Figure*, 1974. Whalebone with black stone insets, 41 × 44.2 × 10.5 cm. National Gallery of Canada, Accession number: 36203; © Estate of Karoo Ashevak and Public Trustee for Nunavut.

Ashevak produced about 250 works during a fifteen-year career tragically cut short by an accident. His sculptures appeal strongly to modernist tastes formed by cubism and surrealism, even though the artist drew his inspiration from a very different world. Raised in a traditional hunting life, he carved lively and often humorous images of shamans, spirits, animals, and birds whose smooth planes and flattened forms remain fully sculptural.

There are, however, no fixed gender traditions related to the production of graphic arts or the introduced medium of printmaking. Through cutting, insetting, and appliquéing skin and cloth, women were accustomed to using outline patterns and two-dimensional forms and they took readily to graphic arts, achieving a level of recognition unusual for women artists working in these media. Jessie Oonark (1906–85), for example, became a major force in the development of the graphic arts program at Baker Lake in the 1960s and 1970s (see chapter 5 and fig. 5.1). She was recognized by membership in the Royal Canadian Academy of Arts (1975) and the award of the Order of Canada, the country's highest recognition of achievement by a citizen. Kenojuak Ashevak (1927–2013), known primarily for her prints, achieved even greater fame in Canada and beyond. The sheer graphic power of her print *The Enchanted Owl* led to multiple reproductions in media ranging from wall calendars to postage stamps; it is probably the single best-known image created by an Inuit artist (fig. 7.20).

A new generation of scholars of Inuit art is exploring the political contexts within which modern Inuit art became established as emblematic of the Canadian nation. Norman Vorano's research illuminates the political agendas that led the Canadian government to promote Inuit art internationally and to circulate it to Iron Curtain countries during the Cold War. Heather Igloliorte points to the domestic agendas that were served by the

printmaking medium to expand the limits of the traditional Northwest Coast formline style and produce images with a strong modernist aesthetic. Others, such as Hamilton and Thompson, used the medium's narrative potential for the recording of oral traditions. These components of artistic renewal and innovation were extended even more widely through the Northwest Coast region with the establishment of the Kitanmax School at K'san in Gitksan territories in northern British Columbia in the 1970s. Master carver Douglas Cranmer and non-Native experts Bill Holm (b. 1925) and Duane Pascoe (b. 1932) helped to train a new generation, including Walter Harris (Tsimshian, b. 1931), Frieda Diesing (Haida, 1925–2002), and Earl Muldoe (Gitksan, b. 1936), who, in turn, taught others and produced art for use in community ceremonies and for sale in commercial art galleries.

Anishinaabe Modern and Plains Abstraction: Morrisseau and Janvier

During the 1950s northern Ontario Anishinaabe artist Norval Morrisseau (1932–2007) also began to collect, record, and illustrate traditional narratives. As an aspiring young artist, he first painted his representations of oral histories and traditional spiritual practices on the insides of birchbark baskets and other souvenir commodities. Encouraged to adopt Western media and formats by several white artist-patrons trained in Western modernism, he began to make paintings on flat panels of birch bark, on brown kraft paper, and on canvas. His book, *Legends of My People, the Great Ojibwa*, was edited by his friend and mentor, the amateur archaeologist and artist Selwyn Dewdney (1909–79), and published in 1965. Morrisseau became nationally known almost overnight after his first, enormously successful 1962 exhibition in a Toronto art gallery. He has stated that "all my painting and drawing is really a continuation of the shaman's scrolls,"[53] and journalists and buyers initially interpreted his work as a direct survival of ancient Ojibwa shamanistic art.[54] Yet Morrisseau is better characterized as a brilliant innovator who created a new kind of art that merged his inherited traditions with a painterly vocabulary inspired by the art books on Picasso and other masters he pored over at the home of his early patrons, Esther and Joseph Weinstein. Morrisseau's art also served as a site for the exploration of his dual religious heritage, influenced by the tutelage of his grandfather, a practitioner of traditional spirituality, and by the Catholic faith he was taught by his grandmother and at the residential school he briefly attended (fig. 7.25).

Between the 1960s and the 1980s Morrisseau's art evolved in palette, style, and subject matter. Initially accepting Dewdney's advice to use the "earth colors" of his ancestors, Morrisseau soon reverted to the intense colorism he preferred. He also elaborated in a highly individual way the mnemonic pictographs his grandfather had taught him into a distinctive style characterized by bold black formlines and "x-ray" depictions of internal organs. His work thus translated traditional pictography into the flatness of pictorial space and primitivizing iconography that appealed to modernist

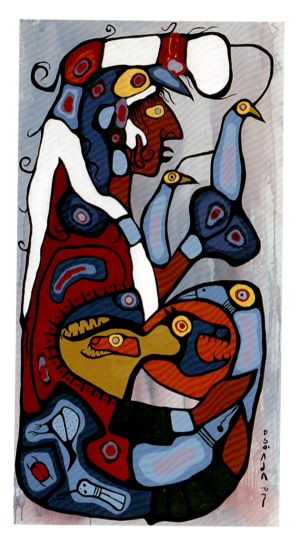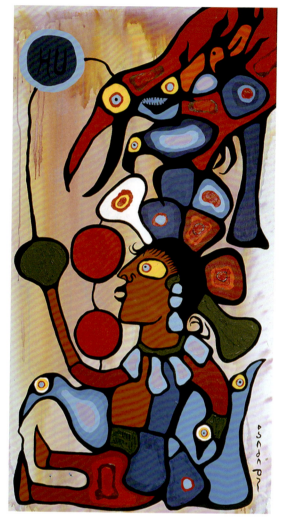

viewers. The originality of his formal and iconographic syntheses of the traditional and the personal and his great commercial success inspired—directly and indirectly—a whole generation of young Anishinaabe painters to take up the brush and the pen, including Carl Ray (1943–78), Jackson Beardy (1944–84), Roy Thomas (1949–2004), Ahmoo Angeconeb (b. 1955), and Blake Debassige (b. 1956) (fig. 1.23). Contemporary artists continue to reference Morrisseau's foundational work, as evidenced by the image on the cover of this book. Duane Linklater commissioned a neon sign manufacturer to pattern the glowing thunderbirds in his 2013 installation *Tautology* on Morrisseau's signature image in his monumental 1983 painting *Androgyny*. Linklater's homage simultaneously honors the importance of Morrisseau (whose Anishinaabe name was Copper Thunderbird) and signals the distance that separates contemporary art-making from that pioneering project.

▲ **7.25** Norval Morrisseau, 1931–2007 (Ojibwa), *The Storyteller: The Artist and His Grandfather*, 1978. Acrylic on canvasboard, 175.3 × 96.6 cm. Courtesy Aboriginal Affairs and Northern Development Canada, Gatineau, Quebec and the artist's estate.

In this diptych, Morrisseau pays tribute to his grandfather, who was both his teacher and a shaman knowledgeable in the teachings of the Midewiwin Society. The work urges the importance of continuing the transmission of oral traditions, the target of repressive assimilationist policies during the artist's youth. Morrisseau inscribed his own features in the portrait of his grandfather, asserting an equivalence between his mission as an artist and his grandfather's spiritual practice.

Indian Artists Incorporated, which they jokingly referred to as the "Indian Group of Seven."[57] The establishment of cultural centers on Native reserves in response to Aboriginal political activism was also important to the development of modern art, and two of the centers have played particularly important roles. The Ojibwa Cultural Foundation on Manitoulin Island in Lake Huron organized a series of summer workshops in traditional culture and art during the late 1970s and early 1980s that brought established artists together with aspiring young artists; the workshops provided inspiration and training for Anishinaabe painters such as Blake Debassige (fig. 1.23, Leland Bell (b. 1953), and James Simon Mishibinijima (b. 1954). Under the direction of Tom Hill, the Woodland Cultural Centre Museum near the Six Nations (Haudenosaunee) reserve in Brantford, Ontario, initiated a series of annual exhibitions in 1975 that was to become a major venue for the exhibition of contemporary Native art.

Professionalization and Experimentation: Decolonizing Modernism

During the 1960s and 1970s a number of local initiatives also inspired and fostered the careers of young Indigenous Canadian artists. In 1972, shortly before his untimely death, the charismatic artist and poet Sarain Stump (Cree, 1945–74) founded the Indian Art Program at the Saskachewan Indian Cultural College (now the First Nations University) in Regina. He and his program were important to the artistic formation of a number of artists, such as Edward Poitras (Plains Cree, b. 1953) and Gerald McMaster (Plains Cree, b. 1953), who would come to prominence in the 1980s.

Concurrently, other Canadian artists were studying at non-Native art schools. The late modernist visual languages in which they were trained provided the foundation for the new postmodern and anticolonial rhetorical strategies they would develop during the 1980s, as well as later work more fully discussed in chapter 8. These artists are bridging figures between late modernism and contemporary art. Joane Cardinal Schubert (Blackfoot, 1942–2009) studied at the Alberta College of Art, going on to create a powerful, politically charged body of painting and installation art that confronts the viewer with the historical violence done to Aboriginal peoples' bodies, their connections to land, and their cultural heritages. Carl Beam (Anishinaabe, 1943–2005) studied at the University of Victoria (fig. 8.5), while Jane Ash Poitras (Cree, b. 1951) trained at the University of Alberta and Columbia University. Both adopted compositional collage in prints, paintings, and mixed media works to examine the relationships that exist among seemingly incompatible knowledge systems—Aboriginal understandings of nature and Western science; shamanistic and Christian spirituality—as well as the interconnections of autobiography, family history, and official narratives of the past.

Robert Houle studied art education at McGill University. He was attracted as a student to the formal language of abstraction, and particularly to the art of Barnett Newman (1905–70) and other New York abstract expressionists. Houle responded in particular to their use of abstraction as a means of

exploring the spiritual dimensions of modernism which Newman and others had articulated but which had been overwritten by the more recent formalist criticism promoted by the influential writing of Clement Greenberg (fig. 8.4). Houle was also returning a compliment; during the 1940s the abstract expressionists had studied and celebrated Native American art for the access to the spiritual they believed it gave to them.

Another formative influence on Houle came about as a result of a contract he received while still a student in the early 1970s to travel to Santa Fe to study the IAIA with a view toward establishing a similar school in Canada. Manitou College at La Macaza, Quebec, opened in 1972 and left a legacy that extended far beyond its four years of operation. The influence of one teacher there, the Mexican artist Domingo Cisneros (b. 1942), on Native art students such as Edward Poitras (fig. 8.2) was particularly important. Cisneros's approach, as Tom Hill has put it, was to "take his students back to their traditional and shamanic roots"[58] through direct experience of life in the woods and by encouraging them to use as artistic media the bones and other natural materials that are of fundamental significance within shamanistic systems.

Houle wrote eloquently of the links between Aboriginal and modernist spirituality in art in the introductory essay to an important show he curated in 1982, *New Work for a New Generation*. He complained of the lack of patronage for Native modernists, particularly from museums that were still applying ethnographic criteria to their work. This "reluctant patronage [was] unable to understand the new work as a genuine indigenous expression of, for, and by Canadian, American and Mexican Indians."[59] Houle's lobbying continued during his brief period as the first curator of Contemporary Indian Art at the National Museum of Man (later the Canadian Museum of Civilization) in the late 1970s. If Oscar Howe's letter of twenty-five years earlier had been a manifesto for Native artists' rights to appropriate a modernist freedom of individual expression, then Houle's essay was a manifesto for modernism's universalism and transcultural potential. He celebrated the Native artists in the show for their invention of a new "language of magic and symbolism" grounded in ancient shamanistic practices. He also insisted on the importance of the Native artist's engagement with the contemporary world. A commitment to the "polemics of modern art," he wrote, was "crucial to the reconstruction of cultural and spiritual values eroded by faceless bureaucracy and atheistic technology." He also turned the primitivist appropriation of tribal art on its head, writing of Native artists that "Being modernists, they carry the privilege of appropriating bits of their traditional and contemporary cultures to form an amalgam strictly reflective of their own identity."[60]

Houle's perceptive statement, together with those of American Aboriginal artists such as Fritz Scholder (see Artist in Focus box), point the way to the full unfolding of the potential of art to serve as a site for social and political critique and cultural renewal. They proceeded to exploit this potential along with the dynamic and dramatically expanded community of contemporary artists we discuss in the final chapter of this book.

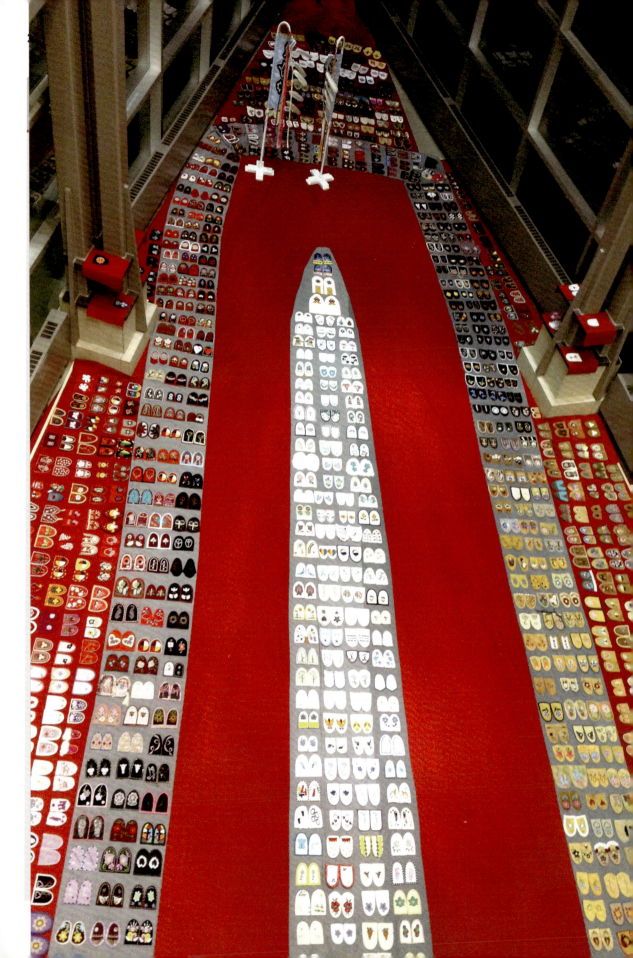

NATIVE COSMOPOLITANISMS: 1980 AND BEYOND

8

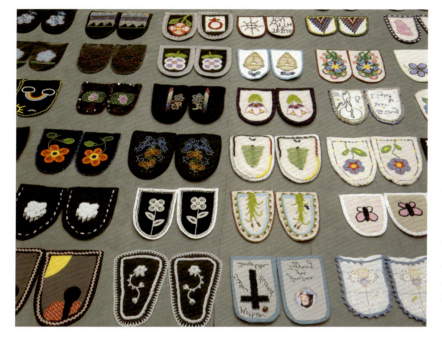

Over 1,700 pairs of beaded moccasin vamps align themselves along the floor of the art gallery, the Aboriginal cultural center, the university atrium. We are in one of the thirty-one community spaces to which *Walking with Our Sisters* will travel between 2013 and 2019 (fig. 8.1). The installation honors the more than 600 Aboriginal women and girls missing or known to have been murdered in Canada over the past twenty years. Like the moccasins, the lives of these women—cut short by violence—were left unfinished. And like the women who are being honored, each pair of lovingly made moccasin "uppers" is imbued with beauty, individuality, and significance. The materials and techniques used by the artists—glass beads, porcupine quills, paint, moosehair, silk embroidery floss, mother-of-pearl buttons, felted wool, fish scales, birchbark bitten into intricate designs—are as rich and varied as the repertoire of Native North American arts (fig. 3.28). Visitors to the installation do not remain passive spectators who stop to view the installation from a fixed vantage point. They remove their shoes and walk along the paths that wind through the unfinished moccasins, enacting a ritual journey of solidarity with the women and girls who are being remembered. To trace these paths is to protest against a society which has failed to pursue and prosecute most of the perpetrators of the violence and to join a collective

▶ **8.1c** Shelley Niro, Moccasin Vamps for *Walking with Our Sisters*, 2013. Photo courtesy of *Walking with Our Sisters*.

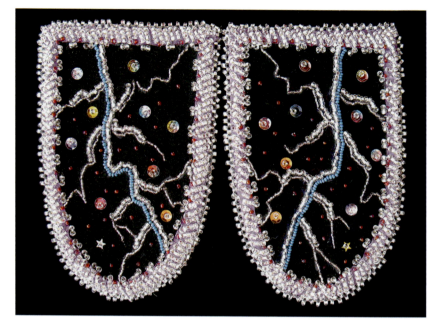

quest for social justice. As the project website states, "There is power in numbers, and there is power in art."[1]

Walking with Our Sisters demonstrates the radically democratic potential of installation and performance arts. Generated entirely through the power of social media, it represents an important direction in contemporary Aboriginal art. Métis artist Christi Belcourt (fig. 4.23) and her fellow organizers used strategies of crowdsourcing with remarkable efficacy. They sent out an initial call for 600 pairs of moccasin vamps on Facebook in June 2012 and received almost three times that number by the deadline a year later. The 1,372 contributing artists are located throughout the Americas and around the world; they include established professionals, respected traditional beadwork artists, amateurs, and novices.

Walking with Our Sisters builds on earlier feminist projects of collective art making, notably Judy Chicago's groundbreaking *The Dinner Party* (1974–79). It adds a performative dimension to Gerald McMaster's well-known and much admired installation of moccasins arranged in a spiral—some on tiptoe as if worn by ancestral performers of a pan-Indian Round Dance—that marked the entrance to the inaugural exhibition *All Roads Are Good* at the National Museum of the American Indian (1994). It also draws on the strategies of multiple replication and collective making used by Chinese artist Ai Weiwei (b. 1957) and British artist Antony Gormley (b. 1950) to raise public consciousness of injustice. In projects such as *Field for the British Isles*, for example, Gormley worked with thousands of untrained volunteers to produce tens of thousands of mouthless terracotta figurines that spilled over the floors of art galleries and churches, calling attention to "the voiceless, the nameless, the powerless."[2] In contrast to these artists, however, Belcourt has chosen to foreground the collective authorship of *Walking with Our Sisters*, stepping back from the individualist tradition of modern Western art in order to stress a broader and far older tradition of community ownership

and responsibility. As Catherine Mattes has observed, the project is informed by an Aboriginal concept of offering—*bii mii-chi-gay*—and she has also noted its resonance with other socially engaged forms of "littoral art" which function on multiple levels of collaboration for social action.[3]

In its specific commemoration of missing and murdered Aboriginal women, *Walking with Our Sisters* also has a powerful precedent in Rebecca Belmore's *Vigil* (2002), a performance that commemorated the abduction and murder of Native women by a serial killer in Vancouver, which we discuss further at the conclusion of this chapter. Belmore was one of a handful of Native artists beginning to explore the possibilities of performance as a critical art form in the 1980s. In 1987, as a young artist fresh from her studies at the Ontario College of Art, she created an absurd version of an eighteenth-century hooped-skirt dress. She beaded a bodice evoking the floral beadwork of historic Anishinaabe clothing (fig. 1.31) and added fringed hide epaulettes that recall military uniforms and men's hide jackets of the fur-trade era, (fig. 4.22), "breast plates" made of flowered china saucers, and a beaver dam bustle made of wire and twigs embedded with kitschy manufactured objects. Belmore wore this dress in *Twelve Angry Crinolines*, a performance staged on the occasion of the royal visit of Prince Andrew and Lady Sarah Ferguson to Thunder Bay, the northern Ontario town where Belmore had attended high school. The dress, titled *Rising to the Occasion* (now in the collection of the Art Gallery of Ontario), is an artifact of that performance, a visual commentary on a tragic and sometimes absurd history of mutual entanglements, hybrid forms, misunderstandings, and cultural losses caused by colonization. As Belmore has remarked: "People think that we sold ourselves for shiny objects. I wanted to make fun of that. We lost a lot because of these new things that came to our land, but at the same time [we were] people who embraced new objects and learned how we wanted to use them."[4]

On the other side of the border, also in 1987, the Luiseño performance artist James Luna lay down on a bed of sand in an exhibition case he had prepared in the San Diego Museum of Man. In *Artifact Piece*, Luna presented his body as an object as a gesture of solidarity with all the Aboriginal bodies that had been appropriated by museums and other institutions over the centuries. "I thought about all our relatives, lying in some museum, on some shelf, in someone's closet, in a box," Luna said.[5] Like Belmore, he confronted the long and fraught entanglement of Native people in western regimes of power and display: put on display at World's Fairs, objectified by mannequins in the glass cases of ethnographic museums, and studied by physical anthropologists in laboratories. By placing himself in the display case, he challenged his viewers to think about this legacy of cultural taxidermy. His performance signaled a taking back of control over the representation of the Aboriginal body by Aboriginal people themselves.

The focus on the body, the ironic humor, and the engagement with issues of history and settler colonialism that informed both Belmore's and Luna's works in 1987 introduce some of the major themes that run through contemporary Native art. Indeed, contemporary artists continue to "rise to the occasion" of decolonization, a process that challenges both the

Indigenous and settler peoples of North America. The era of contemporary art that that we define here as beginning around 1980 has seen an extraordinary outpouring of important work. Some has been created by artists whose careers began earlier and who have come into their full maturity. They have been joined by growing numbers of younger artists who have come to prominence in mainstream art worlds with remarkable rapidity. They create and present art that speaks to their home communities, to broader North American publics, and to the global art world. The number of artists worthy of detailed discussion far exceeds the space available in this chapter. It can serve merely as an introduction to a rich field of works that will have grown even between the time this book goes to press and your reading of it. In the following pages we trace the development of contemporary art since the early 1980s. We consider the key institutional contexts that have given rise to contemporary Indigenous arts, and then consider its diversity of media and themes.

THE 1980S AND THE RISE OF A CONTEMPORARY NATIVE ART MOVEMENT

As the last chapter demonstrated, prior to 1980 a number of Indigenous artists were able to acquire professional training in art schools and universities, but there was little sense of a collectivity of Aboriginal artists whose work contributed to a new articulation of Aboriginal history, identity, spirituality, and aesthetics. The broader context for their work was provided by international and national tides of liberation, the women's movement, and the civil rights movement. The American Indian Movement (AIM) was founded in Minneapolis in 1968 and quickly expanded to address a series of injustices and broken treaty obligations nationally. The nineteen-month-long occupation of Alcatraz Island in San Francisco harbor by Native activists that began in November 1969, and the 1973 armed standoff between AIM members and the FBI at Wounded Knee in South Dakota drew national and international attention to these failures of justice. In 1968, the same year that AIM was founded in the United States, Aboriginal people in Canada successfully organized to oppose a government "White Paper," which, among other things proposed to repeal the federal Indian Act. Despite its oppressive legal features, this law recognizes the distinct legal status of Aboriginal people and guarantees essential funding and government services. Canadian First Nations also succeeded in enshrining their sovereignty in the Canadian constitution in 1982, and in 1991 Mohawk and their supporters confronted the Canadian army at Oka, Quebec, after plans were announced to turn an Aboriginal burial ground into a golf course. Such episodes of political activism and confrontation reinforced a sense of shared history and purpose among artists, together with a determination to make art that would serve as a weapon for social and political change.

This collective purpose was manifested in a 1981 exhibition curated by Lloyd Kiva New, *Native American Art in the 1980s*, shown at the newly opened Native American Cultural Center in Niagara Falls, New York, known as the "Turtle" because its design evoked the being on whose back the earth was formed according to the Haudenosaunee creation story (fig. 3.1).

It featured work in diverse media by 175 artists, many of them art school trained and seeking recognition in a wider art world. That validation was, however, elusive. With only a few exceptions, the doors of the largest art museums remained closed to contemporary Aboriginal work through the 1980s. A number of smaller art institutions did, however, begin to exhibit work by this new generation of artists. As noted in chapter 7, works by Fritz Scholder (fig. 7.27), T. C. Cannon (fig. 7.14), and Jimmie Durham (fig. 8.3) began to appear in mainstream museums in the United States, while in Canada Robert Houle (fig. 8.4) was joined by Carl Beam (fig. 8.5), Edward Poitras (fig. 8.2), and others.

The Artist as Trickster

The continuing exclusion was just one of many paradoxical aspects of late twentieth-century Indigenous life that artists began to address through their work. Although living fully modern lives, they and their communities were still represented through stereotypical images of noble savages, fierce warriors, Indian princesses, or exotic shamans. And despite the impact of activist campaigns for justice, little change occurred. To advance their urgent political and social agendas, a number of artists turned to an ancient figure central to their oral traditions in order to bring to the fore the paradoxes, ironies, and moments of violence that informed their lives. In these traditions, the contradictions that mark human existence—sometimes tragic, sometimes funny—are explained by the actions of the great trickster figures whose acts helped to create the world, such as Raven on the Northwest Coast, Gloosecap in the Northeast, Nanabozo in the Great Lakes, and Coyote throughout the Plains and in the Southwest. The past actions and magical transformational powers of these beings created our imperfect but vital world, complete with its dualities, oppositions, contradictions, and deceptive appearances.

The prominence of trickster figures, and especially of Coyote, in late twentieth-century Aboriginal art has been so strong a theme that it led Allan Ryan to entitle a book that addresses these arts *The Trickster Shift*. Ryan borrowed the phrase from Carl Beam but points also to its centrality in the work of playwright Tomson Highway and novelist Gerald Vizenor, who identify as distinctively Aboriginal, a worldview that is both comic and tragic and rooted in collective rather than individual action. As Ryan writes, "What Beam calls the 'Trickster shift' is perhaps best understood as serious play, the ultimate goal of which is a radical shift in viewer perspective and even political positioning by imagining and imaging alternative viewpoints."[6]

During the 1980s and 1990s, Coyote in particular served as a potent trope of the in-between-ness many Native artists experienced. He is untamed and dangerous, yet he closely resembles the dog, the most domesticated of animals. A target of persecution, the coyote has been hunted and hounded off white settlers' lands for years in irrational campaigns of eradication. Yet "Elder Brother Coyote" also instructs by means of his own scrapes and pratfalls. As Gerald McMaster has observed, "Trickster has lain dormant for five hundred years, but now he has surfaced in many new guises, particularly the guise of artist. It is the persona of Trickster that enables artists to engage in

Durham's subsequent career also reveals the arbitrariness and further absurdity that has resulted from legally imposed definitions of Indian identity. In 1990, the Indian Arts and Crafts Act was passed into U.S. law, requiring documents of authenticity for anyone claiming to make Indian art. Durham, of mixed Cherokee heritage, but not an enrolled member, was disinvited from participation in several exhibits of Native art. He issued a statement:

> I hereby swear to the truth of the following statement: I am a full-blood contemporary artist, of the subgroup (or clan) called sculptors. I am not an American Indian, nor have I ever seen or sworn loyalty to India. I am not a Native "American," nor do I feel that "America" has any right to either name me or un-name me. I have previously stated that I should be considered a mixed-blood: that is, I claim to be male but in fact only one of my parents is male.[8]

In the 1980s, few Native artists (except perhaps for Fritz Scholder) had an international platform for their work. Durham was the great exception. Having lived abroad as a young artist, he subsequently became an artist of the world, living in Mexico and Europe during the subsequent years of his illustrious career.

Institutional Contexts

Since the early 1990s, the support of institutions and foundations has been fundamental to the exhibition and dissemination of contemporary Native art. The year 1992, marking the five-hundredth anniversary of Columbus's arrival in the Americas, offered an opportunity for Native artists to present a strong counterdiscourse to the widespread public celebration of an event that, for many Native people, was seen as initiating a massive genocide. Two of Canada's national institutions presented influential exhibitions. *Land/Spirit/Power* at the National Gallery of Canada was the first comprehensive exhibition of contemporary Native art to be mounted by a major public art museum. With this exhibition, which featured the work of eighteen Indigenous artists from Canada and the United States, the Gallery responded to a decade of lobbying by the Society of Canadian Artists of Native Ancestry (SCANA) to have their work shown in major Canadian art institutions. A second ambitious exhibition, *Indigena: Contemporary Native Perspectives*, was organized by Native curators Gerald McMaster and Lee-Ann Martin for Canada's national anthropology and history museum, the Canadian Museum of Civilization (now the Canadian Museum of History). The eighteen artists and the all-Aboriginal contributors of catalogue essays were asked to address what the 500 years since Columbus's arrival meant to them. The show also broke new ground in including contemporary Inuit art that had seldom been exhibited in conversation with other Native works.

In the United States, no national institution marked the quincentennial with a major, similarly ambitious show of contemporary Native art. Although the National Museum of the American Indian's George Gustav Heye Center in New York City was in development, its first exhibits would not open for two more years. It fell to the Native arts organization Atlatl

and artist-curator Jaune Quick-to-See Smith (see Artist in Focus box and fig. 8.6) to organize *The Submoloc Show/Columbus Wohs: A Visual Commentary on the Columbus Quincentennial from the Perspective of America's First People*. As the reverse spellings in the title suggest, the exhibition registered grief for the immensity of loss and suffering endured by Indigenous peoples over 500 years. Yet, as in Canada, the show was also a celebration. As Quick-to-See Smith noted in her curatorial statement, the assembled works revealed Native artists' continued visual creativity even in the darkest moments of those centuries.[9]

Starting with its inaugural exhibit in 1994, *This Path We Travel: Celebrations of Contemporary Native American Creativity*, the NMAI's New York venue has regularly shown modern and contemporary work in both solo and group exhibits. In part, perhaps, because of the existence of NMAI, and in part because of an ongoing resistance to recognizing the validity of Native art as fully contemporary and transnational, most American art museums have been slow to initiate major exhibits of contemporary Native art, systematically collect contemporary Native works for their permanent collections, or even include more than the occasional Native artist in a group show. Exceptions include the Denver Art Museum, the Minneapolis Institute of Arts, the Detroit Institute of Arts, and the Peabody Essex Museum. *The Decade Show*, an influential 1990 exhibit co-organized by New York City's Studio Museum in Harlem, New Museum of Contemporary Art, and Museum of Contemporary Hispanic Art, included a significant number of the most important Native artists of the 1980s. Edgar Heap-of-Birds, Peter Jemison, George Longfish, James Luna, Jaune Quick-to-See Smith, Kay WalkingStick, and Richard Ray Whitman were all represented by multiple works. Luna restaged his *Artifact Piece* of 1986 at the Studio Museum in Harlem, and Jimmie Durham did a performance and wrote about the other artists in the catalogue.[10]

When important art museums such as New York's Metropolitan Museum of Art and the Boston Museum of Fine Arts began to add installations of Native American art to their permanent Pre-Columbian, African, and Oceanic displays, they chose to display primarily historical works with an occasional contemporary example of painting or ceramics to signal their recognition of the existence of modern Native American communities. That this exclusionary tendency continues at the time of writing is particularly striking in light of the moves such institutions have made toward the inclusion of modern and contemporary African American arts and their interest in global contemporary art. In Canada, where Aboriginal people occupy a more prominent position in national life, there have been more comprehensive attempts at inclusivity. In 2002, the National Gallery began to integrate examples of historical, modern, and contemporary Aboriginal art into its long-term exhibitions of Canadian art, followed by similar initiatives at the Art Gallery of Ontario in 2008 and the Montreal Museum of Fine Arts in 2011. Although the sustainability of such initiatives, which depend on expensive loans from other institutions, is not yet clear, they signal the success of Aboriginal artists' campaigns for a more pluralist conceptualization of "Canadian" art.

reference to Newman's 1967 *Voice of Fire*, whose purchase by the National Gallery of Canada in 1989 had caused a national controversy.[14] The flat expanses of pure color, applied with close attention to the texture and quality of the surface, are at once a homage to the aesthetic power of Newman's work, an affirmation of Houle's modernist heritage, and a political reference to the emblematic colors of the French and British armies.[15]

Six years before Houle painted *Kanata*, the National Gallery had purchased Carl Beam's *The North American Iceberg* (1985), its first work by a contemporary Aboriginal painter, Like Houle, Beam was art school trained and drew on mainstream contemporary movements to create decolonizing strategies that rupture standard historical narratives of history and art history. In contrast to Houle, however, Beam found in the collaged, mixed media works of artists like Robert Rauschenberg (American, 1925–2008) an approach that suited his own explorations of cultural relativism and Aboriginal historical experience. Beam's prints and paintings challenge the viewer by juxtaposing icons of Western and Indigenous knowledge systems.

The North American Iceberg was a summary work of Beam's early explorations of the contrasts, equivalencies, and oppositions presented by Indigenous and Western intellectual traditions. It brings together many images that the artist had explored individually and in combination in other prints and paintings. Letters of the alphabet, numerical sequences, and grids signal Western rationalism; images of embryos and dissected animals reference the invasiveness of Western science; and mug shots of his own and other faces represent the objectification, analytical power, and surveillance of Western colonial regimes. Other images—shamanic figures, ravens, soaring eagles, turtles—convey the alternative power of Indigenous knowledge systems. To these pairings, Beam added historical photographs of Indigenous peoples—the face of Sitting Bull and an image of three figures standing at a graveside haunt his work of the 1980s, signaling the oppression and impoverishment visited on Indigenous peoples and the suppression of their ways of knowing.

Beam's intellectual intensity and breadth of concerns led him to extend his art to other media and to global issues. During the 1980s and 1990s he also worked in ceramics, appropriating the narrative pictorial space of Mimbres bowls (figs. 2.6 and 2.7) to address twentieth-century people and events that ranged from Anne Frank to the assassination of Egyptian leader Anwar Sadat. The approach of the Columbus quincentennial stimulated two of his most compelling series, *Burying the Ruler* (fig. 8.5) and *The Columbus Project*. In prints, paintings, sculptures, performances, installations, and a video he broadened his exploration of the implications of Aboriginal-European contact to express the power both of Christian and Indigenous spirituality and the tragic outcomes of their historical encounters.

While much of the excitement about Native art in recent decades has focused on works of mixed media, installation, and new media, some artists continue to be drawn to the materiality of paint and color, the representational possibilities of a realist style, or the gestural marks made on a

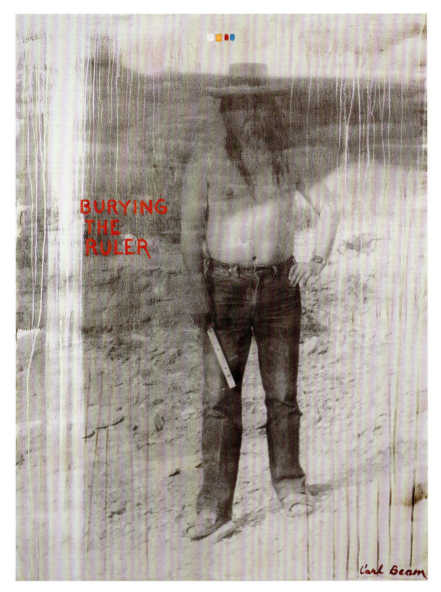

◀ **8.5** Carl Beam, 1943–2005 (Anishinaabe), *Burying the Ruler #1*, 1991. Collection of the Canada Council Art Bank, Art © Estate of Carl Beam/CARCC, Ottawa/VAGA, New York.

The artist grasps a ruler that symbolizes Western systems of measurement and standardization imposed on Indigenous peoples to classify, objectify, and dehumanize them. Through the double meaning of the word "ruler," it also references colonial power. In a video he made as part of this project, Beam buried the ruler in Southwestern desert sands to affirm the determination of Aboriginal peoples that the next 500 years of the post-Columbus age will see Aboriginal peoples' liberation from both regimes.

canvas or a sheet of paper. The prolific Hopi artist Dan Namingha, whose work is illustrated in this volume by abstract sculpture (fig. 2.28), is best known as a painter of both figurative and semiabstract works. Navajo artist Emmi Whitehorse (b. 1957) has, for more than twenty-five years, inserted subtle references to Navajo life and land into abstract compositions in which she manipulates oil pastel crayons on paper, smudging with her hands the marks and gestures of her personal iconography. Rick Bartow (b. 1946, Yurok/Mad River Band) "paints" in charcoal, graphite, and pastel, producing gestural self-portraits such as *Selbst* (1999). He also pays homage to great painters of the past, as in *After Vermeer: Girl with Pearl Earring* (1998).

Kent Monkman's work as a painter has already been addressed (fig. 1.32). In 2006 and 2009, Monkman took on the narratives of art

ARTIST IN FOCUS
Jaune Quick-to-See Smith—Artist and Advocate

Jaune-Quick-To-See Smith was born at St Ignatius Mission, on the Flathead Indian Reservation in Montana in 1940, to a part-Cree mother and a father who was Flathead, Shoshone, and Métis. Much of her childhood was peripatetic, as she accompanied her horse-trader father on his travels on the rodeo circuit. Her earliest memories include drawing with a stick in the dirt, and she continued to make art through years spent traveling and working as a waitress, a maid, a secretary, and at other jobs. Smith earned her MA in painting at the age of 40, producing a body of work that demonstrated her encyclopedic knowledge of art

history. Her visual quotations include the prehistoric cave paintings of Lascaux, France, the ancient petroglyphs of North America, the semiabstract figuration of Plains hide paintings and ledger drawings, and the modernist visual language of Paul Klee and Joan Miró. Her later work has ranged widely in its referencing of everything from popular and vernacular imagery, to Indian stereotypes, to modern masters such as Jasper Johns and Robert Rauschenberg, often in large-scale mixed-media works that combine collage and painting, sometimes with three-dimensional elements.

Yet it is her father whom she credits as the source of her aesthetic inheritance: "In early memory, I watch him split shingles for our cabin and cover the walls in careful rows. This was beautiful to me. I drew on his discarded shingles and he hung one by his bed—a tribute to my work which spurred me on."[16]

In 1992, the year that the United States was celebrating the five-hundredth anniversary of Christopher Columbus's "discovery" of North America, Smith boldly took on five centuries of a Eurocentric tradition of male artistry (fig. 8.6). She lay down on two canvases she had collaged with pages of the weekly newspaper of the Salish Kootenai Reservation and directed her studio assistant to outline the shape of her body. Over this, she painted a red quartered circle. With her title *The Red Mean: Self-Portrait*, Smith referenced Leonardo daVinci's famous fifteenth-century drawing *Vitruvian Man*. Leonardo, in his turn, had illustrated an observation by the ancient Roman architect Vitruvius: "If a man is imagined lying back with outstretched arms and feet within a circle whose center is at the navel, the fingers and toes will trace the circumference of this circle." Smith's circle does not contain her body; her outline extends beyond it "as if breaking free from the weight of patriarchy and Western art history," as art historian Carolyn Kastner has observed. While some have called Smith's circle a medicine wheel, it also can be read as a target, its central X crossing over the lower abdomen of the female figure.

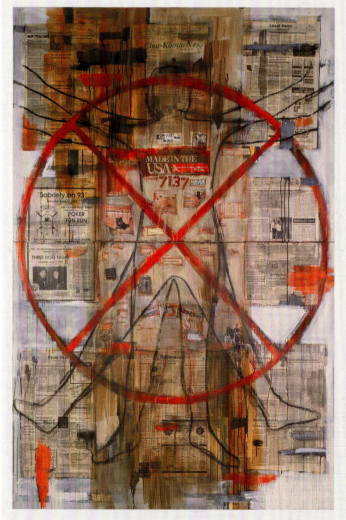

▲ **8.6** Jaune-Quick-To-See Smith, b. 1940 (Salish/Kootenai), *The Red Mean: Self-Portrait*, 1992. Acrylic, newspaper, shellac, and mixed media on canvas, 90 × 60 in. Courtesy artist, the Accola Griefen Gallery, New York, and Smith College Museum of Art.

In this work, then, Smith's concerns reach beyond those of the European male artist. Her determination to make a mark in

the small but decidedly masculine world of contemporary Native art was evident in the early 1980s, when she was a graduate student in studio art at the University of New Mexico and was beginning to attract national critical attention. Smith was committed to make a place not just for herself but for all Native women artists. She collaborated with artist Harmony Hammond to curate the influential traveling exhibit *Women of Sweetgrass, Cedar and Sage* (1985), a show that did much to bring the artwork of contemporary Native women to attention. She has gone on to curate many other exhibits of contemporary art, including *Our Land/Ourselves: Contemporary Native American Landscape* (1991) and *The Submuloc Show/Columbus Wohs* (1992).

history itself in two large paintings commissioned for the new installations of historical Canadian art at Toronto's Art Gallery of Ontario and the Montreal Museum of Fine Art—both of which, as we have noted, were incorporating historical Aboriginal art into their permanent galleries of Canadian art for the first time. Placed at the entrances to the displays, each inverts the power dynamics previously implied by these museums' historical sequences. In Toronto's *The Academy* (2008), Monkman reimagines a nineteenth-century art academy for the training of young artists as taking place inside a Mandan earth lodge. A tour de force that is packed with visual quotations from other paintings hanging nearby, it represents the pioneering Anishinaabe artist Norval Morrisseau (fig. 7.26) as the only "student" actively painting the life group in the center. Although the models are posed as the Laocoön, one of the most famous sculptures of Greco-Roman antiquity, the scene of torment also evokes the agonized conflicts of Morrisseau's own self-portraits.

Lorenzo Clayton is known for his mixed-media installations as well as his meticulous mixed-media prints (fig. 8.7). Raised on the Navajo Reservation, he moved to the New York area in 1973 to attend art school at Cooper Union, where today he is a professor of printmaking and master printmaker. In 1999, Clayton was in the first group of artists to be awarded an Eiteljorg Fellowship for Native American Fine Art. He finds in the conceptual world of Navajo aesthetics and philosophy a place where meaning and power are distilled. His predilection for what he calls abstraction—meaning the abstracting of the essence of an idea, image, or symbol—is evident in this work that is at once autobiographical and universal. Just as Clayton's cultural references are multilayered, so are his printmaking processes. *Come Across I—White Heat* is one of four related prints that comprise a technical tour-de-force of the printmaker's repertoire. They combine lithography, silkscreen, and woodblock printing—each of which has its own long trajectory within the history of art—together with Xerox transfer, a twentieth-century process.

As discussed in chapters 5 and 7, Inuit graphic arts ranging from drawing to lithography, silkscreen and stonecut processes have been central to self-expression in the Canadian Arctic since the 1950s (figs. 5.1, 5.27, 5.28, and 7.20). Napachie Pootoogook (1938–2002) and her mother Pitseolak Ashoona (c. 1907–83) were both concerned with representing Inuit life as it changed from the old ways before their people settled in Cape Dorset in the 1950s. Both are well known for the prints they issued in Cape Dorset's annual print editions; less appreciated are the thousands of drawings they

▶ **8.13** Sarah Sense, b. 1980 (Chitimacha), *Panajachel* from *Weaving the Americas* series, 2011. Digital photographs, photo silkscreen prints, tape. 47 × 71 in. Courtesy the artist.

Panajachel is the name of a Maya village in highland Guatemala, one of the many places the photographer visited during her year of exploring Indigenous arts from Canada to Chile. A youthful bike rider passes through her camera frame, interrupting the careful interweaving of the photo in the distinctive pattern of the Chitimacha basketry that is the artist's maternal heritage. Sense describes the ambitious, long-term project of which this is but one example, as "weaving a cultural landscape of the Western Hemisphere."

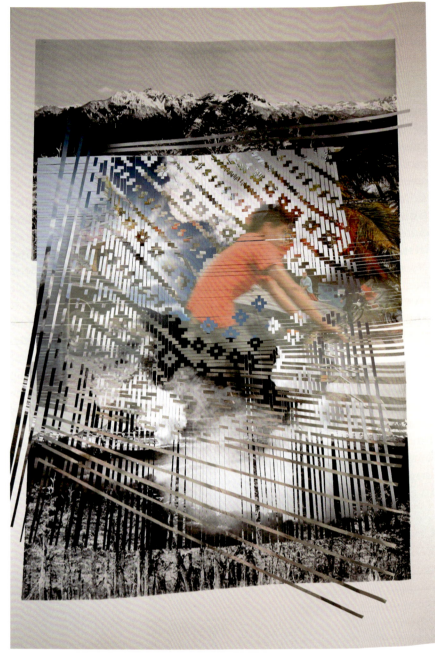

Between 2002 and 2012, New York's Museum of Arts and Design (formerly the American Craft Museum) initiated a series of three exhibitions entitled *Changing Hands: Art Without Reservation*.[26] This began as a survey of contemporary Native craft (which the museum describes broadly as "creativity in wood, glass, ceramics, metalwork, fiber, and mixed media"), but by the final iteration it explored mixed media more broadly. These traveling shows exposed the general public to a wide range of traditional and innovative works of art made across North America.

CONCEPT IN FOCUS
What is "Craft"?

For much of the twentieth century, Native art was hampered by the fact that the general public thought of Native visual production as "mere" craft, rather than fine art. Such a judgment implies that the work is more about repetition and skill than creativity and artistry. Many artists believe that this reductive understanding has kept Native works out of art museums and relegated them to lesser status, both economically and aesthetically. The word "craft" has many different meanings and implications, some negative and some positive. To some, the phrase "arts and crafts" suggests something frivolous, made by an amateur or a child. But throughout much of history, the word "craft" has also stood for the highly skilled, the handmade, and the product of generations of experimentation and refinement. "He really knows his craft" or "she practices fine craftsmanship" are phrases used in many contexts, ranging from woodworking to poetry to theatrical performance.

Fine craftsmanship is a key criterion of aesthetic quality in many Indigenous traditions.[27] In 1930, the Museum of Northern Arizona inaugurated the annual juried Hopi Craftsman's Show, to distinguish the fine workmanship of capable artists from the tourist trinkets (many of non-Native manufacture) that were being sold to the public. Pueblo potters appreciate the technical perfection of a finely coiled bowl that has been smoothed and burnished to perfection. Haida wood-carvers know that one cannot make a bentwood box, with its steamed and kerfed corners, without a thorough understanding of cedar and its properties, as well as a gentle touch with the adze and the knife. In this regard, the word "craft" connotes consummate skill and functionality, as well as respect for traditional knowledge.

But twentieth- and twenty-first-century thinking about craft is not just about traditional processes. In the European and North American craft worlds of the early twentieth century, there was much talk about how craftsmanship could be wedded to new design, to make useful, beautiful, and modern works. The modernist explorations in precious metals and fine stones by Hopi jeweler Charles Loloma (fig. 2.27) and Haida jeweler Bill Reid paved the way for generations of younger jewelers, such as Denise Wallace

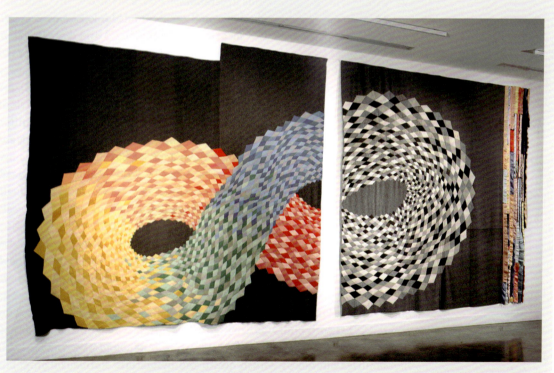

▲ **8.14** Marie Watt, b. 1967 (Seneca, New York), *Braid*, 2004. Reclaimed wool blankets, satin bindings, thread, 259 × 128 in. Courtesy of the Eiteljorg Museum of American Indians and Western Art, Indianapolis. Although this is a work of collective "craft," it is also a painterly exploration of color and geometry, as befits a graduate of the Yale School of Art, where the legacy of Bauhaus master Josef Albers, and his rigorous examinations of color and geometry, lives on.

(cont.)

▶ **8.16** Margaret Wood, b. 1950 (Navajo/Seminole), *Blackfoot Boy's Shirt Quilt*, 1983. Cotton fabric and thread. Courtesy the artist and Michigan State University Museum.

For Margaret Wood the medium of quilting—adopted by Native artists more than a century ago—provides a pictorial space in which to continue the expressive values of traditional clothing and textile design. Through quilt designs, she explores not only specific aesthetic traditions but also the philosophical principles embedded in stories and teachings.

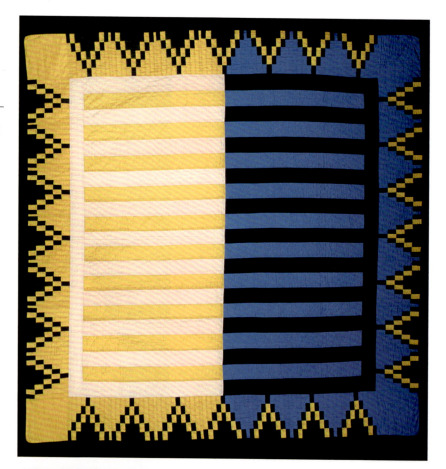

▶ **8.17** Jeremy Frey, b. 1978 (Passamaquoddy, Maine), *Point Basket*, 2011. Brown ash, sweet grass, H: 20 × 11 in., view from top. Courtesy the artist.

For over two centuries, Passamaquoddy women, like others throughout the Northeast, have woven fancy baskets of splints cut with great precision from the black ash tree. Jeremy Frey has made this a man's art as well, and his superb virtuosity and control of form have taken the basketry tradition to new heights.

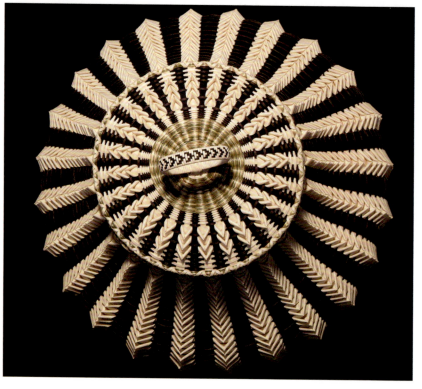

Fine bookmaking has long been considered one of the fine crafts, but Nicholas Galanin disrupts both bookmaking and craft, when he reshapes a published book into a sculptural self-portrait (fig. 1.8) that is a devastating critique of anthropology's part in the colonial enterprise. Will Wilson demonstrates that definitions of craft change with every generation, and it is the artist's job to push the boundaries of such categories. Beads—whether Indigenous handmade shell beads or manufactured glass ones from Venice or Czechoslovakia—have been social currency for Native Americans for countless generations, as has been evident in every chapter in this book. Best known as a photographer and installation artist, Wilson has pushed the boundaries of beadwork in *eyeDazzler: Trans-customary Portal to Another Dimension*. He brought a 1970s family weaving by his grandmother, Martha Etsitty, into the twenty-first century. While keeping the weaving format, he transformed it by replacing the fiber weft of the work with more than 76,000 small square glass beads (fig. 8.18). In the middle of the multicolored geometric design, he inserted a black and white QR code, so that the viewer who participates in the artwork by scanning the QR code with a smart phone is led to a split-screen video offering glimpses of Wilson and of others who participated in the weaving of the beads, as well as portions of the beaded weaving and its historical prototype. Overlaid on the video is a conversation in Navajo about weaving by weavers in the artist's own family.

In using the term "trans-customary" in the title, Wilson is influenced by Maori artist and educator Robert Jahnke, who heads a Maori studio art program at Massey University in New Zealand. Jahnke spurns the word "traditional," which is overused in the discourse of both Maori and Native American art; he prefers "cus-tomary." In turn, "trans-customary" art has "a visual or perceptual relationship" with Indigenous historical forms, the prefix "trans-" connoting a transformative process. *eyeDazzler: Trans-customary Portal to Another Dimension* provides a bridge between the contemporary and the historical, the work of the twenty-first-century multimedia artist and the Navajo weavers who were his forbearers. It is also a portal between the reality of a viewer who stands in a gallery and the multidimensional, multimedia world

▲ **8.18** Will Wilson, b. 1969 (Navajo), *eyeDazzler: Trans-customary Portal to Another Dimension*, 2011. Courtesy Will Wilson, Pamela Brown, Jay Farley, Jaime Smith and Dylan McLaughlin. Collection, New Mexico Art in Public Places.

The designs of a classic Navajo woven blanket express both mathematical intelligence and artistic creativity. In Wilson's "blanket" they are realized with 76,050 square-cut beads, which took 1,000 hours to weave. At the center are surprising motifs, two QR codes which challenge young Native people to use contemporary technology as a portal that can engage not only contemporary culture but also Navajo history.

▶ **8.21** Nadia Myre, b. 1974 (Algonquin), *Indian Act*, detail from work of fifty-six units, each 8 ½ × 11 in., 2000–3. Paper, seed beads, stroud cloth, thread. Art © Nadia Myre/CARCC, Ottawa/VAGA, New York.

By covering over the fifty-six pages of Canada's Indian Act with beads, Myre and her collaborators symbolically deactivated its oppressive force. Like an ancient script we can no longer read, we see words but cannot decipher their meanings. Her project commemorated the reversal of another erasure, when her mother and she had their Aboriginal status restored in 1997.

exposure to images of the crucified Christ shaped her work: "When I began my formal art training, these influences surfaced in the form of biomorphic images, skeletal armatures with vestiges of 'flesh,' using architectural and figurative language. Monochromatic, after the solitude and simplicity of the prairie. Sometimes building the surface up and then working back from there, peeling the layers."[32]

Nadia Myre's *Indian Act*, discussed earlier, is a three-dimensional mixed-media work that—not quite sculpture and not quite installation—is one of many such works that blur the boundaries between the genres (fig. 8.21). Like those Plains Indian graphic artists in the 1870s who drew right over the supply lists in ledger books, thus superimposing their own reality (chapter 4), Myre's collaborative act of beading over and obliterating the text of Canada's Indian Act is a way of claiming Native space—in blood-red beads, through art.

Installation

Many installations are, by their nature, ephemeral or transitory. Mounted for a specific exhibit, or a specific place, they may be dismantled or erased.

◀ **8.22** Marianne Nicolson, b. 1969 (Kwakwaka'wakw), *House of Origin*, 1998. Mixed media installation. Courtesy Canadian Museum of History, S2006-00006, and the artist.

A traditional Kwakwaka'wakw house, with its painted façade and monumental architectural carvings, tells the history of the family within. Nicholson uses the media of contemporary art—easel painting, photographic collage, and texts in the Kwakwala language and English—to add to inherited narratives the modern historical experience of the members of the house.

For example, earlier in his career, HOCK E AYE VI Edgar Heap of Birds became well known for temporary installations that addressed the contentious or tragic political histories of particular locales. Ranging from an electronic billboard in Times Square, New York (1982), to metal signage along the banks of the Mississippi River in Minneapolis (1990), to billboards on the sides of buses in San Jose, California (1990), each was an artist's response to specific histories of injustice. Today, each is known only from its photographic documentation. In this work, he was participating in a larger movement within the contemporary art world that came to prominence in the 1980s in which contemporary advertising genres and popular culture media, such as billboards and the then-new LED-lighting displays, became sites for artists' politically motivated work. Heap of Birds' use of these media suggests comparison with that of non-Native feminist artists Barbara Krueger (b. 1945) and Jenny Holtzer (b. 1950) in the 1980s. His site-specific and sometimes ephemeral works comprise one of the most extensive and influential achievements in this genre.

In some cases, objects from within an installation, especially objects such as prints or photographs that can exist in multiples, have an independent aesthetic life outside of the installation. This has been the case for the photographs from Will Wilson's *Auto-immune Response* series. But the installation of which they were a part gave the viewers the experience of walking not only into the photographic environment but also into an architectural one. Marianne Nicolson's *House of Origin*, made for the influential exhibition *Reservation X* in 1998, deconstructs the space of a community house in Kingcome Inlet, British Columbia (fig. 8.22). Using architectural elements, photographs, paintings, and texts, the work emphasizes the unity of concepts such as home, community, and spiritual origin (too often seen as separate spheres in the modern world). It asserts their importance—and the literal permeability of their walls—within the space of a museum. The large, ancestral houses of Northwest Coast peoples were made of massive cedar posts and planks with carved and painted component parts (fig. 6.9). Here, the structural corner beams are absent, so that viewers can move about the space.

(cont.)

almost anthropomorphic—like a circle of dancers with arms raised. The curve of this circle of pillars is echoed in a curved wall of the North Building of the museum, which the artist has appropriated as part of the installation. There, large-scale raised letters spell out *NAH-KEV-HO-EYEA-ZIM* ("turning back around to where we come from"), a phrase that the artist's grandmother used for returning home.

As with any richly layered work of art, viewers bring various interpretations to Heap of Birds' imagery. Its vertical piers recall Stonehenge, the 3,000-year-old monument on England's Salisbury Plain, as well as large twentieth-century minimalist sculpture. The vivid red evokes bloodshed in the Sun Dance as well as bloodshed when soldiers of Colorado's Third Cavalry massacred 160 Cheyenne people at Sand Creek in 1864. This monumental work of art stakes a claim in the twenty-first-century metropolis—a claim for Native sovereignty, remembrance, and endurance.

Performance

Earlier in this chapter we discussed the performance art of Rebecca Belmore and James Luna. Both understand performance as a vibrant creative mode that bridges past to present. Luna has said that performance "offers an opportunity like no other for Indian people to express themselves without compromise," while Belmore has remarked, "It is my role as an artist to articulate the questions we should be asking."[35]

Luna's performance *Emendatio* was done in conjunction with the fifty-first Venice Biennale in 2005, to complement his installation *Chapel for Pablo Tac* (fig. 1.1). He repeated it in 2006 at the National Museum of the American Indian when that work was reinstalled. The performance was silent, for, as the artist has said, "My silence is probably the most strategic and strongest voice I can have."[36] *Emendatio*, a word meaning "emendation" or "corrective" in Latin, reflects the language used in the Roman Catholic liturgy that Pablo Tac (1822–41) was taught during his missionary training in Italy. Luna's installation and performance were a corrective to the Roman Catholic historical record that represents Tac simply as a successful convert and seminarian of the Church. In both installation and performance, Luna inserted into the mix both Luiseño ritual paraphernalia and the detritus of contemporary Native life. For his performance he created on the floor a space that was roughly the size of a Navajo sandpainting and suggestive of a sacred, circular altar (fig. 2.21). Stones mark the perimeter, as do cans of Spam, vials of insulin, and hypodermic needles that remind the viewer of the diabetes epidemic that is rife in Native communities caused by the shift from a traditional diet to unhealthy processed and fatty foods. The artist enters the circle four times, first in a loincloth and rattle, and subsequently in full ceremonial garb, a black leather jacket, and, finally, dressed in the garish red tuxedo he uses in other performances in his persona as "The Lounge Luna." The artist is careful to point out that this is not a ceremony and he is not a shaman; he is an artist respectfully using some of the protocols and gestures of ceremony to bear witness, and to ask us to bear witness to the somber, sobering, and contradictory facts of what is called "history."

The work of Luna and Belmore is located between the long history of Indigenous ritual performances—the shaman, the ceremonial performer, the celebratory dancer—and international contemporary performance art. Through their art school training and subsequent international travels, both

artists have been influenced by an earlier generation of performance artists of the 1960s and 1970s and by their contemporaries. Feminist artist Eleanor Antin (b. 1935) and Dutch conceptual artist Bas Jan Ader (1942–75) influenced Luna, while Belmore's work draws on the generation of female performance artists who preceded her, such as Yayoi Kusama (Japanese, b. 1929), Hannah Wilke (American, 1940–93), Marina Abramovic (Yugoslavian, b. 1946), and Lisa Steele (Canadian, b. 1947). All of these women used their own bodies in wrenchingly memorable performances, some as early as the 1950s. In contemporary Native art, as in much other recent art, artists continue to use the body as the site for playing out many of the most complex issues of our time.

Performance art is necessarily ephemeral. Its traces can exist in film and video, in still images, and in descriptions or scripts. Increasingly, YouTube and CDs have become the performance archive. Lawrence Paul Yuxwelupton's 1997 performance, *Shooting the Indian Act*, lives on in both of those formats. Like Nadia Myre's work (fig. 8.21), its ostensible subject is Canada's Indian Act of 1876. Here, the artist literally takes aim at the paper version of the legislation, shooting it to the point of obliteration. The performances took place at two places in the English countryside, though Yuxwelupton's primary audience was his Native peers, who would find humor and irony in this act that would elude British viewers, despite the fact that the British legal system was ultimately the source of such colonial legislation.

Film, Video, and New Media

Native North American visual culture today embraces media that extend far beyond the traditional purview of art history. The technological aspects of new media have invited separate study, but they are also integral to the spectrum of contemporary Aboriginal artistic practice. We thus consider several examples here as part of the continuum of visual production covered by this book, although we can address them only briefly. As we have seen, many Native painters and photographers have considered it essential to engage with the history of their representation and misrepresentation by outsiders. The time-based arts take up this issue as well, redressing the one-dimensional image of Aboriginality perpetrated by popular culture.

Native people have long participated in the film industry as actors, but it is only recently that more than a handful have worked behind the camera. Since 1971, Abenaki filmmaker Alanis Obamsawin (b. 1932) has pioneered the making of documentaries on Native issues from an Aboriginal perspective in her work for the National Film Board of Canada. It took longer for Aboriginal directors to acquire the backing to make feature films. When it appeared in 1998, director Chris Eyre's (b. 1968, Cheyenne-Arapaho) independent hit *Smoke Signals*, based on a short story by Sherman Alexie (b. 1966, Coeur d'Alene-Flathead), set an important precedent as the first Native-made film that was a mainstream success. Filmmaker Zacharias Kunuk (b. 1957) believes he was the first Inuk to own and use a video camera, which he purchased in 1981. A year later the Inuit Broadcasting Network (IBC) began to broadcast local content in the Inuktitut language to Canadian Arctic communities, and Kunuk took a job as a programmer that

lasted for eight years. In 1991 he and his partner Norman Cohn started the first Inuit-owned film production company, Igloolik Isuma Productions. Ten years later, Kunuk's first film, *Atanarjuat/The Fast Runner*, won the *Camera d'Or* prize at the Cannes Film Festival and gained acclaim from audiences worldwide. The former stone carver who, twenty years earlier, sold three of his carvings in Montreal in order to buy a porta-pack video camera, a TV, and a VCR had become a well-known filmmaker.[37]

Atanarjuat was notable for being the first feature-length film written, directed, produced, and acted entirely by Inuit people speaking Inuktitut. Kunuk used contemporary technology to tell an ancient story—one that took place long before the coming of outsiders to the Arctic. Elders were consulted as to story line, dialogue, and the design of sets and costumes. While the makers said that the film was made primarily for Inuit audiences, its story of love, jealousy, hunting, family, and religious strife captured audiences worldwide.

Work in video has been a natural development for a number of photographic artists, such as Shelley Niro (b. 1954, Mohawk). Video has given Niro the scope to use movement, speech, and dramatic narrative to deepen the explorations of traditional and popular culture concepts of women's responsibilities, roles, and ideals of beauty that she had first explored in much admired photographic work such as her series, *Mohawks in Beehives*. She has also embraced video because of its broader accessibility to members of her community. Her 1998 *Honey Moccasin* was, like her other videos, filmed on her home reserve in southern Ontario, the Six Nations of the Grand River but set on the fictional Grand Pine reserve. Although an intentional pastiche of styles, it is structured as a detective story set in the bar run by the lead character Honey Moccasin. She sets out to discover who has stolen all the outfits needed for the coming community powwow (all, as it will turn out, made out of hilariously funny assemblages of kitsch materials in the absence of "authentic" materials). The culprit turns out to be the drag-queen owner of a rival bar, a man who has returned to the reserve from the big city, allowing Niro to present the viewer with the dilemma faced by many contemporary Aboriginal people who feel caught between two worlds. Niro has also incorporated her own contemporary beadwork into mixed media installations (fig. 8.1c).

Unlike the United States, in Canada there is state support for Indigenous media production. Such funding began more than forty-five years ago with the National Film Board (NFB)'s Challenge to Change Program (1969–80). It was premised on the new lightweight and portable camera that extended the tools of visual storytelling to all. An Aboriginal Production Studio was established within NFB in 1991. As visual anthropologist Kristin Dowell has noted, "Aboriginal media production simultaneously alters the visual landscape . . . by representing Aboriginal stories on screen and serves as a vital off-screen practice through which new forms of sociality and community are created and negotiated."[38] These new media communities serve as one way to heal the rupture of communities that occurred through colonization and urbanization. Among many ongoing initiatives, the imagineNative Film and Media Arts Festival, established in Toronto in 1998, aids in the development and dissemination of Native film and video. It is exciting to

many Indigenous media-makers that their work connects even remote communities with a larger world of Native concerns. Some, such as Kevin Burton in his short film *Nikamowin* ("Song," in Cree), are adamant that video can even be a tool to maintain and reinvigorate diminishing languages.

Some of the most exciting time-based work is carried out in "new media," a rubric that encompasses digitally-based initiatives, many of which are interactive. What Native artists find liberating about new media is the democratization of both authorship and consumption; rather than being subject to the fantasies of a Hollywood elite whose understandings of Native experience are limited, Native artists themselves can create content. The website *Beat Nation: Hip Hop as Indigenous Culture*, curated by Tania Willard and Skeena Reece, proclaims that it offers "new tools to rediscover First Nations culture." It was one of the first places that the world saw Nicholas Galanin's now-famous video, *Tsu Héidei Shugaxtutaan I* and *Tsu Héidei Shugaxtutaan (We Will Again Open This Container of Wisdom That Has Been Left in Our Care)* II, later widely viewed on YouTube. It is a mesmerizing two-part work in which a dancer dressed in Tlingit ceremonial regalia moves to a hip hop beat, while a breakdancer in jeans and sneakers moves to Tlingit music. Galanin, as a multimedia artist, explains that it is only by taking the container of culture and opening it up "creatively with a new conceptual voice that is not limited by boundaries" that culture continually renews itself (see fig. 1.8).[39]

New media artists Jason Edward Lewis and Skawennati Fragnito have commented that "The era of networked digital media presents a unique opportunity for Aboriginal people to present a self-determined image to the world. Since contact, we have had to contend with a lack of access to the means by which our lives were illustrated by others. The written and printed word, photography, film, and television, have all been used by the settler culture(s) to describe us while we were kept mute due to a lack of training, a lack of access to the technology, and a lack of access to the means of distribution."[40] In 2006 they founded AbTeC (Aboriginal Territories in Cyberspace) to develop strategies for greater participation by Native people, especially youth, in new media in order to aid in "the continual retelling of old stories and the imagining of new ones."[41]

It is in imagining Native people in the future that Skawennati (the single name she uses as an artist) finds particular creative joy. Her multipart *TimeTraveller*[TM] series has not only been seen online but has been part of important contemporary art exhibits, including *The Eiteljorg Fellowship in Contemporary Art* (2011) and *Changing Hands 3* (2012). It won imagine Native's Best New Media Award in 2009. In one episode (fig. 8.24), Karahkwenhawi, a young Mohawk woman from the twenty-first century time-travels to Iroquoia in 1680, to meet the historical figure Kateri Tekakwitha (1656–80), who was beatified by the Catholic Church in 1980. Kateri dies of smallpox just as she is imagining that by founding an order of Native nuns, Mohawk women will have "a place to practice our ceremonies in peace." Skawennati has Kateri say that she seeks to "tap into the spiritual power of Sky Woman and Mary," and is sure that upon her death from smallpox she will find that Sky World and Heaven are one. (The timeliness of this episode is underscored by the fact that the Vatican named Kateri as the first Native American saint in 2012.)

▶ **8.24** Skawennati, b. 1969 (Mohawk, Khanawake, Quebec), "Saying Goodbye," Production still from *TimeTraveller™*, Episode 5, 2012. Machinima on Blu-Ray DVD, courtesy of the artist.

We witness this seventeenth-century scene of the death of the Mohawk Catholic saint Kateri Tekakwitha through the eyes of a young twenty-first-century Mohawk woman. Using computer-generated imagery to revisit the past, Skawennati asks contemporary Indigenous questions of histories that have most often been told from non-Native perspectives.

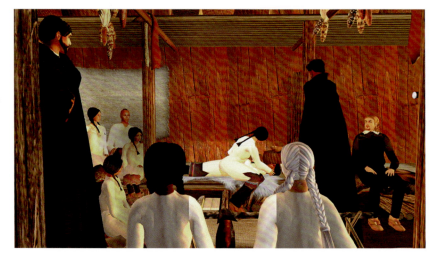

TimeTraveller™ exists in the online virtual world of *Second Life*, used by more than twenty million people across the globe. Historians of Native art participating in *TimeTraveler™* will note the accuracy of the log church (modeled on the seventeenth-century Sainte-Marie Among the Hurons, on Georgian Bay), the use of wampum belts, and the recreated interior of a longhouse. While in the longhouse, the time traveler from the twenty-first century remarks, "I didn't know it would be so smoky," giving a sense of historical immediacy to the action.

While much of the fantasy of digital gaming and virtual worlds allows the participant to escape reality, Indigenous curator Candice Hopkins points out that the main characters and the participants in *TimeTraveller™* are reinscribed both within Native history and a Native future. It is an alternative way to narrate Native histories and, more important, to imagine aboriginality in centuries to come. Like Kunuk's *Atanarjuat*, such stories make history relevant for a new generation, one that often finds the virtual more compelling than traditional genres of literature or fine art.

PREEMINENT ISSUES IN NATIVE ART SINCE 1980

A delineation by medium is not fully adequate to the understanding of late-twentieth- and early-twenty-first-century Native North American arts. Many contemporary artists, such as Kent Monkman and Shelley Niro, move fluidly among different media. Often, politically relevant subject matter drives an artist's choice of medium or format. Many artists trained today are proficient in a range of media and choose what is effective for the visual realization of the ideas they want to express. The artists discussed here address issues that have become central in the arts of the early twenty-first century, not only among Native North American artists but also globally: the unfinished business of settler colonialism, the body, and environmental degradation.

Postcolonial Perspectives on Sovereignty, Home, and Homelands

As Elizabeth Kalbfleisch has noted, Aboriginal artists' representations of "home," broadly defined, "invite a discussion of colonialism, nation, family,

and identity" that is dynamic and multifaceted.[42] As we saw in chapter 4, as far back as the 1870s, Kiowa artist Wohaw pondered the ways that traditional notions of dwelling were unsettled by settler colonialism when he portrayed himself with one foot near the tipi and the buffalo and the other near the plowed field and settler-style log home (fig. 4.15). Many contemporary artists have taken up these issues as well.

In 2004, Mohawk artist Hannah Claus (b. 1969) exhibited *unsettlements*, an installation of 100 simple frame houses, set off-kilter in a seemingly random way. These beguiling miniatures were made of printouts of historic wallpaper designs, glued to wooden frames. The artist subtly interrupted these decorative wallpaper patterns by pricking through them with Iroquois beadwork designs. Each house sits within an ordered arrangement of white beads, each suggesting a white footprint. Dramatic lighting casts each house's shadow in a different direction from its white beaded base. These small dwellings for nuclear families, arranged helter-skelter, remind the viewer that the traditional Iroquois dwelling, the longhouse, embraced extended families (fig. 3.2). Yet the foundation of white beads seems to suggest that even the "unsettled" houses are firmly rooted in matrilineal traditions.

But domestic space is not the exclusive concern of female artists. As discussed in chapter 4, Lakota artist Arthur Amiotte depicted his great-grandparents' log home in *The Visit* (fig. 4.17), as well as in a nearly full-size installation of that home in the Plains Indian Museum in Cody, Wyoming, complete with some original family objects. Mohawk artist Alan Michelson reflects on settler colonialism and Aboriginality in *Prophetstown* (fig. 8.25), an installation of a number of small, carefully constructed dwellings that have significance not only in the American imagination but elsewhere as well. Among them are Thoreau's cabin in the woods at Walden Pond, a Cherokee house, an Australian prison in which Aboriginal prisoners were incarcerated, and a low, cribbed-wall dugout from the John Wayne western film *The Searchers*. As installed at the Sydney Biennale in 2012, *Prophetstown* was unsettling in its deliberate use of dramatic lighting that bounced off the cases, creating a hall-of-mirrors effect that destabilized the gaze, leaving the viewer unsure which houses were real and which ghostly reflections. As Kathleen Ash-Milby remarked, "the power of his work is not just its ability to reveal hidden history, or offer easy answers, but to make us question and become critical thinkers ourselves."[43]

Prophetstown engages not only with the issues of settler colonialism and various versions of domestic history but also with transnational ideas of the shifting landscape of the home for the unsettled or resettled artist. In global contemporary art, houses as well as artists are on the move; the sense of dislocation can be mitigated by reminders of home, and any space can be claimed as home space. Caribbean-British artist Donald Rodney (1961–98) created many works relating to family and home. Perhaps most moving was *In the House of My Father* (1996–7), a fragile, portable dwelling small enough to fit in the palm of his hand and made from the skin grafts he endured as he wasted away from sickle-cell anemia.[44] Korean artist Do-Ho-Suh (b. 1962) created his *Seoul Home* (1999) of diaphanous silk, and his twenty-foot-long house hung as a ghostly presence in numerous international exhibits. In *Teahouse* (2011),

▶ **8.25** Alan Michelson, b. 1953 (Mohawk), *Prophetstown*, 2012. Inkjet prints on handmade paper, Davey board, gold leaf, grout, and archival adhesive. Courtesy the artist; photograph by Alexander Brier Marr, © 2012.

Michelson appropriates the old-fashioned museum format of the miniaturized diorama but uses standard museum cases to display meticulously crafted models of specific houses, both fictional and historic. With the omission of the tiny figures that peopled such dioramas and reduced Native presence to doll-like representations, Michelson's houses become ghostly reminders of a contested history.

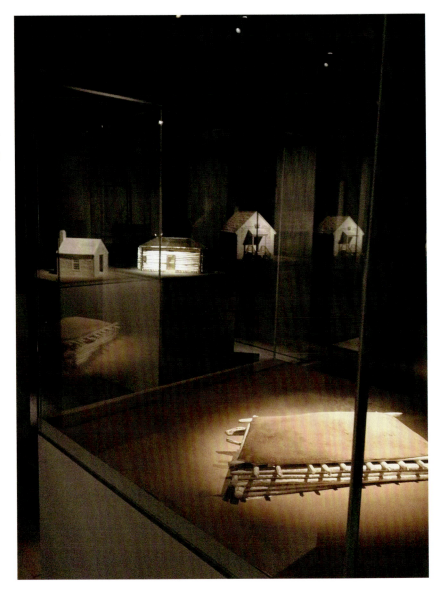

Chinese artist Ai Weiwei compressed solid blocks of tea into forms that resemble Hannah Claus's houses. Sitting on beds of loose tea, they merge ideas of the modern and the traditional in Chinese culture.

Tuscarora artist, historian, and critic Jolene Rickard has been an eloquent spokesperson for the principles of Indigenous sovereignty that inform her artistic work. Her multimedia installation, *Corn Blue Room*, first traveled with the landmark *Reservation X*, organized by the Canadian Museum of Civilization in 1998 (fig. 8.26) and is now in the permanent collection at the Denver Art Museum.[45] At the core of this complex installation is a cascade of enormous ears of Tuscarora White Corn, bathed in an otherworldly blue glow. Encircling the corn are easels forming a traditional Haudenosaunee longhouse, displaying photos of corn kernels, power lines, generating stations, and political marches. The images offer

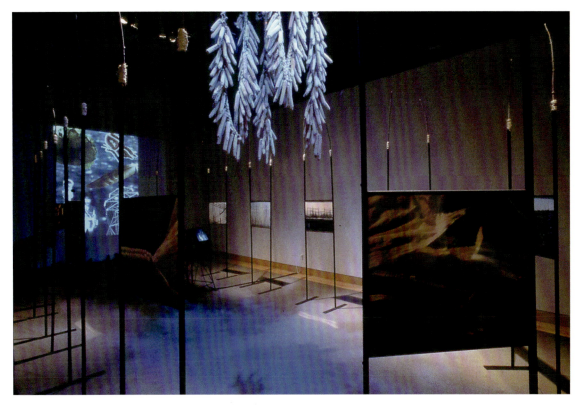

▲ **8.26** Jolene Rickard, b. 1956 (Tuscarora), *Corn Blue Room*, 1998. Mixed media installation. Denver Art Museum Collection: William Sr. and Dorothy Harmsen Collection, by exchange, 2007.47. Courtesy the artist.

Everyone, including Rickard's Tuscarora nation, lives today in the blue glow of electronic technologies. They are fueled by electricity from sources like the hydroelectric plant built on appropriated Tuscarora territory during the 1950s. But ancient traditions of corn cultivation and ceremony also persist in the modern world, and artists such as Rickard seek to "move knowledge from one generation to the next."

different representations of power, ranging from the industrial energy generated by the Niagara Mohawk Power Authority (which in 1957 flooded one-third of Tuscarora land) to the tradition of protests that sustain Hauenosaunee self-governance. *Corn Blue Room* also pays tribute to the ancient collaboration of the "Three Sisters"—corn, beans, and squash—and the humans who rely on them. Tuscarora women have carefully maintained Tuscarora White Corn for size, flavor, and nutrition; its kernels have far more protein than mass-marketed corn and a lower glycemic index.[46] Today, these ancient strains of corn are under threat from the genetically modified corn hybrids ubiquitous in American agribusiness.

The installation invites reverence for these ancestral strains of corn, while the blue glow calls to mind other recent artworks invoking the ultraviolet light under which the GFP—green fluorescent protein—gene is rendered visible for engineering.[47] This installation is intended to remind viewers of the necessity of, in Rickard's words, "taking seriously a civilization that has been thousands of years in existence." Reminding us what is at stake in discussions of home and homeland, she asserts, "We simultaneously appropriated the

European word sovereignty and rejected a U.S. legal interpretation of it while creating a uniquely Haudenosaunee understanding . . . that embodies our philosophical, political, and renewal strategies."[48]

Ecology and the Land

A sense of reverence for land and landscape is evident in many works being made by Native artists of the last several decades. For Emmi Whitehorse and D. Y. Begay, it is often the desert colors of their Navajo homelands. For Truman Lowe (fig. 8.20), the driftwood and water of his Great Lakes childhood shape many of his massive abstract sculptures.

Other artists make provocative social commentary about the natural world through their choice of materials. In her 1997 performance and installation, Dana Claxton (b. 1959, Lakota) memorialized the buffalo, the animal most sacred to the Lakota. In the late nineteenth century, these animals were hunted to the brink of extinction. Hides were sent east for processing and tens of thousands of tons of buffalo bones were shipped east on the railroad to be used in manufacturing the bone china that consumers prized for its durability and delicacy. In her performance *Buffalo Bone China*, the artist, dressed as a lab technician with gloves, body covering, and face protection, selected items from stacks of fine, industrially produced bone china and methodically smashed them with a mallet. In the related installation, stanchions marked off piles of broken china like a memorial, while a succession of images was projected on the wall, including a buffalo skull, stampeding buffalo, and the artist/technician poised to begin her work of ritual destruction.

Brian Jungen's *Cetology* (fig. 8.27) is a giant diving whale skeleton constructed of plastic garden chairs, materials as "inauthentically Native" as the Nike Air Jordan sneakers out of which he made the witty Northwest Coast style masks and totems of his influential *Prototypes for a New Understanding* series (1998–2005). Jungen questions the dominant culture's ineradicable stereotype of Indigenous peoples' alleged closeness to nature. Unlike the huge killer whale totems painted on Northwest Coast housefronts, this whale is

▶ **8.27** Brian Jungen, b. 1970 (Dunne-Za Nation, British Columbia), *Cetology*, 2002. Plastic chairs, 63 ft. × 496 in. × 66 in. Provided by the Gallery: Collection of the Vancouver Art Gallery.

Although they recall the whale and dinosaur skeletons that form the centerpieces of natural history museums, the giant sea beings Jungen creates out of deconstructed lawn chairs call attention to both the ubiquity of mass-produced consumer goods and the ecological nightmare they create—an inheritance that is shared by Indigenous and non-Indigenous peoples.

neither totem nor celebration of natural forces. It is, rather, an indictment of our age of global warming, depletion of the oceans, and excessive consumption of petrochemicals to make the plastics that overflow in our lives, clogging landfills and bodies of water. *Cetology* prompts questions about our "romance" with nature, the future of endangered species, and the ubiquity of human-made detritus. At the same time, Jungen's work is also playful, and the delight it inspires replicates the central paradox of the destructive cycle of consumption in which we are caught.

Will Wilson addresses issues of nuclear poisoning of the American Southwest in his widely exhibited photographs and installation *Auto Immune Response* (2005). Large-scale digitally collaged photographs present a character, played by Wilson, who walks the land, at times wearing a gas mask, streaks of chalky paint on his face. In *Auto-Immune Response #4* the unseen protagonist has set up shop in a *hogan* (see chapter 2), which he has turned into an ad-hoc laboratory.[49] The artist writes,

> *The work has focused on a post-apocalyptic Navajo man's journey through an uninhabited landscape. The character in the images is searching for answers. Where has everyone gone? What has occurred to transform the familiar and strange landscape that he wanders? Why has the land become toxic to him? How will he respond, survive, reconnect to the Earth?*[50]

Wilson credits a youth devoted to comic books and 1970s, science fiction films for his interest in a postapocalyptic world. Moreover, his knowledge of the ecological Armageddon that is the twentieth-century legacy of the American Southwest informs his work. Nuclear waste from the uranium mining conducted by the U.S. government and private companies from the late 1940s poisoned the environment of the Navajo reservation and killed family members of Wilson's grandmother's generation.

When the hogan from Wilson's photographs was temporarily installed in museums, such as NMAI's Heye Center in New York, and non-Native art museums in 2005–6, it remained part of a Diné geopolitical framework. Visitors entered a skeletal hogan framed in metal and lay on a chair made of the same material. The open-frame structure invited the viewer to imagine a "home" that extended well beyond the artificial borders of the "Navajo reservation" as defined by the U.S. government, and to understand political sovereignty in a way quite different from Western legal definitions. Like Rickard's *Corn Blue Room* (fig. 8.26), Wilson's *Auto-Immune Reponse* invokes Indigenous knowledge as a key to survival in a despoiled world.

The Native Body

James Luna's *Artifact Piece*, discussed at the start of this chapter, was one of the first to fully address the notion of the colonized body, and the integrity of the taking back of that body for Aboriginal articulation and exploration. Rebecca Belmore has remarked, with regard to the Native body in contemporary art, "It's the politicized body, it's the historical body, it's the body that didn't disappear.[51] Belmore has used her own body most effectively in her performances but also in an arresting life-sized photo entitled *Fringe*

▶ **8.28** Erica Lord (Athabaskan/Inupiaq, Alaska), *I Tan to Look More Native*, 2006. Digital print. Courtesy the artist.

Lord's art, like that of other Native artists, explores the "cultural limbo" she experiences because of the misfit between her mixed heritage and federal laws that enforce a single official identity. The photographs in her Tanning Project play with the superficiality and arbitrariness these contradictions produce.

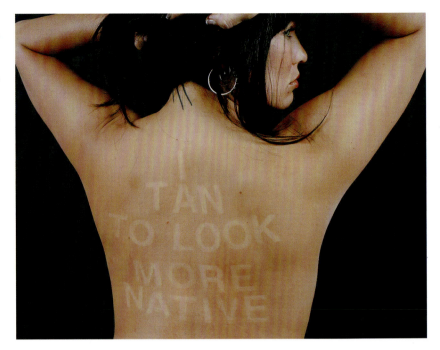

(2008) in which the sinuous back of a seminude woman appears to be dripping blood. On closer inspection, the back appears to have been slit open diagonally and sutured shut. The drops of blood are actually a red beadwork fringe. *Fringe* was also mounted on a billboard in Montreal, allowing passersby to consider the connection between the female body, the colonized body, and the land.

Alaskan artist Erika Lord, who defines her heritage as Athabascan, Inupiaq, Finnish, Swedish, English, and Japanese, is also concerned with the female Native body. In *The Tanning Project* of 2005–7, Lord photographed parts of her own nude body after having masked off portions of her flesh with tape and spending time in a tanning salon. *Untitled (I Tan to Look More Native)* is an indictment of the identity politics which has led both Native and non-Native to question the authenticity of those whose skin color does not conform to shades of "red" imagined to define Native status (fig. 8.28). She shot one of the works in the series, *Untitled (Halfbreed)*, from the front to reveal the word 'HALFBREED' spelled out in the untanned skin that had been masked by tape while she lay in the salon. The artist's blue eyes hold the viewer's gaze, as if to challenge, before the fact, the questioning of authentic identity to which those who do not look "Native enough" are subjected. *Untitled (Colonize Me)* is a provocative nude self-portrait shot from the side, with the words "Colonize me" lettered along Lord's thigh. Each of these digital inkjet prints is very small scale—four by five inches—recalling the instant snapshot photography of the mid-twentieth century. Yet each has a monumental presence that belies its tiny format. In a series entitled *Un/Defined Self-Portrait* (2005–7), Lord adopts the tactics of Cindy Sherman, photographing her own face at close range in different guise and hair colors, as if to show that a mixed-race woman can "pass" by adopting many different personas. She has also appropriated the tactics of

James Luna himself. With his permission, in 2008, Lord staged *Artifact Piece, Revisited* at the National Museum of the American Indian in order to explore the valances of this work when rendered by a female rather than a male performer, and within the context of a museum run by Native Americans rather than a conventional settler museum of natural history.

Globalism and the Transnational

The Venice Biennale, founded in 1895, was once the definitive taste maker in the world of contemporary art. Recent decades have seen a huge proliferation in biennials, triennials, and art fairs all over the globe, in metropolises such as Gwangju, Johannesburg, Dakar, Basel, Kassel, Lyon, Istanbul, Havana, and Miami Beach.[52] Increasingly, Native artists take part in this global circuit of art fairs. In addition to Edward Poitras (fig. 8.2) and Rebecca Belmore as Canada's official entries at Venice, and the counterbiennials staged there by American Native artists, work by Brian Jungen (fig. 8.27) was included in the Gwangju Biennial in Korea (2004) and Alan Michelson's *Prophetstown* (fig. 8.25) was featured in Eighteenth Sydney Biennale (2012). That Biennale was, furthermore, codirected by Plains Cree curator Gerald McMaster. Titled *All Our Relations*, the exhibition took a global look at contemporary art practice that considers and creates interpersonal connections. Seeking to move beyond a long-standing critical frame of art discourse emphasizing opposition, fragmentation, and alienation, the *Biennale* incorporated artists from diverse backgrounds. Works by Michelson, Nadia Myre (fig. 8.21), and Shuvenai Ashoona came into conversation with contemporary art from around the world. The term "All Our Relations" is a Lakota invocation—*Mitakuye Oyasin*—a shorthand acknowledgment of the truth that we are all related—all the people on the earth, all the two-legged and four-legged beings, the sky beings and the underwater beings, all of the ancestors, the stones and the plants.

The most transnational of contemporary Native artists is Jimmie Durham (fig. 8.3), whose work is celebrated across the globe. In *Encore Tranquilité* (2009), Durham crushed a small aircraft in Berlin by dropping a huge boulder on it. Apparently the decommissioned Soviet airplane, considered unsafe by European standards, was destined for sale in Africa. Durham saw in this an indictment of so much that is wrong, paternalistic, and corrupt in the actions of modern nation-states toward their ex-colonies or internal colonies. Displayed in Durham's 2009 retrospective in Paris, *Jimmie Durham: Rejected Stones*, its critique of colonialism was easily understood. Other references to Aboriginal spirituality and worldview were, however, less obvious. In chapter 1, we discussed anthropologist Irving Hallowell's elucidation of the "other-than-human beings" that share the world with humans in many Native belief systems. As Hallowell's Anishinaabe consultant told him, some stones can be locations of such personified spiritual power. Stone, for Durham, can have still other significations. The incarceration of AIM leader Russell Means (1939–2012) inspired his 1983 poem "They Forget That Their Prison Is Made of Stone, and Stone Is Our Ally." *Encore Tranquilité* eloquently demonstrated the way in which the force of stone could be turned against a colonialist regime.[53]

CONCLUSION: "CELEBRATE 40,000 YEARS OF AMERICAN ART"—BUT BE VIGILANT

In 2002, Rebecca Belmore enacted a profoundly moving performance of rage and pain in the streets of the Downtown Eastside of Vancouver, an area where many Aboriginal women—some of them homeless, some of them prostitutes—had disappeared. It was later discovered that they had been murdered by a serial killer whose career of violence might have been stopped earlier if the police—and society—had cared more for his victims. In the live performance entitled *Vigil* (and the ensuing video installation called *The Named and the Unnamed*), Belmore scrubbed the pavement of the street where the women disappeared. Her labor expressed multiple realities: the devaluation of Aboriginal women's lives; the material and emotional filth of a neighborhood rife with drug use, prostitution, and the abduction and murder of sex workers; and the futility of trying to "clean up" all of this by the elemental female, domestic act of scrubbing. She called the names of the victims, stripping the petals and leaves from a cut rose with her teeth after each. In a third phase, she donned a long red dress and repeatedly nailed portions of it to a telephone pole and ripped herself free. She and the audience lit tea lights as a concluding act of the vigil. Charlotte Townsend-Gault wrote that through Belmore's actions, "crimes against the body, the native body, the woman's body, are embodied in, enacted by, or inscribed on her own body, as if in an act of atonement."[54]

One hundred years ago, most North Americans—Native and non-Native alike—believed that Native art and culture was doomed to disappear. Instead, through the vigilance and vision of Aboriginal artists all across the continent, Indigeneity—and Indigenous arts—continue to flourish and pulse with vitality. In 2002, Jaune Quick-to-See Smith published a brief article in *Frontiers: A Journal of Women Studies*. Entitled "Celebrate 40,000 Years of American Art," it was a commentary on a large collagraph etching of the same name that she had done in 1995, in an edition of ten. Smith wrote, "In educational institutions in this country, reference is often made to the age of America as being two hundred years or five hundred years, but because we still live under the aegis of colonial thinking, it's never taken into consideration that some of the world's greatest cultures and cities were here in the Americas for thousands of years—and are still here."[55] Like *The Red Mean* (fig. 8.6), *Celebrate 40,000 Years of American Art* is life size: six feet tall. It depicts rabbit-like human figures that recall both the Peterborough petroglyphs in Ontario and the trickster figures with which we opened this chapter (fig. 8.2). Smith described it as her "succinct comment on colonial thinking." While this book covers only 3,000 years of the time span she commemorates, her work reminds us to be wary of narratives of the art history of North America that fail to acknowledge the great depth and the contemporary vitality of Indigenous art-making on this continent.

NOTES

Chapter 1

1. Vizenor, *Fugitive Poses*, 15.
2. White, *Middle Ground*, in bibliography for chapter 3.
3. This collection, made by John Bargrave, a Canon of Canterbury Cathedral, is discussed by Bann, *Under the Sign*.
4. See Batkin, *Pottery of the Pueblos*, in bibliography for chapter 2.
5. Philip J. Deloria, 90.
6. See Rushing, *Native American Art and the New York Avant-Garde*, in bibliography for chapter 7; and Barbara Buhler Lynes and Carolyn Kastner, *Georgia O'Keeffe in New Mexico: Architecture, Katsinam, and the Land* (Santa Fe: Museum of New Mexico Press, 2012).
7. For a multivocal examination of the successes and failures of NMAI's opening exhibitions, see Lonetree and Cobb, eds., *Understanding the National Museum of the American Indian*.
8. See Gell, *Art and Agency*; and A. Hallowell, "Ojibwa Ontology, Behavior, and World View," in bibliography for chapter 3.
9. See Jonaitis, *A Wealth of Thought*.
10. Clifford, "On Collecting Art and Culture."
11. See, for example Boas, *Primitive Art*; Bunzel, *The Pueblo Potter*, in bibliography for chapter 2; and Maurer, "Determining Quality in Native American Art," in Wade, ed., *The Arts of the North American Indian*, 142–55.
12. Doxtator and Clark, 11.
13. Abrams, "The Case for Wampum," in bibliography for chapter 3; and Fenton, "Return of Eleven Wampum Belts."
14. The American law, the Native American Graves Protection and Repatriation Act, or NAGPRA, was passed in 1990. The Canadian policy is outlined in Canadian Museums Association and Assembly of First Nations, *Turning the Page* (Ottawa, Ontario: Canadian Museums Association, 1992).
15. Webster, "U'mista Cultural Center," 135.
16. James Clifford, "Four Northwest Coast Museums," in Karp and Lavine, eds., *Exhibiting Cultures*, 212–54.
17. Brown, *Who Owns Native Culture?*, x.
18. Abrams, "The Case for Wampum;" and Fenton, "Return of Eleven Wampum Belts."
19. Ferguson and Martza, "The Repatriation of *Ahayu:da*;" and Merrill et al., "The Return of the *Ahayu:da*."
20. Brown, *Who Owns Native Culture?*, xi.
21. Hollowell, "St. Lawrence Island's Legal Market," 104.
22. Henry B. Collins, *The Far North*, 1–44, in bibliography for chapter 5; Fitzhugh et al., eds. *Gifts from the Ancestors*, in bibliography for chapter 5.
23. Crowell et al., *Looking Both Ways*, 89, in bibliography for chapter 5.
24. See Martin Jay, *Downcast Eyes* (Berkeley: University of California Press, 1994).
25. See Barreiro, ed., special issue, *Akwe:kon*; and McMaster and Martin. eds., *Indigena*, in bibliography for chapter 8.
26. In Canada, for example, until 1985 the children of non-Native fathers and Native mothers were legally regarded as non-Native and lost their treaty rights, while those of Native fathers and non-Native mothers were considered Native. In the United States the ancestry necessary for enrollment is determined by the individual tribes according to the "blood quantum" or percentage of a person's Indian ancestry that each has established.
27. In the United States, for example, the Indian Arts and Crafts Act of 1990 made illegal the identification of an artist as a Native American in a venue supported by federal funds unless he or she is an enrolled member of a tribe. Since tribes vary widely in the percentage of Native ancestry required for enrollment, and since numerous Native communities are still struggling for legal recognition, laws such as this further complicate problems of identity.

in crest designs have to do with transfers of power between animal and human beings rather than actual descent.

34. Jonaitis and Glass, *The Totem Pole: An Intercultural History*.

35. This account is based on the summary provided by Laforet in *The Book of the Grand Hall*, 79–80.

36. Anderson and Halpin, *Potlatch at Gitsegukla*.

37. In Alaska, poles were removed from Sitka and other sites and re-erected in "totem parks" at Saxman, Totem Bight, and Klawock. In some instances the restoration was carried out by carvers from other villages, resulting in alterations that permanently changed their meaning. See Jonaitis and Glass, *The Totem Pole: An Intercultural History*.

38. The Dog-Salmon Pole, which was originally carved around 1860, stood on its original site along the river until 1926, when it was restored by the National Museum of Canada and the Canadian National Railway. In 1936, when the river bank was eroding, it was moved to a different location. By 1961 it had fallen down. It was purchased by the National Museum in 1970 and taken to Ottawa and is now displayed in the Grand Hall of the Canadian Museum of History. A fiberglass replica was erected at Gitwangak. See MacDonald, *Totem Poles and Monuments*.

39. "The Contemporary Potlatch," in Jonaitis, *Chiefly Feasts*, 229.

40. This film was lost for many years, but when a partial copy was found in the 1970s it was re-edited by Bill Holm in collaboration with contemporary Kwakwaka'wakw under the title *In the Land of the War Canoes*. In 2008, when Glass discovered additional footage and the original musical score, he worked with Brad Evans to restore it further for re-release. See Evans and Glass, *Return to the Land of the Head Hunters*.

41. Glass, "Frozen Poses."

42. Argillite is similar in properties to catlinite, the red mineral found in a Minnesota quarry used by peoples of the Great Lakes and Plains to make pipe bowls.

43. Macnair and Hoover, *The Magic Leaves*, 162, fig. 171.

44. Margaret B. Blackman, *During My Time*, 68.

45. See Laforet, "Regional and Personal Style in Northwest Coast Basketry," in Porter, *The Art of Native American Basketry*, 295, in bibliography for chapter 1.

46. Text panel, "Signed without Signature: Works by Charles and Isabella Edenshaw," UBC Museum of Anthropology, November 2010–September 2011, curated by Bill McLennan.

47. Dauenhauer, "Tlingit At.óow," in Brown, ed., *The Spirit Within*, 21–9.

48. World, *Celebration*, 41.

Chapter 7

1. Quoted in Jann L. M. Bailey, "Daphne Odjig," *Herizons* (Spring 2011), http://www.herizons.ca/node/481, accessed January 19, 2014.

2. Marshall Berman, *All That Is Solid Melts into Air* (New York: Simon and Schuster), 36.

3. Ibid, 17.

4. Anthes, *Native Moderns*, 114.

5. Goldwater, *Primitivism in Modern Art*, 271.

6. J. J. Brody, "Other Native Modernists."

7. A useful introduction to the competing claims made for modern art is Pam Meecham and Paul Wood, "Modernism and Modernity: An Introductory Survey," in *Investigating Modern Art*, ed. Dawtry et al. (New Haven, Conn.: Yale University Press, 1996).

8. Video interview, http://www.ccca.ca/video portrait/english/letendre.html?language Pref=en&, accessed November 25, 2012.

9. T. J. Jackson Lears, *No Place of Grace: Antimodernism and the Transformation of American Culture, 1880* (New York: Pantheon Books, 1981).

10. Hutchinson, *The Indian Craze*.

11. Doxtator, *Basket, Bead and Quill*, 18, in bibliography for chapter 1.

12. As cited in Dunn, *American Indian Painting*, 96.

13. Heap of Birds, in Ingberman, *Claim Your Color*, 22.

14. See Bernstein and Rushing, *Modern by Tradition*, 27.

15. See Brody, *Indian Painters and White Patrons*, 73–117.

16. Bernstein and Rushing, *Modern by Tradition*, 54, 10.

17. In Canada a total of about 150,000 First Nations, Inuit, and Métis children attended residential schools.

18. K. Tsianina Lamawaima, "Estelle Reel, Superintendent of Indian Schools, 1898–1910,"

Journal of American Indian Education 25, no. 3 (May 1996): 5–32.

19. Ibid., 194.

20. Berlo, "The Szwedzicki Portfolios, Part I," quoting Oscar Jacobson, *Kiowa Indian Art*, Nice, France, 1929, 8.

21. See Fewkes, "Hopi Kachinas Drawn by Native Artists."

22. Brody, *Pueblo Indian Painting*, 1997, 182.

23. Ibid., Horton and Berlo, "Pueblo Indian Painting in 1932."

24. Schrader, *The Indian Arts and Crafts Board*, 195–6.

25. Henderson, "A Boy Painter."

26. Sloane and LaFarge, *Introduction to American Indian Art*, 7–9.

27. Horton, chapter 2 in *Places to Stand*.

28. René d'Harnoncourt letter, December 23, 1941, as quoted by W. Jackson Rushing, in "Marketing the Affinity," 214.

29. Goldwater, *Primitivism in Modern Art*.

30. Jack E. Caughran II, *Coming Out of the Cave: The Biography of a Totem Pole* (Senior Thesis, Harvard University, 2003), 33–50.

31. Tonita Peña and Pablita Velarde worked together on murals at the Santa Fe Indian School; Velarde painted others at Bandelier National Monument in New Mexico; Kiowa Five painters created murals at the Oklahoma Historical Society in Oklahoma City, the Post Office in Anadarko, Oklahoma, and the Department of the Interior; and Oscar Howe painted a mural in the Carnegie Library in Mitchell, South Dakota.

32. As quoted in Dockstader, *Oscar Howe*, 19.

33. We are grateful to Lakota artist Arthur Amiotte, who studied with Oscar Howe, for this information about the spider web.

34. Seymour, *When the Rainbow Touches Down*, 149.

35. Unpublished interview, on file at the Native American Artists Resource Collection, The Heard Museum, Phoenix, Arizona.

36. Traugott, "Native American Artists and the Postmodern Cultural Divide," 43.

37. Breeskin, *Two American Painters*, 1972.

38. The show included Frank Stella, Jules Olitski, and Kenneth Noland, and was organized by Michael Fried for the Fogg Art Museum at Harvard University.

39. Abbott, *I Stand in the Center of the Good*, 287, in bibliography for chapter 8.

40. Jones, *Eskimo Drawings*.

41. See Lee, "Betwixt and Between."

42. See Crosby, *Indian Art/Aboriginal Title*, 102–3.

43. The following account is based on Dempsey, *Tailfeathers*, 6.

44. Hall, "Charles Gimpel."

45. George Swinton, *Sculpture of the Eskimo*, 107.

46. Ibid., 129–30.

47. Vorano, *Inuit Prints*.

48. "Introduction: Early Printmaking in Cape Dorset," in Vorano, *Inuit Prints*.

49. Goetz, "Cape Dorset," 42.

50. Routledge and Jackson, *Pudlo*.

51. Graburn, "Eskimo Art."

52. Heather Igloliorte, "The Inuit of Our Imagination," in McMaster ed., *Inuit Modern*, 45.

53. Quoted in Sinclair and Pollock, *The Art of Norval Morrisseau*, 26.

54. See Blundell and Phillips, "If It Isn't Shamanic."

55. Quoted in Martin, *The Art of Alex Janvier*, 9.

56. See Brydon, "The Indians of Canada Pavilion at Expo 67."

57. The other artists were Jackson Beardy (1944–84), Eddy Cobiness (1933–96), Carl Ray (1942–78), and Joseph Sanchez (b. 1948).

58. Hill and Duffek, *Beyond History*, 10.

59. Ibid., 4.

60. Robert Houle, "The Emergence of a New Aesthetic Tradition," 3.

61. http://nmai.si.edu/exhibitions/scholder/biography.html, accessed March 5, 2013.

62. Scholder, "On the Work of a Contemporary American Indian Painter," 110.

63. http://nmai.si.edu/exhibitions/scholder/works.html, accessed March 5, 2013.

Chapter 8

1. http://walkingwithoursisters.ca/about/the-project/, accessed December 12, 2013.

2. Antony Gormley, speaking of *Amazonian Field*. http://whitecube.com/channel/in_the_museum/antony_gormley_on_amazonian_field/, accessed December 11, 2013.

3. Catherine Mattes, "Christi Belcourt—Walking with Our Sisters as a Littoral Work and Decolonization," paper delivered to the Native American Art Studies Association, October 2013.

4. "Rebecca Belmore on 'Rising to the Occasion,'" uploaded to YouTube by the Art Gallery of Ontario, copyright 2009. http://www.youtube.com/watch?v=ANQTQcS8pgo, accessed March 18, 2011.

5. Luna, "Sun and Moon Blues," 151. Luna repeated his performance of *Artifact Piece* at the New Museum of Contemporary Art in New York in 1990. See Nilda Peraza et al., *The Decade Show*, 171–2 and plate IL.

6. Ryan, *The Trickster Shift*.

7. McMaster, *Edward Poitras*, 38, in bibliography for chapter 7.

8. As quoted in Turney, "Ceci n'est pas Jimmie Durham," 430.

9. Smith, *The Submoloc Show*, 111.

10. Peraza et al., *The Decade Show*. See especially, Jimmie Durham, "A Central Margin," 162–75.

11. Aboriginal Affairs and Northern Development Canada, formerly known as the Department of Indian Affairs and Northern Development and Indian and Northern Affairs Canada.

12. Talk by the artist, Carleton University Art Gallery, Ottawa during the showing of *Contact/Content/Context*, April 1, 1993.

13. Artist's statement in Stedelijk Museum, *Notion of Conflict*, 24.

14. The controversy was caused by the 1.8 million dollars of public money spent for a painting by an American artist whose abstract work many people did not understand. See Bruce Barber et al., *Voices of Fire: Art, Rage, Power and the State* (Toronto: University of Toronto Press, 1996).

15. For an extended discussion see Phillips, "Settler Monuments, Indigenous Memory;" and Bell, *Kanata*.

16. Hammond and Smith, *Women of Sweetgrass*, unpaginated.

17. The drawing is in the National Gallery of Canada, see David Franklin, ed. *Treasures of the National Gallery of Canada* (New Haven, Conn.: Yale University Press, 2003), 232–3.

18. Quoted in Archuleta, "Kay WalkingStick (Cherokee)," in *Path Breakers*, ed. Nottage and McNutt, 23.

19. Tsinhnahjinnie, "When Is a Photograph Worth a Thousand Words?" in *Native Nations*, ed. Allison, 42.

20. Abbott, *I Stand in the Center of the Good*, 32, in bibliography for chapter 7.

21. Rushing, "Street Chiefs and Native Hosts," 28.

22. Quoted in Podedworny, "New World Landscape," 2, 39.

23. Larry McNeil Photography, http://www.larrymcneil.com/.

24. As quoted in Conrad, "'A Many Splendoured Thing'—Liminality as Empowering Discursive Space in Rosalie Favel's Digital Art," 51.

25. Rickard, "Skins Seven Spans Thick," 92.

26. McFadden and Taubman, *Changing Hands*, 2002; Taubman and McFadden, *Changing Hands*, 2005, 2012.

27. See Maurer, "Determining Quality in Native American Art," in Wade, ed. *The Arts of the North American Indian*, 142–55, in bibliography for chapter 1.

28. Pat Pruitt, artist's website, http://www.patpruitt.com/man.shtml, December 7, 2012.

29. Black and Burish, "Craft Hard, Die Free," 611.

30. Vigil, "Gail Tremblay," in Mithlo, ed., *Manifestations*, 99.

31. Kastner, "An Interview with Dan Namingha," in Barbara Buhler Lynes and Carolyn Kastner, *Georgia O'Keeffe in New Mexico* (Santa Fe: Museum of New Mexico Press, 2012), 121.

32. Quoted from the National Gallery of Canada website: http://www.gallery.ca/en/see/collections/artist.php?iartistid=2372, April 2013.

33. "Marianne Nicolson Speaks . . ." in McMaster, ed., *Reservation X*, 101.

34. Heap of Birds, "Life as Art," 35.

35. Luna, *Emendatio*, 16. Enright, "The Poetics of History."

36. Nottage, *Diversity and Dialogue*, 25.

37. Svenson, "Growing Up in Igloolik."

38. Dowell, *Sovereign Screens*.

39. As quoted in Russell, *Shapeshifting*, 49, in bibliography for chapter 1.

40. Lewis and Fragnito, "Art Work as Argument," 206.

41. Ibid.

42. Kalbfleisch, "Women, House, and Home," 1.

43. Kathleen Ash-Milby, "Alan Michelson: Landscapes of Loss and Presence," in McNutt, ed., *We Are Here*, 31.

44. Marsha Meskimmon, *Contemporary Art and the Cosmopolitan Imagination* (London: Routledge, 2011), 38–9.

45. Paul Chaat Smith, "Jolene Rickard, Corn Blue Room: Unplugging the Hologram," in McMaster, ed., *Reservation X*, 121–31.

46. See "White Corn Inventory Project," Haudenosaunee Environmental Task Force, http://tuscaroraenvironment.org/index.php/programs/tuscarora-soil-survey/78-white-corn-inventory-project, and Iroquois White Corn Project, Rochester Institute for Technology, Center for Imaging Science, http://www.cis.rit.edu/node/642, accessed April 13, 2012.

47. Carol Becker, "GFP Bunny." *Art Journal* 59, no. 3 (Fall 2000): 45–7.

48. Rickard, "Visualizing Sovereignty," 466–7.

49. Vigil, "Will Wilson: Fellowship Artist," in Mithlo, ed., *Manifestations*, 128.

50. Will Wilson, personal communication to Janet Catherine Berlo, January 2012.

51. Augaitis and Ritter, *Rebecca Belmore,* 55.

52. Anthes, "Contemporary Native Artists."

53. Horton and Berlo, "Through the Mirror"; Durham, "1000 Words."

54. Kalbfleisch, "Bordering on Feminism," and Townsend-Gault et al., *Rebecca Belmore: The Named and the Unnamed*, 18.

55. Smith, "Celebrate 40,000 Years of American Art," 154.

Berlo, Janet Catherine, and Ruth B. Phillips. "Our (Museum) World Turned Upside-Down: Re-Presenting Native American Arts." *Art Bulletin* 77, no. 1 (1995): 6–10.

Boas, Franz. *Primitive Art*. New York: Dover, 1955. First published 1927.

Brown, Michael. *Who Owns Native Culture?* Cambridge, Mass.: Harvard University Press, 2004.

Canadian Museums Association and Assembly of First Nations. *Turning the Page: Forging New Partnerships between Museums and First Peoples*. Ottawa, Ontario: Canadian Museums Association, 1992.

Clifford, James. "On Collecting Art and Culture." In *The Predicament of Culture: Twentieth Century Ethnography, Literature, and Art*, by James Clifford, 215–51. Cambridge, Mass.: Harvard University Press, 1988.

Danto, Arthur C. "Artifact and Art." In *Art/Artifact: African Art in Anthropology Collections*. New York: Museum for African Art, 1988.

Deloria, Philip J. *Playing Indian*. New Haven, Conn.: Yale University Press, 1998.

Dippie, Brian W. *The Vanishing American: White Attitudes and US Indian Policy*. Lawrence: University Press of Kansas, 1995.

Feest, Christian F. "The Collecting of American Indian Artifacts in Europe, 1473–1750." In *America in European Consciousness, 1493–1750*, edited by Karen Ordahl Kupperman, 324–60. Chapel Hill: University of North Carolina Press, 1995.

Fenton, William. "Return of Eleven Wampum Belts to the Six Nations Iroquois Confederacy on Grand River, Canada." *Ethnohistory* 36, no. 4 (Autumn 1989): 392–410.

Ferguson, T. J., and Barton Martza. "The Repatriation of Ahayu:da: Zuni War Gods." *Museum Anthropology* 14, no. 2 (1990): 7–14.

Gell, Alfred. *Art and Agency: An Anthropological Theory*. Oxford: Clarendon, 1998.

Gladstone, Mara, and Janet Catherine Berlo. "The Body in the White Box: Corporeal Ethics and Museum Representation." In *Routledge Companion to Museum Ethics: Redefining Ethics for the Twenty-First Century Museum*, edited by Janet Marstine, 353–78. New York: Routledge, 2011.

Glass, Aaron. "Return to Sender: On the Politics of Cultural Property and the Proper Address of Art." *Journal of Material Culture* 9, no. 2 (2004): 115–39.

Hollowell, Julie. "St. Lawrence Island's Legal Market in Archaeological Goods." In *Archaeology, Cultural Heritage, and the Antiquities Trade*, edited by Neil Brodie, Morag M. Kersel, Christina Luke, and Kathryn Walker Tubb, 98–132. Gainesville: University of Florida Press, 2006.

Impey, Oliver, and Arthur McGregor, eds. *The Origin of Museums: The Cabinet of Curiosities in Sixteenth and Seventeenth Century Europe*. Oxford: Oxford University Press, 1985.

Jessup, Lynda, and Shannon Bagg, eds. *On Aboriginal Representation in the Gallery*. Hull, Quebec: Canadian Museum of Civilization, 2002.

Johnston, Basil. *Indian School Days*. Norman: University of Oklahoma Press, 1995.

Karp, Ivan, and Steven D. Lavine, eds. *Exhibiting Cultures: The Poetics and Politics of Museum Display*. Washington, DC: Smithsonian Institution Press, 1991.

Lonetree, Amy, and Amanda J. Cobb, eds. *Understanding the National Museum of the American Indian*. Lincoln: University of Nebraska Press, 2008.

Merrill, William L., E. J. Ladd, and T. J. Ferguson. "The Return of the Ahayu: da: Lessons for Repatriation from Zuni Pueblo and the Smithsonian Institution." *Current Anthropology* 34, no. 5 (1993): 523–67.

Mihesuah, Devon A., ed. *Repatriation Reader: Who Owns American Indian Remains?* Lincoln: University of Nebraska Press, 2000.

Miller, J. R. *Shingwauk's Vision: A History of Native Residential Schools.* Toronto: University of Toronto Press, 1996.

The Native Universe and Museums in the Twenty-First Century: The Significance of the National Museum of the American Indian. Washington, DC: National Museum of the American Indian, 2005.

Phillips, Ruth B. *Museum Pieces: Toward the Indigenization of Canadian Museums.* Montreal: McGill-Queen's University Press, 2011.

Phillips, Ruth B. "Fielding Culture: Dialogues between Art History and Anthropology." *Museum Anthropology* 18, no. 1 (1994): 39–46.

Phillips, Ruth B., and Christopher B. Steiner, eds. *Unpacking Culture: Art and Commodity in Colonial and Postcolonial Worlds.* Berkeley: University of California Press, 1998.

Price, Sally. *Primitive Art in Civilized Places.* Chicago: University of Chicago Press, 1989.

Rubin, William, ed. *"Primitivism" in Twentieth Century Art: Affinity of the Tribal and the Modern.* New York: The Museum of Modern Art, 1985.

Rushing, W. Jackson. *Native American Art and the New York Avant-Garde, 1910–1950.* Austin: University of Texas Press, 1995.

————. "Marketing the Affinity of the Primitive and the Modern: René d'Harnoncourt and 'Indian Art of the United States.'" In *The Early Years of Native American Art History*, edited by Janet C. Berlo. Seattle: University of Washington Press, 1992.

Smith, Linda T. *Decolonizing Methodologies.* London: Zed Books, 1999.

Tayac, Gabrielle, ed. *IndiVisible: African-Native American Lives in the Americas.* Washington, DC: National Museum of the American Indian, 2009.

Thomas, Nicholas. *Entangled Objects: Exchange, Material Culture and Colonialism in the Pacific.* Cambridge, Mass.: Harvard University Press, 1991.

Vizenor, Gerald. *Fugitive Poses: Native American Indian Scenes of Absence and Presence.* Lincoln: University of Nebraska Press, 1998.

Webster, Gloria Cranmer. "The U'mista Cultural Center." *Massachusetts Review* 31, no. 1–2 (Spring 1990): 132–43.

West, W. R. "Research and Scholarship at the National Museum of the American Indian: The New Inclusiveness." *Museum Anthropology* 17, no. 1 (1993): 5–8.

West, W. R., ed. *The Changing Presentation of the American Indian.* Seattle: University of Washington Press, 1999.

Social and Spiritual Practices and the Making of Art

Berlo, Janet Catherine. "Dreaming of Double Woman: The Ambivalent Role of the Female Artist in North American Indian Mythology." *American Indian Quarterly* 17, no. 1 (1993): 31–43.

Deloria, Ella. *Waterlily.* Lincoln: University of Nebraska Press, 1990.

Doxtator, Deborah, and Janet Clark, eds. *Basket, Bead and Quill.* Thunder Bay, Ontario: Thunder Bay Art Gallery, 1996.

Eliade, Mircea. *Shamanism: Archaic Techniques of Ecstasy.* Princeton, N.J.: Princeton University Press, 2004. First published 1951.

Hultkrantz, Ake. *Native Religions of North America.* Long Grove, Ill.: Waveland, 1987.

Pueblo Arts

Adams, Charles E. *The Origin and Development of the Pueblo Katsina Cult*. Tucson: University of Arizona Press, 1991.

Babcock, Barbara. "Marketing Maria: the Tribal Artist in the Age of Mechanical Reproduction." In *Looking High and Low: Art and Cultural Identity,* edited by Brenda Bright and Liza Bakewell. Tucson: University of Arizona Press, 1995.

Batkin, Jonathan. *Clay People: Pueblo Indian Figurative Traditions*. Santa Fe: The Wheelwright Museum, 1999.

————. *Pottery of the Pueblos of New Mexico, 1700–1940*. Colorado Springs: Colorado Springs Fine Arts Center, 1987.

Blair, Mary Ellen, and Laurence R. Blair. *The Legacy of a Master Potter: Nampeyo and Her Descendants*. Tucson, Ariz.: Treasure Chest, 1999.

Brody, J. J. *Anasazi and Pueblo Painting*. Albuquerque: University of New Mexico Press, 1991.

Bunzel, Ruth. *Zuni Katcinas: An Analytical Study*. Glorieta, N.Mex.: Rio Grande Press, 1984. First published 1932.

————. *The Pueblo Potter: A Study of Creative Imagination in Primitive Art*. New York: Dover, 1972. First published 1929.

Cushing, Frank Hamilton. *Zuni: Selected Writings of Frank Hamilton Cushing*, edited by Jesse Green. Lincoln: University of Nebraska Press, 1979.

Dillingham, Rick. *Fourteen Families in Pueblo Pottery*. Albuquerque: University of New Mexico Press, 1994.

Dockstader, Frederick J. *The Kachina and the White Man: The Influences of White Culture on the Hopi Kachina Cult*. Albuquerque: University of New Mexico Press, 1985. First published 1954.

Gillespie, Nancy. "Interview with Roxanne Swentzell," Contemporary Artists' Archives, Heard Museum, Phoenix, Ariz., n.d.

Gutiérrez, Ramon A. *When Jesus Came, the Corn Mothers Went Away: Marriage, Sexuality, and Power in New Mexico, 1500–1846*. Palo Alto, Calif.: Stanford University Press, 1991.

Kent, Kate Peck. *Pueblo Indian Textiles: A Living Tradition*. Santa Fe, N.Mex.: School for American Research Press, 1983.

King, Charles S., and Richard L. Spivey. *The Life and Art of Tony Da*. Tucson, Ariz.: Rio Nuevo, 2011.

Kramer, Barbara. *Nampeyo and Her Pottery*. Albuquerque: University of New Mexico Press, 1996.

Kubler, George. *The Religious Architecture of New Mexico: In the Colonial Period and Since the American Occupation*. Albuquerque: University of New Mexico Press, 1940.

Marriott, Alice. *Maria: The Potter of San Ildefonso*. Norman: University of Oklahoma Press, 1948.

Mindeleff, Victor. *A Study of Pueblo Architecture in Tusayan and Cibola*. Washington, DC: Smithsonian Institution Press, 1989. First published 1891.

Nabokov, Peter. *Architecture of Acoma Pueblo: The 1974 Historic American Buildings Survey Project*. Santa Fe, N.Mex.: Ancient City Press, 1986.

Nahohai, Milford, and Elisa Phelps. *Dialogues with Zuni Potters*. Zuni, N.Mex.: Zuni A:shiwi Publishing, 1995.

Minge, Ward Alan. *Acoma: Pueblo in the Sky*. Albuquerque: University of New Mexico Press, 1991.

Pearlstone, Zena, ed. *Katsina: Commodified and Appropriated Images of Hopi Supernaturals*. Los Angeles: UCLA Fowler Museum of Cultural History, 2001.

Peckham, Stewart. *From the Earth: The Ancient Art of Pueblo Pottery*. Santa Fe: Museum of New Mexico Press, 1990.

Peterson, Susan. *Pottery by American Indian Women: The Legacy of Generations*. New York: Abbeville Press, and the National Museum of Women in the Arts, 1997.

————. *Lucy M. Lewis*. Tokyo: Kodansha International, 1985.

————. *Maria Martinez: Five Generations of Potters*. Washington, DC: The Smithsonian Institution Press, 1978.

————. *The Living Tradition of Maria Martinez*. Tokyo: Kodansha International, 1977.

Roscoe, Will. *The Zuni Man-Woman*. Albuquerque: University of New Mexico Press 1991.

Scully, Vincent. *Pueblo: Mountain, Village, Dance*. Chicago: University of Chicago Press, 1975.

Secakuku, Alph H. *Following the Sun and Moon: Hopi Kachina Traditions*. Flagstaff, Ariz.: Northland Press, 1995.

Schaafsma, Polly, ed. *Kachinas in the Pueblo World*. Albuquerque: University of New Mexico Press, 1994.

Shutes, Jeanne, and Jill Mellick. *The Worlds of P'Otsunu: Geronima Cruz Montoya of San Juan Pueblo*. Albuquerque: University of New Mexico Press, 1996.

Spivey, Richard L. *The Legacy of Maria Poveka Martinez*. Santa Fe: Museum of New Mexico Press, 2003.

Stevenson, Matilda Coxe. "The Zuni Indians." *23rd Annual Report of the Bureau of American Ethnology for the Years 1901–1902*. Washington, DC: United States Government Printing Office, 1904.

Struever, Martha Hopkins, ed. *Loloma: Beauty Is His Name*. Santa Fe: Wheelwright Museum of the American of the American Indian, 2005.

————. *Painted Perfection: The Pottery of Dextra Quotskuyva*. Santa Fe: Wheelwright Museum of the American Indian, 2001.

Sweet, Jill D. "Burlesquing 'The Other' in Pueblo Performance." *Annals of Tourism Research* 16, no. 1 (1989): 62–75.

Tedlock, Barbara. "The Beautiful and the Dangerous: Zuni Ritual and Cosmology as an Aesthetic System." In *Arts of Africa, Oceania, and the Americas: Selected Readings*, edited by Janet Berlo and Lee Anne Wilson, 48–63. Englewood Cliffs, N.J.: Prentice Hall, 1993.

Tedlock, Dennis. "Zuni Religion and World View." In *Handbook of the North American Indians*, vol. 9, *Southwest*, edited by Alfonso Ortiz, 499–508. Washington, DC: Smithsonian Institution Press, 1979.

Trimble, Stephen. *Talking with the Clay: The Art of Pueblo Pottery*. Santa Fe: School for Advanced Research Press, 1987.

Washburn, Dorothy K., ed. *Hopi Kachina: Spirit of Life*. Seattle: University of Washington Press, 1980.

Wright, Barton. *Pueblo Cultures*. Leiden, the Netherlands: E. J. Brill, 1986.

————. *Kachinas: A Hopi Artist's Documentary*. Flagstaff, Ariz.: Northland Press, 1973.

Navajo and Apache Arts

Bennett, Noel, and Tiana Bighorse. *Working with the Wool: How to Weave a Navajo Rug.* Flagstaff, Ariz.: Northland, 1971.

Berlant, Anthony, and Mary Hunt Kahlenberg. *Walk in Beauty: The Navajo and Their Blankets.* New York: Little Brown and Company, 1977.

Berlo, Janet Catherine. "Alberta Thomas, Navajo Pictorial Arts and Eco-Crisis in Dinetah." In *A Keener Perception: Eco-critical Studies in American Art History,* edited by A. Braddock and C. Irmscher, 237–53. Tuscaloosa: University of Alabama Press, 2009.

Blomberg, Nancy J. *Navajo Textiles: The William Randolf Hearst Collection.* Tucson: University of Arizona Press, 1988.

Bonar, Eulalie H., ed. *Woven by the Grandmothers: Nineteenth-Century Navajo Textiles from the National Museum of the American Indian,* Washington, DC: Smithsonian Institution Press, 1996.

Bsumek, Erika Marie. *Indian-Made: Navajo Culture in the Marketplace, 1868–1940.* Lawrence: University of Kansas Press, 2008.

Campbell, Tyrone and Joel and Kate Kopp. *Navajo Pictorial Weaving, 1880–1950.* New York: Dutton Studio Books, 1991.

Dockstader, Frederick J. *The Song of the Loom: New Traditions in Navajo Weaving.* New York: Hudson Hills, 1987.

Epple, Carolyn. "Coming to Terms with Navajo *Nádleehí*': A Critique of Berdache, 'Gay,' 'Alternative Gender,' and 'Two-Spirit.'" *American Ethnologist* 25, no. 2 (May 1998): 267–90.

Gallagher, Marsha. "The Weaver and the Wool." *Plateau Magazine* 52, no. 4 (1987): 22–7.

Griffin-Pierce, Trudy. *Earth Is My Mother, Sky Is My Father: Space, Time and Astronomy in Navajo Sandpaintings.* Albuquerque: University of New Mexico Press, 1992.

Hedlund, Ann Lane. "Adventures in Modern Tapestry: Gloria Ross, Kenneth Noland, and Navajo Weavers." *American Indian Art Magazine* 37, no. 1 (2011): 54–63, 78.

————. *Navajo Weaving in the Late Twentieth Century: Kin, Community, and Collectors.* Tucson: University of Arizona Press, 2004.

————. *Reflections of the Weavers World: The Gloria F, Ross Collection of Contemporary Navajo Weaving.* Denver: Denver Art Museum, 1992.

Kent, Kate Peck. *Navajo Weaving: Three Centuries of Change.* Santa Fe: School of American Research Press, 1985.

Mackey, Brant, ed. *Rainbow Yarn: Navajo Weavings, Germantown Yarns and the Pa. Connection.* Lancaster, Pa.: Lancaster Quilt & Textile Museum, 2009.

McCoy, Ronald. "GAN: Mountain Spirit Masks of the Apache." *American Indian Art Magazine* 10, no. 3 (Summer 1985): 52–8.

McLerran, Jennifer, ed. *Weaving Is Life: Navajo Weavings from the Edwin L. and Ruth E. Kennedy Southwest Native American Collection.* Athens, Ohio: Kennedy Museum of Art, Ohio University, 2006.

McLerran, Jennifer. "Woven Chantways: The Red Rock Revival." *American Indian Art Magazine* 28, no. 1 (2002): 64–73.

Newcomb, Franc Johnson. *Hosteen Klah: Navajo Medicine Man and Sand Painter.* Norman: University of Oklahoma Press, 1964.

Newcomb, Franc Johnson, and Gladys A. Reichard. *Sandpaintings of the Navajo Shooting Chant.* New York: Dover, 1975. First published in 1937.

Parezo, Nancy J. *Navajo Sandpainting: From Religious Act to Commercial Art*. Tucson: University of Arizona Press, 1983.

Reichard, Gladys. *Weaving a Navajo Blanket*. New York: Dover, 1974. First published as *Navajo Shepherd and Weaver*. New York: J. J. Augustin, 1936.

Rodee, Marian. *Old Navajo Rugs: Their Development from 1900 to 1940*. Albuquerque: University of New Mexico Press, 1981.

Wheat, Joe Ben. *Blanket Weaving in the Southwest*, edited by Ann Lane Hedlund. Tucson: University of Arizona Press, 2003.

Winter, Mark. *Dances with Wool: Celebrating One Hundred Years of Woven Images from Southwestern Mythology*. Toadlena, N.Mex.: Toadlena Trading Post, 2002.

Witherspoon, Gary. *Language and Art in the Navajo Universe*. Ann Arbor: University of Michigan Press, 1977.

CHAPTER 3: THE EAST

General and Introductory Texts

Baillargeon, Morgan. *North American Aboriginal Hide Tanning: The Act of Transformation and Revival*. Seattle: University of Washington Press, 2011.

Brasser, Ted J. *"Bo' jou, Neejee!" Profiles of Canadian Indian Art*. Ottawa, Ontario: National Museum of Man, 1976.

Fogelson, Raymond D., ed. *Southeast*. Vol. 14 of *Handbook of North American Indians*. Washington, DC: Smithsonian Institution Press, 2004.

Hallowell, Irving. "Ojibwa Ontology, Behavior, and World View." In *Culture in History: Essays in Honor of Paul Radin*, edited by Stanley Diamond, 19–52. New York: Columbia University Press, 1978.

Johnston, Basil. *Ojibway Ceremonies*. Toronto: McClelland and Stewart, 1982.

———. *Ojibway Heritage*. Toronto: McClelland and Stewart, 1976.

Orchard, William. *The Technique of Porcupine Quill Decoration Among the Indians of North America*. Ogden, Utah: Eagles View Publishing, 1984. First published in 1916.

———. *Beads and Beadwork of the American Indians*. New York: Museum of the American Indian, Heye Foundation, 1929.

Penney, David. *Art of the American Indian Frontier: The Chandler-Pohrt Collection*. Seattle: University of Washington Press, 1992.

Phillips, Ruth B. "Like a Star I Shine." In *The Spirit Sings: Artistic Traditions of Canada's First Peoples*, edited by Julia Harrison. Toronto: McClelland and Stewart, 1987.

The Ancient World

Brose, David, James A. Brown, and David Penney. *Ancient Art of the American Woodland Indians*. Detroit, Mich.: Detroit Institute of Arts, in association with H. N. Abrams, Inc., 1985.

Brown, James A. "The Falcon and the Serpent: Life in the Southeastern United States at the Time of Columbus." In *Circa 1492: Art in the Age of Exploration,* edited by Jay Levenson. Washington, DC: National Gallery of Art, 1991.

———. "Spiro Art and Its Mortuary Contexts." In *Death and the Afterlife in Pre-Columbian America*, edited by Elizabeth Benson, 1–32. Washington, DC: Dumbarton Oaks Research Library and Collections, 1975.

Dobyns, Henry F. *Their Numbers Became Thinned: Native American Population Dynamics in Eastern North America*. Knoxville: University of Tennessee Press, 1983.

Kennedy, Roger G. *Hidden Cities: The Discovery and Loss of Ancient North American Civilization*. New York: Penguin, 1994.

Milner, George R. *The Moundbuilders: Ancient Peoples of Eastern North America*. London: Thames & Hudson, 2004.

Morgan, William N. *Prehistoric Architecture in the Eastern United States*. Cambridge, Mass.: MIT Press, 1980.

O'Connor, Mallory McCane. *Lost Cities of the Ancient Southeast*. Gainesville: University Press of Florida, 1995.

Penney, David W, ed. *Art of the Ancient American Woodland Indians*. Abrams, Inc., in association with Detroit Institute of Arts, 1985.

Phillips, Philip, and James A. Brown, *Pre-Columbian Shell Engravings from the Craig Mound at Spiro, Oklahoma—Part 1*. Cambridge, Mass.: Peabody Museum Press, 1978.

Purdy, Barbara A., and Roy C. Craven, Jr. *Indian Art of Ancient Florida*. Gainesville: University Press of Florida, 1996.

Reilly, Kent F., and James F. Garber, eds. *Ancient Objects and Sacred Realms: Interpretations of Mississippian Iconography*. Austin: University of Texas Press, 2007.

Thomas, David Hurst. *Exploring Ancient Native America: An Archaeological Guide*. New York: MacMillan, 1994.

Townsend, Richard F. ed. *Hero, Hawk, and Open Hand: American Indian Art of the Ancient Midwest and South*. Chicago: The Art Institute of Chicago, in association with Yale University Press, 2004.

Silverberg, Robert. *Mound Builders of Ancient America: The Archaeology of a Myth*. Greenwich, Conn.: New York Graphic Society, 1968.

Young, Biloine Whiting, and Melvin L. Fowler. *Cahokia: The Great Native American Metropolis*. Urbana: University of Illinois Press, 2000.

Southeast

Black, Patti Carr. *Persistence of Pattern in Mississippi Choctaw Culture*. Jackson: Mississippi Department of Archives and History, 1987.

Downs, Dorothy. *Art of the Florida Seminole and Miccosukee Indians*. Gainesville: University Press of Florida, 1997.

Gaskell, Ivan. "Clara Darden: Brief Life of an Overlooked Artist: c. 1829–1910." *Harvard Magazine* (July–August 2010), 30–1.

———. "Some Cherokee and Chitimacha Baskets: Problems of Interpretation." In *Iconography without Texts*, edited by Paul Taylor, 175–93. London: Warburg Institute, 2008.

Milanich, Jerald T., and Susan Milbraith, eds. *First Encounters: Spanish Explorations in the Caribbean and the United States, 1492–1570*. Gainesville: University Press of Florida, 1989.

Swanton, John R. "The Indians of the Southeastern United States." *Bureau of American Ethnology Bulletin* 137. Washington, DC: Smithsonian Institution, 1946.

Wright, Jr., J. Leitch. *Creeks and Seminoles: The Destruction and Regeneration of the Muscogulge People*. Lincoln: University of Nebraska Press, 1986.

Northeast and Great Lakes

Berlo, Janet Catherine. "Dennis Cusick: The Transcultural Perspectives of a Tuscarora Artist in 1820." In *On the Trails of the Iroquois*, edited by Sylvia Kasprycki, 178–81. Berlin: Nicolai, 2013.

Biron, Gerry. *A Cherished Curiosity: The Souvenir Beaded Bag in Historic Haudenosaunee (Iroquois) Art*. Saxtons River, Vt.: privately published, 2012.

Brasser, Ted J. *Riding on the Frontier's Crest: Mahican Indian Culture and Culture Change*. Ottawa, Ontario: National Museum of Canada, 1974.

Casagrande, Louis B. and Melissa M. Ringheim. *Straight Tongue: Minnesota Indian Art from the Bishop Whipple Collections*. St. Paul: Science Museum of Minnesota, 1980.

Cornplanter, J. J. *Legends of the Longhouse*. Osweken, Ontario: Iroqrafts, 1986. First published 1938.

Council Fire: A Resource Guide. Brantford, Ontario: Woodland Cultural Center, 1989.

Densmore, Frances. *Chippewa Customs*. Washington, DC: Smithsonian Institution Press, 1929.

De Stecher, Annette. *Engaged Histories: Wendat Women's Souvenir Arts of Cultural Preservation and Entrepreneurial Invention*. PhD dissertation in Cultural Mediations. Carleton University, 2013.

Dewdney, Selwyn. *The Sacred Scrolls of the Southern Ojibway*. Toronto: University of Toronto Press, 1975.

Dewdney, Selwyn, and Kenneth E. Kidd. *Indian Rock Paintings of the Great Lakes*. 2nd ed. Toronto: University of Toronto Press, 1973.

Dièreville, Sieur de. *Relation of the Voyage to Port Royal in Acadia or New France*, edited by J. C. Webster. Toronto: Champlain Society, 1933.

Fenton, William. *The False Faces of the Iroquois*. Norman: University of Oklahoma Press, 1987.

Flanders, Richard, David Armour, Mary Good, and Benson Lanford. *Beads: Their Use by Upper Great Lakes Indians*. Grand Rapids, Mich.: Grand Rapids Public Museum, 1977.

Flint Institute of Arts, *The Art of the Great Lakes Indians*. Flint, Mich.: Flint Institute of Arts, 1973.

Gilman, Carolyn. *Where Two Worlds Meet: The Great Lakes Fur Trade*. St Paul: Minnesota Historical Society, 1982.

Hamell, George R. "Strawberries, Floating Islands, and Rabbit Captains: Mythical Realities and European Contact in the Northeast During the Sixteenth and Seventeenth Centuries." *Journal of Canadian Studies* 21, no. 4 (1986–7).

———. "Trading in Metaphors: The Magic of Beads." In *Proceedings of the 1982 Glass Trade Bead Conference*, edited by Charles F. Hayes. Rochester, N. Y.: Rochester Museum and Science Center, 1983.

Handsman, Russell G., and Ann McMullen, eds. *A Key into the Language of Wood Splint Basketry*. Washington, Conn.: American Indian Archaeological Institute, 1987.

Harbor Springs Historical Commission, *Beadwork and Textiles of the Ottawa*. Harbor Springs, Mich.: Harbors Springs Historical Commission, 1984.

———. *Ottawa Quillwork and Birchbark*. Harbor Springs, Mich.: Harbor Springs Historical Commission, 1983.

Hoffman, Walter J. *The Midewiwin or 'Grand Medicine Society' of the Ojibwa*. Seventh Annual Report of the Bureau of American Ethnology. Washington, DC: Smithsonian Institution, 1891.

Holler, Deborah. "The Remarkable Caroline G. Parker Mountpleasant, Seneca Wolf Clan." *Western New York Heritage* 14 (summer 2010): 9–18.

Horse Capture, George P., ed. *Native American Ribbon Work: A Rainbow Tradition*. Cody, Wyo.: Buffalo Bill Historical Center, 1980.

Kasprycki, Sylvia, ed. *On the Trails of the Iroquois*. Berlin: Nicolai, 2013.

Keating, Neal. *Iroquois Art, Power, and History*. Norman: University of Oklahoma Press, 2012.

Kenyon, W. A. *The Grimsby Site: A Historic Neutral Cemetery*. Toronto: Royal Ontario Museum, 1982.

King, J. C. H. *Thunderbird and Lightning: Indian Life in Northeastern North America*. London: British Museum Press, 1982.

King, J. C. H., and Christian F. Feest, eds. *Three Centuries of Woodlands Indian Art*. Altenstadt, Hesse, Germany: ZKF Publishers, 2007.

Lester, Joan. *History on Birchbark: The Art of Tomah Joseph*. Providence, R. I.: Haffenreffer Museum of Anthropology, Brown University, 1992.

Lyford, Carrie. *Iroquois Crafts*. 1945. Reprint, Oshweken, Ontario: Schneider Publications, 1982.

Morgan, Lewis Henry. *League of the Iroquois*. 1851. Reprint, Secaucus, N. J.: Citadel Press, 1972.

Pelletier, Gaby. *Abenaki Basketry*. Ottawa, Ontario: National Museum of Canada, 1982.

Penney, David. W., ed. *Great Lakes Indian Art*. Detroit, Mich.: Detroit Institute of Arts, 1989.

Penney, David W., and Gerald McMaster eds., *Before and After the Horizon: Anishinaabe Artists of the Great Lakes*. Washington, DC: National Museum of the American Indian, 2013.

Phillips, Ruth B. *Trading Identities: The Souvenir in Native North American Art from the Northeast, 1700–1900*. Seattle: University of Washington Press, 1998.

————. *Patterns of Power: The Jasper Grant Collection and Great Lakes Indian Art of the Early Nineteenth Century*. Kleinburg, Ontario: McMichael Canadian Collection, 1984.

Science Museum of Minnesota. *Straight Tongue: Minnesota Indian Art from the Bishop Whipple Collections*. St Paul: Science Museum of Minnesota, 1980.

Silverstein, Cory [Willmott], *Clothed Encounters: The Power of Dress in Relations between Anishnaabe and British Peoples in the Great Lakes Region, 1760–2000*. PhD thesis, Department of Anthropology, McMaster University, 2001.

Snow, Dean R. *The Iroquois*. Oxford: Wiley Press, 1996.

Speck, Frank. "The Double-Curve Motive in Northeastern Algonkian Art." In *Native North American Art History: Selected Readings*, edited by Zena Pearlstone Mathews and Aldona Jonaitis. Trinidad, Colo.: Peek Publications, 1982.

Tooker, Elisabeth. *Lewis H. Morgan on Iroquois Material Culture*. Tucson: University of Arizona Press, 1994.

Torrence, Gaylord, and Robert Hobbs. *Art of the Red Earth People: The Mesquakie of Iowa*. Iowa City: University of Iowa Museum of Art, 1989.

Traill, Catharine Parr. *The Backwoods of Canada: Being Letters from the Wife of an Emigrant Officer, Illustrative of the Domestic Economy of British America*. London: C. Knight, 1836.

Trigger, Bruce G., ed. *Northeast*. Vol. 15 of *Handbook of North American Indians*. Washington, DC: Smithsonian Institution Press, 1978.

Vastokas, Joan, and Roman Vastokas. *Sacred Art of the Algonkians: A Study of the Peterborough Petroglyphs*. Peterborough, Ontario: Mansard Press, 1973.

Vennum, Jr., Thomas. *The Ojibwa Dance Drum: Its History and Construction*. Washington, DC: Smithsonian Institution Press, 1982.

Wallace, Anthony F. C. *The Death and Rebirth of the Seneca*. New York: Alfred A. Knopf, 1969.

White, Richard. *The Middle Ground: Indians, Empires, and Republics in the Great Lakes Region, 1650–1815*. Cambridge, UK: Cambridge University Press, 1993.

Whitehead, Ruth Holmes. *Micmac Quillwork-Micmac Techniques of Porcupine Quill Decoration: 1600–1950*. Halifax: Nova Scotia Museum, 1982.

————. *Elitekey: Micmac Material Culture from 1600 AD to the Present*. Halifax: Nova Scotia Museum, 1980.

CHAPTER 4: THE WEST

General and Introductory Texts

Bebbington, Julia M. *Quillwork of the Plains*. Calgary, Alberta: Glenbow-Alberta Institute, 1982.

Catlin, George. *Letters and Notes on the Manners, Customs, and Conditions of the North American Indian*. New York: Dover, 1973. First published 1844.

d'Azevedo, Warren L., ed. *Great Basin*. Vol. 11 of *Handbook of the North American Indians*. Washington, DC: Smithsonian Institution Press, 1986.

DeMallie, Raymond J., ed. *Plains*. Vol. 13 of *Handbook of the North American Indians*. Washington, DC: Smithsonian Institution Press, 2001.

Heizer, Robert F., ed. *California*. Vol. 8 of *Handbook of the North American Indians*. Washington, DC: Smithsonian Institution Press, 1978.

Walker, Deward E., Jr., ed. *Plateau*. Vol. 12 of *Handbook of the North American Indians*. Washington, DC: Smithsonian Institution Press, 1988.

The Great Plains and Intermontaine Region

Ackerman, Lillian A., ed. *A Song to the Creator: Traditional Arts of Native American Women of the Plateau*. Norman: University of Oklahoma Press, 1995.

Albers, Patricia, and Beatrice Medicine. "The Role of Sioux Women in the Production of Ceremonial Objects: The Case of the Star Quilt." In *The Hidden Half: Studies of Plains Indian Women*, edited by Patricia Albers and Beatrice Medicine. Washington, DC: University Press of America, 1983.

Amiotte, Arthur. "An Appraisal of Sioux Arts." In *An Illustrated History of the Arts of South Dakota*, edited by Arthur Huseboe, 109–46. Sioux Falls, S.Dak.: The Center for Western Studies, Augustana College, 1989.

————. "The Lakota Sun Dance: Historical and Contemporary Perspectives," in *Sioux Indian Religion: Tradition and Innovation*, edited by Raymond J. DeMallie and Douglas R. Parks. Norman: University of Oklahoma Press, 1987.

Bailey, Garrick, and Daniel C. Swan. *Art of the Osage*. St Louis: Saint Louis Art Museum, in association with University of Washington Press, 2004.

Bastien, Betty. *Blackfoot Ways of Knowing: The Worldview of the Siksikaitsitapi*. Calgary, Alberta: University of Calgary Press, 2004.

Bebbington, Julia M. *Quillwork of the Plains/Le "travail aux piquants" des indiens des plaines*. Calgary, Alberta: Glenbow-Alberta Institute, 1982.

Berlo, Janet Catherine. *Arthur Amiotte: Collages, 1988–2006*. Santa Fe: Wheelwright Museum of the American Indian, 2006.

————. *Spirit Beings and Sun Dancers: Black Hawk's Vision of the Lakota World*. New York: George Braziller, 2000.

————. "Dreaming of Double Woman: The Ambivalent Role of the Female Artist in North American Indian Mythology." *American Indian Quarterly* 17, no. 1 (1993): 31–43.

————, ed. *Plains Indian Drawings, 1865–1935: Pages from a Visual History*. New York: Abrams, in association with the American Federation of Arts, 1996.

Blish, Helen. *A Pictographic History of the Oglala Sioux*. Lincoln: University of Nebraska Press, 1967.

Bol, Marsha. "Lakota Beaded Costumes of the Early Reservation Era." In *Arts of Africa, Oceania and the Americas: Selected Readings*, edited by Janet Berlo and Lee Anne Wilson, 363–70. Englewood Cliffs, N.J.: Prentice Hall, 1993.

————. "'All Around Rise Hundreds of Habitations of Buffalo Skin, Some . . . Covered with Fantastic and Primitive Paintings': The Painted Tepee of the Lakota People." In *Archaeology, Art and Anthropology: Papers in Honor of J. J. Brody*, edited by Meliha S. Duran and David T. Kirkpatrick, 23–38. Albuquerque: The Archaeological Society of New Mexico, 1992.

Bradbury, Ellen, Eileen Flory, and Moira Harris. *I Wear the Morning Star: An Exhibition of American Indian Ghost Dance Objects*. Minneapolis, Minn.: Minneapolis Institute of Arts, 1976.

Bradley, Douglas. *White Swan: Crow Indian Warrior and Painter*. Notre Dame, Ind.: The Snite Museum of Art, 1991.

Brasser, Ted J. "In Search of Métis Art." In *The New Peoples: Being and Becoming Métis in North America*, edited by Jacqueline Peterson and Jennifer Brown. Winnipeg: University of Manitoba Press, 1985.

————. *"Bo'jou, Neejee!" Profiles of Canadian Art*. Ottawa, Ontario: National Museum of Man, 1976.

Brown, Joseph Epes. *The Sacred Pipe: Black Elk's Account of the Seven Rites of the Oglala Sioux*. Norman: University of Oklahoma Press, 1953.

Bryan, Liz. *The Buffalo People: Prehistoric Archaeology on the Canadian Plains*. Edmonton: University of Alberta Press, 1991.

Calloway, Colin G., ed., *Ledger Narratives: The Plains Indian Drawings of the Lansburgh Collection at Dartmouth College*. Norman: University of Oklahoma Press, 2012.

Conn, Richard. *A Persistent Vision: Art of the Reservation Days*. Denver: Denver Art Museum, 1986.

————. *Circles of the World*. Denver: Denver Art Museum, 1982.

Denig, Edwin T. *Five Indian Tribes of the Upper Missouri: Sioux, Arickaras, Assiniboines, Crees, Crows*, edited by John C. Ewers. Norman: University of Oklahoma Press, 1961.

Donnelly, Robert. *Transforming Images: The Art of Silver Horn and His Successors*. Chicago: Smart Museum, University of Chicago, 2000.

Dubin, Lois Sherr. *Grand Procession: Contemporary Artistic Visions of American Indians*. Denver: Denver Art Museum, 2010.

Earenfight, Phillip, ed. *A Kiowa's Odyssey*. Seattle: University of Washington Press, 2007.

Eddy, John A. "Medicine Wheels and Plains Indian Astronomy," in *Native American Astronomy,* edited by Anthony Aveni. Austin: University of Texas Press, 1977.

Ewers, John C. *Blackfeet Crafts.* Stevens Point, Wisc.: Schneider, 1986. First published 1945.

————. *Plains Indian Sculpture: A Traditional Art from America's Heartland.* Washington, DC: Smithsonian Institution Press, 1986.

————. *Views of a Vanishing Frontier.* Omaha, Neb.: Joslyn Art Museum, 1984.

————. *Murals in the Round: Painted Tipis of the Kiowa-Apache Indians.* Washington, DC: Smithsonian Institution Press, 1978.

————. *Plains Indian Painting: A Description of an Aboriginal American Art.* Palo Alto, Calif.: Stanford University Press, 1939.

Gilman, Carolyn, and Mary Jane Schneider. *The Way to Independence: Memories of a Hidatsa Indian Family, 1840–1920.* St Paul: Minnesota Historical Society, 1987.

Greci-Green, Adriana. *Performances and Celebrations: Displaying Lakota Identity, 1880–1915.* PhD dissertation, Department of Anthropology, Rutgers University, 2001.

Greene, Candace. *One Hundred Summers: A Kiowa Calendar Record.* Lincoln: University of Nebraska Press, 2009.

————. "Arikara Drawings: New Sources of Visual History," *American Indian Art Magazine* 31, no. 2 (2006): 74–85.

————. "Art Until 1900." In *Handbook of North American Indians, Plains,* Volume 13, Part 2, *Plains,* edited by Raymond DeMallie, 1039–54. Washington, DC: Smithsonian Institution, 2001.

————. *Silver Horn: Master Illustrator of the Kiowa People.* Norman: University of Oklahoma Press, 2001.

————. "Soft Cradles of the Central Plains." *Plains Anthropologist* 37, no. 139 (1992): 95–113.

Greene, Candace, and Thomas Drescher. "The Tipi with Battle Pictures: The Kiowa Tradition of Intangible Property Rights." *Trademark Reporter* 84, no. 4 (1994): 418–33.

Grinnell, George Bird. *The Cheyenne Indians: History and Society.* Lincoln: University of Nebraska Press, 1972. First published in 1923.

Grinnell, George B. "The Lodges of the Blackfeet." *American Anthropologist* 3, no. 4 (1901): 650–68.

Hail, Barbara A. *Hau, Kola.* Providence, R.I.: Haffenreffer Museum of Anthropology, Brown University, 1980.

Hail, Barbara, ed. *Gifts of Pride and Love: Kiowa and Comanche Cradles.* Providence, R.I.: Haffenreffer Museum of Anthropology, Brown University, 2000.

Her Many Horses, Emil, and Colleen Cutschall. *Identity by Design: Tradition, Change, and Celebration in Native Women's Dress.* Washington, DC: National Museum of the American Indian, 2007.

Hansen, Emma I. *Memory and Vision: Arts, Cultures, and Lives of Plains Indian People.* Cody, Wyo.: Buffalo Bill Historical Center, 2007.

Hanson, James A. "Laced Coats and Leather Jackets: The Great Plains Intercultural Clothing Exchange," in *Plains Indian Studies: A Collection of Essays in Honor of John C. Ewers and Waldo R. Wedel,* edited by Douglas H. Ubelaker and Herman J. Viola. Washington, DC: Smithsonian Institution Press, 1982.

Hassrick, Royal. *The Sioux: Life and Customs of a Warrior Society.* Norman: University of Oklahoma Press, 1964.

Horse Capture, George P. *Pow Wow*. Cody, Wyo.: Buffalo Bill Historical Center, 1989.

Horse Capture, Joe D., and Emil Her Many Horses. *A Song for the Horse Nation: Horses in Native American Cultures*. Washington, DC: National Museum of the American Indian, in association with Fulcrum Publishing, 2006.

Horse Capture, Joe D., and George P. Horse Capture. *Beauty, Honor, and Tradition: The Legacy of Plains Indian Shirts*. Washington, DC: National Museum of the American Indian, in association with Minneapolis Institute of Arts, 2001.

Linn, Natalie. *The Plateau Bag: A Tradition in Native American Weaving*. Overland Park, Kans.: Johnson County Community College, Gallery of Art, 1994.

Lomahaftewa, Gloria M., and Barbara Loeb. *Glass Tapestry: Plateau Beaded Bags from The Elaine Horwitch Collection*. Phoenix: Heard Museum, 1993.

Louie, Penny. *My Story of Making and Sewing Hides*, edited by Kathleen Morin, Peter Morin, and Helen Marzolkf. Victoria, B.C.: Open Space Arts Society, 2012.

Lowie, Robert. "The Religion of the Crow Indians." *Anthropological Papers of the American Museum of Natural History* 25, no. 2 (1922): 309–444.

Lyford, Carrie A. *Quill and Beadwork of the Western Sioux*. Boulder, Colo.: Johnson Book, 1979. First published 1940.

McClintock, Walter. "Painted Tipis and Picture-Writing of the Blackfoot Indians, Part 2. *The Masterkey* 10, no. 5 (1936): 120–33, 168–79.

McLaughlin, Castle, ed. *Arts of Diplomacy: Lewis & Clark's Indian Collection*. Seattle: University of Washington Press, 2003.

Marriot, Alice. "Objects and Identities: Another Look at Lewis and Clark's Side-Fold Dress." *American Indian Art Magazine* 29, no. 1 (Winter 2003): 76–87.

Mallery, Garrick. *Picture-Writing of the American Indians*. Tenth Annual Report of the Bureau of Ethnology. Washington, DC: Smithsonian Institution, 1888–9.

————. "The Trade Guild of the Southern Cheyenne Women." *Bulletin of the Oklahoma Anthropological Society* 4 (1956): 19–27.

Marriott, Alice and Carol Rachlin. *Dance Around the Sun: The Life of Mary Little Bear Inkanish, Cheyenne*. New York: Thomas Y. Crowell Co., 1977.

Maurer, Evan, ed. *Visions of the People: A Pictorial History of Plains Indian Life*. Minneapolis, Minn.: Minneapolis Institute of Art, 1992.

Mercer, Bill. *People of the River: Native Arts of the Oregon Territory*. Seattle: University of Washington Press, 2005.

Miller, Lynette. "Flat Twined Bags of the Plateau." MA thesis, Department of Art History, University of Washington, 1986.

Mooney, James. *Calendar History of the Kiowa Indians*. 17th Annual Report of the Bureau of American Ethnology. Washington, DC: Smithsonian Institution, 1898.

Peterson, Jacqueline, and Laura Peers, *Sacred Encounters: Father De Smet and the Indians of the Rocky Mountain West*. Norman: University of Oklahoma Press, 1993.

Penney, David W. *Art of the American Indian Frontier: The Chandler-Pohrt Collection*. Detroit, Mich.: Detroit Institute of Arts, 1992.

Petersen, Karen Daniels. *Plains Indian Art from Fort Marion*. Norman: University of Oklahoma Press, 1971.

Powell, Peter J., ed. *Crow Indian Art from The Goelet and Edith Gallatin Collection of American Indian Art*. Chicago: Foundation for the Preservation of American Indian Art and Culture, 1988.

Pulford, Florence. *Morning Star Quilts*. Los Altos, Calif.: Eddie's Quilting Bee, 1989.

Racette, Sherry Farrell. *Sewing Ourselves Together: Clothing, Decorative Arts and the Expression of Métis and Half Breed Identity*. PhD dissertation, University of Manitoba, 2004.

Robinson, Jane Ewers, ed. *Plains Indian Art: The Pioneering Work of John C. Ewers*. Norman: University of Oklahoma Press, 2011.

Schlesier, Karl H. *Plains Indians, A.D. 500–1500: The Archaeological Past of Historic Groups*. Norman: University of Oklahoma Press, 1994.

Schlick, Mary Dodds. *Columbia River Basketry: Gift of the Ancestors, Gift of the Earth*. Seattle: University of Washington Press, 1994.

————. "Plains Indian Clothing: Stylistic Persistence and Change." *Bulletin of the Oklahoma Anthropological Society* XVII (November 1968): 1–55.

Schuler, Harold. *Fort Pierre Chouteau*. Vermillion: University of South Dakota Press, 1990.

Spector, Janet D. *What This Awl Means: Feminist Archaeology at a Wahpeton Dakota Village*. St Paul: Minnesota Historical Society, 1993.

Stern, Theodore. "Columbia River Trade Network." In *Handbook of North American Indians*, Vol. 12, *Plateau*, edited by Deward W. Walker, Jr. Washington, DC: Smithsonian Institution, 1998.

Szabo, Joyce M. *Imprisoned Art, Complex Patronage: Plains Drawings by Howling Wolf and Zotom at the Autry National Center*. Santa Fe, N.Mex.: School for Advanced Research Press, 2011.

————. *Art from Fort Marion: The Silberman Collection*. Norman: University of Oklahoma Press, 2007.

————. *Howling Wolf and the History of Ledger Art*. Albuquerque: University of New Mexico Press, 1994.

Teit, James. *Mythology of the Thompson Indians*. The Jessup North Pacific Expedition, Vol. 8, no. 2, Memoirs of the American Museum of Natural History Vol. 12. Leiden, the Netherlands: EJ Brill, 1912.

Torrence, Gaylord. *The American Indian Parfleche: A Tradition of Abstract Painting*. Des Moines, Iowa: Des Moines Art Center, 1994.

Vatter, Ernst. "Historienmalerei und Heraldische Bilderschrift der Nordamerikanischen Prairiestamme." *IPEK: Jahrbuch für Prahistorische & Ethnographische Kunst* (1927), 44–81.

Vitart, Anne, and George Horse Capture. *Parures d'Histoire: Peaux de Bisons Peintes des Indiens d'Amérique du Nord*. Paris: Musée de l'Homme, 1993.

Wildschut, William, and John C. Ewers. *Crow Indian Beadwork: A Descriptive and Historical Study*. New York: Museum of the American Indian, Heye Foundation, 1959.

Witte, Stephen, and Marsha Gallagher, eds. *The North American Journals of Prince Maximilian of Wied*. 3 vols. Norman: University of Oklahoma Press, 2010.

Arts of California and the Great Basin

Allen, Elsie. *Pomo Basketmaking: A Supreme Art for the Weaver*. Happy Camp, Calif.: Naturegraph, 1972.

Bates, Craig D., and Martha Lee. *Tradition and Innovation: A Basket History of the Indian of the Yosemite-Mono Lake Area*. Yosemite, Calif.: Yosemite Association, 1990.

Cohodas, Marvin. *Basket Weavers for the California Curio Trade*. Tucson: University of Arizona Press, 1997.

_____. "Louisa Keyser and the Cohns: Myth Making and Basket Making in the American West." In *The Early Years of Native American Art History: The Politics of Scholarship and Collecting*, edited by Janet C. Berlo. Seattle: University of Washington Press, 1992.

_____. *Degikup: Washoe Fancy Basketry, 1895–1935*. Vancouver: Fine Arts Gallery of the University of British Columbia, 1979.

Fields, Virginia M. *The Hover Collection of Karuk Baskets*. Eureka, Calif.: Clarke Memorial Museum, 1985.

Fowler, Catherine S., and Don D. Fowler, eds. *The Great Basin: People and Place in Ancient Times*. Santa Fe: School for Advanced Research Press, 2000.

Fowler, Catherine, Eugene Hattori, and Amy Dansie. "Ancient Matting from Spirit Cave, Nevada: Technical Implications." In *Beyond Cloth and Cordage: Archaeological Textile Research in the Americas*, edited by Penelope Ballard Drooker and Laurie Webster, 119–39. Salt Lake City: University of Utah Press, 2000.

Grant, Campbell. *The Rock Paintings of the Chumash*. Berkeley: University of California Press, 1965.

Grant, Campbell, James W. Baird, and J. Kenneth Pringle. *Rock Drawings of the Coso Range*. China Lake, Calif.: Maturango Museum, 1968.

Hutchinson, Elizabeth. *The Indian Craze: Primitivism, Modernism, and Transculturation in American Art, 1890–1915*. Durham, N.C.: Duke University Press, 2009.

Kroeber, Alfred L. *Handbook of the Indians of California*. Bulletin 78 of the Bureau of American Ethnology. Washington, DC: Smithsonian Institution, 1925.

Lightfoot, Kent. *Indians, Missionaries and Merchants: The Legacy of Colonial Encounters on the California Frontiers*. Berkeley: University of California Press, 2005.

McLendon, Sally, and Brenda Holland. "The Basketmaker: The Pomoans of California" In *The Ancestors: Native Artisans of the Americas*, edited by Anna Roosevelt and James G. E. Smith. New York: National Museum of the American Indian, 1979.

O'Neale, Lila. "Yurok-Karok Basket Weavers." *University of California Publications in American Archaeology and Ethnology* 32 (1932).

Sarris, Greg. *Mabel McKay: Weaving the Dream*. Berkeley: University of California Press, 1994.

Whitley, David S. *The Art of the Shaman: Rock Art of California*. Salt Lake City: University of Utah Press, 2000.

Winthur, Barbara. "Pomo Banded Baskets and Their Dau Marks." *American Indian Art Magazine* 10, no. 4 (Autumn, 1985): 50–57.

CHAPTER 5: THE NORTH

General and Introductory Texts

Collins, Henry B., Frederica de Laguna, Edmund Carpenter, and Peter Stone. *The Far North: 200 Years of American Eskimo and Indian Art*. Bloomington: Indiana University Press, 1973.

Damas, David, ed. *Arctic*. Vol. 5 of *Handbook of North American Indians*. Washington, DC: Smithsonian Institution Press, 1984.

Fitzhugh, William, and Aron Crowell, eds. *Crossroads of Continents: Cultures of Siberia and Alaska*. Washington, DC: Smithsonian Institution Press, 1988.

Helm, June, ed. *Subarctic.* Vol. 6 of *Handbook of North American Indians.* Washington, DC: Smithsonian Institution Press, 1981.

Varjola, Pirjo. *The Etholen Collection: The Ethnographic Alaskan Collection of Adolf Etholen and His Contemporaries in the National Museum of Finland.* Helsinki: National Board of Antiquities, 1990.

The Subarctic

Andrews, Thomas D., ed. *Dè T'a Hoti Ts'eeda: We Live Securely by the Land.* Yellowknife, Northwest Territories: Government of the Northwest Territories, 2006.

Brasser, Ted. "Pleasing the Spirits: Indian Art Around the Great Lakes." In *Pleasing the Spirits: A Catalogue of a Collection of American Indian Art,* edited by Douglas C. Ewing. New York: Ghylen, 1982.

Burnham, Dorothy K. *To Please the Caribou: Painted Caribou-Skin Coats Worn by the Naskapi, Montagnais, and Cree Hunters of the Quebec-Labrador Peninsula.* Toronto: Royal Ontario Museum, 1992.

Duncan, Kate C. *Northern Athapaskan Art: A Beadwork Tradition.* Seattle: University of Washington Press, 1989.

Hail, Barbara, and Kate C. Duncan. *Out of the North: The Subarctic Collection of the Haffenreffer Museum of Anthropology.* Bristol, R.I.: Haffenreffer Museum of Anthropology, 1989.

Kristensen, Todd J., and Donald H. Holly, Jr. "Birds, Burials and Sacred Cosmology of the Indigenous Beothuk of Newfoundland, Canada." *Cambridge Archaeological Journal* 23 (2013): 41–53.

Kritsch, Ingrid, and Karen Wright-Fraser. "The Gwich'in Traditional Caribou Skin Clothing Project: Repatriating Traditional Knowledge and Skills." *Arctic* 55, no. 2 (June 2002): 205–10.

Marshall, Ingeborg. *The Beothuk.* St John's, Newfoundland: Newfound Historical Society, 2001.

Oberholtzer, Cath. *Dream Catchers: Legend, Lore and Artifacts.* Richmond Hill, Ontario: Firefly, 2012.

Oberholtzer, Cath. "Together We Survive: East Cree Material Culture." PhD dissertation, McMaster University, Canada, 1994.

Pastore, Ralph T. *Shanawdithit's People: The Archaeology of the Beothuks.* St John's, Newfoundland: Atlantic Archaeology, 1992.

Speck, Frank. *Naskapi: The Savage Hunters of the Labrador Peninsula.* Norman: University of Oklahoma Press, 1977. First published in 1935.

Tanner, Adrian. *Bringing Home Animals: Religious Ideology and Mode of Production of the Mistassini Cree Hunters.* London: C. Hurst & Co., 1979.

Thompson, Judy. *Women's Work, Women's Art: Nineteenth-Century Northern Athapaskan Clothing.* Montreal: McGill-Queen's University Press, 2013.

Thompson, Judy. *From the Land: Two Hundred Years of Dene Clothing.* Ottawa, Ontario: Canadian Museum of Civilization, 1994.

_____. "No Little Variety of Ornament: Northern Athapaskan Artistic Traditions." In *The Spirit Sings: Artistic Traditions of Canada's First Peoples,* edited by Julia Harrison. Toronto: McClelland & Stewart, 1987.

Thompson, Judy and Ingrid Kritsch, *Yeenoo Dai' K'etr'ijilkai' Ganagwaandaii: Long Ago Sewing We Will Remember—The Story of the Gwich'in Traditional Caribou Skin Clothing Project.* Gatineau, Quebec: Canadian Museum of Civilization, 2005.

Webber, Alika Podolinsky. "Ceremonial Robes of the Montagnais-Naskapi." *American Indian Art Magazine* 9, no. 1 (1993): 60–9, 75–7.

The Ancient Arctic

Helge, Larsen, and Froelich Rainey, *Ipiutak and the Arctic Whale Hunting Culture*, Anthropological Papers of the American Museum of Natural History 42. New York: American Museum of Natural History, 1948.

McGhee, Robert. *Ancient People of the Arctic*. Vancouver: University of British Columbia Press, 1996.

Taylor, William E., and George Swinton, "The Silent Echoes: Prehistoric Canadian Eskimo Art." *The Beaver* 298 (1967): 32–47.

Historic and Contemporary Arctic

Berlo, Janet Catherine. "Voices of Her Ancestors: Denise Wallace." *National Museum of the American Indian* 7, no. 1 (Spring 2006): 42–9.

————. "Drawing (Upon) the Past: Negotiating Identities in Inuit Graphic Arts Production." In *Unpacking Culture: Art and Commodity in Colonial and Postcolonial Worlds*, edited by Ruth B. Phillips and Christopher B. Steiner. Berkeley: University of California Press, 1998.

————. "Drawing and Printmaking at Holman." *Inuit Art Quarterly* 10, no. 3 (Fall 1995): 22–30.

————. "Portraits of Dispossession in Plains Indian and Inuit Graphic Arts." *Art Journal* 49, no. 2 (summer 1990): 133–41.

————. "Inuit Women and Graphic Arts: Female Creativity and Its Cultural Context." *Canadian Journal of Native Studies* 9, no. 2 (1989): 293–315.

Black, Lydia T. *Glory Remembered: Wooden Headgear of the Alaska Sea Hunters*. Juneau: Alaska State Museum, 1991.

————. *Aleut Art: Unangam Aguqaadangin*. Anchorage, Alas.: Aang Anĝaĝin, Aleutian/Pribilof Islands Association, 1982.

Blodgett, Jean. *In Cape Dorset We Do It This Way: Three Decades of Inuit Printmaking*. Ontario: McMichael Canadian Art Collection, 1991.

————. *North Baffin Drawings*. Toronto: Art Gallery of Toronto, 1986.

————. *Kenojuak: Graphic Masterworks of the Inuit*. Toronto: Firefly Books, 1985.

————. *Grasp Tight the Old Ways: Selections from the Klamer Family Collection of Inuit Art*. Toronto: Art Gallery of Ontario, 1983.

————. *The Coming and Going of the Shaman: Eskimo Shamanism and Art*. Winnipeg, Manitoba: The Winnipeg Art Gallery, 1978.

Blodgett, Jean, and Marie Bouchard. *Jessie Oonark: A Retrospective*. Winnipeg, Manitoba: Winnipeg Art Gallery, 1986.

Butler, Sheila. "The First Printmaking Year at Baker Lake: Personal Reflections." *The Beaver* 304, no. 4 (Spring 1976): 17–26.

————. "Wall Hangings from Baker Lake." *The Beaver* 303, no. 2 (Autumn 1972): 26–31.

Cowling, Elizabeth. 'The Eskimos, the American Indians, and the Surrealists." *Art History* 1, no. 4 (December 1978): 484–99.

Crowell, Aron L., Amy Steffian, and Gordon Pullar, eds. *Looking Both Ways: Heritage and Identity of the Alutiiq People*. Fairbanks: University of Alaska Press: 2001.

Dewar, Patricia. "You Had to Be There." *Inuit Art Quarterly* 9, no. 1 (1994): 20–9.

Driscoll, Bernadette. "Pretending to Be Caribou: The Inuit Parka as an Artistic Tradition." In *The Spirit Sings: Artistic Traditions of Canada's First Peoples*, edited by Julia Harrison. Toronto: McClelland & Stewart, 1987.

————. *The Inuit Amautik: I Like My Hood To Be Full*. Winnipeg, Manitoba: Winnipeg Art Gallery, 1980.

Driscoll-Engelstad, Bernadette, and Bernadette Miqqusaaq Dean. "Inuit amauti or tuilli." In *Infinity of Nations: Art and History in the Collections of The National Museum of the American Indian*, edited by C. R. Gantaume, 259. New York: Harper Collins, 2010.

Dubin, Lois. *Arctic Transformations: The Jewelry of Denise and Samuel Wallace*. Westport, Conn.: Easton Studio, 2005.

Fair, Susan W. *Alaska Native Art: Tradition, Innovation, Continuity*. Fairbanks: University of Alaska Press, 2006.

Fienup-Riordan, Ann. "Tumaralria's Drum." *Shaman* 17, nos. 1–2 (Spring–Autumn 2009): 5–27.

————. *Yuungnaqpiallerpt/The Way We Genuinely Live: Masterworks of Yup'ik Science and Survival*. Seattle: University of Washington Press, in association with Anchorage Museum Association, and Calista Elders Council, 2007.

————. *The Living Tradition of Yup'ik Masks: Agayuliyararput, Our Way of Making Prayer*. Seattle: University of Washington Press, 1996.

Finkenstein, Maria von, ed. *Nivisavik: The Place Where We Weave*. Montreal: McGill-Queen's University Press, 2002.

Fitzhugh, William and Aron Crowell. *Crossroads of Continents: Cultures of Siberia and Alaska*. Washington, DC: Smithsonian Institution Press, 1988.

Goetz, Helga. *The Inuit Print*. Ottawa, Ontario: National Museum of Man, 1977.

Graburn, Nelson H. H. "Eskimo Art—the Eastern Canadian Arctic." In *Ethnic and Tourist Arts: Cultural Expressions from the Fourth World*, edited by Nelson H. H. Graburn. Berkeley: University of California Press, 1976.

————. "Some Problems in the Understanding of Contemporary Inuit Art." *Western Canadian Journal of Anthropology* 4, no. 3 (January 1975): 63–72.

Gronholdt, Andrew. *Chagudax: A Small Window into the Life of an Aleut Bentwood Hat Carver*, edited by Michael Livingston and Sharon Gronholdt-Dye. San Francisco: Blurb Press, 2012.

Hall, Judy, Jill Oakes, and Sally Qjmmiu'naaq Webster. *Sanatujut. Pride in Women's Work: Copper and Caribou Inuit Clothing Traditions*. Ottawa, Ontario: Canadian Museum of Civilization, 1994.

Hickman, Pat. *Innerskins and Outerskins: Gut and Fishskin*. San Francisco: San Francisco Craft and Folk Art Museum, 1987.

Himmelheber, Hans. *Eskimokünstler*. Zurich: Museum Rietberg, 1938.

Houston, Alma, ed. *Inuit Art: An Anthology*. Winnipeg, Manitoba: Watson and Dwyer, 1998.

Inuit Art Quarterly. All vols. Ottawa, Ontario, 1986–2010.

Jackson, Marion. *Baker Lake Inuit Drawings*, unpublished doctoral dissertation, Department of Art History, University of Michigan, 1985.

Jackson, Marion E., and Judith Nasby, *Contemporary Inuit Drawings*. Guelph, Ontario: Macdonald Stewart Art Centre, 1987.

Jones, Suzi, ed. *The Artists Behind the Work: Life Histories of Nick Charles, Sr., Frances Demientieff, Lena Sours, Jennie Thlunaut*. Fairbanks: University of Alaska Museum, 1986.

————, ed. *Eskimo Dolls*. Anchorage: Alaska State Council on the Arts, 1982.

Kaplan, Susan A., and Kristin J. Barsness, eds. *Raven's Journey: The World of Alaska's Native People*. Philadelphia: University of Pennsylvania Museum, 1986.

Lee, Molly. "Appropriating the Primitive: Turn-of-the-Century Collection and Display of Native Alaskan Art." *Arctic Anthropology* 28, no. 1 (1991): 6–15.

————. *Baleen Basketry of the North Alaskan Eskimo*. Barrow, Alas.: North Slope Borough Planning Department, 1983.

Lee, Molly, and Gregory Reinhardt. *Eskimo Architecture: Dwelling and Structure in the Early Historic Period*. Fairbanks: University of Alaska Press, 2003.

Leroux, Odette, Marion E. Jackson, and Minnie Aodla Freeman, eds. *Inuit Women Artists*: *Voices from Cape Dorset*. Vancouver: Douglas and McIntyre, 1994.

Martijn, Charles A. "Canadian Eskimo Carving in Historical Perspective." *Anthropos* 59 (1964): 546–96.

Myers, Marybelle. "Inuit Arts and Crafts Co-operatives in the Canadian Arctic," *Canadian Ethnic Studies* Vol. 16, no. 3 (1984): 132–52.

Nasby, Judith. *Irene Avalaaqiaq: Myth and Reality*. Montreal: McGill-Queen's University Press, 2002.

Nelson, Edward. *The Eskimo About Bering Strait*. Washington, DC: Smithsonian Institution Press, 1983. First published in 1899.

Phebus, Jr., George. *Alaskan Eskimo Life in the 1890s as Sketched by Native Artists*. Fairbanks: University of Alaska Press, 1995.

Ray, Dorothy Jean. "Happy Jack and his Artistry." *American Indian Art* 15, no. 1, (Winter 1989): 40–53.

————. *Artists of the Tundra and the Sea*. Seattle: University of Washington Press, 1980. First published in 1961.

————. *Eskimo Art, Tradition and Innovation in North Alaska*. Seattle: University of Washington Press, 1977.

————. *Eskimo Masks: Art and Ceremony*. Seattle: University of Washington Press, 1967.

Routledge, Marie, and Marion E. Jackson. *Pudlo: Thirty Years of Drawing*. Ottawa, Ontario: National Gallery of Canada, 1990.

Steinbright, Jan. *Arts from the Arctic: An Exhibition of Circumpolar Art by Indigenous Artists from Alaska, Canada, Greenland Sami (Lapland), Russia*. Anchorage: Institute of Alaska Native Arts, 1993.

————, ed. *Alaskameut '86: An Exhibition of Contemporary Alaska Native Masks*. Fairbanks: Institute of Alaska Native Arts, 1986.

Swinton, George. *Sculpture of the Eskimos*. Toronto: C. Hurst, 1972.

Vastokas, Joan M. "Continuities in Eskimo Graphic Style." *Artscanada* (December 1971/January 1972): 69–83.

Wallen, Lynn Ager. *Bending Tradition*. Fairbanks: University of Alaska Museum, 1990.

Wight, Darlene. "Harold Qarliksaq: A Decade of Drawings." *Inuit Art Quarterly* 16, no. 3 (Fall 2001): 18–21.

————. *Out of Tradition: Abraham Anghik/David Ruben Piqtoukun*. Winnipeg, Manitoba: Winnipeg Art Gallery, 1989.

CHAPTER 6: THE NORTHWEST COAST

General and Introductory

Abbott, Donald N., ed. *The World Is as Sharp as a Knife: An Anthology in Honour of Wilson Duff*. Victoria: British Columbia Provincial Museum, 1981.

Ames, Kenneth and Herbert Maschner. *Peoples of the Northwest Coast: Their Archaeology and Prehistory*. London: Thames & Hudson, 1999.

Barbeau, Marius. *Totem Poles*. Ottawa, Ontario: National Museum of Canada, 1950.

Blackman, Margaret B. "Creativity in Acculturation: Art, Architecture and Ceremony from the Northwest Coast." *Ethnohistory* 23, no. 4 (Autumn 1976): 387–413.

Brown, Steve. *Spirits of the Water: Native Art Collected on Expeditions to Alaska and British Columbia, 1774–1910*. Seattle: University of Washington Press, 2000.

————. *Native Visions: Evolution in Northwest Coast Art from the Eighteenth Century through the Twentieth Century*. Seattle: University of Washington Press, 1998.

Carlson, Roy, ed. *Indian Art Traditions of the Northwest Coast*. Burnaby, British Columbia: Archaeology Press, Simon Fraser University, 1982.

Cole, Douglas. *Captured Heritage: The Scramble for Northwest Coast Artifacts*. Seattle: University of Washington Press, 1985.

Cole, Douglas, and Ira Chaikin. *An Iron Hand upon the People: The Law Against the Potlatch on the Northwest Coast*. Vancouver: Douglas & McIntyre, 1990.

Drucker, Philip. *Indians of the Northwest Coast*. Garden City, N.Y.: Natural History Press, 1963. First published 1955.

Duff, Wilson. "The World Is as Sharp as a Knife: Meaning in Northwest Coast Art." In *Indian Art Traditions of the Northwest Coast*, edited by Roy Carlson, 47–56. Burnaby, British Columbia: Archaeology Press, 1983.

————. *Images Stone B.C.: Thirty Centuries of Northwest Coast Indian Sculpture*. Saanichton, British Columbia: Hancock House, 1975.

Duff, Wilson, Bill Holm, and Bill Reid. *Arts of the Raven: Masterworks by the Northwest Coast Indian*. Vancouver: Vancouver Art Gallery, 1967.

Fladmark, Knut R. *British Columbia Prehistory*. Ottawa, Ontario: Archaeological Survey of Canada, in association with the National Museum of Man, 1986.

Feest, Christian. "Cook Voyage Material from North America: The Vienna Collection." *Archiv für Volkerkunde* 49 (1995): 111–86.

Glass, Aaron, ed. *Objects of Exchange: Social and Material Transformation on the Late Nineteenth-Century Northwest Coast*. New York: Bard Graduate Center, 2010.

Gunther, Erna. *Indian Life on the Northwest Coast of North America: As Seen by the Early Explorers and Fur Traders during the Last Decades of the Eighteenth Century*. Chicago, Ill.: University of Chicago Press, 1972.

Haeberlin, Herman. "Principles of Esthetic Form in the Art of the North Pacific Coast." *American Anthropologist* 20, no. 3 (1918): 258–64.

Hall, Edwin S., Margaret B. Blackman, and Vincent Rickard. *Northwest Coast Indian Graphics: An Introduction to Silk Screen Prints*. Vancouver: Douglas & McIntyre, 1981.

Holm, Bill. *Spirit and Ancestor: A Century of Northwest Coast Art at the Burke Museum*. Seattle, Wash.: Douglas & McIntyre, 1987.

_____. *Northwest Coast Art: An Analysis of Form*. Seattle: University of Washington Press, 1965.

Holm, Bill, and Thomas Vaughan. *Soft Gold—The Fur Trade and Cultural Exchange on the Northwest Coast of America*. Portland: Oregon Historical Society, 1982.

Inverarity, Robert. *Art of the Northwest Coast Indians*. Berkeley: University of California Press, 1950.

Jensen, Doreen, and Polly Sargent. *Robes of Power: Totem Poles on Cloth*. Vancouver: University of British Columbia Press, 1986.

Jensen, Vickie. *Totem Pole Carving: Bringing a Log to Life*. Vancouver: Douglas & McIntyre, 2004.

Jonaitis, Aldona. *Art of the Northwest Coast*. Seattle: University of Washington Press, 2006.

_____. *A Wealth of Thought: Franz Boas on Native American Art*. Seattle: University of Washington Press, 1995.

_____. *From the Land of the Totem Poles*. New York: American Museum of Natural History, 1988.

Jonaitis, Aldona, and Aaron Glass. *The Totem Pole: An Intercultural History*. Seattle: University of Washington Press, 2010.

King, J. C. H. *Artificial Curiosities from the Northwest Coast of America: Native American Artefacts in the British Museum Collected on the Third Voyage of Captain James Cook and Acquired through Sir Joseph Banks*. London: British Museum Publications, 1981.

Laforet, Andrea. *The Book of the Grand Hall*. Hull, Quebec: Canadian Museum of Civilization, 1992.

Lévi-Strauss, Claude. *The Way of the Masks*. Seattle: University of Washington Press, 1982. First published in French, 1979.

Macnair, Peter L., Alan L. Hoover, and Kevin Neary. *The Legacy: Continuing Traditions of Canadian Northwest Coast Indian Art*. Victoria: British Columbia Provincial Museum, 1980.

Macnair, Peter, Robert Joseph, and Bruce Grenville. *Down from the Shimmering Sky: Masks of the Northwest Coast*. Vancouver: Douglas & McIntyre, 1998.

Malloy, Mary. *Souvenirs of the Fur Trade: Northwest Coast Indian Art and Artifacts Collected by American Mariners, 1788–1844*. Cambridge, Mass.: Peabody Museum of Archaeology and Ethnology, Harvard University, 2000.

McLennan, Bill, and Karen Duffek, *The Transforming Image: Painted Arts of Northwest Coast First Nations*. Vancouver: University of British Columbia Press, 2000.

Ostrowitz, Judith. *Privileging the Past: Historicism in the Art of the Northwest Coast*. Seattle: University of Washington Press, 1999.

Suttles, Wayne, ed. *Northwest Coast*. Vol. 7 of *Handbook of the North American Indians*. Washington, DC: Smithsonian Institution Press, 1990.

Townsend-Gault, Charlotte, Jennifer Kramer, and Ki-ke-in, eds. *Native Art of the Northwest Coast: A History of Changing Ideas*. Vancouver: University of British Columbia Press, 2013.

Wardwell, Allen. *Objects of Bright Pride: Northwest Coast Indian Art from the American Museum of Natural History*. New York: Center for Inter-American Relations and the American Federation of Arts, 1978.

Wingert, Paul S. *American Indian Sculpture: A Study of the Northwest Coast*. New York: Hacker Art Books, 1949.

Wright, Robin K. "Northwest Coast Carving and Sculpture." *The Dictionary of Art*, vol. 22. London: MacMillan, 1996.

————. "Northwest Coast Painting." In *The Dictionary of Art*, vol. 22. London: MacMillan, 1996.

Northern Coast—Tlingit, Tsimshian, Haida, Haisla, Nisga'a, Gitxsan, Tahltan

Anderson, Margaret Seguin, and Marjorie M. Halpin, eds. *Potlatch at Gitsegukla: William Beynon's 1945 Field Notebooks*. Vancouver: University of British Columbia Press, 2000.

Augaitis, Daina, ed., *Raven Travelling: Two Centuries of Haida Art*. Vancouver: Vancouver Art Gallery, in association with Douglas & McIntyre, 2006.

Barbeau, Marius. *Haida Carvers in Argillite*. Ottawa, Ontario: National Museum of Man, 1974. First published 1959.

————. *Haida Myths: Illustrated in Argillite Carvings*. Ottawa, Ontario: Department of Resources and Development, National Parks Branch, and the National Museum of Canada, 1953.

————. *Totem Poles of the Gitksan, Upper Skeena River, British Columbia*. Ottawa, Ontario: F. A. Acland, 1929.

Berlo, Janet C. "Dreaming of Double Woman." *American Indian Quarterly* 17, no.1 (1993): 31–43.

Blackman, Margaret B. *During My Time: Florence Edenshaw Davidson, A Haida Woman*. Seattle: University of Washington Press, 1982.

————. "Totems to Tombstones: Culture Change as Viewed through the Haida Mortuary Complex, 1877–1971." *Ethnology* 12 (1973): 47–56.

Dauenhauer, Nora Marks, and Richard Dauenhauer. *Haa Kusteeyi: Our Culture: Tlingit Life Stories*. Seattle: University of Washington Press, 1994.

Duff, Wilson, ed. *Histories, Territories and Laws of the Kitwancool*. Victoria: British Columbia Provincial Museum, 1959.

Ellis, Donald, ed. *Tsimshian Treasures: The Remarkable Journey of the Dundas Collection*. Vancouver: Douglas & McIntyre, 2007.

Emmons, George T. *The Basketry of the Tlingit* and *The Chilkat Blanket*. Sitka, Alas.: Sheldon Jackson Museum, 1993. First published 1903 and 1907.

————. *The Tlingit Indians*. ed. Frederica de Laguna. Seattle: University of Washington Press, 1991.

Garfield, Viola, ed. *The Tsimshian: Their Arts and Music*. New York: J. J. Augustin, 1951.

Halpin, Marjorie. *The Tsimshian Crest System: A Study Based on Museum Specimens and the Marius Barbeau and William Beynon Field Notes*. Unpublished PhD dissertation, University of British Columbia, 1973.

Holm, Bill. *Northwest Coast Indian Art*: An Analysis of Form. Seattle: University of Washington Press, 1965.

Jonaitis, Aldona. *The Art of the Northern Tlingit*. Seattle: University of Washington Press, 1986.

Kaplan, Susan, and Kristin Barsness. *Raven's Journey: The World of Alaska's Native People*. Philadelphia: University of Pennsylvania Museum, 1986.

MacDonald, George. *The Totem Poles and Monuments of Gitwangak Village*. Ottawa, Ontario: Canadian Government Publication Center, 1984.

_____. *Haida Monumental Art: Villages of the Queen Charlotte Islands*. Vancouver: University of British Columbia Press, 1983.

Macnair, Peter L., and Alan L. Hoover. *The Magic Leaves: A History of Haida Argillite Carving*. Victoria: British Columbia Provincial Museum, 1984.

Paul, Frances. *The Spruce Root Basketry of the Alaska Tlingit*. Lawrence, Kans.: Haskell Institute, 1944.

Reid, Bill. *The Haida Legend of the Raven and the First Humans*. Museum Note No. 8. Vancouver: University of British Columbia Museum of Anthropology, 1980.

Samuel, Cheryl. *The Chilkat Dancing Blanket*. Norman: University of Oklahoma Press, 1990.

_____. *The Raven's Tail*. Vancouver: University of British Columbia Press, 1987.

Shadbolt, Doris. *Bill Reid*. Seattle: University of Washington Press, 1998.

Sheehan, Carol. *Pipes That Won't Smoke: Coals That Won't Burn: Haida Sculpture in Argillite*. Calgary, Alberta: Glenbow Museum, 1981.

Thorn, Ian M. *Robert Davidson: Eagle of the Dawn*. Vancouver: Douglas and MacIntyre, 1992.

Wardwell, Allen. *Tangible Visions: Northwest Coast Indian Shamanism and Its Art*. New York: Monacelli, 1996.

Worl, Rosita, ed. *Celebration: Tlingit, Haida, Tsimshian Dancing on the Land*. Seattle: University of Washington Press, 2008.

Worl, Rosita, and Charles Smythe. "Jennie Thlunaut: Master Chilkat Blanket Artist." In *The Artists Behind the Work*, 122–46. Fairbanks: University of Alaska Museum, 1986.

Wright, Robin K. *Northern Haida Master Carvers*. Seattle: University of Washington Press, 2001.

_____. "The Depiction of Women in Nineteenth Century Haida Argillite Carving." *American Indian Art Magazine* 11, no. 4 (Autumn 1986): 36–45.

Wright, Robin K., Daina Augaitis, and Jim Hart. *Charles Edenshaw*. London: Black Dog, 2013.

Central Coast—Kwakwaka'wakw, Heiltsuk, Nuxalk

Black, Martha. *Bella Bella: A Season of Heiltsuk Art*. Toronto: Royal Ontario Museum, 1997.

Boas, Franz. "The Social Organization and the Secret Societies of the Kwakiutl Indians." In *Report for the U.S. National Museum for 1895*. Washington, DC: U.S. Government Printing Office, 1897, 311–738.

Evans, Brad, and Aaron Glass, eds. *Return to the Land of the Head Hunters: Edward Curtis, the Kwakwaka'wakw, and the Making of Modern Cinema*. Seattle: University of Washington Press, 2014.

Glass, Aaron. "Frozen Poses: Hamat'sa Dioramas, Recursive Representation and the Making of a Kwakwaka'wakw Icon." In *Photography, Anthropology, and History: Expanding the Frame*, edited by Christopher Morton and Elizabeth Edwards, 89–116. London: Ashgate Press, 2009.

Hawthorn, Audrey. *Kwakiutl Art*. Vancouver: University of British Columbia, 1967.

Holm, Bill. *Smoky-Top: The Art and Times of Willie Seaweed*. Seattle: Douglas & McIntyre, 1983.

Jacknis, Ira. *The Storage Box of Tradition: Kwakiutl Art, Anthropologists and Museums, 1881–1981*. Washington, DC: Smithsonian Institution Press, 2002.

Jonaitis, Aldona, ed. *Chiefly Feasts: The Enduring Kwakiutl Potlatch*. Seattle: University of Washington Press, 1991.

Kramer, Jennifer. *Switchbacks: Art, Ownership, and Nuxalk National Identity*. Vancouver: University of British Columbia Press, 2006.

Nuytten, Phil. *The Totem Carvers: Charlie James, Ellen Neel and Mungo Martin*. Vancouver: Panorama Publications, 1982.

Stott, Margaret. *Bella Coola Ceremony and Art*. Ottawa, Ontario: National Museum of Man, 1975.

Webster, Gloria Cranmer. "The Contemporary Potlatch." In *Chiefly Feasts: The Enduring Kwakiutl Potlatch*, edited by Aldona Jonaitis, 135–68. New York: American Museum of Natural History, 1991.

Southern Coast—Nuu-chah-nulth, Makah, Coast Salish

Arima, Eugene. *The Westcoast People: The Nootka of Vancouver Island and Cape Flattery*. Victoria: British Columbia Provincial Museum, 1983.

Backstory: Nuuchaanulth Ceremonial Curtains and the Work of Ki-ke-in. Introduction by Charlotte Townsend-Gault. Vancouver: Belkin Art Gallery, 2010.

Black, Martha. *HuupuKanum-Tupaat: Out of the Mist, Treasures of the Nuu-chah-nulth Chiefs*. Victoria: Royal British Columbia Museum, 1999.

Feder, Norman. "Incised Relief Carving of the Halkomelem and Straits Salish," *American Indian Art Magazine* 8, no. 2 (1983): 46–55.

Gustafson, Paula. *Salish Weaving*. Seattle: University of Washington Press, 1980.

Haeberlin, Herman Karl, and Erna Gunther. *The Indians of Puget Sound*. Seattle: University of Washington Press, 1930.

Hoover, Alan L., ed. *Nuu-chah-nulth Voices: Histories, Objects and Journeys*. Victoria: Royal British Columbia Museum, 2000.

Johnson, Elizabeth L., and Kathryn Bernick. *Hands of Our Ancestors: The Revival of Salish Weaving at Musqueam*. Vancouver: University of British Columbia Museum of Anthropology, 1986.

Jonaitis, Aldona. *The Yuquot Whalers' Shrine*. Seattle: University of Washington Press, 1999.

Kew, Michael. *Sculpture and Engraving of the Central Coast Salish Indians*. Vancouver: University of British Columbia Museum of Anthropology, 1980.

Mercer, Bill. *People of the River: Native Arts of the Oregon Territory*. Portland, Oreg.: Portland Art Museum, 2005.

Suttles, Wayne. *Coast Salish Essays*. Seattle: University of Washington Press, 1987.

Thompson, Nile, and Catherine Marr. *Crow's Shell: Artistic Basketry of Puget Sound*. Seattle: Dushuyay Publications, 1983.

Wright, Robin K., ed. *A Time of Gathering*. Seattle: Burke Museum, 1990.

CHAPTER 7: NATIVE ART FROM 1900 TO 1980: MODERNS AND MODERNISTS

General Works, Directories, and Exhibition Catalogues

Anthes, Bill. *Native Moderns: American Indian Painting, 1940–1960*. Durham, N.C.: Duke University Press, 2006.

Archuleta, Margaret, and Rennard Strickland. *Shared Visions: Native American Painters and Sculptors in the Twentieth Century*. Phoenix: The Heard Museum, 1991.

Berlo, Janet C. "The Szwedzicki Portfolios of American Indian Art, 1929–1952, Part I." *American Indian Art Magazine* 34, no. 2 (Feb. 2009): 36–45.

————. "The Szwedzicki Portfolios of American Indian Art, 1929–1952, Part II." *American Indian Art Magazine* 34, no. 3 (May 2009): 58–67.

Bernstein, Bruce, and W. Jackson Rushing. *Modern by Tradition: Native American Painting in the Studio Style.* Santa Fe: Museum of New Mexico Press, 1995.

Blundell, Valda, and Ruth B. Phillips. "If It Isn't Shamanic Is It Sham? An Examination of Media Responses to Woodland School Art." *Anthropologica* 25, no. 1 (1995): 117–32.

Brody, J. J. *Indian Painters and White Patrons.* Albuquerque: University of New Mexico Press, 1971.

————. "Other Native Modernists: What's in a Name?" In *Essays on Native Modernism: Complexity and Contradiction in American Indian Art.* Washington, DC: National Museum of the American Indian, 2006.

————. *Pueblo Indian Painting: Tradition and Modernism in New Mexico, 1900–1930.* Santa Fe: School of American Research, 1997.

Brydon, Sherry. "The Indians of Canada Pavilion at Expo 67." *American Indian Art Magazine* 22, no. 3 (Summer 1997): 55–62.

Clark, Janet, ed. *Basket, Bead and Quill.* Thunder Bay, Ontario: Thunder Bay Art Gallery, 1996.

Covarrubias, Miguel. *The Eagle, the Jaguar, and the Serpent: Indian Art of the Americas: North America: Alaska, Canada, the United State.* New York: Alfred A. Knopf, 1954.

Crosby, Marcia. *Indian Art/Aboriginal Title.* MA thesis, University of British Columbia, 1994.

Dunn, Dorothy. *American Indian Painting of the Southwest and Plains Area.* Albuquerque: University of New Mexico Press, 1968.

Fewkes, Jesse Walter. "Hopi Kachinas Drawn by Native Artists." *21st Annual Report of the Bureau of American Ethnology.* Washington, DC: United States Government Printing Office, 1903.

Goetz, Helga. "Cape Dorset." In *The Inuit Print.* Ottawa, Ontario: National Museum of Man, 1977.

Goldwater, Robert. *Primitivism in Modern Art.* Rev. ed., New York: Vintage, 1967. [original edition: *Primitivism in Modern Painting,* 1938]

Graburn, Nelson H.H. "Eskimo Art—The Eastern Arctic." In *Ethnic and Tourist Arts: Cultural Expressions from the Fourth World,* edited by Nelson H. H. Graburn. Berkeley: University of California Press, 1976.

Gray, Viviane, and Mora Dianne O'Neill. *Pe'lA 'tukwey: Let Me . . . Tell a Story—Recent Work by Mi'kmaq and Maliseet Artists.* Halifax: Art Gallery of Nova Scotia, 1993.

Hall, Judy. "Charles Gimpel: Early Promotion of Inuit Art in Europe." *Inuit Art Quarterly* 24, no. 1 (Spring 2009): 34–9.

Harlan, Theresa, ed. *Strong Hearts: Native American Visions and Voices.* Special issue, *Aperture* 139 (1995).

Highwater, Jamake. *Song from the Earth: American Indian Painting.* Boston: Bow Historical Books, 1976.

Hill, Rick, ed. *Creativity Is Our Tradition: Three Decades of Contemporary Indian Art at the Institute of American Indian Arts.* Santa Fe: Institute of American Indian Arts, 1992.

Hill, Tom, and Karen Duffek. *Beyond History*. Vancouver: Vancouver Art Gallery, 1989.

Hoffman, Gerhard, ed., *In the Shadow of the Sun: Perspectives on Contemporary Native Art*. Hull, Quebec: Canadian Museum of Civilization, 1993.

Horton, Jessica L. *Places to Stand: Native Art Beyond the Nation*. PhD dissertation, Visual and Cultural Studies, University of Rochester, Rochester, N.Y., 2013.

Horton, Jessica L. and Janet Catherine Berlo, "Pueblo Indian Painting in 1932: Folding Narratives of Native Art into American Art History," in *The Blackwell Companion to American Art History*, ed. Jennifer Greenhill, John Davis, & Jason LaFountain. London: Blackwell, 2014.

Houle, Robert, "The Emergence of a New Aesthetic Tradition," in *New Work by a New Generation*. Regina, Saskatchewan: Norman Mackenzie Art Gallery, 1982.

Hutchinson, Elizabeth. *The Indian Craze: Primitivism, Modernism, and Transculturation in American Art, 1890–1915*. Durham, N.C.: Duke University Press, 2009.

Igloliorte, Heather. *Nunatsiavummi Snanguagusigisimajangit / Nunatsiavut Art History: Continuity, Resilience, and Transformation in Inuit Art*. Doctoral dissertation, Cultural Mediations, Carleton University, Ottawa, Ontario, 2013.

Jacobson, Oscar. *Kiowa Indian Art*. Nice, France: C. Szwedzicki, 1929.

Jones, Suzi, ed. *Eskimo Drawings*. Anchorage, Alas.: Anchorage Museum of History and Art, 2003.

Libhart, Myles, ed. *Contemporary Southern Plains Indian Painting*. Anadarko: Oklahoma Indian Arts & Craft Cooperative, 1972.

Lippard, Lucy, ed. *Partial Recall: Photographs of Native North Americans*. New York: The New Press, 1992.

Matuz, Roger, ed. *St James Guide to Contemporary Native North American Artists*. Detroit, Mich.: St James Press, 1998.

McGeough, Michelle. *Through Their Eyes: Indian Painting in Santa Fe, 1918–1945*. Santa Fe: Wheelwright Museum of the American Indian, 2009.

McLerran, Jennifer. *A New Deal for Native Art: Indian Arts and Federal Policy, 1933–1943*. Tucson: University of Arizona Press, 2009.

McLuhan, Elizabeth, and Tom Hill. *Norval Morrisseau and the Emergence of the Image Makers*. Toronto: Art Gallery of Ontario, 1984.

McMaster, Gerald, ed. *Inuit Modern: The Samuel and Esther Sarick Collection*. Toronto: Art Gallery of Ontario, 2011.

National Museum of Canada. *'Ksan, Breath of our Grandfathers: An Exhibition of 'Ksan Art*. Ottawa, Ontario, 1972.

New, Lloyd Kiva. *American Indian Art in the 1980s*. Niagara Falls, N.Y.: Native American Cultural Center, 1981.

Nelson, Christine. "Indian Art in Washington: Native American Murals in the Department of the Interior Building." *American Indian Art* 20, no. 2 (Spring 1995): 70–81.

Phillips, Ruth B. "The Turn of the Primitive: Modernism, the Stranger and the Indigenous Artist," in *Exiles, Diasporas & Strangers*, edited by Kobena Mercer. Cambridge, Mass.: MIT Press, 2008.

Prudek, Wolfgang M. *Carrying the Message: An Introduction to Iroquois Stone Sculpture*. Dundas, Ontario: Wolfwalker Enterprises, 1986.

Royal Ontario Museum. *The Art of the Anishnawbek: Three Perspectives*. Toronto: Royal Ontario Museum, 1996.

Royal Ontario Museum Ethnology Department. *Contemporary Native Art of Canada—The Woodland Indians*. Toronto, 1976.

Rushing, W. Jackson, ed. *Native American Art in the Twentieth Century*. New York: Routledge, 1999.

_____. *Native American Art and the New York Avant-Garde: History of Cultural Primitivism*. Austin: University of Texas Press, 1995.

_____. "Ritual and Myth: Native American Culture and Abstract Expressionism." In *The Spiritual in Art: Abstract Painting, 1890–1985*, edited by Maurice Tuchman et al., 273–95. New York: Abbeville Press, 1986.

Schrader, Robert. *The Indian Arts and Crafts Board: An Aspect of New Deal Indian Policy*. Albuquerque, N.Mex.: Olympic Marketing Corp., 1983.

Seymour, Tryntje Van Ness. *When the Rainbow Touches Down: The Artists and Stories Behind the Apache, Navajo, Rio Grande Pueblo, and Hopi Paintings in the William and Leslie Van Ness Denman Collection*. Phoenix: Heard Museum, 1987.

Sheffield, Gail K. *The Arbitrary Indian: The Indian Arts and Crafts Act of 1990*. Norman: University of Oklahoma Press, 1997.

Sloane, John, and Oliver LaFarge. *Introduction to American Indian Art*. New York: Exposition of Indian Tribal Arts, 1931.

Snodgrass, Jeanne. *American Indian Painters: A Biographical Directory*. New York: Heye Foundation, 1968

Southcott, Mary E. *The Sound of the Drum: The Sacred Art of the Anishnabec*. Erin, Ontario: Boston Mills Press, 1984.

Swinton, George. *Sculpture of the Inuit*. Toronto: McLelland and Stewart, 1992 (second revised edition).

Traugott, Joseph. "Native American Artists and the Postmodern Cultural Divide." *Art Journal* 51, no. 3 (1992): 43.

Vorano, Norman, ed. *Inuit Prints: Japanese Inspiration, Early Printmaking in the Canadian Arctic*. Gatineau, Quebec: Canadian Museum of Civilization, 2011.

Wade, Edwin L., and Rennard Strickland. *Magic Images: Contemporary Native American Art*. Norman, Okla.: Philbrook Art Center, 1981.

Wight, Darlene Coward, ed. *Creation and Transformation: Defining Moments in Inuit Art*. Vancouver: Douglas and McIntyre, 2012.

Winnipeg Art Gallery. *Treaty Numbers 23, 287, 1171: Three Indian Painters of the Prairies*. Winnipeg, Manitoba: Winnipeg Art Gallery, 1972.

Wyckoff, Lydia, ed. *Visions and Voices: Native American Painting from the Philbrook Museum of Art*. Tulsa, Okla.: Philbrook Museum of Art, 1996.

Young Man, Alfred, ed. *Networking: Proceedings from National Native Indian Artists' Symposium IV*. Lethbridge, Alberta: Graphcom Printers, 1988.

Individual Artists

Boyer, Bob. *Kiskayetum: Allen Sapp, a Retrospective*. Regina, Saskatchewan: Mackenzie Art Gallery, 1994.

Breeskin, Adelyn. *Two American Painters: Fritz Scholder and T. C. Cannon*. Washington, DC: Smithsonian Institution Press, 1972.

Broder, Patricia Janis. *Hopi Painting: The World of the Hopis*. New York: E. P. Dutton, 1978.

Callander, Lee A., and Ruth Slivka. *Shawnee Home Life: The Paintings of Earnest Spybuck*. New York: National Museum of the American Indian, 1984.

Dempsey, Hugh A. *Tailfeathers, Indian Artist*. Calgary, Alberta: Glenbow-Alberta Institute, 1978.

Devine, Bonnie. *Daphne Odjig*. Ottawa, Ontario: National Gallery of Canada, 2007.

Dockstader, Frederick J. ed. *Oscar Howe: A Retrospective Exhibition*. Tulsa, Okla.: Thomas Gilcrease Museum Association, 1982.

Dobkins, Rebecca. *Memory and Imagination: The Legacy of Maidu Indian Artist Frank Day*. Oakland, Calif.: Oakland Museum of California, 1997.

Duffek, Karen. *Bill Reid: Beyond the Essential Form*. Vancouver: University of British Columbia Press, 1986.

Heard Museum. *Houser and Haozous: A Sculptural Retrospective*. Phoenix: The Heard Museum, 1984.

Hill, Greg A., ed. *Norval Morrisseau: Shaman Artist*. Ottawa, Ontario: National Gallery of Canada, 2006.

Hughes, Kenneth. *The Life and Art of Jackson Beardy*. Winnipeg, Manitoba: Canadian Dimension Publishers and Toronto: J. Lorimer, 1979.

Hyer, Sally. *"Woman's Work": The Art of Pablita Velarde*. Santa Fe: Wheelwright Museum of the American Indian, 1993.

Ingberman, Jeanette. *Claim Your Color: Hachivi Edgar Heap of Birds*. New York: Exit Art, 1990.

King, Charles S., and Richard L. Spivey. *The Life and Art of Tony Da*. Tucson, Ariz.: Rio Nuevo Publishers, 2011.

Lee, Molly. "Betwixt and Between: The Art of James Kivetoruk Moses." In *Eskimo Drawings*, edited by Suzi Jones. Anchorage, Alas.: Anchorage Museum of History and Art, 2003.

Lowe, Truman, ed. *Native Modernism: The Art of George Morrison and Allan Houser*. Washington, DC: National Museum of the American Indian, 2004.

Lucie-Smith, Edward. *Fritz Scholder: A Survey of Paintings, 1970–1993*. Munich: Nazraeli, 1993.

Martin, Lee-Ann. *Bob Boyer: His Life's Work*. Regina, Saskatchewan: Mackenzie Art Gallery, 2008.

McLuhan, Elizabeth. *Altered Egos: The Multimedia Work of Carl Beam*. Thunder Bay, Ontario: Thunder Bay National Exhibition Centre and Centre for Indian Art, 1984.

McLuhan, Elizabeth, and R. M. Vanderburgh. *Daphne Odjig: A Retrospective 1946–1985*. Thunder Bay, Ontario: Thunder Bay National Exhibition Centre and the Centre for Indian Art, 1985.

McMaster, Gerald. *Edward Poitras: Canada XLVI Biennale di Venezia*. Hull, Quebec: Canadian Museum of Civilization, 1995.

Martin, Lee-Ann. *The Art of Alex Janvier: His First Thirty Years, 1960–1990*. Thunder Bay, Ontario: Thunder Bay Art Gallery, 1993.

Morrison, George, with Margo Fortunato Galt. *Turning the Feather Around: My Life in Art*. St Paul: Minnesota Historical Society Press, 1998.

Mulvey, Laura, Dirk Snauwaert, and Mark Alice Durant. *Jimmie Durham*. New York: Phaidon, 1995.

Perry, Robert. *Uprising! Woody Crumbo's Indian Art*. Ada, Okla.: Chickasaw Press, 2009.

Poolaw, Linda. *War Bonnets, Tin Lizzies, and Patent Leather Pumps: Kiowa Culture in Transition, 1925–1955*. Palo Alto, Calif.: Stanford University Press, 1990.

Routledge, Marie, and Marion Jackson. *Pudlo: Thirty Years of Drawing*. Ottawa, Ontario: National Gallery of Canada, 1990.

Rushing, W. Jackson III, and Kristin Makholm. *Modern Spirit: The Art of George Morrison*. Norman: University of Oklahoma Press, 2013.

————. *Allan Houser: An American Master*. New York: Abrams, 2004.

Scholder, Fritz. "On the Work of a Contemporary American Indian Painter." *Leonardo* 6, no. 2 (Spring 1973): 109–12.

Scholder, Fritz, and Joshua C. Taylor. *Fritz Scholder/ The Retrospective 1960–1981*. Tucson, Ariz.: Tucson Museum of Art, 1981.

Scott, Jay. *Changing Woman: The Life and Art of Helen Hardin*. Flagstaff, Ariz.: Northland Publishing, 1989.

Sims, Lowery Stokes, ed. *Fritz Scholder: Indian/Not Indian*. Washington, DC: National Museum of the American Indian, 2008.

Sinclair, Lister, and Jack Pollock. *The Art of Norval Morrisseau*. Toronto: Methuen, 1979.

Stewart, Hilary. *Robert Davidson, Haida Printmaker*. Seattle: University of Washington Press, 1979.

Wallo, William, and John Pickard. *T. C. Cannon Native American: A New View of the West*. Oklahoma City: National Cowboy Hall of Fame and Western Heritage Center, 1990.

Winnipeg Art Gallery. *Jackson Beardy: A Life's Work*. Winnipeg, Manitoba: Winnipeg Art Gallery, 1995.

Zepp, Norman, and Michael Parke-Taylor. *Bob Boyer, Edward Poitras: Horses Fly Too*. Regina, Saskatchewan: Mackenzie Art Gallery, 1984.

CHAPTER 8: NATIVE COSMOPOLITANISMS: 1980 AND BEYOND

General Works, Directories, and Exhibition Catalogues

Abbot, Lawrence, ed., *I Stand in the Center of the Good: Interviews with Contemporary Native American Artists*. Lincoln: University of Nebraska Press, 1994.

Acland, Joan Reid. *First Nations Artists in Canada: A Biographical/Bibliographical Guide, 1960–1999*. Montreal: The Gail and Stephen A. Jarislowsky Institute for Studies in Canadian Art, 2001.

Allison, Jane, ed., *Native Nations: Journeys in Native American Photography*. London: Barbican Art Gallery, 1998.

Anthes, Bill. "Contemporary Native Artists and International Biennial Culture." *Visual Anthropology Review* 25, no. 2 (2009): 109–27.

Ash-Milby, Kathleen, ed. *Hide: Skin as Material and Metaphor*. Washington, DC: National Museum of the American Indian, 2009.

————, ed. *Off the Map: Landscape in the Native Imagination*. Washington, DC: National Museum of the American Indian, 2007.

Baker, Joe, and Gerald McMaster, ed. *Remix: New Modernities in a Post-Indian World*. Washington, DC: National Museum of the American Indian, 2007.

Bigfeather, Joanna, ed. *Native Views: Influences of Modern Culture, A Contemporary Native American Art Exhibition*. Ann Arbor, Mich.: Artrain USA, 2004.

Black, Anthea and Nicole Burish. "Craft Hard, Die Free: Radical Curatorial Strategies for Craftivism in Unruly Contexts." In *The Craft Reader*, edited by Glenn Adamson, 609–19. Oxford: Berg, 2010.

Blomberg, Nancy, ed. *Action and Agency: Advancing the Dialogue on Native Performance Art*. Denver: Denver Art Museum, 2010.

Blomberg, Nancy, ed. *[Re]inventing the Wheel: Advancing the Dialogue on Contemporary American Indian Art*. Denver: Denver Art Museum, 2008.

Claxton, Dana, Steven Loft, Melanie Townsend, Candice Hopkins, eds. *Transference, Tradition, Technology: Native New Media Exploring Visual and Digital Culture*. Banff, Alberta: Walter Phillips Gallery Editions, 2006.

Decker, Julie. *Icebreakers: Alaska's Most Innovative Artists*. Anchorage, Alas.: Decker Art Services, 1999.

Dowell, Kristin L. *Sovereign Screens: Aboriginal Media on the Canadian West Coast*. Lincoln: University of Nebraska Press, 2013.

Essays on Native Modernism: Complexity and Contradictions in American Indian Art. Washington, DC: National Museum of the American Indian, 2006.

Gonzalez, Jennifer A. *Subject to Display: Reforming Race in Contemporary Installation Art*. Cambridge, Mass.: MIT Press, 2008.

Hammond, Harmony, and Jaune Quick-to-See Smith, eds. *Women of Sweet Grass, Cedar and Sage*. New York: Gallery of the American Indian Community House, 1985.

Horton, Jessica, and Janet Catherine Berlo. "Beyond the Mirror: Indigenous Ecologies and 'New Materialisms' in Contemporary Art." *Third Text* 27, no. 1 (2013): 17–28.

Kastner, Carolyn, ed., *Fusing Traditions: Transformations in Glass by Native American Artists*. San Francisco: Museum of Craft & Folk Art, 2002.

Lamar, Cynthia Chavez, Sherry Farrell Racette, and Lara Evans, eds. *Art in Our Lives: Native Women Artists in Dialogue*. Santa Fe, N.Mex.: School of Advanced Research, 2010.

Lidchi, Henrietta, and Hulleah Tsinhnahjinnie, eds. *Visual Currencies: Reflections in Native Photography*. Edinburgh: National Museums of Scotland, 2009.

McFadden, David, and Ellen Taubman, eds. *Changing Hands: Art Without Reservation 1: Contemporary Native American Art from the Southwest*. London: Merrell Publishers, in association with American Craft Museum, 2002.

McMaster, Gerald, ed. *Reservation X: The Power of Place in Aboriginal Contemporary Art*. Seattle: University of Washington Press, 2001.

McMaster, Gerald, and Lee-Ann Martin, eds. *Indigena: Contemporary Native Perspectives*. Gatineau, Quebec: Canadian Museum of Civilization, 1992.

McNutt, Jennifer Complo, ed. *We Are Here! The Eiteljorg Contemporary Art Fellowship, 2011*. Indianapolis, Ind.: Eiteljorg Museum of American Indians and Western Art, 2011.

Metcalf, Bruce. "Replacing the Myth of Modernism." In *Neocraft: Modernity and the Crafts*, edited by Sandra Alfoldy, 4–32. Halifax: Nova Scotia College of Art and Design Press, 2007. [originally published in *American Craft*, Feb/March 1993].

Mithlo, Nancy Marie, ed. *Manifestations: New Native Art Criticism*. Santa Fe, N.Mex.: Museum of Contemporary Native Arts, 2011.

Nahwooksy, Fred, and Richard Hill, Sr., eds. *Who Stole the Tee Pee?* New York: National Museum of the American Indian, 2000.

National Museum of the American Indian. *Vision, Space, Desire: Global Perspectives on Cultural Hybridity*. Washington, DC: National Museum of the American Indian, 2006.

Nottage, James, ed. *Art Quantum: The Eiteljorg Fellowship for Native American Fine Art, 2009.* Indianapolis, Ind.: Eiteljo2rg Museum of American Indians and Western Art, 2009.

———, ed. *Diversity and Dialogue: The Eiteljorg Fellowship for Native American Fine Art, 2007.* Indianapolis, Ind.: Eiteljorg Museum of American Indians and Western Art, 2007.

———, ed. *Into the Fray: The Eiteljorg Fellowship for Native American Fine Art, 2005.* Indianapolis, Ind.: Eiteljorg Museum of American Indians and Western Art, 2005.

Nottage, James H., and Jennifer Complo McNutt, eds. *Path Breakers: The Eiteljorg Fellowship for Native American Fine Art, 2003.* Indianapolis, Ind.: Eiteljorg Museum of American Indians and Western Art, 2003.

Pearlstone, Zena, and Allan J. Ryan, eds. *About Face: Self-Portraits by Native American, First Nations, and Inuit Artists.* Santa Fe, N.Mex.: Wheelwright Museum of the American Indian, 2006.

Peraza, Nilda, Marcia Tucker, and Kinshasha Conwil, eds. *The Decade Show: Frameworks of Identity in the 1980s.* New York: Museum of Contemporary Hispanic Art, The New Museum of Contemporary Art, The Studio Museum in Harlem, 1990.

Phillips, Ruth B. "Settler Monuments, Indigenous Memory: Dis-Membering and Re-Membering Canadian Art History." In *Monuments and Memory: Made and Unmade,* edited by Robert Nelson and Margaret Olin, 281–304. Chicago: University of Chicago Press, 2003.

Racette, Sherry Farrell, ed. *Close Encounters: The Next 500 Years.* Winnipeg, Manitoba: Plug In Editions, 2011.

Rickard, Jolene. "Visualizing Sovereignty in the Time of Biometric Sensors." *The South Atlantic Quarterly* 110, no. 2 (Spring 2011): 465–82.

Rushing, W. Jackson, ed. *After the Storm: The Eiteljorg Fellowship for Native American Fine Art, 2001.* Indianapolis, Ind.: Eiteljorg Museum of American Indians and Western Art, 2001.

Ryan, Allen. *The Trickster Shift: Humour and Irony in Contemporary Native Art.* Vancouver: University of British Columbia Press, 1999.

Smith, Jaune Quick-to-See, ed. *The Submuloc Show/Columbus Wohs.* Phoenix: Atlatl Press, 1992.

Stedelijk Museum. *Notion of Conflict: A Selection of Contemporary Canadian Art.* Amsterdam: Stedelijk Museum, 1995.

Sweet, Jill D., and Ian Berry, eds. *Staging the Indian: The Politics of Representation.* Saratoga Springs, N.Y.: The Tang Teaching Museum and Art Gallery at Skidmore College, 2002.

Taubman, Ellen, and David McFadden, eds. *Changing Hands: Art Without Reservation 3, Contemporary Native North American Art from the Northeast and Southeast.* New York: Museum of Arts and Design, 2012.

———, eds. *Changing Hands: Art Without Reservation 2, Contemporary Native North American Art from the West, Northwest, and Pacific.* New York: Museum of Arts and Design, 2005.

Tsinhnahjinnie, Hulleah J., and Veronica Passalacqua, eds. *Our People, Our Land, Our Images: International Indigenous Photographers.* Berkeley, Calif.: Heyday Books, 2006.

Wilmer, S. E., ed. *Native American Performance and Representation.* Tucson: University of Arizona Press, 2009.

Individual Artists

Allen, Jan. *Annie Pootoogook: Kingait Compositions*. Kingston, Ontario: Agnes Etherington Art Centre, 2011.

Anreus, Alejandro, ed. *Subversions/Affirmations: Jaune Quick-to-See Smith: A Survey*. Jersey City, N.J.: Jersey City Museum, 1996.

Augaitis, Diana, and Kathleen Ritter, eds. *Rebecca Belmore: Rising to the Occasion*. Vancouver: Vancouver Art Gallery, 2008.

Bailey, Jann L. M., and Scott Watson. *Rebecca Belmore: Fountain*. Vancouver: Kamloops Art Gallery and the Morris & Helen Belkin Art Gallery, University of British Columbia, 2005.

Bell, Michael. *Kanata: Robert Houle's Histories*. Ottawa, Ontario: Carleton University Art Gallery, 1993.

Berlo, Janet Catherine. *Arthur Amiotte: Collages, 1988–2006*. Santa Fe: Wheelwright Museum of the American Indian, 2006.

Breunig, Robert. *Houser and Haozous: A Sculptural Retrospective*. Phoenix: The Heard Museum, 1983.

Conrad, Amalia Pistilli. "'A Many Spendoured Thing'—Liminality as Empowering Discursive Space in Rosalie Favel's Digital Art." In *Visual Currencies: Reflections on Native Photography*, edited by Henrietta Lidchi and Hulleah J. Tsinhnahjinnie, 37–54. Edinburgh: National Museums Scotland, 2009.

Decker, Julie. *John Hoover: Art and Life*. Seattle: University of Washington Press, 2002.

Dobkins, Rebecca. *Rick Bartow: My Eye*. Salem, Oreg.: Hallie Ford Museum of Art, 2002.

Dubin, Lois Sherr. *Arctic Transformations: The Jewelry of Denise and Samuel Wallace*, Easton Studio Press, 2005.

Duffek, Karen, ed. *Robert Davidson: The Abstract Edge*. Vancouver: University of British Columbia, Museum of Anthropology, 2004.

Duffek, Karen, and Charlotte Townsend-Gault, eds. *Bill Reid and Beyond: Expanding on Modern Native Art*. Vancouver: Douglas & McIntyre, 2004.

Durham, Jimmie. "1000 Words." *Artforum InterNational* 47, no. 5 (January 2009): 189.

————. *Jimmie Durham: Rejected Stones/Jimmie Durham: Pierres Rejetées*. Paris: Musée d/art modern de la ville de Paris, 2009.

————. *Jimmie Durham: Between the furniture and the Building (Between a Rock and a Hard Place)*. Munich: Kunstverein München; Berliner Künstlerprogramm DAAD, 1998.

————. "They Forgot That Their Prison Is Made of Stone, and Stone Is Our Ally." In *Columbus Day: Poems, Drawings and Stories about American Indian Life in the Ninetten-Seventies*. Minneapolis, Minn.: West End Press, 1983.

Egger, Ronald. "Nicholas Galanin—Tlingit/Aleut." *Contemporary North American Indigenous Artists*, March 28, 2010: http://contemporarynativeartists.tumblr.com/post/479617639/nicholas-galanin-tlingit-aleut.

Enright, Robert. "The Poetics of History: An Interview with Rebecca Belmore." *Border Crossings* 24, no. 3 (November 2005): 63–70.

Gardiner, Paul, ed. *Robert Houle's Paris/Ojibwa*. Peterborough, Ontario: Art Gallery of Peterborough, 2011.

Haas, Lisbeth, Paul Chaat Smith, and Truman Lowe. *James Luna: Emendatio*. Washington, DC: National Museum of the American Indian, 2005.

Hill, Greg A. "Caught . . . (Red-handed)." In *Caught in the Act: The Viewer as Performer*, edited by Josée Drouin-Brisebois. Ottawa, Ontario: National Gallery of Canada, 2008.

Hill, Richard William. "Jeff Thomas: Working Histories." In *Jeff Thomas: A Study of Indian-Ness*, 8–19. Toronto: Gallery 44, 2004.

Horton, Jessica L. "Alone on the Snow/Alone on the Beach: 'A Global Sense of Place' in *Atanarjuat* and *Fountain*." *Journal of Transnational American Studies* 4, no. 1 (2012): 1–25.

Houle, Robert. "Translation/Transportation." In *Nadia Myre, Cont[r]act*, edited by Rhonda l. Meier, 20–9. Montreal: Dark Horse Productions, 2004.

Hoving, Thomas. *The Art of Dan Namingha*. New York: Abrams Press, 2000.

Jungen, Brian, and Diana Augaitis. *Brian Jungen*. Vancouver: Vancouver Art Gallery, in association with Douglas & McIntyre, 2005.

Kalbfleisch, Elizabeth. "Bordering on Feminism: Space, Solidarity and Transnationalism in Rebecca Belmore's *Vigil*." In *Indigenous Feminism: Culture Politics, Activism*, edited by Cheryl Suzack, Shari Huhndorf, Jeanne Perreault, and Jean Barman. Vancouver: University of British Columbia Press, 2010.

————. *Bordering on Feminism: Home and Transnational Sites in Recent Visual Culture and Native Women's Art*. PhD dissertation, Program in Visual and Cultural Studies, University of Rochester, Rochester, N.Y., 2009.

Kastner, Carolyn. *Jaune Quick-To-See Smith: An American Modernist*. Albuquerque: University of New Mexico Press, 2013.

Lewis, Jason Edward, and Skawennati Fragnito. "Art Work as Argument." *Canadian Journal of Communication* 37, no. 1 (2012): 205–12.

Lewis, Randolph. *Alanis Obamsawin, The Vision of a Native Filmmaker*. Lincoln: University of Nebraska Press, 2006.

Liss, David, and Shirley Madill. *Kent Monkman: The Triumph of Mischief*. Hamilton, Ontario: Art Gallery of Hamilton, 2007.

Lowe, Truman. *Haga (Third Son): An Exhibition of Sculpture, Drawing and Painting*. Indianapolis, Ind.: Eiteljorg Museum of American Indians and Western Art, 1994.

Luna, James. *Emendatio*. Washington, DC: National Museum of the American Indian, 2005.

————. "Sun and Moon Blues." In *Obsession, Compulsion, Collection: On Objects, Display Culture, and Interpretation*, edited by Anthony Kiendl. Toronto: Banff Centre Press, 2004.

Majkowski, Tina. "Gypsies, Tramps, Half-Indian, All Queer, and Cher: Kent Monkman Defining Indigeneity through Indian Simulation and Accumulation." In *Action and Agency: Advancing the Dialogue on Native Performance Art*, edited by Nancy Blomberg, 102–25. Denver: Denver Art Museum, 2010.

Madill, Shirley, ed. *Robert Houle: Sovereignty over Subjectivity*. Winnipeg, Manitoba: The Winnipeg Art Gallery, 1999.

McAlear, Donna, ed. *Rosalie Favell: I Searched Many Worlds*. Winnipeg, Manitoba: The Winnipeg Art Gallery, 2003.

McIntosh, David. "Miss Chief Eagle Testickle, Postindian Diva Warrior, in the Shadowy Hall of Mirrors." In *Kent Monkman: The Triumph of Mischief*. Hamilton, Ontario: Art Gallery of Hamilton, 2008.

Meier, Rhonda L., ed. *Nadia Myre: Cont[r]act*. Montreal: Dark Horse Productions, 2004.

Nichols, David, ed. *Instrument of Change: James Schoppert Retrospective*. Anchorage, Alas.: Anchorage Museum of History and Art, 1997.

Nicholson, Marianne. "Marianne Nicolson Speaks . . ." In *Reservation X: The Power of Place in Aboriginal Contemporary Art*, edited by Gerald McMaster, 99–101. Hull, Quebec: Canadian Museum of Civilization, 1998.

Ortel, Jo. *Woodland Reflections: the Art of Truman Lowe*. Madison: University of Wisconsin Press, 2003.

Phillips, Ruth B. "Cayuga Cosmopolitanism: The Beaded Art of Sam Thomas." In *Power of Place-Strength of Being*, edited by Samuel Thomas, 17–20. De Pere, Wisc.: The Oneida Museum. 2012.

Podedworny, Carol. *Troubling Abstraction: Robert Houle*. Hamilton, Ontario: McMaster Museum of Art, 2007.

————. "New World Landscape: Urban First Nations Photography, Interview with Jeffrey Thomas." *Fuse* 19, no. 2 (1996): 2, 39.

Rickard, Jolene. "Skins Seven Spans Thick." In *Hide: Skins as Material and Metaphor*, edited by Kathleen Ash-Milby. Washington, DC: National Museum of the American Indian, 2010.

Rhyne, Charles S. *Expanding the Circle: The Art of guud san glans, Robert Davidson*. Portland, Oreg.: Douglas F. Cooley Memorial Art Gallery, 1998.

Rushing, W. Jackson. "Street Chiefs and Native Hosts: Richard Ray (Whitman) and Hachivi Edgar Heap of Birds Defend the Homeland." In *Green Acres: Neo-Colonialism in the U.S.*, edited by Christopher Scoates, 22–40. St. Louis: Washington University Gallery of Art, 1992.

Sense, Sarah. *Weaving the Americas/ Tejiendo las Américas, A Search for Native Art in the Western Hemisphere*. Rocklin, Calif.: Pascoe, 2012.

Simmons, Deidre, ed. *Colleen Cutschall: Voice in the Blood*. Brandon: Art Gallery of Southwestern Manitoba, 1990.

Smith, Jaune Quick-to-See. "Celebrate 40,000 Years of American Art." *Frontiers: A Journal of Women Studies* 23, no. 2 (2002): 154–5.

Struever, Martha Hopkins, ed., *Loloma: Beauty Is His Name*. Santa Fe, N.Mex.: Wheelwright Museum of the American Indian, 2005.

Svenson, Michelle. "Growing Up in Igloolik: An Interview with Zacharias Kunuk." *Native Networks*, April 1, 2002: http://www.nativenetworks.si.edu/eng/rose/kunuk_z_interview.htm

Thomas, Jeff, ed. *Jeff Thomas: A Study of Indian-Ness*. Toronto: Gallery 44 Centre for Contemporary Photography, 2004.

Thomas, Samuel. *Power of Place-Strength of Being*. De Pere, Wisc.: The Oneida Museum, 2012.

Tougas, Colette, Édit-Anne Pageot, Sandra Dick, and Amanda Jane Graham. *Nadia Myre: En[counter]s*. Montreal: Éditions Art Mûr, 2011.

Townsend-Gault, Charlotte. "Rebecca Belmore and James Luna on Location in Venice: The Allegorical Indian Redux." *Art History* 29, no. 4 (2006): 721–55.

Townsend-Gault, Charlotte, Rebecca Belmore, James Luna, and Scott Watson. *Rebecca Belmore: The Named and the Unnamed*. Vancouver: The Morris and Helen Belkin Art Gallery, 2003.

Townsend-Gault, Charlotte, Scott Watson, and Lawrence Paul Yuxweluptun, eds. *Lawrence Paul Yuxweluptun: Born to Live and Die on Your Colonialist Reservations*. Vancouver: Morris and Helen Belkin Art Gallery, 1995.

Turney, Laura. "Ceci n'est pas Jimmie Durham." *Critique of Anthropology* 19, no. 4 (1999): 423–42.

Vigil, Jennifer. "Will Wilson: Fellowship Artist." In *Diversity and Dialogue: The Eiteljorg Fellowship for Native American Fine Art*, edited by James H. Nottage, 98–106. Seattle: University of Washington Press, 2007.

Wlasenko, Olexander. *Michael Belmore: Embankment*. Whitby, Ontario: Station Gallery, 2009.

Wyatt, Gary, ed. *Susan Point: Coast Salish Artist*. Vancouver: Douglas & McIntyre, 2000.

INDEX

NOTE: Italicized page numbers indicate an illustration, work of art, photograph, or map on the indicated page.